Ancestral Caddo Ceramic Traditions

ANCESTRAL CADDO CERAMIC TRADITIONS

EDITED BY

Duncan P. McKinnon, Jeffrey S. Girard, and Timothy K. Perttula

Louisiana State University Press

Baton Rouge

Published with the assistance of the V. Ray Cardozier Fund

Published by Louisiana State University Press

www.lsupress.org

Manufactured in the United States of America
First printing

Designer: Laura Roubique Gleason
Typeface: Adobe Jenson Pro
Printer and binder: Sheridan Books

Cover images (*clockwise*): Ripley Engraved, Nash Neck Banded, and Johns Engraved, photos by Bo Nelson; Intertwining Scrolls, from the Smithsonian National Museum of the American Indian (26/5160); Fired Pot "Hadiku," photo by Chase Earles.

Library of Congress Cataloging-in-Publication Data

Names: McKinnon, Duncan P. (Duncan Paul), 1971– editor. | Girard, Jeffrey S., editor. | Perttula, Timothy K., editor.
Title: Ancestral Caddo ceramic traditions / edited by Duncan P. McKinnon, Jeffrey S. Girard, and Timothy K. Perttula.
Description: Baton Rouge : Louisiana State University Press, [2021] | Includes bibliographical references and index.
Identifiers: LCCN 2020025832 | ISBN 978-0-8071-7118-9 (cloth)
Subjects: LCSH: Caddo Indians—Antiquities. | Caddo Indians—History. | Indian pottery—Southern States. | Excavations (Archaeology)—Southern States.
Classification: LCC E99.C12 A63 2021 | DDC 975/.0049793—dc23
LC record available at https://lccn.loc.gov/2020025832

To the Caddo Nation of Oklahoma and to Dr. Ann Early

CONTENTS

III. Contemporary Caddo Ceramic Traditions

PREFACE

The study of ceramics is a key part of understanding the lifeways and heritage of the Caddo peoples in ancestral and modern times. Ceramic vessels made for cooking, storage, and serving were of primary importance to the ancestral Caddo peoples who, between ca. AD 800 and the early nineteenth century, inhabited southwestern Arkansas, northwestern Louisiana, eastern Oklahoma, and East Texas, an extensive region known as the Caddo Archaeological Area. The Woodland period ancestors of the Caddos began manufacturing ceramics as much as 3,000 years ago; several members of the modern Caddo Nation of Oklahoma continue this tradition to the present, and this work provides much-needed new perspectives for archaeologists studying ancestral Caddo ceramics. The styles, forms, and craftsmanship of ceramics found on archaeological sites in the region highlight the variety, temporal span, and geographic extent of ancestral Caddo groups spread across the landscape. Decorations and shapes of Caddo ceramics are diverse as well as unique in Southeastern Native American ceramic traditions, including both utility-ware jars and bowls, as well as fine-ware bottles, carinated bowls, and compound vessels. The Caddos also occasionally made ceramic smoking pipes, ear ornaments, figurines, beads, and other items from clay. Caddo artistic, symbolic, and expressive traditions are tied to distinctive communities of identity and practice. Analyses of technological and stylistic attributes carried out since the mid-twentieth century have enabled Caddo researchers to recognize the existence of social networks that were present in ancestral times.

In this book, the contributors provide a combination of both archaeological and modern Caddo potter perspectives on ancestral Caddo ceramic traditions. There are discussions of how Caddo potters made ceramics in a wide variety of vessel shapes, employing distinctive technological traditions of clay and temper choice, surface finishing techniques, and firing conditions. The Caddos employed an abundance of well-crafted and executed rim and body design elements and motifs. From studies of archaeological contexts, as well as from inferences about manufacture and use, it is evident that ceramics were important to ancestral Caddo peoples in the cooking and serving of foods and beverages, in the storage of foodstuffs and other goods (i.e., pigments and ritually used items), as personal possessions or heir-

looms, and as beautiful works of art and craftsmanship since some vessels clearly were not made to be used in domestic contexts. Ceramics also operated as social identifiers; that is, certain shared and distinctive stylistic motifs and decorative patterns marked closely related communities and constituent groups. Other motifs may have been more personal, perhaps deriving from body tattoo motifs or from specific family lineages, traditions, or a shared heritage.

The book contains three sections. Part I begins with an essay tracing the history of archaeological studies from the early descriptive efforts of Clarence B. Moore and Mark R. Harrington in the early twentieth century to the development of traditional typological approaches pioneered by James A. Ford, Clarence H. Webb, and Alex D. Krieger. More recent studies comprise nontypological examinations of style (i.e., decoration and design patterns, rules of grammar, and iconography), analyses of vessel forms and functions, and studies of technological attributes, including chemical compositional analyses and petrographic characterizations of vessel pastes.

The remaining essays in Part I are written by regional Caddo ceramic experts and include discussions of the character of Woodland period ceramic antecedents (dating from ca. 3,000–1,150 years ago, depending on the region); the temporal framework—periods and phases—used to organize Caddo ceramic assemblages in specific regions; the stylistic-technological-functional character of assemblages and traditions; and the principal defined ceramic types and their temporal/spatial distributions. These essays are well illustrated with vessel images and key decorative elements from sherd assemblages. The Part I essays highlight the regional diversity of ancestral Caddo ceramic traditions throughout the Caddo Archaeological Area.

Although there is no unanimity between archaeologists working in different regions within the Caddo Archaeological Area about the establishment of meaningful chronological boundaries, it is useful to divide the ancestral Caddo record into different periods for the purposes of this book. Commonly, archaeological contexts are assigned to one or more of these periods—or a portion of a period—by the character of temporally diagnostic ceramic and/or lithic artifacts more than any other aspect of the Caddo archaeological record. Nevertheless, Caddo archaeological components are increasingly assigned ages based on calibrated radiocarbon dates, age ranges, and the data combination process to refine site-specific probability distributions.

The essays in Part II concern the study of ceramic variation and social interactions through stylistic analysis and grammar, 3D geometric analyses, the use of instrumental neutron activation analysis (INAA), iconographic analysis, and considerations of community identity and practice in ceramic assemblages in different times and different parts of the Caddo world. They explore ancestral Caddo ceramic style zones and the recognition and definition of past social groups and

social networks, as well as community interactions and large-scale ceramic and social variations across the Caddo Area.

Part III concludes the book with essays from two contemporary Caddo potters, Jeri Redcorn and Chase Earles. They discuss the revival of the Caddo ceramic tradition since the 1990s, ceramic making, identity, and artistic expression from modern Caddo perspectives.

This book is the first comprehensive consideration of the craftsmanship, artistry, and stylistic-technological characteristics of ancestral Caddo ceramic traditions. It offers a valuable synthesis on the current state of the study of ancestral Caddo ceramic traditions as well as the modern manufacture of ceramic vessels by Caddo potters. It will also serve as a current reference regarding both archaeological and modern Caddo ceramic studies. Because the book includes contributions by ceramic experts that highlight both archaeological and modern Caddo ceramic perspectives, it will be of interest to the archaeological community, the Caddo peoples and other Native American groups that made or continue to make pottery, as well as to the general public.

I

The Framework of Studies of Ancestral
Caddo Ceramics and Regional Traditions

I

Approaches to the Study of Ancestral Caddo Ceramics

Timothy K. Perttula, Jeffery S. Girard, Duncan P. McKinnon, and David G. Robinson

Traditional Studies of Caddo Ceramics

Most analyses of Caddo ceramics aim to identify past social groups and determine their spatial and temporal parameters in the Caddo Area since Woodland period times (figure 1.1 and table 1.1). Traditional approaches were relatively straightforward: identify (principally decorative) variation in recovered ceramic vessels and/or sherds, formulate classes of similar decorative styles, and map these geographically (and when possible, temporally). Clusters of stylistic classes (types or varieties of types) in time and space were interpreted as products of distinct social groups. This basic strategy often is still employed today, although complexities are now recognized for understanding past social relationships from ceramic analyses, and many recent studies pursue different topics such as production technology, the gifting or exchange of ceramic vessels, and understanding past worldviews and cosmologies.

The earliest published and widely disseminated studies of Caddo ceramics, such as that of Clarence B. Moore (1912), did not attempt to classify ceramic vessels but provided illustrations and descriptions that were later used for comparative purposes. Mark Harrington's (1920) report on the ceramics recovered from sites in southwestern Arkansas is the first major study of Caddo ceramics. Harrington attributed archaeological sites and artifacts to an ancestral Caddo culture and referred to ethnohistoric information on the Tejas or Cenis (Hasinai) of East Texas. He labeled engraved pottery "Red River ware" because of its apparent concentration along the Red River in the Great Bend and Little River areas, and he noted stylistic similarities with ceramics to the east in the Ouachita River drainage. Although lacking specific information (other than Moore's illustrations), he speculated that similar pottery would be found to the south. Harrington (1920:164) was impressed by both the quantity and quality of pottery in the Arkansas sites. Engraving was considered characteristic of the Caddos, but he recognized its

Figure 1.1. Southern and northern Caddo Areas.

Legend:
- Caddo Area
- Trans-Mississippi South

Map labels: Kansas, Missouri, Oklahoma, Arkansas, Northern Caddo Area, Southern Caddo Area, Texas, Louisiana; Arkansas R., Ouachita R., Caddo R., Little R., Red R., Sulphur R., Cypress C., Sabine R., Red R., Angelina R., Neches R.

Scale: 0 20 40 80 kilometers / 0 20 40 80 miles

Table 1.1. A Chronological Framework for Caddo Archaeology

Period	Age Range
Woodland period	ca. 1000 BC–AD 800
Formative Caddo	ca. AD 800/850–1000
Early Caddo	ca. AD 1000–1200
Middle Caddo	ca. AD 1200–1400
Late Caddo	ca. AD 1400–1680
Historic Caddo	ca. AD 1680–1840+

occasional appearance in the Southeast United States at the Moundville site in Alabama and elsewhere in the region, suggesting "affiliations of the old Caddo culture with that of the southeastern region." Other decorative techniques such as trailing, incising, impressed decorations (punctations), appliqued nodes and ridges, and red slip were noted as was the absence of paddle-stamped decorations commonly found in other areas of the Southeast. Harrington organized his discussion of pottery by vessel form: bowls, pots (or jars), bottles, and unusual forms (combinations, triangular vessels, as well as fish and turtle effigies). He also offered functional interpretations, arguing that distinct vessels likely were used for cooking, storage of water and oils, serving and ceremonies, and as toys.

Major changes in the interpretation of Caddo ceramics took place in the 1930s with the formulation of both ceramic types and cultural taxonomies. Chronology became important particularly with the work of James Ford (1936) in the Lower Mississippi Valley. Ford devised a descriptive system for sherds based on combinations of design elements, but initially he did not identify styles or define types.

He worked out spatial patterns and assigned clusters to historic tribal groups: Choctaw, Natchez, Caddo, and Tunica. He also recognized earlier complexes and defined three entirely prehistoric cultural units: Deasonville, Coles Creek, and Marksville based on the little stratigraphic data then available, including results from his ongoing work at the Greenhouse site in central Louisiana.

Typological Approaches

Ceramic typology was worked out in the Caddo area separately from, but not completely independently of, developments in the Lower Mississippi Valley and the Southeast. In the Southeast, a binomial typology had been constructed by the late 1930s and reported in the proceedings of a 1938 conference held at the University of Michigan (Ford and Griffin 1938). Until that time, comparisons across regions relied on descriptions of individual vessels. As information accumulated, it was considered necessary to group similar ceramic vessels and sherds into types as a means for interpreting broad patterns of culture history. The conference attempted to establish a unified typology across the Southeast with a review board to consider and validate changes. Although it was considered necessary for types to be defined independently of their context, they could later be divided if initially unrecognized attribute variation appeared to have historical significance. Emphasis was placed on analysis of sherds because they were available in large quantities.

Researchers in the Caddo Area participated in the Southeast conference, and Webb and Dodd (1941) offered the first formal typology of Caddo ceramics (from the Belcher site in northwestern Louisiana, see Essay 2), with input from James Griffin and James Ford who were working in the Lower Mississippi Valley. By 1941, when Alex Krieger arrived at the University of Texas and began work with H. Perry Newell on the Works Progress Administration (WPA) materials from the George C. Davis site in East Texas, Webb had excavated at the Gahagan, Smithport Landing, and Belcher sites in northwestern Louisiana, and he had accumulated surface sherd collections from numerous sites in northwestern Louisiana. Krieger, Newell, Webb, and others established the first Caddo Area wide types at a small weekend meeting at Webb's house in January 1942 (Webb 1978).

Krieger's ideas about establishing types were presented in a 1944 article published in *American Antiquity* (Krieger 1944a). He argued that the analyst, through trial and error, established types. The analyst identified what appeared to be consistent styles and then determined their historical significance by examining distributions to see if they exhibited temporal-spatial contiguity. Once established, types related in time and space could then be used to define material-cultural complexes that represented past cultural units. The types were constructed and their validity tested empirically. There were no theoretical arguments linking styles or types to specific past social behaviors or ideas about historical or evolutionary pro-

cesses (Lyman et al. 1997:108–9), although Krieger acknowledged that past mental patterns and behaviors lay behind the existence of types.

In their 1951 report on the archaeology of the Lower Mississippi Valley, Phillips et al. (1951) explicitly discussed the theoretical basis that warranted their concept of ceramic types. Although there were some differences in how types were used in the Caddo Area, the general ideas were similar. Types consisted of clusters of attributes that reflected past "styles" characteristic of different social groups. Analysts created types with two different interests in mind: "(1) interest in objects as expressions of the ideas and behavior of the people who made and used them; and (2) interest in objects as fossils for the determination of time and space relations" (Phillips et al. 1951:62). The first interest was considered cultural, the latter empirical. Phillips, Ford, and Griffin took a "frankly, if not fanatically, empirical attitude toward the material." Types were summations of style, and it was assumed that cultural groups made and discarded ceramics with unique sets of styles. They recognized that more than one type could be related to any particular community—perhaps made for different purposes—or derived from different sources. Despite their empirical attitude, however, the type definition was considered a description of the past norm or essence in the minds of the makers:

> If any one of these particular styles is examined at a single place and a single point in time, it will be seen that, while each vessel varies in minor detail, such variations tend to cluster about a norm. This norm represents the consensus of community opinion as to the correct features for this particular kind of vessel. Variations from the norm reflect the individual potter's interpretation of the prevailing styles, and the degree of variation tolerated is also culturally controlled. (Phillips et al. 1951:62)

For the Lower Mississippi Valley, Wheat et al. (1958) and Phillips (1958) employed the concept of type "varieties" to deal with variation in ceramic styles that was considered minor empirically but potentially useful for cultural-historical interpretation. The type-variety system, however, was not used in Caddo ceramic typology until many years later. Phillips et al. (1951:63) noted the "arbitrariness of the whole typological procedure" but they aspired to construct types that corresponded with the categories of the ceramic makers. They saw continuous variability of style in time and space: ". . . faced with this three-dimensional flow, which seldom if ever exhibits 'natural' segregation, and being obliged to reduce it to some sort of manageable form, we arbitrarily cut it into units. Such created units of the ceramic continuum are called pottery types."

The ambiguities inherent in forming ceramic types proved problematic and have never been fully resolved. Brew (1946) argued that types are tools of the researcher; categories are imposed on data rather than discovered empirically. In contrast, Spaulding (1953) saw types as discoveries of clustering of styles in time and space.

Phillips et al. (1951), and Krieger (1944a) before them, acknowledged the arbitrary nature of typological boundaries but argued that types could be empirically recognized and were thus not completely imposed on the ceramics present in the archaeological record. Because of the empirical nature of the type concept, it was assumed that as data accumulated from archaeological investigations, typological boundaries would become increasingly clear. This trend, however, has proven not to be the case as typological classes have proliferated and classificatory disputes have become more pronounced. As new variations came to light in ceramic analyses, there were no rules regarding either the expansion of definitions of existing types, or for the establishment of new types. Due to a lack of theoretical backing, no necessary and sufficient principles for the formulation of types have been developed in the Caddo Area. Although defining ceramic types and varieties remains somewhat of a folk art in Caddo Area ceramic research, it continues to be considered useful for describing stylistic variation through time and across space. As described below, however, other ways of examining ceramic variability currently are being explored by Caddo archaeologists.

As the archaeological record becomes better understood, notions about how the Caddo people organized themselves across the landscape change substantially. For traditional culture history, the creation and use of ceramic typology was considered fundamentally important because combinations of types were used as definitive criteria for the formulation of cultural historical taxonomic units—initially foci using the Midwestern Taxonomic Method in the Caddo Area, then later as phases (see Girard et al. [2014:17–22] for a discussion of the use of foci and phases in the Caddo Area). Although constructed in different ways, both the focus and phase concepts were employed to identify past social groups who lived within specific territories and produced ceramics of distinctive styles. Groups that persisted for sufficient intervals of time generated an archaeological manifestation such as a focus or phase within a particular territory, and thus distinctive past societies were discoverable through ceramic classification and mapping of types in time and space. Even by the late 1950s, however, based on accumulating empirical evidence, doubts were raised about the degree to which ceramic types and other cultural traits neatly clustered in space and time (e.g., Davis 1961:10). Theoretical challenges to the culture history approach in the following decades changed discussions regarding the use of ceramic types for definition of cultural units.

Researchers continue to connect ceramic variability to past social groups in Caddo Area studies but now expand their ideas regarding the nature of the social connections to which ceramic types can be related. It has become clear that past peoples, like those today, were socially connected at varying spatial scales, and many relationships crosscut local groups or communities. Some ceramic traits were maintained over long spans of time, while others were not. Some styles were shared across vast regions, while others existed only locally. Krieger's empirical test

of spatial-temporal contiguity for understanding past cultural patterns is based on premises that now are recognized as too simplistic. Ceramic styles and technological practices transmit information and relate to past networks of kinship, communication, and interaction that formed distinctive communities of identity and practice. Although local group or community affiliation is important in determining the makeup of site assemblages, it no longer is assumed that each local community produced, used, and discarded vessels and sherds that are part of a unique set of ceramic types. Spatial and temporal distributions of many types are not attributable solely to community or "tribal" affiliation.

Nontypological Approaches to Understanding Ceramic Stylistic Diversity

DESCRIPTIVE SYSTEM

Archaeologists in Arkansas have developed a nontypological analysis known as the descriptive system, starting with rim and body ceramic sherd assemblages from the Shallow Lake site situated within the Felsenthal region, a cultural region on the border of the Caddo Area to the south and east (Schambach 1981:fig. 22). Since that time, a select group of researchers have applied this system to assemblages at a few Arkansas and Louisiana sites (DeMaio 2013; Early 1988, 1993; Early ed. 2000; Kelley 1997; Lafferty et al. 2000; Schambach 1981; Schambach and Miller 1984; Trubitt 2012). The descriptive system is sometimes referred to as the collegiate system, largely because the classificatory naming convention assigned to ceramic rim and body patterns was derived using names of North American colleges and universities (Schambach 1981:102).

The primary goal with the descriptive system is to address ceramic design applications where Caddo ceramic vessel rim and bodies are treated as representing distinct decorative fields that are regularly interchangeable in pattern, design, and technique (i.e., punctations, incising, brushing, etc.) (Early 2012:43; Schambach 1981:107; Schambach and Miller 1984:113). The interchangeable nature of the designs within the fields, it is argued, could readily lead to the mistyping of sherds: for example, those that "overlap" with type-varieties assigned to Caddo assemblages recognized from whole vessels with those established types in the Lower Mississippi Valley based on sherd assemblages, or the assignment of Lower Mississippi Valley types to sherds that may represent new stylistic innovations (types) in the Caddo Area. Thus, the system was largely designed to address the "nearly universal practice of Caddo potters to use different design and, frequently, different decorative techniques on the rim and body of the same vessel" (Schambach and Miller 1984:113). Additionally, the fine-grained analysis that the descriptive classification offers suggests that such a method can differentiate a suite of design

elements specific to potters or communities of potters across space (cf. Early ed. 2000:111; Early and Trubitt 2013).

The descriptive classification system is organized into three hierarchical levels: class, pattern, and design fields on the rim and body. The levels move from generalized classification (class) to more specific categories (design). Class is based on decoration method where the technique (punctations, incising, brushing, etc.) is primary. Eight classes (A–H) represent different techniques. For example, Class A consists of those design elements with diagonally incised lines, whereas Class B contains horizontally incised lines. Class C is reserved for punctated designs, Class D for brushed ceramics, Class E for engraved ceramics, Class F for stamped, Class G for slipped, and Class H for ceramics with applique as the dominant technique. Within classes are patterns that represent groups of similar designs that are differentiated by surface finish, line quality, and variation in technique (Schambach 1981:115; Schambach and Miller 1984:114). The collegiate names are used to distinguish patterns where rim patterns are listed first, followed by body patterns. Within patterns are designs that represent variations that are referred to numerically. For example, a jar with a distinctive pattern of diagonally incised lines around the rim with an equally distinctive pattern of horizontal incised lines on the body would be described as Alfred 1 :: Babson 1, where Alfred 1 describes the rim pattern and design and Babson 1 describes the body pattern and design (fig. 1.2).

While this method has been applied to a few sites and has the potential to develop fine-grained design analyses of Caddo ceramic assemblages, it is, at present, incomplete. First, since its introduction 35 years ago, a reference book of patterns has yet to be published. Therefore, only those patterns that have been published as

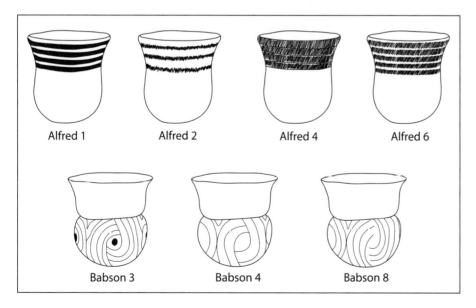

Figure 1.2. An example of the descriptive (collegiate) system of classification and notation commonly employed in Caddo ceramic analysis (after Schambach and Miller 1984:figs. 11.1, 11.3).

site-specific examples in various site reports define the comparative corpus. Second, the lack of application throughout the broader Caddo Area (applications have been largely limited to Arkansas) limits larger scale comparative distributional analysis of patterns and design variability as indicators of specific potter communities.

ICONOGRAPHIC ANALYSIS

Iconography is the description and interpretation of distinct motifs and styles on material culture objects such as ceramic vessels, marine shell, etc., and an elucidation of the meaning in those motifs and styles (Knight 2012). Iconographic analyses have a long tradition at the Spiro site in eastern Oklahoma, situated within the northern Caddo Area, with studies associated with the numerous engraved conch shells placed within the Craig Mound (Phillips and Brown 1978–84). More broadly, this type of analysis has largely been applied to assemblages east of the Mississippi River in the midcontinent and the Southeast (see Reilly and Garber 2009; Lankford et al. 2011). Perhaps this is a product of the fact that engraved marine shell is rarely present on sites in much of the Caddo Area and that the Caddo ceramic tradition primarily emphasizes abstract designs that are largely geometric, rather than figural or representational, in design.

Although a geometric tradition in decorative motifs and elements largely defines the stylistic applications of most ancestral Caddo potters, exceptions include vessels constructed in representational forms (i.e., effigy vessels) or that have been engraved with zoomorphic representations (amphibian, avian, or mammal) (Dowd 2011a; Gadus 2013a; Hart and Perttula 2010; Hammerstedt and Cox 2011). There have been some iconographic studies of these types of representations (see Essay 11). For example, Gadus (2013a) analyzed primary and secondary motifs on Ripley Engraved, Wilder Engraved, and Johns Engraved bottles and concluded that the designs and bottle form embody "a multilevel world order with the sacred pole, the center, connection to all worlds . . . occupied by various powerful beings" (Gadus 2013a:239). The designs and motifs present on the bottles (snakes, serpents, and associated swirl motifs) suggest connections with underworld or lower world themes. Hart and Perttula (2010) also highlight the dualistic representations on northeastern Texas ancestral Caddo ceramics. Vessels containing figural snakes and rattlesnakes, symbols such as the swastika and scroll, and the use of red pigment are likely associated with the underworld whereas those with sun symbols and white pigment may well be associated with above world themes.

Caddo Vessel Forms and Functions

There are differences in Caddo vessel forms through time and among contemporaneous Caddo groups, and these changes appear to be stylistic, social, and functional. According to Sadie Bedoka, a Caddo-Delaware woman interviewed by his-

torians employed by the WPA in the 1930s, "each [Caddo] clan had its own shape to make its pottery. One clan never thought of making anything the same pattern of another clan. You could tell who made the pottery by the shape" (La Vere 1998:92).

Nine distinctive vessel forms can be defined from ancestral Caddo sites, as well as more than 100 vessel shapes within the vessel form categories: bottles, bowls, carinated bowls, compound bowls (with upper and lower rim panels), conjoined vessels (including bottles, bowls, and carinated bowls joined together), deep bowls, effigy bowls, jars, and ollas (fig. 1.3a–i). The first distinction is between open con-

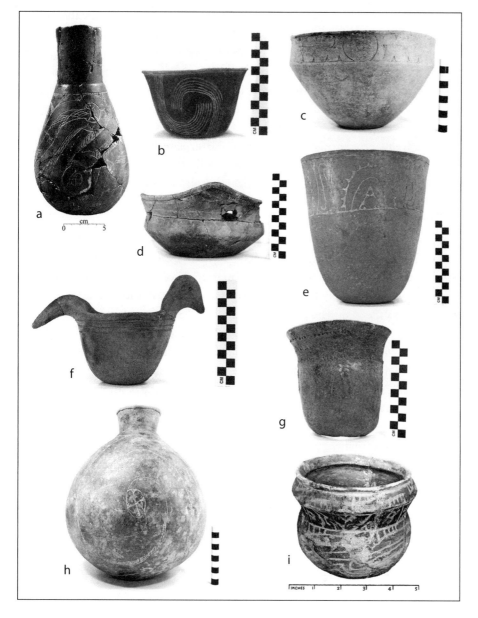

Figure 1.3. Examples of ancestral Caddo vessel forms: *a*, bottle (Washington Square Mound, 41NA49); *b*, bowl (Clements, 41CS25); *c*, carinated bowl (Shelby Mound, 41CP71); *d*, compound bowl (Johns, 41CP12); *e*, deep bowl (Boyce Smith Collection); *f*, effigy vessel (Boyce Smith Collection); *g*, jar (Sam Kaufman, 41RR16); *h*, olla (Johns, 41CP12); *i*, conjoined vessel (H. R. Taylor, 41HS3).

tainers (bowls, deep bowls, carinated bowls, and compound bowls, etc.) and restricted containers, including jars, bottles, and ollas of several shapes and sizes; conjoined vessels can be both open and restricted containers. As restricted containers, jars allow access by hand but bottles and ollas do not (Brown 1996:335). Key attributes in distinguishing the many vessel shapes among the different vessel forms include such attributes as plan view or silhouette, vessel contour, the presence of appendages or pedestals, rim height, rim profile, and lip profile.

Plain (or undecorated) ware and utility ware (i.e., decorated with wet paste designs) vessels, typically jars, were used for cooking, storage, and probably other culinary activities; they tend to have a coarse paste, thick body walls, smoothed interior surfaces, and are either undecorated or are decorated with wet paste designs (i.e., decorations were made with tools and fingers prior to the vessel being fired, when the vessel had a wet exterior surface). Fine wares are engraved (i.e., decorations cut into the vessel surface after firing) and red-slipped vessels that were used for food service and to hold liquids perhaps primarily for ritual and other communal and formal practices. They tend to have fine pastes, with finely crushed tempers, are frequently burnished on interior and/or exterior vessel surfaces (except the bottles, which were burnished on exterior surfaces only), and have relatively thin body walls compared with the plain and utility wares.

Technological Attributes

Nonplastics are the deliberate and indeterminate materials added to the clay (Rice 1987:411), including a variety of tempers (grog or crushed sherds, bone, hematite, shell, quartz sands, etc.) and "particulate matter of some size." The bone used for temper by Caddo potters likely was burned and calcined, then crushed, before it was added to the clay. The paste represents the natural constituents of the clay used, once temper is added, by Caddo potters to manufacture vessels. The paste may be a homogeneous clay, or have sand and silt inclusions, along with minerals such as iron, hematite, plagioclase feldspar, chert, microline, micrite, biotite, and quartz sands, etc., of various sizes and angularity naturally occurring in clay beds.

Clays used for vessel manufacture were probably gathered from nearby alluvial settings, but almost certainly within a short (1–7 kilometers away, at most) distance from a Caddo settlement (e.g., Arnold 2000:343), so that an inordinate amount of time and energy was not expended by potters in hauling clay back to the site. Arthur (2006:52) points out that potters would likely select lower quality, rather than higher quality, clays if the latter were farther away.

Caddo vessels tend to be fired in a variety of different ways, presumably reflecting personal preferences in firing, the desired vessel color, the kinds of clays that were used, and the functional and technological requirements of the kinds of vessel forms that were being manufactured at a specific site. Vessels were likely fired

in an open fire, with the vessels either set atop the fire or nestled in the coals and ash for reduced firing.

Variations in vessel wall thickness are likely related to functional and technological decisions made by Caddo potters in how the different ceramic wares were intended to be used. The less substantial vessel walls in some of the plain and utility wares would be well suited to the cooking and heating of foods and liquids and, because heat would have been conducted efficiently while heating rapidly, would have contributed to their ability to withstand heat-related stresses; also, the much thicker plain and utility ware vessels (with rim thicknesses greater than 9 millimeters and body wall thicknesses greater than 10–11 millimeters) would have created stronger and more stable vessels and would have been well suited for use as long-term storage containers (Rice 1987:227). Fine wares were probably intended for use in the serving of foods and liquids, and thinner and less porous vessel walls may have helped to maintain the temperature of served food and liquids; thinner and lighter vessels would have also contributed to the ease with which serving vessels could be handled, used, and transported.

Another factor that would have influenced vessel body wall thickness would have been the sequence in which a vessel was constructed (Krause 2007:35). Vessels constructed from the bottom up, as most Caddo vessels likely were, would tend to have thinner walls moving up the vessel body towards the rim, with the significantly thicker lower portion of the vessel serving as a support during later vessel construction.

The primary methods of finishing the surface of Caddo ceramic vessel include smoothing, burnishing, and polishing (Rice 1987:138), although polishing is rarely seen on vessels in burial contexts or in sherd assemblages because of preservation conditions (Perttula 2013). Smoothing creates "a finer and more regular surface . . . [and] has a matte rather than a lustrous finish" (Rice 1987:138). Burnishing, on the other hand, creates an irregular lustrous finish marked by parallel facets left by the burnishing tool (perhaps a pebble or bone). A polished surface treatment is marked by a uniform and highly lustrous surface finish, done when the vessel is dry, but without "the pronounced parallel facets produced by burnishing leather-hard clay" (Rice 1987:138).

The application of a hematite-rich clay slip (Ferring and Perttula 1987), either red or black after firing in an oxidizing or reducing (i.e., low-oxygen) environment, is another form of surface treatment that is present in some Caddo vessel assemblages. The clay slip is more frequently applied on the vessel exterior than on the interior surface, and then was either burnished or polished after it was leather-hard or dry.

The orifice diameters of vessels used for cooking, food service, and the storage of food stuffs and liquids, provide some indication of the scale of food preparation

and food serving in a Caddo vessel assemblage, as well as whether vessels were intended for individual or communal use. That vessels from Caddo sites are all hollow wares (i.e., jars, bowls, and carinated bowls), indicates that the Caddo diet was based almost entirely on liquid-based foods cooked in jars, including stews, corn and bean dishes, and gruels. Vessel size (in conjunction with wall thickness) may also be useful in identifying storage vessels and vessels used to prepare food for feasts. Vessels used in domestic contexts at Caddo sites tend to be larger than those placed in burials with the deceased.

Materials and Technology (INAA and Petrography)

One recent advance in the study of Caddo ceramics is increasing our knowledge about stylistic, technological, and functional changes in this material culture. Compositional analyses using chemical (primarily instrumental neutron activation analysis [INAA], see Glascock and Neff 2003) and petrographic characterizations are now being used with regularity on samples of Caddo ceramics to discern manufacturing techniques, the source and regional distributions of particular wares, and the functional characteristics of different kinds of vessels. Analyses of the chemical and petrographic constituents in the pastes of Caddo ceramic assemblages in East Texas, for example, has shown that there appear to be consistent paste differences between the ceramics in each of the river and creek basins (fig. 1.4). This is turn seems to reflect the local basin-specific production by Caddo groups of ceramic vessels from locally available clays, with some evidence for the exchange or gifting of vessels from one group to another in different basins. This type of analysis will, one hopes, continue to be used for considerations of cultural affiliation and trade and exchange between Caddo and non-Caddo groups, as well as for discerning manufacturing techniques, raw material use, source/regional distributions of particular wares, and specific functional characteristics of different kinds of vessels (see Essay 8).

The regional analysis of the chemical compositional makeup of Caddo pottery has the potential to help with the reconstruction of how people create, modify, or move pottery within particular cultural landscapes. It is likely that the vast majority of Caddo pottery was produced at the household or community level and then distributed and used locally, with an unknown quantity of that pottery being made for gifts or exchange with neighbors, both near and far-flung. However, because of the apparent chemical heterogeneity in locally abundant clays and the still limited number of sites with INAA sherd or clay samples in all parts of East Texas (or other parts of the Caddo area where INAA has been done), the INAA database available at present is not sufficiently robust to establish with certainty the source of clays used by Caddo potters or to link those clays with tempered Caddo pottery vessels and vessel sherds of known styles and temporal ranges. Continued

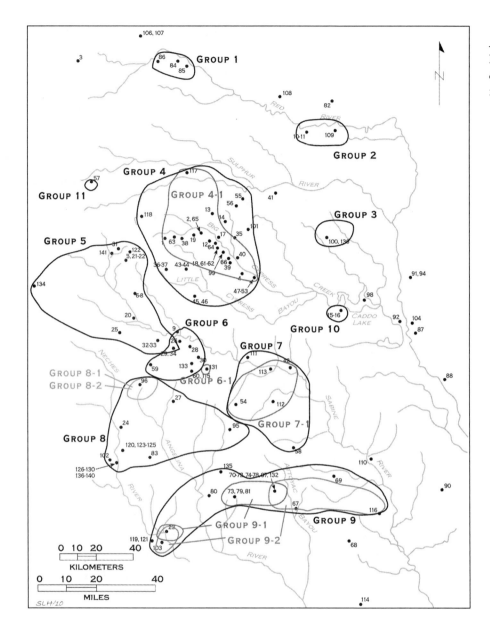

Figure 1.4. Defined ceramic chemical groups 1–11 in East Texas.

INAA analyses from a range of sites—and on both utility and fine wares—will be important in establishing production locales and their spatial scope, as well as for delimiting both the kinds of ceramics made in each production locale and the extent to which they may have been gifted and exchanged amongst neighboring Caddo groups.

Ceramic petrography is complementary to INAA in that it confirms and gives precision to the broad patterns identified in the geochemical results. The combined comparative use of INAA and ceramic petrography represents an advance in ce-

ramic technological research, particularly in the Caddo region of East Texas, where much of this work has been done. Petrography also links the chemistry of Caddo ceramics and the geological background for identified ceramic resources.

Iron illustrates this relationship in the southern Caddo Area. Mineral iron there takes several forms, including hematite, limonite, magnetite, and others. These mineral forms register simply as iron (Fe) in INAA and would be considered a major element on the basis of abundance. Yet the mineral forms are common in thin sections from the region. Mineral iron is a major constituent of important East Texas geologic formations, including the Weches, Wilcox, Sparta Sand, and Queen City Sand (Perttula 2017a:18–20). These are the most extensive formations in the central parts of the Neches, Angelina, and Sabine Rivers in East Texas. Petrography and INAA confirm the contribution of iron to Caddo ceramic pastes and red and black exterior slips.

Complementary distributions establish boundaries and the spatial scale of transport and exchange/trade. Although the Neches and Sabine Rivers flow through upper coastal Texas into the Gulf of Mexico and presumably move iron downstream in their bed loads, scanned sections of upper coastal ceramics contain little iron in any form. Caddo ceramics identified by grog temper and other attributes in Montgomery and San Jacinto Counties in southeastern Texas also contain telltale mineral iron (up to 3.5 percent) (Robinson 2018). These contrastive relations suggest a cultural boundary north of these counties but a southward extension of ceramic trade networks perhaps as far as the Gulf coast.

The identification of trace amounts of rocks and minerals is also an important aspect of ceramic petrographic research. For example, the mica group and its two common minerals, biotite and muscovite, are common on earth but often of differential distribution, as in East Texas. Where mica occurs naturally, it becomes part of local ceramics unintentionally due to its small grain size and unsuitability as a tempering agent. It thus becomes a telltale marker for the local pottery. Ceramic pastes at an East Texas Caddo site lacking mica imply nonlocal production locales and importation. The reverse is also true. Alkali and plagioclase feldspars are found in trace amounts in ceramics in the region, but they are restricted in regional deposits to the bed loads of the Trinity and Sulphur Rivers. The presence of feldspars in Caddo ceramics across the region is a marker of the regions where feldspars occur and imply transport of nonregionally produced ceramic vessel into regions lacking feldspars. Some mineral iron species, ilmenite, and distinctive grog types may also indicate restricted or nonlocal source areas.

2

Caddo Ceramics in the Red River Basin in Northwestern Louisiana and Southwestern Arkansas

Jeffrey S. Girard, David B. Kelley, and Duncan P. McKinnon

Introduction

This essay examines the diversity of ceramic vessels made and used in Caddo communities that were dispersed throughout the Red River drainage in southwestern Arkansas and northwestern Louisiana. We focus on descriptions of the major design styles pertaining to general temporal periods and examine how these reflect the changing social and economic landscape. For the Caddo people, ceramic design styles, summarized by archaeologists in the concepts of "types" and type "varieties," served as media of communication, particularly to transmit social information. This information was organized, configured, and presented in standardized ways to facilitate communication. Ceramic design styles were not simply personal expressions of artisans; they were constrained within parameters set by social rules or standards. The social environment, however, was not static, and meanings of design styles changed through time with differing communication needs of Caddo society. The Caddo people and their predecessors in the Red River region employed ceramic design styles to: (1) demonstrate connections among localized residential communities; (2) establish and confirm relationships with distant groups in adjoining regions, particularly the Lower Mississippi Valley; (3) express group distinctions, either between local communities or between corporate groups such as lineages or clans that maintained presences in multiple communities; and (4) signify group relationships to cosmic configurations to institute and sustain social hierarchies.

Woodland Period Antecedents

Untempered pottery was present in southern Louisiana, primarily in the Mississippi River valley and near the Gulf coast, by about 800 BC (Hays and Weinstein

2010:110), but manufacture and use of ceramics appear to have been limited in the lower Red River region until late in the first millennium BC. Schambach (1982a:161) identified the earliest pottery in the Great Bend region of southwestern Arkansas as Cooper Boneware, a "crude, plain, often sandy pottery that is always liberally tempered with large chunks of bone." Vessels were globular bowls and flowerpot-shaped jars, often slipped on the interiors. A recent radiocarbon date suggests that Cooper Boneware dates as early as 1050–895 cal. BC (see Essay 4).

Schambach (1982a, 2001) has argued that during the Woodland period, a distinct split existed between Marksville-Troyville cultures of the Lower Mississippi Valley and Fourche Maline culture in the Trans-Mississippi South. Throughout both regions, undecorated pottery dominated, but ceramics were more frequently decorated in the Lower Mississippi Valley and a wider range of vessel forms were used. North of the Natchitoches, Louisiana, region, throughout the early centuries of the first millennium AD, the Woodland period peoples made undecorated bowls and jars with thick vessel walls and bases (Williams Plain). Pastes contained relatively coarse tempering materials such as grog, sand, and crushed bone (a temper rarely used in the Lower Mississippi Valley). Curiously, no Woodland period decorative tradition unique to the Trans-Mississippi South appears to have developed. The few known examples of decorated pottery that appear throughout the region pertain to types common in the Lower Mississippi Valley. For example, such vessels are found in a series of solitary mounds (designated taxonomically as the Bellevue focus) situated on upland ridges overlooking the Red River floodplain or major tributaries such as Bodcau Bayou that date between approximately 200 BC and AD 400 (Schambach 1982a; Fulton and Webb 1953; Webb 1984; Girard 2012a). Most of the pottery from these sites is undecorated and has grog (and/or crushed bone) temper that often is coarse. A limited number of vessel forms seem to be represented, probably mostly simple bowls and jars. These sites yielded a few Marksville Stamped and Marksville Incised sherds, and a complete Marksville Stamped jar with a raptorial bird design was found at the Red Hill Mound (another such vessel was recovered in the Sabine River Valley to the west at the Coral Snake Mound). It is not known whether the Marksville pottery was made locally or imported from the Lower Mississippi Valley.

There is considerably more information about ceramics that date to the interval from about AD 400 to AD 800, contemporary with Troyville and early Coles Creek occupations in the Lower Mississippi Valley. A variety of bowls and jars were made, many with thickened and stylized rims. Although decorated pottery continued to constitute only small percentages of ceramic assemblages, decorations occasionally were made by rectilinear and curvilinear incising, punctating, stamping, and red filming (and some painting). The most detailed information comes from what would become the southeastern edge of the Caddo Area in the vicinity of present-day Natchitoches. Recovered from the Fredericks site (16NA2), a small

mound center, was a ceramic assemblage that relates to the Troyville culture of the Lower Mississippi Valley (Ford 1936; Gregory and Curry 1977; Girard 2000). Eight radiocarbon dates obtained from both habitation area and mound contexts fall between cal. AD 400–800. Only about 5 percent of the over 6,000 recovered sherds are decorated. Paste varies, but generally resembles Phillips's (1970) grog-tempered Baytown Plain, *var. Satartia.* Most numerous among the decorated sherds are late varieties of Marksville Incised (*vars. Yokena, Spanish Fort, Leist,* and *Steele Bayou*) and Marksville Stamped (mostly *var. Troyville*). Also present are smaller quantities of Churupa Punctated, Alligator Incised, and Larto Red. Several sherds from the Fredericks site have single horizontal incised lines and probably relate to the *Hunt* and *Phillips* varieties of Coles Creek Incised. Conspicuously absent (or very rare) are cord-marked sherds, common in contemporary sites in the northern area of the Lower Mississippi Valley. A similar ceramic complex was recovered at the Montrose site (16NA37) located south of the present city of Natchitoches in the Red River floodplain (Heartfield, Price, and Greene, Inc. 1985). Small numbers of Marksville Incised, Marksville Stamped, and Churupa Punctated sherds have been recovered in sites upstream from Fredericks in the lower Red River region, almost all from surface sherd collections that also contain later Caddo pottery. Although sizeable middens developed at some Fourche Maline sites, suggesting the sustained use of particular settlements over successive generations, upstream from the Natchitoches area pottery appears to have been used primarily for basic utilitarian purposes such as cooking, food preparation, storage, and serving. Concern with decorative style and social display was minimal during the Woodland period.

The Formative Caddo Period (ca. AD 800/850–1000)

The period from about AD 850 to AD 1000 has been variously labeled as Formative Caddo, Early Caddo, or Late Fourche Maline, depending on interpretations of overall cultural developments. It is generally agreed, however, that it was a time of profound changes in settlement configurations, material assemblages, artistic styles, social organization, ritual practices, and perhaps subsistence systems throughout the Caddo Area. These changes were part of the initial development of the Mississippian cultural phenomenon in what is now the midwestern and southeastern United States.

Changes in ceramic assemblages continued to resemble those in the Lower Mississippi Valley during the ninth and tenth centuries, with an apparent contemporaneous shift in decorated types from those generally classified as Troyville to those classified as early Coles Creek. Several temporal trends are evident in vessel decoration. First is a simplification of design elements. Complex curvilinear patterns, often with stamping (Marksville Incised and Marksville Stamped) were replaced by designs consisting of simple horizontal bands, usually with only one or two lines

(Coles Creek Incised, *vars. Hunt, Phillips, Stoner,* and *Wade*). Second, the distinctive wide, U-shaped lines of the Marksville tradition gave way to more variation. Narrow lines became dominant, occasionally with an overhanging line separating the rim from the vessel body. Finally, the overall frequency of decoration on vessels appears to decline after the eighth century. Although these trends also occurred to the east in the lower Ouachita River drainage and Lower Mississippi Valley, two ceramic traits of the late Woodland or Baytown period in the Lower Mississippi Valley rarely are seen in the Caddo Area. Cord-marked pottery occurred as far west as the Catahoula Basin and Little River areas of central Louisiana, but only a few sherds with this surface treatment have been reported along the Red River in the Natchitoches area. Stamping continued (albeit in small quantities) to the east in the form of the type Chevalier Stamped but disappeared in the Red River region until the Late Caddo period.

Small upland sites dominated by undecorated and Coles Creek Incised pottery have been identified throughout the eastern tributaries of the Red River, but most information comes from large ceremonial centers in the Red River floodplain, particularly Crenshaw (3MI6) and Mounds Plantation (16CD12). In early (apparently pre-mound) residential areas at Mounds Plantation, two forms of Coles Creek Incised pottery are by far the most common. Sherds with multiple wide-spaced horizontal lines around the rim are similar or identical to *var. Greenhouse* or *Blakely* as defined by Phillips (1970). Also common are specimens with closely spaced lines, most rather sloppily applied (Coles Creek Incised, *var. Hardy*), or with lines that overlap and, in some cases, have a band of triangular punctations beneath the lowest line (Coles Creek Incised, *var. Coles Creek*) (Phillips 1970). Newell and Krieger's (1949:116–19) type Davis Incised from the George C. Davis site in East Texas essentially mirrors this design variation. A few specimens align with other varieties of Coles Creek Incised such as *vars. Hunt, Wade, Chase, Stoner, Phillips,* and *Keo*. Several of these varieties may date as early as the ninth century, but Late Woodland period varieties of Marksville Incised, Marksville Stamped, and Churupa Punctated are not present at Mounds Plantation or Crenshaw.

As a general comparison, it appears that contemporary Coles Creek sites in central Louisiana and the Lower Mississippi Valley have higher percentages of decorated sherds and greater decorative variability (i.e., a wider range of types and varieties). Technological variation also is apparent with the use of poorly sorted upland clays in the Caddo Area as well as the frequent inclusion of crushed bone as a temper (Girard and Cecil 2015). This variation is subtle but enough to suggest that most Coles Creek Incised pottery in the Caddo Area was made locally. If immigration from the Lower Mississippi Valley occurred, it did not involve large-scale movement of ceramic vessels.

At the Crenshaw site, early burials on or beneath surfaces later covered by mounds include vessels of several varieties of Coles Creek Incised, as well as a few

French Fork Incised jars characterized by complex incised meanders and punctations or closely spaced parallel lines in the interstices. A red slip and white pigment are present on some specimens. French Fork Incised also occurs in the Little River region at the Hutt (3HE3) and Old Martin (3LR49) sites but is rare at Mounds Plantation and elsewhere in northwestern Louisiana. Schambach (1982a:170–71) argued that rather than having been imported from the Lower Mississippi Valley, this pottery is an indigenous local type (Agee Incised) and perhaps the earliest Caddo fine ware. He contends that Marksville and Coles Creek-looking pottery in the Caddo Area resulted from a shared "horizon style" between the regions and not the use of the same type.

The Early Caddo Period (ca. AD 1000/1050–1200)

Although an increasing divergence between Caddo and Coles Creek ceramic assemblages can be discerned for the late tenth and eleventh centuries, little geographic variation has been recognized *within* the Great Bend and Natchitoches regions and strong resemblances to assemblages in surrounding areas continued. Sites in northwestern Louisiana are usually assigned to a single cultural taxonomic unit, the Alto phase, also present to the west in the East Texas Gulf coastal plain. In southwestern Arkansas, the Lost Prairie phase was designated for sites in the Red River floodplain and immediately surrounding uplands, and the Miller's Crossing phase denotes Early Caddo sites in the Little River drainage (Hoffman 1970). However, these are primarily geographical designations and ceramic assemblages unique to each phase have not been differentiated. Early Caddo period ceramics extend downstream along the Red River into the Natchitoches area. They have not been found in the major drainages of the uplands between the Red and Ouachita Rivers in Louisiana, where Coles Creek types prevailed throughout the period.

Type Descriptions

By the late eleventh century, it is possible to distinguish fine and utilitarian wares throughout the Caddo Area. Fine wares, at least in some sense, probably date back to the Woodland period in the form of Marksville Stamped vessels recovered from Middle Woodland period mounds, but this type is highly unusual in this region and does not constitute significant percentages of site ceramic assemblages. In contrast, by the middle eleventh century, fine wares were manufactured and used in substantial numbers and exhibit considerable variability in form and decorative style. Most distinctive are polished engraved vessels (bottles, carinated bowls, simple bowls, and jars) typed as Holly Fine Engraved, Spiro Engraved, and Hickory Engraved. Fine wares also are distinguished by relatively thin vessel walls and fine-grained pastes tempered with sparse finely crushed grog or bone or hav-

ing no visible temper. Holly Fine Engraved designs consist of close-spaced finely engraved lines in geometric patterns most often with multiple parallel lines forming concentric circles or arcs embedded in broad vertical, horizontal, or diagonal bands or scrolls (fig. 2.1). Areas between bands often are excised and red or white pigment sometimes was rubbed into lines and excised areas. Bolder, wider-spaced lines characterize Spiro Engraved, sometimes with punctations rather than excised areas in the interstices between the design bands (Newell and Krieger 1949; Suhm and Jelks 1962). The simple lines on bottle shoulders or bowl rims of the type Hickory Engraved resemble Coles Creek Incised. Neither bottles nor carinated bowls are common in contemporary Lower Mississippi Valley assemblages, however, and Holly Fine Engraved and Spiro Engraved have no precursors to the east. Sometimes also considered fine wares are zoned punctated vessels with curvilinear (Crockett Curvilinear Incised) or rectilinear (Pennington Punctated-Incised) patterns. These types consist of carinated and globular bowls—no bottles—and often were placed in burials. Although there is considerable variation in decorative elements and motifs on fine wares in the Early Caddo period, no varieties diagnostic of particular regions or time intervals have been identified. Other possible fine wares have a heavy red slip and neatly organized horizontal incised lines along the rims of simple bowls (East Incised) and distinctive fluted and lobed vessels recovered primarily in burial contexts at the Crenshaw site (Crenshaw Fluted and Crenshaw Lobed).

In contrast to fine wares, the Caddos made a variety of utilitarian bowls, jars, and bottles that were either left undecorated or were decorated with relatively simple incised and/or punctated elements. Grog, crushed bone, and sand were used as temper either separately or in combination. These vessels likely were used for everyday tasks such as cooking, storage, food preparation, and serving. Utilitarian vessels occasionally were included in burials but occur less frequently than fine wares. Most Early Caddo period utilitarian ceramics in the Great Bend and Natchitoches regions are simple bowls and jars with slightly constricted necks and tall rims that when decorated serve as separate design fields. Types were defined from studies of whole vessels, but because of frequent breaks at the rim and body juncture, it often is not possible to sort sherds into specific types. Early Caddo period sherd assemblages are characterized by high percentages of undecorated specimens, many incised and punctated sherds, but little or no brushing. Jars with multiple closely spaced horizontal incised lines on the rim are classified as Hardy Incised if ves-

Figure 2.1. Holly Fine Engraved vessels from the Mounds Plantation (*top*) and Gahagan (*bottom*) sites in northwest Louisiana.

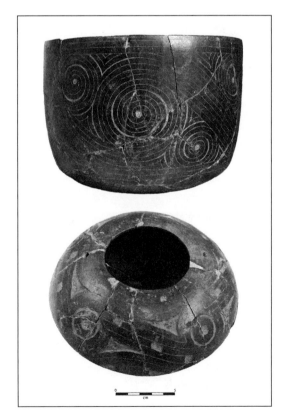

sel bodies are undecorated, or Kiam Incised if bodies have punctations or vertical incised lines. Wilkinson Punctated jars or simple bowls have unzoned punctations that cover the entire vessel. Jars with diagonal incised triangles, chevrons, or nested "herringbone" patterns are classified as Dunkin Incised. Jars with simple cross-hatched incised lines on rims are known as Harrison Bayou Incised. Pinched (Hollyknowe Ridge Pinched) and noded (Moore Noded) sherds are found at many sites, but always in small quantities.

Discussion

Unlike earlier Formative Caddo period ceramics, polished engraved fine-ware vessels represent a ceramic decorative (and perhaps technological) tradition indigenous to the Caddo Area in Early Caddo period times. Contexts of production are not well understood, but early fine wares appeared throughout the Caddo Area over the course of a relatively short span of time. Possible antecedents of polished and engraved pottery have been noted in the Huastecan area along the Gulf Coast of Mexico (Newell and Krieger 1949:224–32; Webb and Gregory 1986:5), and it is possible contacts with this distant region provided the initial inspiration for the Caddo fine-ware pottery. Although there is no indication that distinct design features relate to individual communities, it is possible that localized stylistic variants existed but have not yet been identified. Fine wares have been found in both domestic and mortuary contexts, but they are particularly well represented in mound burials, often on the margins of graves containing multiple individuals rather than with specific individuals. Bottles and carinated bowls, possibly serving vessels and objects of display used in rituals, are the most numerous fine-ware vessel forms. Stable intercommunity political ties likely began to appear within the Caddo Area during the Early Caddo period, and it is possible that emergent polities interacted through mutual participation in rituals that involved display and perhaps exchange or gifting of material goods (including fine-ware pottery) valued across widespread regions (see Essay 8). Girard et al. (2014:55–56) suggest that early fine wares may be linked with the initial development of social hierarchies throughout the Caddo Area:

> The better examples of fine wares likely were produced by highly skilled artisans and were not easily acquired or copied. Intricate designs on many Holly and Spiro vessels perhaps not only reflect craft skills, but also certain ritual knowledge. It is not likely that any particular social status was represented, but possession of certain fine ware vessels was a sign of wealth and connection to the larger social world, and perhaps the cosmological universe as well. Custody and use of fine wares were not restricted to community political or religious leaders, however. They have been recovered in general village scatter, sub-mound middens, and mortuary contexts, but by far are overrepresented in the latter . . .

Of particular importance is that the polished engraved wares were produced, or at least were circulated, throughout the Caddo Area. Use of fine wares was not just a reflection of social hierarchies in individual communities, but fine-ware circulation established connections between multiple communities in widely separated geographic regions. Fine wares were used for purposes of communication, as well as perhaps competition, between groups and elite persons across vast portions of the landscape, even between the distant and in many respects culturally diverse Arkansas and Red River basins.

Decorations on most Early Caddo fine wares are geometric with no obvious representational expressions. There are no depictions of people, animals, or mythical characters. However, recent work has been directed toward interpretation of designs in terms of pan-Southeastern cosmological themes as inferred from the combined study of symbols on pottery and other material media with ritual and ideological concepts derived from ethnohistorical sources. Lambert (2018), for example, attempted to correlate design features of a Spiro Engraved vessel from the Spiro site in eastern Oklahoma with widespread Mississippian iconography and cosmology, particularly the separation of cosmic and underworld realms and identification of a central "axis mundi" (see also Essay 11). In the lower Red River region, an unusual carinated bowl from a burial (probably dating to the early twelfth century) in Mound 5 at Mounds Plantation has elicited considerable interest but only one detailed discussion (Webb and McKinney 1963). The vessel does not neatly fit into an established type but is similar to the types Crockett Curvilinear Incised and Pennington Punctated-Incised with excised areas as in Holly Fine Engraved (fig. 2.2). Decoration is not confined to the rim but also is present on both the in-

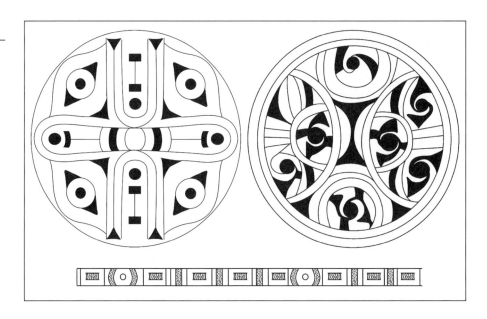

Figure 2.2. Patterns on a unique carinated bowl from Mound 5, Mounds Plantation Site, Caddo Parish, Louisiana: (*left*), interior; (*right*), base; (*bottom*), exterior rim.

terior and exterior of the lower portion of the vessel. Circle and arc elements on the rim are separated by horizontal and vertical rectangles filled with punctations. Four symbolic eye elements on the bowl interior are separated by what Webb and McKinney (1963:2) interpreted as thumb and finger designs. The underneath portion of the bowl has a complex design of concentric circles, arcs, and spirals ending in triangles. These design elements indicate connections to the early development of what has become known as the Southeastern Ceremonial Complex and, together with the presence of exotic items in other Early Caddo period sites, indicate that the Caddo people were not socially isolated but were part of the beginnings of the widespread Mississippian world.

The Middle Caddo Period (ca. AD 1200–1400)

After about AD 1200 considerable diversity in ceramic assemblages is evident throughout the Caddo Area and multiple cultural taxonomic units have been defined. In the Great Bend region, residential use of ceremonial centers such as Crenshaw and Mounds Plantation appears to have diminished, although their sacrosanct status likely continued, particularly at Crenshaw where elaborate rituals, possibly involving human sacrifice, were carried out (Jackson et al. 2012; Samuelsen 2016; Schambach 1996). New mound centers such as Haley (3MI1) and Mineral Springs (3HO1) were established and there appears to have been a proliferation of small ceremonial centers consisting of one to three mounds, some of which served as mortuary areas and others as platforms for civic structures (Schambach and Early 1982:106–7). In some areas, solitary mounds were erected at one or more locales within dispersed communities (e.g., Girard 2012b). Local polities appear to have become stabilized with ceramic traditions developing within particular regions. Although only two broadly defined cultural taxonomic units are recognized in the Great Bend and Natchitoches regions at this time—the Haley phase primarily in Arkansas and the Bossier phase downstream in Louisiana—finer scale patterns are likely to emerge with additional work.

TYPE DESCRIPTIONS

Between AD 1200 and 1400 regional differentiation of engraved fine wares resulted in a diversity of types and varieties that vary in spatial extents and probably temporal ranges. Although perhaps initially difficult to produce and acquire, by the Middle Caddo period, engraved pottery appears to have become part of standard household ceramic assemblages with specimens representing variable technical and decorative quality. Bottles and carinated bowls continued to be the most common fine-ware vessel forms, but globular bowls and jars also were made. In contrast to the earlier tapered spout forms, Middle Caddo period bottles tend to have significantly taller spouts with parallel or slightly bulging margins.

The previously widespread Holly Fine Engraved and Spiro Engraved Early Caddo types dropped out of use, but Hickory Engraved continued throughout the Middle Caddo period. Design patterns with hatched or cross-hatched bands or zones as basic elements became common and include types such as Hempstead Engraved, Haley Engraved, Carmel Engraved, Adair Engraved, Garland Engraved, and Mineral Springs Engraved. Early cross-hatched pottery (typed by Webb and McKinney [1975] as Maddox Banded Engraved) found in late contexts at Mounds Plantation is known only from sherds but these tend to have thick walls, unpolished surfaces, and elements are sloppily rendered. A common decorative feature of carinated bowls in the region is the use of horizontal panels, sometimes stacked in two or more rows forming stepped rectilinear scrolls: ticked lines, arcs, or hatched bands fill the zones. White pigment is present in engraved lines on many specimens and types, including Glassell and Handy Engraved vessels. Scrolls, meanders, spirals, circles, and other curvilinear elements appear in complex designs on Haley Engraved bottles. Many elements are made with distinctive spurred or ticked lines. Haley Engraved is most common at Haley phase sites in southwestern Arkansas and rarely occurs in the Bossier phase of northwestern Louisiana (fig. 2.3). Other possible fine wares such as East Incised, Pennington Punctated-Incised, and Crockett Curvilinear Incised vessels are rare but have been recovered in apparent Middle Caddo period burials at Mineral Springs and other sites.

The Kiam-Hardy-Wilkinson basic utility jars and simple bowls of the Early Caddo period appear to have gone out of use early in the Middle Caddo period. However, jars with diagonal incising on rims or both rims and bodies (Dunkin Incised or Maydelle Incised) continued. Middle Caddo period jars tend to have more constricted necks, globular bodies, and taller rims than their more cylindrical Early Caddo period counterparts. Webb (1983) distinguished a "late variety" of Dunkin Incised based on this change in vessel form. However, the most readily identifiable trait of the Middle Caddo period in these regions was the use of brushing on utilitarian jars, a trait shared with sites of the Plaquemine culture in the Lower Mississippi Valley. Simple vertical or diagonal brushing on bodies of globular jars with constricted necks was common (Bossier Brushed). Although there is much variation, temporal changes in common jar forms are evident. Earlier rims were relatively tall and vertical or angled outward. Short, flared, rims became more numerous by the end of the period. Rims either were incised (horizontal or diagonal) or brushed (horizontal or diagonal) (fig. 2.4).

Caddo potters frequently divided the bodies of jars into panels, often with vertical panel dividers such as appliqued (or notched applique) bands or vertical rows of punctations (fig. 2.5). Brushing or parallel diagonal incised lines fill the panels. This type, known as Pease Brushed-Incised, occurs throughout this region and also is found in the East Texas and Ouachita regions. The type encompasses much decorative variation, but no regionally distinct patterns have been identified. Some

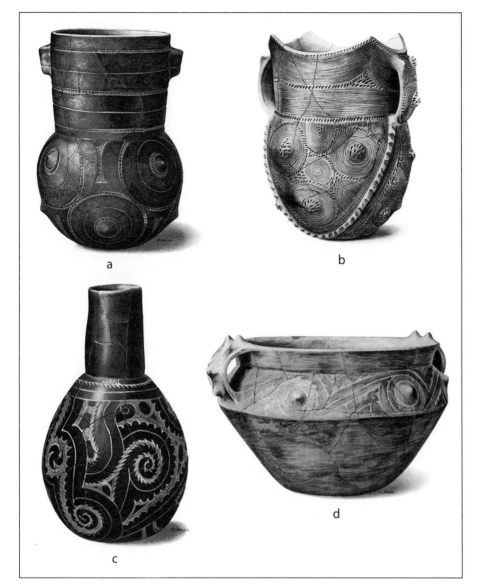

a

b

c

d

Figure 2.3. Vessels from the Haley Site illustrated in Moore (1912): *a*, Handy Engraved; *b*, Haley Complicated Incised; *c* and *d*, Haley Engraved.

Pease Brushed-Incised vessels have closely spaced vertical applique bands with little or no brushing between them. Through time, vertical panels increasingly were partitioned by pinching clay to form vertical ridges (Belcher Ridged) rather than the use of applique panel dividers. In some cases, it is not possible to make clear distinction between the types (Webb 1983; Girard 2007). Appliqued bands also occur on the type Haley Complicated-Incised where the bands are diagonal or curvilinear, and panels are filled with complex arrangements of incised concentric circles, scrolls, and parallel lines filled or interspersed with punctations. Peaked rims and wide strap handles often occur on jars of this type. Similar complex pat-

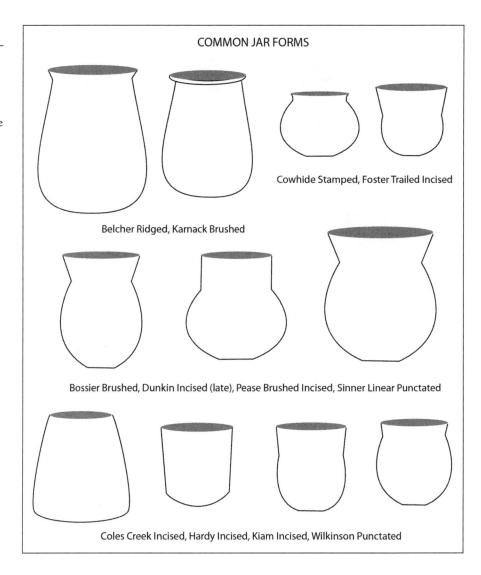

Figure 2.4. Outline drawings of common forms of utilitarian jars: *bottom row,* Early Caddo period; *middle row,* Middle Caddo period; *top row,* Late Caddo period.

COMMON JAR FORMS

Cowhide Stamped, Foster Trailed Incised

Belcher Ridged, Karnack Brushed

Bossier Brushed, Dunkin Incised (late), Pease Brushed Incised, Sinner Linear Punctated

Coles Creek Incised, Hardy Incised, Kiam Incised, Wilkinson Punctated

terns of incised lines or punctations, occasionally with appliqued bands, appear on other types such as Military Road Incised in the Ouachita River drainage and Sinner Linear Punctated; the latter is common both in the Red River drainage and in surrounding regions.

Discussion

As noted above, compared with the Early Caddo period, Middle Caddo period fine-ware types became more numerous and spatially delimited. Despite this trend, spatial distributions of ceramic types do not associate exclusively with specific sites or localities and thus may not have been community-specific. Multiple types (and varieties) were in use in all communities, and types occur in multiple sites, lo-

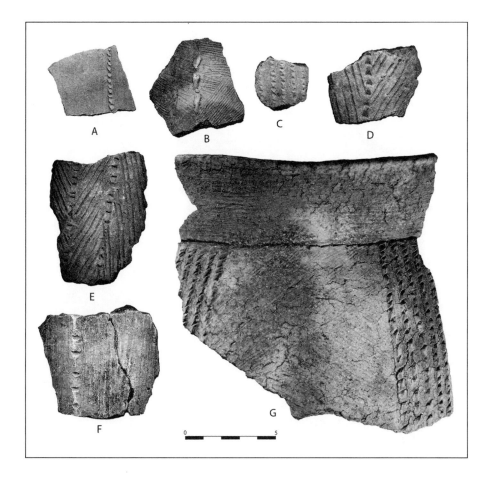

Figure 2.5. Sherds showing variation in attributes of the Middle Caddo period type Pease Brushed Incised: *A–C*, Werner Site (16B08); *D–E*, Smithport Landing Site (16RR4); *F*, Byram Ferry Site (16B017); G, Vanceville Site (16B07).

calities, and regions. Although it is possible that the division of types into more detailed varieties will yield coherent spatial distributions that may represent different residential communities, alternative models should be considered. If types, particularly those pertaining to fine wares, were active in the sense of purposively transmitting social information (Weissner 1983:257), the "social" does not appear to have equated with spatially circumscribed residential communities but is more likely to have related to cohorts of potters expressing social affiliations that cross-cut local communities. It seems reasonable to infer that for the Caddo people, as in most other groups not tied to widespread mercantile or industrial economies, social order resulted from the distinctions of kinship rather than the production of goods (Sahlins 1976:211; Sabo 1998:163). Although information about Caddo kinship configurations is sketchy in early historic documents, later evidence suggests that Kadohadacho groups along the Red River practiced matrilineal descent and may have been organized into ranked matrilineal and exogamous clans (Swanton 1942; Sabo 1998). Communities were comprised of multiple lineages or clans, and intercommunity marital patterns resulted in these kinship groups having a

presence in multiple communities. Women may have made ceramic vessels, particularly fine wares, signifying their kinship affiliation, thus resulting in multiple "types" within communities and similar types spread over multiple communities. It is unlikely that a simple correspondence existed between particular ceramic types and individual kinship groups. However, connections between design variation and kinship groups may have been sufficiently strong to have resulted in the disjointed archaeological patterns we see. Considering Mississippian societies in general, Muller (1997:191) argued:

> Clans share a tradition of common descent, usually from a natural or mythological ancestor. Clan membership had important functions in the historical Southeast. Support in other communities could be expected from one's kin. This would mean assistance when traveling or even provisioning in times of need. Much of what is loosely called "trade" in these societies could arguably have been distribution of goods in lineages and clans, at least before the coming of the European traders. In the Southeast, males of a lineage would often have been dispersed across the region, so male-held emblems of membership in matrilineages, for example, may also have been dispersed.

At larger spatial scales, such a relationship would result in the dispersion of types across large areas (that we recognize archaeologically as the spatial dimension of phases) broadly reflecting the differential presence of these kin groups across the landscape. "Sets" of ceramics constituting phases denote the differential presence of kin groups within a territory. Although the degree and nature of boundary maintenance varied, it is clear that regional spatial clustering existed and persisted long enough to form observable patterns in the archaeological record, perhaps indicating the initial development of social networks between communities that may have resulted in stable political (tribal) entities such as those noted in ethnohistoric accounts (e.g., Swanton 1942). Thus, more coherence to ceramic type distributions may be manifest at broader spatial scales than within sites or localities (see Essay 10).

Utilitarian wares appear to have more passive styles, possibly simply signifying local conventions regarding the manufacture of functional vessels. Variation can be modeled in terms of "communities of practice" where potters learned and copied traditional patterns from their cohorts during the manufacturing process in more routinized and less conscious ways. Although often combined into complicated patterns, design elements were relatively easy to implement as they were composed of simple elements such as linear bands and fields of punctations, brushing, or parallel-incised lines. Spatial distributions are more likely to demarcate past residential communities that can be discerned through detailed analyses of decorative patterns.

The Late Caddo Period (ca. AD 1400–1680/1700)

During the Late Caddo period, a "proto-Kadohadacho" core area developed in the Great Bend region with ceramic assemblages forming the Texarkana and Belcher phases that share many types. Settlements consisted of dispersed villages and small mound centers, primarily located in the Red River floodplain. Final construction stages of the immense Battle Mound (3LA1) and occupation of the surrounding areas in the Spirit Lake locality took place during this period (McKinnon 2017; Trubowitz 1984; Kelley 1998, 2012). Mound sites of the Late Caddo period in the Great Bend Region, including Belcher (16CD13), Friday (3LA28), Foster (3LA27), and McClure (3MI29), probably were abandoned by AD 1650, prior to sustained European contact (Perttula 1992:122). Continued use of mounds in dispersed villages is depicted by the 1691–1692 Teran map that probably shows the Hatchel Mound and surrounding Hatchel-Mitchell-Moores archaeological complex of the Texarkana phase, centered upstream in northeastern Texas from the Belcher phase occupations (Perttula 2005a; Wedel 1978; see also Essay 3).

TYPE DESCRIPTIONS

Although no sharp break between the Middle and Late Caddo periods in ceramics is evident, the fifteenth century seems to have been a time of multiple changes in ceramic assemblages (fig. 2.6). For the fine wares, Glassell Engraved carinated bowls continued to be in use but eventually declined and apparently were rare by the seventeenth century (Webb 1959; Kelley 2012). A newly important type, Hodges Engraved, has curvilinear negative bands (sometimes with ticked lines through them) forming meanders and scrolls with fine cross-hatching and negative circles in the interstices. Hodges Engraved is a widespread type that also is common in the Ouachita River drainage to the northeast but rare to the west and south. A broad range of vessel forms is represented, including carinated and simple bowls; bottles with bulges in the spouts and thickened rims; globular jars with tall rims; and a few effigy vessels from the Ouachita River region. In contrast to Hodges Engraved and Glassell Engraved, Belcher Engraved appears much more restricted geographically (and perhaps temporally as well), being limited to the Great Bend region and extending as far south as the Belcher site in Caddo Parish, Louisiana. Belcher Engraved bottles have concentric circles (usually four, but occasionally three) separated by dashed lines. Circle elements are usually spurred on the exterior and divided by a triskele, cross, or swastika on the interior. Use of white pigment is common. Also typed as Belcher Engraved are carinated bowls with sharply acute angled shoulders and four nodes. These vessels are decorated with rectilinear engraved lines and dashed lines with short diagonal lines on the nodes. Other fine-ware types associated with Belcher phase sites include Taylor Engraved,

Figure 2.6. Late Caddo period vessels from the Belcher Site (16CD13).

Belcher Engraved

Foster Trailed Incised

Belcher Ridged

Glassell Engraved

Hodges Engraved

Cowhide Stamped

Ripley Engraved, and Avery Engraved. Upstream, Texarkana phase fine wares include the types Barkman Engraved, Avery Engraved, Simms Engraved, Hatchel Engraved, and Bowie Engraved (see Essay 3). For all areas, many engraved vessels are difficult to relate to specific recognized types as elements and configurations of multiple types sometimes are represented. Most often, designs are curvilinear with scrolls, arcs, or broad cross-hatched bands with negative circles that form interlocking scrolls or spirals. A wide range of vessel forms are represented, including spool-necked bottles, tall rim jars, carinated bowls, footed jars, compound vessels, and pedestal bottles. Use of both red and white pigment was frequent.

Not clearly classifiable as fine wares or utility wares are three types (Foster Trailed-Incised, Cowhide Stamped, and Keno Trailed) that appear to be closely related. Although perhaps appearing initially in the late fifteenth century, Cowhide Stamped and Foster Trailed-Incised became common only in the sixteenth and seventeenth centuries. Keno Trailed likely dates to the seventeenth and early

eighteenth centuries. Tall rim globular jars are the most common vessel form for Foster Trailed-Incised, whereas short rim jars are more frequent with Cowhide Stamped, but there are many exceptions. Keno Trailed occurs on bottles with spool necks as well as a variety of jar forms. The wide "trailed" lines and stamping techniques used on these vessels had no significant representation in this region after the Late Woodland period. Concentric circles, arcs, interlocking scrolls, and other curvilinear patterns are characteristic with distinctive nodes on many Foster Trailed-Incised jars. The tall rims on most Foster Trailed-Incised jars were treated as a distinct design field from the vessel bodies. Schambach and Miller (1984:121) defined seven varieties of the type and suggested a temporal sequence for the Cedar Grove site in the Spirit Lake locality of southwestern Arkansas. Based on information from the Belcher Mound (Webb 1959), Cowhide Stamped seems to be the first type in the lower Red River region that often was shell-tempered (11 of 16 whole Cowhide Stamped vessels at Belcher were shell-tempered), but eventually most Foster Trailed-Incised and Keno Trailed vessels also were shell-tempered. These types occur in the upper portion of the lower Red River region, are widely distributed throughout the upper Ouachita River region, and extend into the lower Arkansas River drainage (McKinnon 2011:fig. 4).

Brushed (Karnack Brushed-Incised) and ridged (Belcher Ridged) jars and ollas appear to have been the most common utilitarian vessels, perhaps with a change to predominantly short, rolled, or flared rims. These types have widespread distributions, extending as far to the southeast as the Catahoula Lake basin (Gregory et al. 1987). Many utilitarian vessels were left undecorated, including large, globular ollas from the Belcher Mound that Webb (1959:139–41) typed as Briarfield Plain.

DISCUSSION

We suggested earlier that differences in ceramic assemblages may be sensitive to kinship as well as community affiliation but did not bring up how temporal changes within the broad and imprecise "periods" that we use here to organize our discussion affect our views of the archaeological record. Grave lots are important to archaeological research in part because they are among the few contexts that relate to extremely short intervals of time. With the caveat that in some cases "old" or heirloomed objects were placed in graves, archaeologists usually consider ceramic vessels found together in graves as contemporaneous. In examining grave lots at the Cedar Grove site, Schambach and Miller (1984) used a descriptive classification system (see Essay 1) to construct type varieties that enabled a relatively fine-grained chronology useful for comparison with the four periods of construction recognized by Webb (1959) at the Belcher site. In a later summary of the information, Perttula (1992:122) estimated that the Belcher phase components at Cedar Grove and Belcher III date to the sixteenth and early seventeenth centuries. The

final Belcher IV construction stage occurred in the late seventeenth century, but prior to AD 1700, when the late "Chakanina phase" component at Cedar Grove began to develop.

Individual graves often contain numerous and multiple ceramic types and vessel forms. It is not likely that grave goods simply reflected the identity of the deceased individual but, instead, included community-wide gifts honoring the deceased on their afterlife journey. Some vessels perhaps contained food or medicines, while others were of symbolic importance for connecting the phenomenal and numinous realms (Sabo 1998). Like other Southeastern peoples, it is apparent that the Caddos occasionally used material symbols referencing cosmic principles that represent a decorative dimension distinct from community and kinship affiliations. Webb (1959:123) argued that both Belcher Engraved and the earlier Haley Engraved type have sun (and/or central fire) symbols that consist of widely spaced concentric circles or rayed circles occasionally with red or white (fire and ash?) pigment. Fire was of primary symbolic importance to the Hasinai in the eighteenth century with fire basins as central features in houses and perpetually maintained fires as fundamental components in Caddo communities and perhaps more extensive polities (Swanton 1942; Sabo 1998). Webb (1959:128) further argued that an opposition was represented between cosmic symbolism on Belcher Engraved and underworld (serpent) symbolism on Hodges Engraved (missing in the lower Red River region are rattlesnake elements found on ceramic vessels from a few East Texas sites—see Essay 6). As noted by McKinnon (2016; see also Essay 9) there is patterned spatial variation in the use of rayed circle elements that likely has social implications. It is possible that use of some sacred elements was restricted to certain kin groups, communities, or places within communities.

The Historic Caddo Period (ca. AD 1680/1700–1840)

Sustained exploration and settlement of the lower Red River region by Europeans and non-Caddo Native Americans began during the early eighteenth century. The influx of new peoples resulted in rapid changes in local demographics, settlement systems, and material culture. Kadohadacho villages in the southern Arkansas portions of the Red River floodplain were occupied until 1790 when abandonment took place due to Osage raids and epidemics (Swanton 1942; Smith 1995). Archaeologically, the Kadohadacho and Yatasi/Nakasas villages are represented by sites of the Chakanina phase (Trubowitz 1984; Kelley 1997). Population losses due to disease and warfare resulted in smaller numbers of villages through time and the Kadohadacho were reduced to a single village in 1790 when they moved south into Louisiana and eventually west to the Timber Hill village along James Bayou on Caddo Lake in 1800 (Parsons et al. 2002). In northwestern Louisiana, reported raids by the Chickasaw from east of the Mississippi River valley in 1717 split the

Yatasi into two groups: one moved north to live with the Kadohadacho and the other south, near the Natchitoches and Adai (Swanton 1942:57). The groups coalesced in what is now eastern DeSoto Parish by the middle eighteenth century and became important in French-Caddo commerce (Girard et al. 2008). French settlement developed around Fort St. Jean Baptiste and the village of the Natchitoches Caddo eventually became a predominantly European settlement by the middle eighteenth century. Habitation areas pertaining to the Natchitoches or nearby Doustioni have not been identified in the archaeological record, but three cemeteries along Cane River have yielded ceramic vessels and other burial goods (Walker 1935; Webb 1945). The presidio of Nuestra Señora del Pilár de Los Adaes, which has undergone multiple archaeological investigations (Avery 1997, 2010; Gregory et al. 2004), was a Spanish military outpost occupied between 1721 and 1773; it was surrounded by settlements of the Adaes Caddo. Williams (1964) suggested the name Lawton phase for historic Caddo sites in the Natchitoches area.

Type Descriptions

Perhaps the most widespread Caddo ceramic type associated with the eighteenth century is Natchitoches Engraved, a shell-tempered fine ware with decorative antecedents in the Late Caddo period types Glassell Engraved and Hodges Engraved. Vessels consist of distinctive short-rim carinated ("helmet-shaped") bowls, spool-neck bottles and, infrequently, a variety of other forms including effigy bowls. Carinated bowls have horizontal panels on the rims with ticked lines running through them or scrolls in a manner similar to Glassell Engraved and other fine wares dating back to the Middle Caddo period (fig. 2.7). On the bodies and bases of bowls, and bodies of bottles, are scrolls, meanders, and negative circles with cross-hatched backgrounds often similar to the earlier type Hodges Engraved. Natchitoches Engraved occurs throughout the Great Bend and Natchitoches regions and surrounding Caddo Area and has also been found in the middle Ouachita River drainage, in East Texas, and in the Lower Mississippi Valley (Harris and Harris 1980). Fine wares that first appeared during the Late Caddo period but also are present in Chakanina phase contexts include Simms Engraved, Avery Engraved, and Cabaness Engraved (Schambach and Miller 1984).

Two additional types that appear to relate to both Chakanina and Lawton phase sites have been found in surrounding areas as well. Keno Trailed, first appearing during the Late Caddo period, is characterized by close-spaced wide curvilinear lines arranged in a broad range of patterns. Spool-necked bottles are most common, but a few bowls and jars bearing these designs also are known. Jars similar to the types Foster Trailed-Incised or Emory Punctated-Incised (classifications vary) have distinctive punctated rims that sometimes bulge outward in a manner similar to Winterville Incised, *var. Tunica* found at Tunican sites in the Lower Mississippi Valley (Brain 1988:388–89). Although not common, vessels and sherds of

Keno Trailed

Natchitoches Engraved

colonoware

0 20
cm

Figure 2.7. Historic Caddo period vessels: *top left*, Mounds Plantation 16CD12; *top right and bottom*, Natchitoches Fish Hatchery 16NA9).

the Lower Mississippi Valley types Cracker Road Incised, De Siard Incised, and Fatherland Incised have been found in sites below the Shreveport area (Kelley 1997; Girard 2002).

Brushing and ridging of shell-tempered jars (Karnack Brushed-Incised and Belcher Ridged) may have continued to be made into the eighteenth century, although use of these techniques is rare in the southern portions of the region. Numerous grog-tempered brushed sherds were recovered from the early nineteenth century Timber Hill site (41MR211) on the north side of Caddo Lake (Parsons et al. 2002). Undecorated utilitarian ware was used throughout the region during the eighteenth and early nineteenth centuries. Distinctive bowls with coarse shell temper were used in salt production and transport at salt licks in the region (see Essay 7). Ninety percent of the pottery recovered at the Los Adaes presidio was native-made and most of it was undecorated, with varying temper combinations of shell, grog, and bone (Avery 2010). Cooking, storage, and serving vessels are represented, some of which are obvious copies of European forms, such as brimmed bowls, pitchers, and plates (often referred to as "colonoware") (see fig. 2.7). Colonoware has been recovered both from Caddo sites and sites occupied by people of either American Indian, European, or African heritage. The ethnic affiliation of the makers of colonoware is not known, but Morgan and MacDonald (2011) note that it disappears from ceramic assemblages in the Natchitoches area by about 1840 when most of the Caddos and other American Indian groups were forced out.

Discussion

During the eighteenth century, the Caddo people of the Great Bend and Natchitoches regions underwent complex and rapid alterations that undoubtedly changed the ways that ceramics were produced and used. The widespread intercultural distribution of types like Natchitoches Engraved and Keno Trailed, however, may have resulted from changes in the context of production from embeddedness in kin groups to incorporation into the frontier exchange economy (Usner 2003). Widespread exchange facilitated by the use and trade of horses and the desire and eventual need for acquisition of European-made goods—such as weaponry, cloth, and metal tools—altered Caddo kinship structure, leadership hierarchies, and community composition. Regional configurations evident in the Middle and Late Caddo period archaeological records dissolved. By the late eighteenth century, population

loss, expansion of European settlement, and the influx of other American Indian groups resulted in the marginalization of the Caddos within the larger regional economy. Some of the latest American Indian pottery was manufactured in part as a commodity for sale to others. For example, in 1806 Indian Agent John Sibley noted that throughout the Natchitoches area water was stored "in large earthen jars, which the Indian women make, of good quality, and at a moderate price" (American State Papers 1832). Interestingly, despite these changes, recognizably traditional vessel forms and fine-ware decorative motifs continued into the early nineteenth century in some communities (Lee 2001; see also Essay 6).

Conclusions

Traditional studies of ceramic design variation often assumed that localized communities produced distinctive sets of pottery that are recognizable archaeologically as clusters of ceramic types across the landscape. Many years of research in the Caddo Area has shown that although there is some empirical validity to this notion, factors that resulted in spatial and temporal patterning of ceramic designs are complex and not likely to have resulted exclusively from local production of community diagnostic ceramic sets. Until the Middle Caddo period, there appears to have been little concern for symbolizing communities with pottery decoration. During the Woodland and Formative Caddo periods, few decorated vessels were produced, and when present, decorative styles emulate those of more dynamic and expansive societies to the east in the Lower Mississippi Valley. A distinctive Caddo ceramic decorative tradition began in the Early Caddo period but exhibited relatively little variation across the Caddo Area. The initial development of fine wares appears to have been connected with attempts to link widely dispersed communities perhaps through ritual displays. The intent may have been to celebrate connections and to produce and maintain alliances but not to signal and assert differences. Decorative styles were borrowed and exchanged within what was developing as a distinctive cultural area within the widespread Mississippian world in the eastern United States.

By about AD 1200, conditions changed, and much greater diversity and localized design style distributions are evident in the archaeological record. Research has shown that there is some empirical validity to the notion that distributions of design styles reflect past communities or polities such as the tribal units noted in historic documents (see Essay 12). However, within localities, sites, or features such as grave lots, considerable variability existed. We suggest that one reason for this spatial heterogeneity may be that designs, particularly on fine wares, were linked to kinship groups such as lineages or clans that likely had differential presences in separate communities. Identity and loyalty both to kin group and community were important to the Caddos. Material display of kin affiliation likely

was a critical component of rituals that integrated communities, reproduced the social order, and recognized, celebrated, and sanctified leadership and social hierarchies by making connections to the cosmic order (see Sabo 1998). Through ritual, social conflicts and centrifugal tendencies were mitigated, and alliances with outside groups were formed and maintained. Use of decorative "style" was vital to the reproduction of Middle and Late Caddo period societies in at least three ways: (1) displaying community and kin group affiliation; (2) communicating with outside groups; and (3) linking phenomenal social structures to cosmic principles. All these factors contributed to the complexities evident in the variation and spatial distributions of fine-ware ceramic types and varieties in the Middle and Late Caddo period archaeological record.

With the onset of European colonization beginning in the late seventeenth century, population levels fell drastically, formerly distinct communities consolidated, and the Caddos were drawn into a widespread exchange economy dominated by other cultural groups. Although it appears that attempts were made to follow some traditions regarding the production and decoration of pottery, overall patterns that we see in the archaeological record of the Great Bend and Natchitoches regions were fundamentally altered.

3

Caddo Ceramics in the Red River Basin in Southeastern Oklahoma and Northeastern Texas

Amanda L. Regnier, Timothy K. Perttula, and Patrick C. Livingood

In this essay, we describe ceramics in the western Caddo region, encompassing the Red River, which separates Oklahoma and Texas, the Little River drainage of southeastern Oklahoma, and the Sulphur River drainage in northeastern Texas (fig. 3.1). The limited suite of radiometric dates confirms ceramics on ancestral Caddo sites in the study area date only after ca. AD 200. The earliest ceramics in surrounding regions first appeared much earlier, suggesting that additional archaeological work is needed to determine when pottery was first used in the study area. We begin with Woodland period ceramics and examine the origins of regional Caddo ceramic traditions during the Formative Caddo period. While the regional ceramic traditions may show little variation during the Formative Caddo to Early Caddo period, after AD 1200, Middle Caddo assemblages begin to reflect increasing interregional variation in ceramic practice. By the Late Caddo period, after AD 1400, ceramic assemblages exhibit a wide variety of decorative elaborations that can be used to examine interaction, exchange networks, and ritual developments across the study area.

The Study Area

The western Red River area includes a variety of physiographic provinces within southeastern Oklahoma and northeastern Texas (fig. 3.2). The major drainage, the Red River, flows eastward through the center of the study area in a frequently shifting channel as it crosses the western Gulf coastal plain. North of the Red River, the Little River flows south out of the Ouachita Mountains and turns in the foothills, paralleling the Red River until their confluence in southwestern Arkansas. The Glover and Mountain Fork Rivers flow south from the mountains and into the Little River. Farther west, the Kiamichi River begins in the Ouachita Mountains and flows south to join with the Red. The westernmost south-flowing drainage sys-

Figure 3.1. Western Red River study area in southeast Oklahoma and northeast Texas.

tem consists of Clear and Muddy Boggy Creeks, which join just before emptying into the Red. In the southern portion of the study area, the Sulphur River flows east, paralleling the Red, joining it in the southwest corner of Arkansas, downstream from the Little River confluence.

This area includes a number of physiographic provinces. The northern portion includes the oak-hickory forested ridges and valleys of the western edge of the Ouachita Mountains, which gradually transition to the Post Oak Savannas of the western Gulf coastal plain along the Red River. To the south, the Sulphur River flows through the Post Oak Savannahs into a band of Blackland Prairie with natural cedars and underlying chalk bedrock and then into the Pineywoods of East Texas. While artificial state borders with Arkansas and Louisiana make up the eastern boundary of the project area, the western boundary is marked by the transition to the Cross Timbers region, which lies at the boundary between the Eastern Woodlands and the Southern Plains.

Chronology

Bruseth (1998) conducted a statistical analysis of whole vessels from more than 100 burial lots from sites in the study area to establish five different chronological

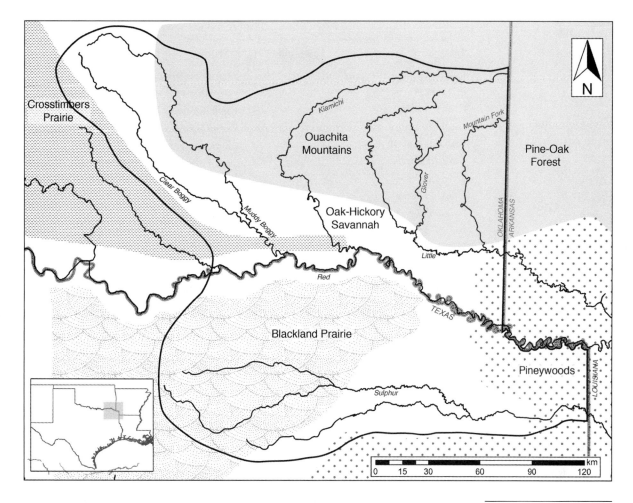

Crosstimbers
Prairie

Kiamichi

Ouachita
Mountains

Mountain Fork

Pine-Oak
Forest

Clear Boggy

Muddy Boggy

Glover

Oak-Hickory
Savannah

OKLAHOMA
ARKANSAS

Little

Red

TEXAS

Blackland Prairie

Pineywoods

Sulphur

LOUISIANA

km
0 15 30 60 90 120

N

Figure 3.2. Physiographic provinces and major rivers in the study area.

clusters of related ceramic types (table 3.1). Ceramics first occur in the western Red River region on Woodland period sites. Woodland occupations in this area extend back to at least AD 200 (Bruseth 1998), and surely date even earlier, but few contexts are securely dated. Woodland period sherd assemblages are primarily from undecorated vessels, with thick-walled, grog-tempered jars and bowls; the handful of decorated sherds have horizontal incised lines (Schambach 1982a, 1998). The beginning of the Formative Caddo period, around AD 800, is characterized by an increase in decorated sherds, with the introduction of Caddo utility wares such as East Incised, Kiam Incised, Davis Incised, Hollyknowe Ridge Pinched, and Weches Fingernail Impressed. The exact timing of the transition from the Formative to Early Caddo periods is difficult to gauge but may have occurred around AD 1000, although there are few dates for sites from this time (Bruseth 1998; Perttula 2008a). Early Caddo ceramic types include grog-tempered fine-ware types Crockett Curvilinear Incised, Pennington Punctated-Incised, Hickory Engraved, Holly Fine Engraved, and Spiro Engraved. These vessels occur in a variety of forms, in-

Table 3.1. Western Red River Area Caddo Ceramic Sets

**Formative to Early Caddo Set,
ca. AD 850–1200**
Coles Creek Incised
Crenshaw Fluted
Crenshaw Lobed
Crockett Curvilinear Incised
Davis Incised
Dunkin Incised
Hickory Engraved
Holly Engraved
Hollyknowe Pinched
Kiam Incised
Pennington Punctated-Incised
Spiro Engraved
Williams Plain

**Middle Caddo Set, ca. AD 1200–1400,
Upper Red River, cf. Sanders Phase**
Bois d'Arc Plain
Canton Incised
Maxey Noded Redware
Monkstown Fingernail Impressed
Paris Plain
Sanders Engraved
Sanders Slipped

**Middle Caddo Set, Lower Red River and
Sulphur River, ca. AD 1200–1400**
Antioch Engraved
Dunkin Incised
East Incised
Friendship Engraved
Haley Complicated Incised
Haley Engraved
Handy Engraved
Hempstead Engraved
Pease Brushed-Incised

McCurtain Phase Set, ca. AD 1400–1680
Avery Engraved
Clark Engraved
Emory Punctated-Incised
Hudson Engraved
McKinney Plain
Nash Neck Banded (shell)
Simms Engraved
Taylor Engraved

**Texarkana Phase Set, ca. AD 1400–1680
Century**
Avery Engraved
Barkman Engraved
Bowie Engraved
Foster Trailed-Incised
Hatchel Engraved
Karnack Brushed-Incised
Keno Trailed (latest part of phase)
McKinney Plain
Moore Noded
Nash Neck Banded
Pease Brushed-Incised
Simms Engraved

**Latest Set, ca. AD 1680–1700+ at the
Clements Site (41CS25)**
Clements Brushed
Darco Engraved
Hatinu Engraved
Keno Trailed
Simms Engraved
Taylor Engraved

Post-AD 1680, Mid-Red River
Emory Punctated-Incised
Natchitoches Engraved
Simms Engraved
Womack Engraved
Womack Plain

cluding bottles, cylindrical jars, and bowls. Utilitarian jar types dating between AD 1000 and AD 1200 include those listed above and Williams Plain. The utility wares are tempered with grog and/or varied combinations of grog, bone, and grit.

The subsequent Middle Caddo period, lasting from roughly AD 1200 to AD 1400, is referred to as the Sanders phase along the western part of the Red River. Perttula (2008b:325) noted the Sanders phase is sorely in need of closer examination since it was created based primarily on data from excavations at only a single site and the handful of other known Sanders phase sites have not been studied extensively. Ceramic types associated with Middle Caddo sites on the Red River include Maxey Noded Redware bottles, Canton Incised jars, and Sanders Engraved bowls and carinated bowls. Surveys along the Red River and at the Sanders site (41LR2) indicate that sites associated with both the Formative/Early Caddo and Middle Caddo periods and the Mound Prairie/Sanders phase were concentrated around a few key places on the landscape.

The majority of Caddo sites excavated in the region date to the Late Caddo period, dating from ca. AD 1400–1680. Along much of the western Red River region, these sites are assigned to the McCurtain phase. Caddo settlements sprawled more widely across the landscape around mound sites during this time (Perttula 2008b:481). Sites at the western margin of the study area were abandoned by the Late Caddo period, probably due to climatic fluctuations that caused a shift in the ecotonal boundary between the Eastern Woodlands and the Southern Plains (Bruseth 1998; Perttula and McGuff 1985; Wyckoff 1970a). The McCurtain phase can be divided into early and late components using pottery traits.

Late Caddo ceramics are far more elaborately decorated than earlier periods, with a wider variety of bottle, bowl, and jar forms. The distinctive Avery Engraved type, characterized by red slipping and sunburst motifs, first appears during the early McCurtain phase. Other early McCurtain phase types include Nash Neck Banded and McKinney Plain utilitarian wares. Shell-tempered ceramics were introduced to the region by ca. AD 1300. The percentage of ceramics with shell as the primary tempering agent rises through time, becoming dominant on Texas sites after AD 1600. Shell-tempered wares never became as dominant on Oklahoma sites. After AD 1500, fine-ware types such as Hudson Engraved, Keno Trailed, and Simms Engraved were introduced. Utility-ware types include Foster Trailed-Incised, McKinney Plain, Emory Punctated-Incised and Belcher Ridged vessels. Sometime after AD 1680, the Oklahoma sites were abandoned. Post-AD 1680 fine wares in northeastern Texas Caddo sites include Avery Engraved, Hudson Engraved, Keno Trailed, Natchitoches Engraved, Simms Engraved, and Womack Engraved. Utility wares include Foster Trailed-Incised and Emory Punctated-Incised.

Research Challenges

Ceramic research in the western Red River region faces a number of challenges, particularly on the Oklahoma side of the river because of a relative lack of data when compared with that of other Caddo regions and the absence of data from excavations since 1980. Professional archaeology in southeastern Oklahoma began with Works Progress Administration (WPA) Great Depression relief projects (fig. 3.3). WPA excavations at the Clement (34MC8–10) and McDonald (34MC11/12) sites along the lower Glover River and the Cook (34CH7) and Nelson (34CH8) sites along the Kiamichi River generated large ceramic collections. Excavations by the University of Oklahoma at the A.W. Davis (34MC6) mound on the lower Glover in the 1950s were halted by an angry landowner but did generate a collection of sherds and whole vessels (Wilson 1962). A number of the unprovenienced vessels from the collections of George T. Wright, an early twentieth century collector who dug in the lower Glover region, are likely from the A.W. Davis and Clement sites. Most of the available ceramic data from Oklahoma are from archaeological surveys, testing, and excavation done in the 1960s and 1970s for the Oklahoma River Basin Survey Project. Projects took place in the Jackfork Reservoir and Hugo Lake areas along the Kiamichi, around Broken Bow Lake on the Mountain Fork, at Pine Creek Lake along the Little River, and along the upper Glover River. Perino (1981) conducted salvage excavations at the Roden site (34MC215) along the Red

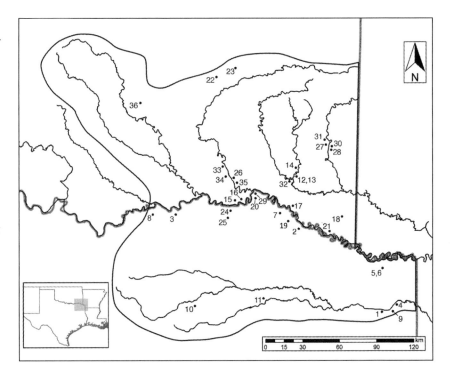

Figure 3.3. Project areas and key sites mentioned in the text: *1*, Snipes; *2*, Bentsen-Clark; *3*, Sanders; *4*, Knights Bluff and Sherwin; *5*, Mitchell; *6*, Hatchel; *7*, Sam Kaufman; *8*, Womack; *9*, Clements; *10*, Cooper Lake; *11*, W. A. Ford; *12*, Clement; *13*, A. W. Davis; *14*, McDonald; *15*, Nelson; *16*, Cook; *17*, Roden; *18*, Bud Wright; *19*, Holdeman; *20*, Fasken; *21*, Viper Marsh; *22*, Bug Hill; *23*, Turtle Luck; *24*, Stallings; *25*, Ray; *26*, Mahaffey; *27*, E. Johnson; *28*, Biggham Creek; *29*, Wright Plantation; *30*, Beaver; *31*, Woods Mound Group; *32*, Grobin Davis; *33*, Payne; *34*, Pat Boyd; *35*, Hugo Dam; *36*, Pittance.

River after looters had done substantial damage and he also conducted excavations at the Bud Wright site (34MC215) near the Arkansas state line (Regnier 2017). Since the 1980s, only a handful of excavations have been conducted in southeastern Oklahoma. The most extensive are the TIAK district excavation projects directed by the United States Forest Service in the mid-1990s (Etchieson 2003) and field schools at the Clement site in 2008 (Hammerstedt et al. 2010) and the Ramos Creek site in 2010 (Dowd 2012; Dowd and Regnier 2014).

In the Caddo Area, more data recovery excavations have taken place in northeastern Texas as cultural resource management archaeology developed in the late twentieth century. Bearing that in mind, the Sulphur and Red River drainages may still be the least well-known areas of Caddo occupation in Texas. Archaeological research began in the western portion of the Red River with the 1931 excavations at the Sanders site (41LR2) by the University of Texas (UT) (Jackson et al. 2000), and UT also worked at sites elsewhere in the Red River basin at that time as WPA projects. Avocational archaeologists began work on sites in the Red River basin in the 1940s (Harris 1953). In the 1960s, a river basin survey along the Sulphur River in the Texarkana Reservoir generated additional archaeological data (Jelks 1961), as did work prior to the construction of Cooper Lake. In the 1960s and 1970s, salvage excavations at the Sam Kaufman site (41RR16) (Skinner et al. 1969) and the Bentsen-Clark site (41RR41) (Banks and Winters 1975) generated collections of whole vessels and sherd assemblages. Perino directed excavations at the Holdeman (41RR11) (Perino 1995) and Sam Kaufman/Bob Williams (Perino 1983) sites on the Red River during the late 1970s/early 1980s. Field projects led by the Texas Archeological Society in the early 1990s focused on both the Sam Kaufman and Fasken (41RR14) sites and a number of surrounding sites along the Red River. More recently, contract work by Prewitt and Associates, Inc., and other firms, has generated additional ceramic data from sites at Cooper Lake along the south Sulphur River. In addition to these projects, private and museum collections of whole vessels have been made available for documentation and study.

Because we are dealing with nearly eighty years of archaeological research in the region, published ceramic data vary in their quality and reliability. Whole vessels typically are categorized according to the typology created by Suhm and Jelks (1962), which is in need of updates and refinement. Using a typology created for whole vessels has obvious limitations when analyzing sherd collections. Another analytical issue is present within the study area. Ceramic analyses from many of the Oklahoma reports, especially from sites in the northern portion of what is considered the Caddo Area, employ types created by Brown (1971; 1996) for the ceramic assemblage from the Spiro site, located along the Arkansas River north of the Ouachita Mountains. Lambert's (2017 and Essay 8) sourcing analysis demonstrated that Caddo fine-ware vessels associated with the AD 1100–1300 Harlan phase, recovered from Spiro and other mound sites, were imported from the Red

River drainage. Lambert's work allowed Hammerstedt and Savage (Essay 5) to refine the local Arkansas drainage ceramic assemblage. This new research calls into question whether Brown's Arkansas River ceramic types should be applied to sites in southeastern Oklahoma. The dividing line between typologies should fall along the Ouachita Mountains divide between the Arkansas and Red River drainages.

Western Caddo Ceramic Assemblages through Time

WOODLAND CERAMICS (CA. AD 200–800)

Woodland period ceramic assemblages in the western Red River area are associated with Fourche Maline culture occupations (see Regnier 2017). The ceramics are primarily plain grog- and bone-tempered jars (i.e., Williams Plain) with flat bases and very thick vessel walls (fig. 3.4). Plain hemispherical bowls also occur in the assemblages. These sherds occasionally have impressions of coiled fabrics on the base (see Vehik 1982:101). Many of the flat-bottomed jars are flared at the base, forming a keel to help prevent the vessel from tipping over (Bruseth et al. 2001). There are also relatively thick bone-tempered sherds as well that may be related to Cooper Boneware (see Schambach 1998), another Woodland period ceramic type. Decorated ceramics with similarities to Lower Mississippi River Valley (LMV) types, including Tchefuncte, Marksville, Troyville, and early Coles Creek, are notable in these assemblages. Both Kidder (1998:131) and Schambach (1991) have pointed out that sherds with Coles Creek designs are executed on a different paste in the Caddo Area than in the LMV. This also holds true for other LMV types found in the Caddo Area, such as French Fork Incised. While there are obvious similarities, Caddo archaeologists should create separate type or variety designations that acknowledge the obvious connection of these ceramics with the LMV while not obscuring differences in paste and execution.

Only a handful of excavated Woodland ceramic assemblages are available in the study area, and very few are securely dated (see fig. 3.3). It is unclear when ceramic technology was initially adopted, but the best estimate seems to be sometime between AD 200–300, if not earlier based on dated Woodland period assem-

Figure 3.4. Profiles of Woodland vessels forms: *a*, jar, *b*, jar with keel around base, *c*, bowl.

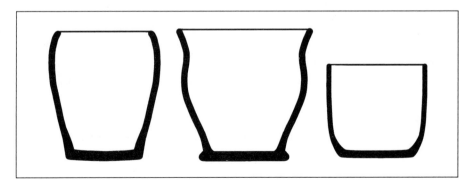

blages elsewhere in the Caddo Area. At the Viper Marsh site (34MC205), Bobalik (1977:26–32) reported the recovery of 15 sherds from excavations. Twelve had a sandy paste, one was grog-tempered, and two were so small that temper was unidentifiable. An archaeomagnetic date from one of two hearths at the site produced a date of AD 1 ± 100 with a 95 percent confidence interval, but this date is tentative due to its wide range (Bobalik 1977:5). At the Bug Hill site (34PU116) in the Jackfork Reservoir, Altschul (1983:292) reported an assemblage of roughly 100 Woodland sherds. These predominantly thick plain grog-tempered sherds also had temper inclusions of grit, shale, and bone. The handful of decorated sherds were untyped but had incised decoration. None were recovered from securely dated contexts. Altschul (1983:156) speculated that these ceramic assemblages predate dated charcoal from the same stratum that returned an age range of cal. AD 214–555. At the nearby Turtle Luck site, Lintz (1982) reported dates with ages of cal. AD 256–299 and cal. AD 233–432 from pit features containing thick grit and grog-tempered Woodland sherds. Additional samples from secure contexts are needed to address the dating of the introduction of ceramics in the western Red River region.

Woodland period burials at the Snipes site (41CS8) had a Coles Creek Incised, *var. Stoner* bowl dated from ca. AD 550–700 (Brown 1998:8, 53) (fig. 3.5), a Williams Plain flowerpot-shaped jar, and three plain, small bowls. The ceramic assemblage includes grog, grog-bone, and bone-tempered Williams Plain and Cooper Boneware vessel sherds, along with Coles Creek Incised and Williams Incised sherds. No Woodland vessels have been recovered from burials in southeastern Oklahoma.

FORMATIVE AND EARLY CADDO (CA. AD 800–1200)

Formative and Early Caddo period assemblages include a wider variety of decorated ceramics. We use the term Formative Caddo to denote sites with Woodland ceramics, Caddo utility wares, and the occasional incised or engraved fine-ware sherd. The practice of interring vessels in burials and other special contexts became more frequent through time, resulting in a large sample of whole vessels for study. Early Caddo sites are recognized by the presence of engraved and incised fine-ware types that include Spiro Engraved, Hickory Engraved, Holly Fine Engraved, Crockett Curvilinear Incised and Pennington Punctated-Incised (fig. 3.6a–i). Fine-ware vessel forms include long-necked bottles, several bowl forms, and cylindrical jars. Utility wares consist of jars, primarily with flat bottoms. Early Caddo utility wares occur together with thick Williams Plain flat-bottomed jars. Exactly when potters transitioned entirely to the thinner Early Caddo utility wares and fine wares is not known, but utility wares seem to have been adopted before the fine wares. The limited data from the few Forma-

Figure 3.5. Coles Creek Incised, *var. Stoner* bowl from the Snipes site.

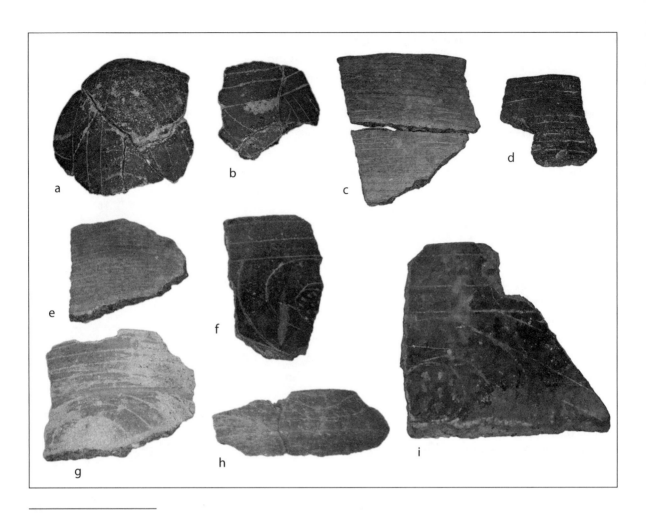

Figure 3.6. Early Caddo fine-ware sherds from sites in the Red River drainage: *a–b*, red-slipped Holly Fine Engraved; *c–e*, Coles Creek-like Incised; *f–i*, Spiro Engraved.

tive to Early Caddo sites hints that Crockett Curvilinear Incised and Pennington Punctated-Incised were the first of the Early Caddo fine wares to be made on sites in the study area and engraved types such as Spiro Engraved, Hickory Engraved, and Holly Fine Engraved were produced slightly later (Regnier 2017:188–89, table 6.2).

Perttula (2018a) documented a small assemblage of ceramics from the Stallings site (41LR297) in the Red River drainage that includes examples of Early Caddo fine and utility wares, Coles Creek *var. Greenhouse* sherds, plain bone-tempered sherds, and thick Williams Plain rims. The assemblage may reflect separate Woodland and Early Caddo occupation components, or it may be a single contemporaneous occupation; this is impossible to differentiate from the available data. At the nearby Ray site (41LR135), 98.3 percent of the largely grog-tempered sherds were undecorated. The few decorated sherds include regional variants of Coles Creek Incised and French Fork Incised along with Crockett Curvilinear Incised. Bruseth (1998:53) and Bruseth et al. (2001:table 11) reported calibrated age ranges from nut-

shells recovered from Feature 2 at the Ray site of AD 690–890 and AD 910–960. A sample of nutshells from Feature 1 has a calibrated age range of AD 690–890, as well as a second date of cal. AD 1055–1270 (Bruseth et al. 2001:206).

Just to the north, excavations at the Mahaffey site (34CH1) on the lower Kiamichi River exposed a cemetery with 44 burials without grave accompaniments and a handful of poorly defined features (Perino and Bennett 1978; Rohrbaugh et al. 1971). The thick Williams Plain sherds there were predominantly grog-tempered; only a handful had bone inclusions. Decorated Early Caddo utility types in the assemblage include Canton Incised, East Incised, and Hollyknowe Ridge Pinched sherds (Regnier 2017:182).

The Bud Wright site (34MC216) is another example of an assemblage that spans the Formative to Early Caddo transition (Regnier 2017). This site, which was excavated by Perino in the 1970s, includes an occupation area and a cluster of burials. None of the burials had ceramic vessels as funerary offerings. Ceramics from habitation areas at Bud Wright include Coles Creek-like sherds executed on the typical thick, grog-tempered Williams Plain paste (fig. 3.7a–e). Caddo utility types such as Davis Incised, Kiam Incised, East Incised, Weches Fingernail Impressed, Hollyknowe Ridge Pinched, and regional variants of Harrison Bayou Incised are found in the assemblage, along with a handful of Crockett Curvilinear Incised and Pennington Punctated-Incised sherds (fig. 3.7f–j; Regnier 2017:183–84).

At the Clement site (34MC8–10) on the lower Glover River, WPA excavations recovered a concentration of Formative to Early Caddo ceramics from one area of the large mound site. The sherd assemblage includes Spiro Engraved, red-slipped Holly Fine Engraved, Crockett Curvilinear Incised and Pennington Punctated-Incised, Coles Creek-like incised sherds, bases of thick Williams Plain jars, and red-slipped East Incised. The collection also has a number of red-slipped sherds from a thick, flat-bottomed grog-tempered jar that would be classified as Williams Plain were it not for the slip (fig. 3.8). The practice of red slipping vessels did not become common in the Red River drainage until around AD 1200; the decoration on these vessels suggest these thick jars were made during the Early Caddo period.

Wyckoff (1965a, 1967a, 1967b) reported incised sherds similar to decorated Fourche Maline sherds in the same assemblage as Early Caddo fine and utility wares at both the E. Johnson (34MC54) and the Biggham Creek (34MC105) sites along the Mountain Fork in the Ouachita Mountains. At the Bug Hill site (34PU116) in the Jackfork Reservoir at the far northwestern edge of the study area, Vehik (1982:96–112) documented thick Fourche Maline sherds, including sherds with mixed grog, grit, and bone temper and basal fabric impressions in contexts with Early Caddo fine and utility wares, including Crockett Curvilinear Incised and Pennington Punctated-Incised as well as Spiro Engraved or Hickory Engraved.

The largest assemblage of whole Early Caddo vessels was recovered from Bentsen-Clark (41RR41), where fine wares, particularly Spiro Engraved, are most

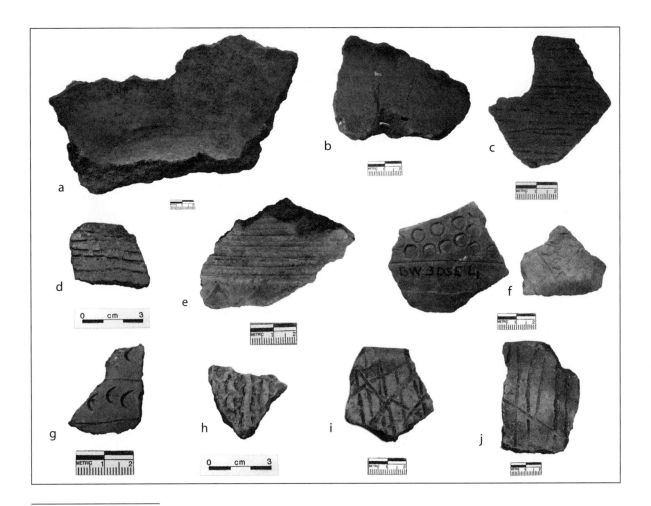

Figure 3.7. Formative/ Early Caddo sherds from the Bud Wright site (34MC216): *a–b*, Williams Plain; *c–e*, Coles Creek-like Incised; *f*, Crockett Curvilinear Incised; *g*, Weches Fingernail Impressed; *h*, Hollyknowe Ridge Pinched; *i–j*, Harrison Bayou Incised.

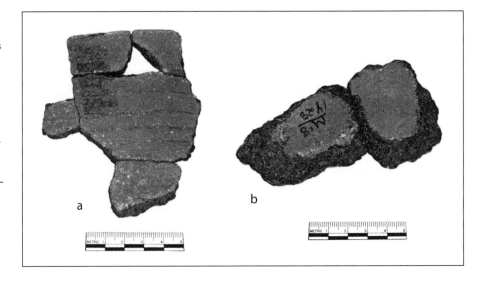

Figure 3.8. Thick, red-slipped Williams Plain-like vessel base sherds from the Clement site (34MC8).

prevalent (fig. 3.9a; see also table 3.1). Of the sixty-one vessels recovered from Feature 1 at the Bentsen-Clark site, twenty-four were Spiro Engraved, two were Holly Fine Engraved bottles and carinated bowls, and two were Hickory Engraved bottles (Banks and Winters 1975:37–44) (fig. 3.9b). Several Crockett Curvilinear Incised vessels were also recovered (fig. 3.9c). There is considerable variation in the decoration of these vessels, unlike the uniform decorations on the Early Caddo fine wares from Arkansas River drainage sites (Lambert 2017 and Essay 8). Utility wares primarily include East Incised and Davis Incised vessels. Plain wares account for 27.8 percent of the Early Caddo ceramic vessels in the George T. Wright Collection attributed to the Wright Plantation (41RR7) and Sam Kaufman (41RR16) sites. Other Early Caddo period vessels in the collection include Holly Fine Engraved bottles, East Incised effigy bowls, Pennington Punctated-Incised bowls (fig. 3.9d), two plain jars, a plain carinated bowl, and a typologically unidentified engraved bottle. Bottles are the most common form in Early Caddo period vessel assemblages, accounting for 58 percent of the sample, followed by carinated bowls (19.7 percent), bowls (12.2 percent), and jars (9.9 percent).

The pottery types present in Early Caddo sites are very uniform across the study area. In the northern portion, Wyckoff (1968a) reports a classic Early Caddo assemblage that included Hickory Engraved, Crockett Curvilinear Incised and Pen-

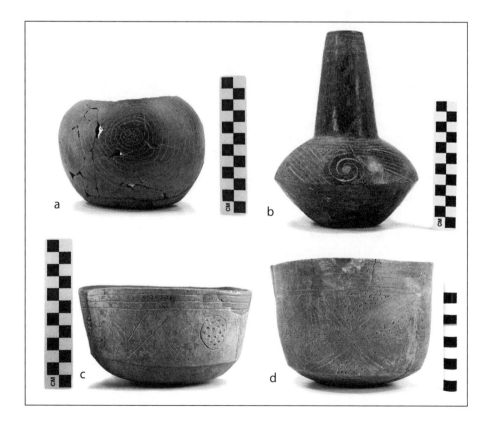

Figure 3.9. Formative to Early Caddo period vessels in the western Red River area: *a*, Spiro Engraved (41RR77); *b*, Holly Fine Engraved (41RR3); *c*, Crockett Curvilinear Incised (41BW3); *d*, Pennington Punctated-Incised (George T. Wright Collection, Sam Noble Oklahoma Museum of Natural History).

nington Punctated-Incised, Kiam Incised, Dunkin Incised, and Davis Incised, Weches Fingernail Impressed, and Wilkinson Punctated from the Beaver site (34MC1) in the Ouachita Mountains. In the southern portion of the study area, on the South Sulphur River at Cooper Lake, Early Caddo sites have grog-tempered sherds, primarily with incised and incised-punctated motifs on Crockett Curvilinear Incised, Pennington Punctated-Incised (Fields et al. 1997:51), and Coles Creek Incised-like vessels (fig. 3.10). There are also sherds from Kiam Incised, Dunkin Incised, and Spiro Engraved vessels. At the western edge of the study area, WPA excavations at the Cook site (34CH7) near the confluence of the Kiamichi River with the Red River recovered a small assemblage of Early Caddo ceramics, including Spiro Engraved, Crockett Curvilinear Incised, Dunkin Incised, Davis Incised, East Incised, and Coles Creek-like sherds (Bell and Baerris 1951:48–53; Rohrbaugh 1973:186). Whether Early Caddo ceramic assemblages are broadly similar, or the use of types is masking important variation, an analysis of variation in decorative styles, ceramic pastes, and vessel forms may reveal important information about Early Caddo social networks and communities of ceramic practice.

Middle Caddo Period Ceramics (ca. ad 1200–1400)

A portion of the Middle Caddo sites in the study area are assigned to the Sanders phase, dating from ad 1200 to 1400 (fig. 3.11). The Sanders phase has been the subject of much debate. Schambach (1995) argued the Sanders phase represents a movement of people out of the Spiro site and the broader Arkansas River drainage into the middle Red River basin, as evidenced by similarities in pottery, house construction, and burial artifacts, particularly shell gorgets. Numerous authors (Brooks 1996; Bruseth et al. 1995) criticized this position; Lambert's (2017 and Essay 8) sourcing study, which demonstrated that Caddo fine wares from Spiro and related sites were imported from the Red River drainage, represents the final blow to this argument. Schambach (2000:11) made a valid point that the Sanders phase is in need of greater evaluation, and archaeologists working in the region agree (Perttula 2008b; Story 1990a:174).

Middle Caddo ceramic assemblages are characterized by both considerable change and some continuity with Early Caddo ceramics. The elaborately decorated Early Caddo fine wares are replaced with more simply decorated Sanders Engraved bowls. The quantity of red-slipped wares increases and bottle and bowl forms change. The use of a red hematite slip on interior and/or exterior surfaces of carinated bowls and bottles occurs with some regularity in ca. ad 1200–1400+ ceramic assemblages in parts of the Red River basin. The use of red slips to cover one or both surfaces of fine-ware bowls, carinated bowls, compound bowls, and bottles is a distinctive feature of Middle Caddo period groups living in the upper parts of the Sulphur and Red River basins as well as other parts of East Texas (fig. 3.12). A new decorative tradition of applying pieces of clay to bottle bodies emerges in the

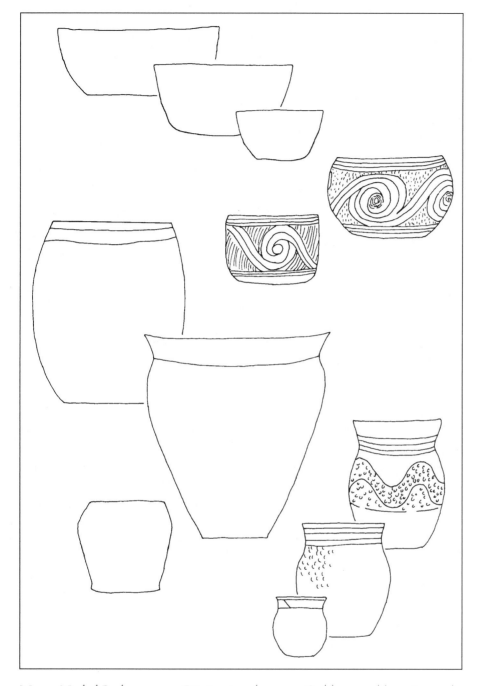

Figure 3.10. Early Caddo vessel forms and most common decorative motifs in Cooper Lake sites (from Fields et al. 1997:fig. 29).

Maxey Noded Redware type. Distinctions between Caddo assemblages in southeastern Oklahoma and the Red River and sites along the Sulphur River and into East Texas become more apparent. Whole vessels assemblages from sites along the Sulphur River, described below, have a much higher diversity of ceramic types than the rest of the study area.

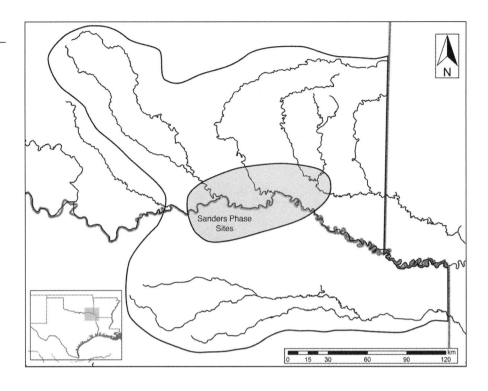

Figure 3.11. Distribution of the Sanders phase in the western Red River area.

Sanders Phase Sites

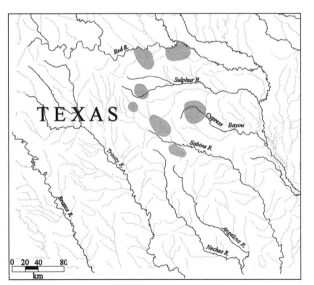

Figure 3.12. Sherd assemblages with >10 percent red-slipped sherds in East Texas.

The Middle Caddo period Sanders phase component at the T. M. Sanders site (41LR2) is represented by nine different ceramic types that are tempered with grog and/or bone and a newly defined variety of one type (Bois d'Arc Plain, *var. Crawford*) (Perttula, Walters, and Nelson 2016). Plain wares comprise 30.3 percent of the vessels from burials, utility wares another 13.1 percent, and the remaining 56.6 percent of the ceramic vessels are fine wares with either engraved and/or red-slipped decorative elements. The principal types are Bois d'Arc Plain (fig. 3.13*a*), Sanders Engraved (fig. 3.13*b*), Maxey Noded Redware (fig. 3.13*c–d*), and Sanders Slipped (fig. 3.13*e*). Five ceramic vessel forms are recognized among defined types of plain, utility, and fine wares. Bottles and neckless bottles account for 30.4 percent of these vessels, another 30.4 percent of the assemblage are simple bowls, 24.6 percent are carinated bowls, and the remaining 14.5 percent are jars. The majority of the bottles are Maxey Noded Redware vessels with appliqued and punctated designs, and the neckless bottles are Sanders Engraved. About half of the Bois d'Arc Plain vessels are bowls, 33 percent of the Sanders Incised vessels are bowls, and

67 percent of the Sanders Slipped vessels are bowls. Only 19 percent of the Sanders Engraved vessels are bowls. Carinated bowls are well represented in the Sanders Incised (67 percent) and Sanders Engraved (44 percent) types and also occur among the Bois d'Arc Plain (26 percent), Bois d'Arc Plain, *var. Crawford* (50 percent), and Sanders Slipped (17 percent) vessels. All of the Canton Incised (fig. 3.13*f*) and Monkstown Fingernail Impressed (fig. 3.13*g*) vessels in the T. M. Sanders vessel assemblage are jars, as are 10.5 percent of the Bois d'Arc Plain vessels. A total of 12.5 percent of the Sanders Engraved vessels are also jars.

Approximately 10 percent of the vessels at the Middle Caddo Knight's Bluff (41CS14) and Sherwin (41CS26) sites on the lower Sulphur River are plain. Utility wares make up about 54 percent of the vessel assemblage. These are all jars, with the exception of a carinated bowl with incised decorative elements from the Sherwin site. The principal utility wares at both sites are Pease Brushed-Incised (*n* = 8) and a grog-tempered early variety of Nash Neck Banded (*n* = 6). Other utility wares have appliqued (*n* = 2), brushed-appliqued (*n* = 1), brushed-punctated (*n* = 1), tool punctated rows (*n* = 1), and punctated-appliqued decorative elements (*n* =

Figure 3.13. Middle Caddo period Sanders phase vessels from the T. M. Sanders site: *a*, Bois d'Arc Plain; *b*, Sanders Engraved; *c–d*, Maxey Noded Redware; *e*, Sanders Slipped; *f*, Canton Incised; *g*, Monkstown Fingernail Impressed.

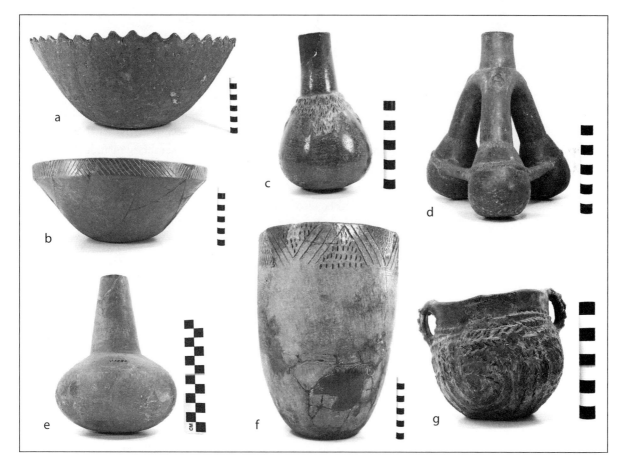

1). Among the fine wares at the sites, the engraved vessels are primarily bottles of Haley Engraved ($n = 4$), Antioch Engraved (see Jelks 1961) ($n = 3$), Higgins Engraved ($n = 2$), and Maddox Engraved ($n = 2$) types. Other fine wares include a Friendship Engraved carinated bowl from Knight's Bluff, a Glassell Engraved bottle from Burial 9 at Knight's Bluff, and a Barkman Engraved compound bowl from Burial 11 at Knight's Bluff. There are stylistic similarities in the engraved fine wares from the Knight's Bluff and Sherwin sites and the Middle Caddo period vessels from the Paul Mitchell site (41BW4) on the Red River (see Perttula, Nelson, and Walters 2016:10–24, 28–34).

In Oklahoma, Sanders phase components are documented at the WPA-excavated Nelson site (34CH8), near where the Kiamichi River joins with the Red. Rohrbaugh (1973) reports his brief analysis of the sherds, noting that the Sanders phase type Canton Incised makes up 14 percent of the ceramic assemblage. A few sherds of Maxey Noded Redware were recovered; Rohrbaugh (1973:187–89) did not report any Sanders Engraved carinated bowl sherds, but Bell and Baerreis (1951:51 and plate 9:19, 21) illustrate two sherds. This assemblage also includes sherds from an Early Caddo component, in the form of a handful of Crockett Curvilinear Incised and Dunkin Incised sherds. Upstream at the Hugo Dam site (34CH112), Burton (1970) documented 10 whole vessels from Early Caddo to Sanders phase burials. Vessel forms present include five bowls, three bottles, and two cylindrical jars. Half of the vessels (two bottles, two bowls, and one jar) were red-slipped. One of the bottles was identified as a Sanders Plain bottle, which would be typed as Sanders Slipped today, and another was Maxey Noded Redware. Burton (1970:43) noted that for a Caddo vessel assemblage, these vessels were smaller than expected and they had irregular forms. The excavated sherd assemblage includes both Early Caddo and Sanders phase types, suggesting the site was occupied during both periods, or at least during the transition between them. Rohrbaugh (1973) documents similar assemblages of Early and Middle Caddo sherds from the Payne (34CH53) and Pat Boyd sites (34CH113). To the north in the Jackfork Reservoir, Vehik (1982:98) notes Sanders Engraved sherds at the Bug Hill site (34PU116). Even farther west, along Potapo Creek, part of the McGee Creek Reservoir, the assemblage from the Pittance site (34AT112) also includes a mixture of Early Caddo and Sanders phase ceramic types, including Spiro Engraved, Holly Fine Engraved, Sanders Engraved, Pennington Punctated-Incised, and Davis Incised (Ferring et al. 1994).

Along the Little River, the small ceramic sample from the multi-mound Grobin Davis site (34MC253) include classic Sanders phase types Maxey Noded Redware, Sanders Engraved, and possibly Canton Incised (Wyckoff and Fisher 1985:96). Due east along the Mountain Fork River, near the Arkansas border, Wyckoff (1967b:124) identified a number of sites with Sanders phase components. Middle Caddo assemblages here include several types typical in Arkansas but not found on Caddo

sites farther west. At the Beaver site (34MC1), ceramic types include Sanders Engraved, Canton Incised, Maxey Noded Redware, and Sanders Slipped, as well as sherds of Haley Engraved and East Incised pottery typically found in southwestern Arkansas. The E. Johnson site (34MC54) also had a significant Sanders phase occupation, with Sanders Engraved, Canton Incised, Maxey Noded Redware, and Sanders Slipped sherds. Although analysis of the massive WPA-excavated sherd collection from the Clement site (34MC8–10) is ongoing, Sanders phase ceramics make up only a small portion of the recovered assemblage (fig. 3.14). Just upstream at the McDonald site (34MC11), only a single sherd of Maxey Noded Redware and a handful of Canton Incised sherds were recovered during WPA excavations of a large sheet midden and cemetery (Regnier 2013).

Middle Caddo sites certainly need additional ceramic work, but some trends are evident across the region. While there is a degree of uniformity to Early Caddo assemblages, Middle Caddo ceramics begin to show some differences within the study area. Along the Mountain Fork River, close to the Arkansas state line, Middle Caddo ceramic assemblages include types typically associated with contemporaneous sites to the east. In the Glover drainage, Middle Caddo ceramics are gen-

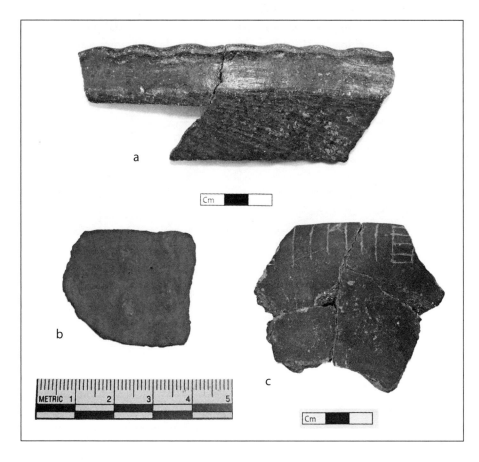

Figure 3.14. Sanders phase sherds recovered from sites in Oklahoma: *a*, Sanders Slipped, Clement; *b*, Maxey Noded Redware, McDonald; *c*, Sanders Engraved, Clement.

erally uncommon. Moving west, Sanders phase occupations are indicated by the same series of ceramic types as far west as Muddy Boggy Creek. In the southern portion of the study area, along the Sulphur River, Middle Caddo ceramic assemblages diverge from those found in the rest of the study area, with the introduction of brushed and incised ceramics and different types of engraved ceramics, suggesting some changes in cultural reference points and contacts after AD 1200.

McCurtain Phase Ceramics (ca. AD 1400–1680)

After AD 1400, Caddo ceramic assemblages become far more stylistically diverse, with an expansion in vessel forms, modes and motifs of decoration, and paste recipes. Heralding the development of a new Caddo ceramic tradition, burned and crushed shells began to be commonly used as temper after ca. AD 1300–1400 among most of the middle Red River Caddo groups, namely, McCurtain phase Caddo groups in the Kiamichi-Red River confluence area. Later Caddo potters in the lower and upper Sulphur River basin (Perttula et al. 2011) also began to commonly use shell temper in vessel manufacture (fig. 3.15).

While shell nearly replaced grog as a tempering agent along the Red River, in the southern Ouachita Mountains at sites along the Mountain Fork, Glover, and Little Rivers, grog-tempered ceramics still made up a substantial portion of McCurtain phase assemblages (Dowd 2012; Hammerstedt et al. 2010; Regnier 2013). Analyses of sherds from the McDonald, A.W. Davis, and Clement sites indicate

Figure 3.15. Late Caddo phase designations in the study area.

that ceramic paste recipes at McCurtain phase sites were highly variable. Ceramic wares were tempered with grog, grit, shell, kaolin, bone, or mixtures of those materials. The different clay bodies crosscut all ceramic types and forms and are not tied to fine or utility wares, specific decorative motifs, or vessels forms (Regnier 2013). Further study is needed to determine if there is any spatial patterning of temper across the area, which may indicate paste recipes that can be tied to specific ceramic communities of practice.

The Caddo fine-ware designs after ca. AD 1400 in the western Red River area include scrolls, scrolls with ticked lines, scrolls and circles, spirals, negative ovals and circles, pendant triangles, diagonal lines and ladders, and S-shaped motifs (fig. 3.16). These kinds of decorative elements continued in use in historic Caddo ceramics until about AD 1800 or later. The best-known and most widely distributed fine-ware type associated with McCurtain phase sites is Avery Engraved, a type that could be subdivided into at least two different types by splitting out bottles and engraved bowls. Using vessels from the Roden site (34MC215), Perino (1981) documented changes in five vessel forms (utilitarian jars, tall bowls, bot-

Figure 3.16. Engraving motifs common on McCurtain phase sherds in Oklahoma: *a*, red-slipped ovals with vertical line filler, Clement; *b–c*, red-slipped sunburst motif with vertical line filler, Clement; *d*, reduction fired sunburst with cross-hatched filler, Clement; *e–g*, reduction fired ovals with vertical line filler, McDonald; *h–i*, red-slipped excised sunburst motifs, McDonald; *j–k*, red-slipped ovals with vertical line filler, McDonald; *l*, later red-slipped scrolls, A. W. Davis.

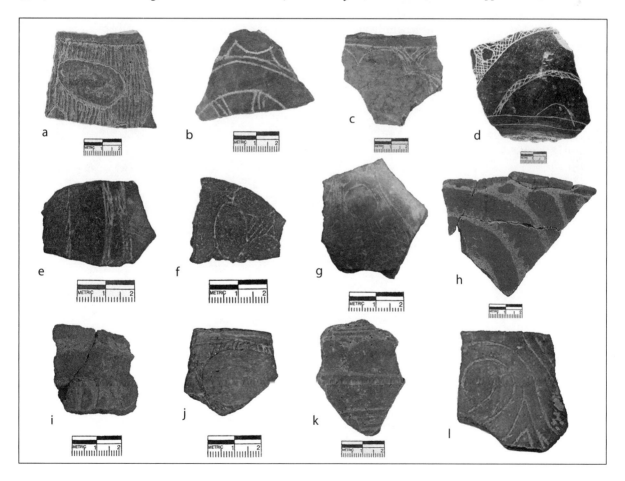

tles, fine-ware jars, and carinated bowls) for the McCurtain phase (fig. 3.17). While it is possible to see how the changes occurred gradually with four of the forms, the bottle form changes from straight-necked, round-bodied vessels of the early McCurtain phase to the spool-necked, pear-shaped bottles of the late McCurtain phase. This seems to be the product of importing ideas from the eastern part of the Caddo Area. These new bottle forms appear on sites in the study area dating after ca. AD 1550.

McCurtain phase fine-ware ceramics at sites such as Sam Kaufman and Roden are well represented by Avery Engraved compound bowls, deep bowls, and bottles (fig. 3.18a–c), often red or black-slipped, with chevron, semicircular, and scroll curvilinear motifs (Skinner et al. 1969; Perttula 1992:table 11). Simms Engraved carinated bowls also occur. Simms Engraved, *var. Darco* is a post-AD 1650 fine-ware style (fig. 3.18d) in late McCurtain phase contexts and at sites in the lower Red River basin and parts of East Texas. Along the Red River and in southeastern Oklahoma, Avery Engraved jar motifs changed over time. Early McCurtain phase motifs include stacked loops, sunbursts, and chevrons with excised areas. Later motifs include pendant scrolls; stacked loops remain popular through time. Effigy vessels generally are uncommon in the Caddo Area (see Essay 6), but reptile and amphibian effigies are found among McCurtain phase assemblages. Dowd (2011a)

Figure 3.17. Changes in Caddo vessel forms during the McCurtain phase based on Perino (1981).

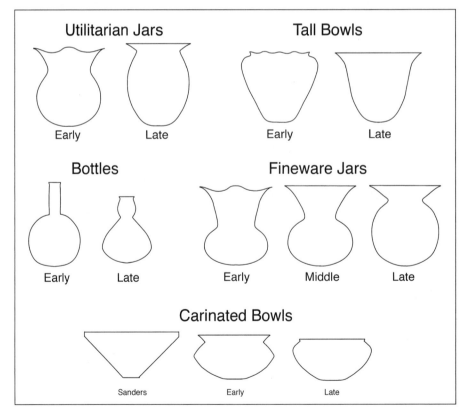

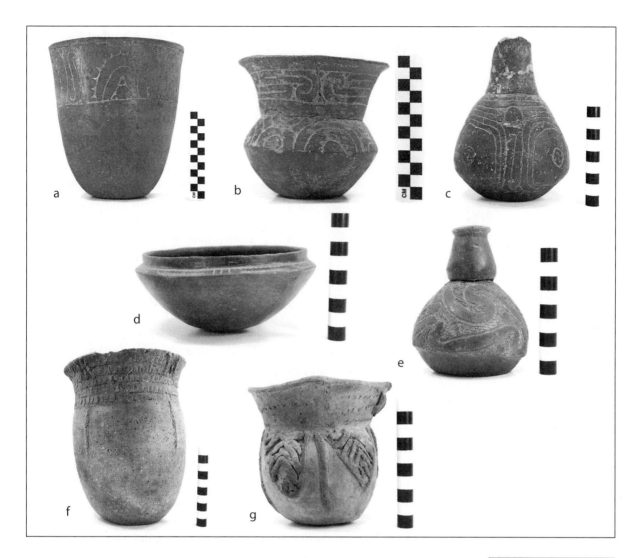

documented frog effigy faces on the edges of rim castellations and noted a number of turtle effigy bottles from sites along the Red River and in the southern Ouachita Mountains (fig. 3.19).

Fine wares dating after ca. AD 1550 in McCurtain phase sites also include Hudson Engraved (see fig. 3.18e) and Keno Trailed vessels, which are pear-shaped with spool-shaped necks. There are fine-wares jars with simple motifs, along with horizontal engraved effigy bowls with modeled bird heads. The common use of a bird's head appendage on effigy vessels has been interpreted as a reference by Caddo potters to the bird emissary that brought corn in all its abundance to the Caddo people (see Lankford 2008:37 and fig. 2.1).

The utility wares in McCurtain phase sites include types such as Nash Neck Banded (see fig. 3.18f) and Emory Punctated-Incised (see fig. 3.18g) jars, and Mc-

Figure 3.18. McCurtain phase vessels from Red River County, Texas, sites: *a–c*, Avery Engraved; *d*, Simms Engraved, *var. Darco; e*, Hudson Engraved; *f*, Nash Neck Banded; *g*, Emory Punctated Incised.

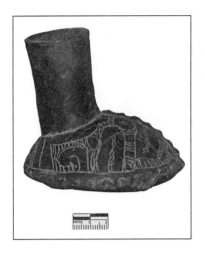

Figure 3.19. Turtle effigy bottle recovered from the WPA excavations at the Clement site (34MC8).

Kinney Plain jars with a plain or roughened rim and vertical appliqued strips on the vessel body. Over time in the McCurtain phase, it appears that designs on Nash Neck Banded jars, which potters made by smoothing over rows of pinched clay running horizontally around the neck of the vessel, evolved into the later horizontal bands of fingernail impressions and/or eventually the roughening seen on Emory Punctated-Incised and McKinney Plain vessels. Early McCurtain phase jars often have peaked rims and strap handles, with separate and distinctive design elements on the rim and body. Later McCurtain phase jars have squatter rims and lack handles. The bodies of McCurtain phase jars can have a variety of different decorations (fig. 3.20). Potters in southeastern Oklahoma used incised chevrons, parallel lines, and cross-hatching; added appliqué strips with tick marks in a chevron pattern; or alternated applique and fingernail impressions and/or incising on the bodies of utilitarian-ware jars (Dowd 2012; Regnier 2013:54–55).

Dowd's (2012) research on ceramics from sites along the Mountain Fork highlighted differences between ceramics from the Ouachita Mountains and the coastal plain. Sherds recovered from the mounds at Woods Mound group (34MC104), dating between AD 1350 and AD 1450, are almost entirely from utilitarian jars. Only 6 percent are engraved or red-slipped fine wares. Dowd (2012) interprets these jars as vessels brought to the site for food-based rituals that emphasized social equality and cooperation. Early McCurtain ceramic assemblages from the Mountain Fork also show closer ties to the east in Arkansas, leading Dowd (2012) to speculate the Mountain Fork residents were part of an east-west trending exchange network that stretched across the Ouachita Mountains. Regnier and Dowd (2013) later expanded this analysis and found that during the early McCurtain phase Caddo fine wares are generally rare on mound sites in the mountains in the western drainages as well, suggesting they may have participated in the same exchange network and ritual practices. At mound sites south of the mountains, fine wares are far more common. At Clement, 27 percent of the ceramic assemblage is made up of fine-ware sherds. After AD 1450, it appears that an expansion of Caddo ritual along the Red River, which also triggered the abandonment of Clement and the establishment of the nearby A.W. Davis Mounds, spread to sites along the Mountain Fork. At the post AD 1450 Biggham Creek site (34MC105), Caddo engraved and red-slipped fine wares make up 15 percent of the assemblage, and types and vessel forms suggest closer ties to the Red River than to sites to the east in Arkansas.

By the Late Caddo period, the differences between ceramic assemblages along

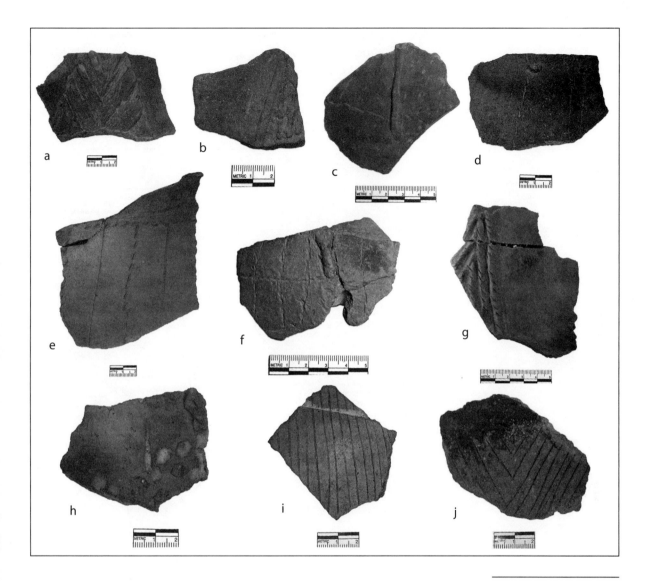

a

b

c

d

e

f

g

h

i

j

Figure 3.20. Decorated body sherds from Mc-Curtain phase utility jars from the McDonald site in Oklahoma: *a–b*, applique; *c–d*, applique and fingernail punctate; *e*, fingernail punctate and incised; *f–g*, applique and fingernail punctate; *h*, applique; *i–j*, incised.

and north of the Red River and the Sulphur drainage become increasingly pronounced. Late Caddo period ceramics at the Peerless Bottoms site (41HP175) at Cooper Lake are both grog- and shell-tempered (Fields et al. 1997:table 5). Decorated sherds are commonly red-slipped, engraved, punctated, and brushed, and the decorative styles on the vessel sherds compare favorably to both Titus phase types (Ripley Engraved and Wilder Engraved) and McCurtain phase types (Avery Engraved, Simms Engraved, Nash Neck Banded, McKinney Plain, and Emory Punctated-Incised) (fig. 3.21).

Although Titus phase components are most widely distributed in the Big Cypress and Sabine River basins (see Essay 6), they are also present in the upper Sulphur River basin (see fig. 3.15). The Titus phase vessels at the W. A. Ford site

(41TT2) are tempered with grog (72 percent), grog-bone (8 percent), and shell (20 percent); the shell-tempered vessels were apparently manufactured by Red River McCurtain phase Caddo potters (see Perttula et al. 2011). The vessels include jars (28 percent), bowls (4 percent), carinated bowls (52 percent), bottles (8 percent), and compound bowls (8 percent). The types represented in the shell-tempered vessels are Emory Punctated-Incised (fig. 3.22a), Simms Engraved, Simms Plain (fig.

Figure 3.21. Late Caddo period vessel forms and decorations in Cooper Lake sites (from Fields et al. 1997:fig. 31).

3.22*b*), and Avery Engraved; these are common McCurtain phase types. The grog and grog-bone-tempered vessels (*n* = 20) feature Titus phase types including Ripley Engraved (*n* = 8) carinated bowls (fig. 3.22*c*) and compound bowls, Wilder Engraved (*n* = 2) bottles (fig. 3.22*d*), and La Rue Neck Banded (*n* = 3) jars. There are also four plain vessels, two incised-punctated and appliqued utility ware vessels, and a vessel with an unidentified engraved motif (Perttula 2016a).

Late Caddo Texarkana phase contexts (see fig. 3.15) at the Hatchel site (41BW3) on the Red River include fine wares of the types Simms Engraved (fig. 3.23*a*), Barkman Engraved (fig. 3.23*b*–*c*), Hatchel Engraved (fig. 3.23*d*), Hodges Engraved, Taylor Engraved (fig. 3.23*e*), Avery Engraved (fig. 3.23*f*–*g*), and Keno Trailed; these are primarily grog- and grog/bone-tempered. Shell-tempered ceramics are rare (Perttula 2018a) and are primarily from red-slipped vessels or from utility-ware and fine-ware vessels traded from other Red River Caddo groups living upstream in the Mound Prairie area.

Foster Trailed-Incised is a common utility-ware type on Texarkana phase sites (fig. 3.24*a*–*b*), along with McKinney Plain, and an assortment of punctated, brushed, brushed-incised (Karnack Brushed-Incised, fig. 3.24*c*), brushed-appliqued, neck banded (fig. 3.24*d*), appliqued, and Belcher Ridged vessels (Webb 1959:136–39). Moore Noded vessels have also been found in burials at the Hatchel and Mitchell sites (fig. 3.24*e*); they have small appliqued nodes that cover the en-

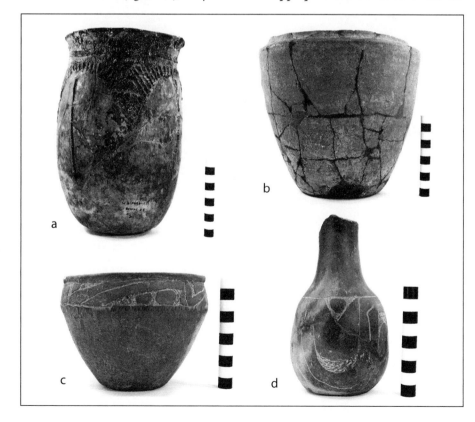

Figure 3.22. Titus phase component vessels at the W. A. Ford site (41TT2) on the Sulphur River: *a*, Emory Punctated-Incised; *b*, Simms Plain; *c*, Ripley Engraved; *d*, Wilder Engraved.

Figure 3.23. Fine-ware vessels from Texarkana phase components at Bowie County, Texas, sites: *a*, Simms Engraved; *b–c*, Barkman Engraved; *d*, Hatchel Engraved; *e*, Taylor Engraved; *f–g*, Avery Engraved.

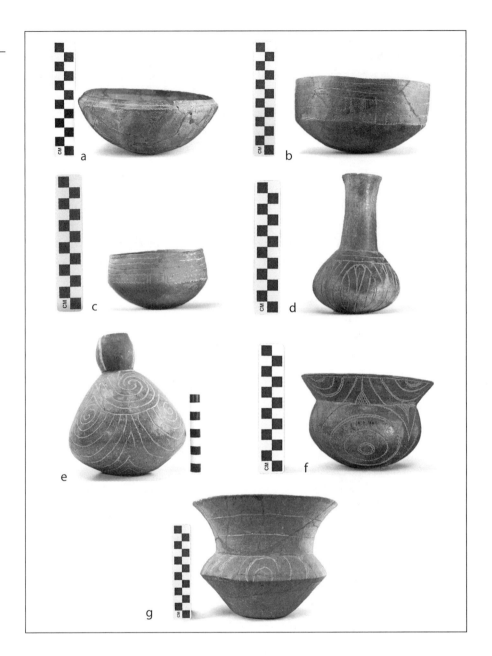

tirety of the vessel surface. Similar knobby or noded vessels found in the American Southwest and central Mississippi valley have been suggested to have been ceramic datura fruit effigies used for the storage and consumption of prepared datura (or jimson weed), a hallucinogenic plant (Lankford 2012:60). The Caddo were known to consume datura and peyote as part of shamanistic rituals (see Swanton 1942), and these noded vessels may reflect the use of these rituals after ca. AD 1400 by Red River Caddo peoples.

Due to a proliferation of sites during the Late Caddo period, far more ceramics are available for study. Late Caddo ceramics have been used to understand changes in exchange networks and to examine aspects of important ritual life for Caddo groups. Far more remains to be done with these ceramics, however, including examining communities of practice and style choices among Caddo potters, microseriation of fine-ware styles and aspects of utilitarian wares to further refine the chronology, and network analysis of ceramics from sites across the study area.

Historic Caddo Ceramics (ca. ad 1680-Late 18th Century)

By the late seventeenth century, southeastern Oklahoma and much of northeastern Texas Red River sites were abandoned (Perttula 2018b); this is indicated by the lack of Natchitoches Engraved ceramics and the absence of European trade goods in burials (Bruseth 1998:62). Settlement shifted to the south and east along the Red River in the early eighteenth century as the Caddo were drawn toward French outposts in what is now Bowie County, Texas, and in Louisiana. The historic Caddo ceramic assemblage at the Clements site (41CS25), a late seventeenth to early eighteenth century Nasoni Caddo settlement and cemetery near the headwaters of Black Bayou, a tributary to the Red River (see fig. 3.3), includes bottles, an olla, jars, bowls, compound bowls, and carinated bowls (Perttula 2015a). Bottles are the most common vessel form (44 percent, including two unique small and narrow forms), followed by carinated bowls (30 percent), jars (15 percent), simple or conical

Figure 3.24. Utility-ware vessels from Texarkana phase components at Bowie County, Texas, sites: *a–b*, Foster Trailed-Incised; *c*, Karnack Brushed-Incised; *d*, Nash Neck Banded; *e*, Moore Noded.

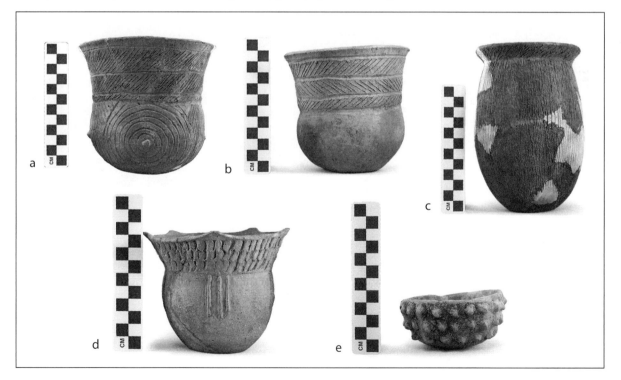

bowls (6 percent), and compound bowls (6 percent). Most of the vessels from the Clements site are fine wares, as only four vessels (12 percent) are utility-ware jars.

Post-AD 1680 fine wares in the western Red River area are best exemplified by the intricate scrolls, ovals, and circles on Hudson Engraved and Keno Trailed bottles and Natchitoches Engraved bowls (fig. 3.25a) and the pendant triangles and engraved scrolls on Womack Engraved bowls (fig. 3.25b–c) from sites such as Womack (41LR1) (see fig. 3.2). Natchitoches Engraved, widely distributed across the southern Caddo Area, is a type found most often as carinated bowls with elaborate engraved scrolls, ticked lines, S-shaped elements, and negative ovals surrounded by cross-hatching or hatching on vessel bodies, and rectilinear design elements, ticked lines, and negative ovals on the rim. Other important fine wares in post-AD 1685 Caddo sites include Simms Engraved, var. Darco and Avery Engraved. Utility wares include Foster Trailed-Incised and Emory Punctated-Incised.

In terms of the ceramic types represented in the funerary vessels at the Clements site, the principal types are Hodges Engraved with negative scrolls defined by cross-hatched or hatched scroll dividers (fig. 3.26a), Taylor Engraved (fig. 3.26b), and Simms Engraved. Other types among the fine wares from mortuary contexts include Keno Trailed (fig. 3.26c), Bailey Engraved, and Fatherland Incised. Several narrow beaker-shaped engraved bottles are present in the assemblage. Utility wares consist of single vessels of Clements Brushed, Pease Brushed-Incised, Cass Appliqued (fig. 3.26d), and Mockingbird Punctated. Another simple jar is red slipped.

Figure 3.25. *a*, Natchitoches Engraved; *b–c*, Womack Engraved.

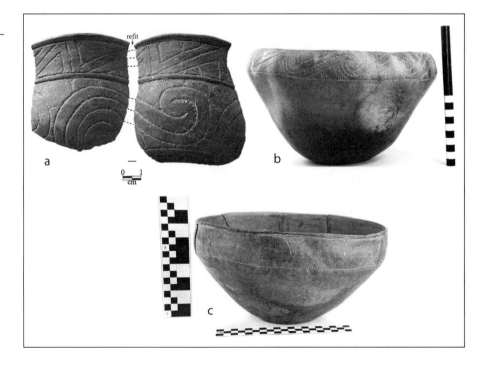

Amanda L. Regnier et al.

One unique bottle form from the Clements site is a spool-necked and red-slipped engraved bottle. There are red-slipped scrolls and triangular areas in relief across the body and at the base of the vessel, and red-slipped areas around the scrolls and triangular areas have been scraped away showing the original color of the vessel before it was slipped, which emphasizes the distinctive red scrolls. This form of decorated bottle is defined as Hatinu Engraved (see fig. 3.26*e*), because of the red (*Hatinu* is the Caddo word for red) and raised scrolls (Perttula, Nelson, Cast, and Gonzalez 2010). Other examples of Hatinu Engraved have been noted in collections at the Hatchel site, the Friday site along the Red River in southwestern Arkansas (Moore 1912:figs. 106 and 107), and in a very late Titus phase site (Shelby Mound, 41CP71) in the Big Cypress Creek basin in northeastern Texas (see Essay 6). Hatinu Engraved is a late seventeenth–early eighteenth century Caddo pottery type that was probably made in the Great Bend area along the Red River and traded/exchanged with other contemporaneous Caddo groups.

Conclusions

In this essay, we have traced the emergence of the Caddo ceramic tradition in the western Red River region of southeastern Oklahoma and northeastern Texas. This work highlights several critical problems for future research. First, old collections, particularly those from the Oklahoma WPA excavations and River Basin surveys, need to be reanalyzed using Red River rather than Arkansas River typologies. Ad-

Figure 3.26. Vessels from the Clements site (41CS25): *a*, Hodges Engraved; *b*, Taylor Engraved; *c*, Keno Trailed; *d*, Cass Appliqued; *e*, Hatinu Engraved.

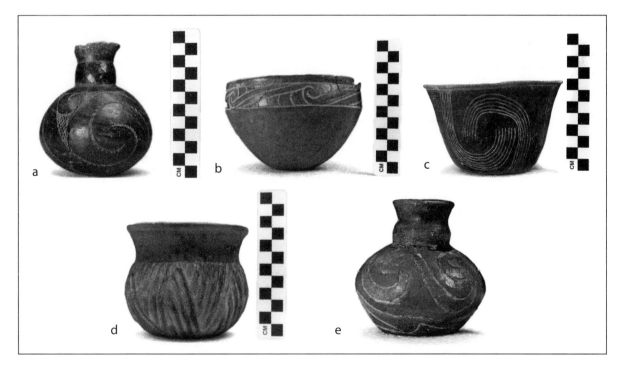

ditional excavations at sites with well-dated Woodland to Early Caddo ceramics would certainly help address some of the questions about the timing of the earliest Woodland ceramics and the ceramic transitions to the Early Caddo period. Future research should address the degree of similarity of Early Caddo assemblages across this wide area, which means looking beyond typological designations and addressing decorative styles. Archaeologists working in the region should also address the continued use of Coles Creek and other LMV type designations and their applicability to Caddo assemblages. There is also a pressing need to address Middle Caddo occupations in the area, which could begin with reanalysis of collections from sites such as Holdeman (41RR11). While we have the greatest understanding of Late Caddo period ceramics in the western Red River region, there is always room for more research, particularly looking more closely at vessel form and decorative styles to begin identifying communities of practice and social networks. In this region, we are fortunate that the ancestral Caddo left behind an abundance of sites with elaborately decorated and finely crafted ceramics that can be used to answer a variety of questions about their past.

Acknowledgments

Thanks to Prewitt & Associates, Inc., for the use of figures 3.10 and 3.21. Lance Trask prepared many of the figures in this essay.

4

Caddo Ceramics in the Ouachita River Basin in Southwestern Arkansas

Ann M. Early and Mary Beth D. Trubitt

In this essay, we review the ceramic sequence—from both the Caddo period and its Woodland period antecedents—in the Ouachita River basin. The setting is the Ouachita River drainage from the Ouachita Mountains in west-central Arkansas to the coastal plain in south-central Arkansas (fig. 4.1).

Figure 4.1. Map of southern Arkansas showing sites mentioned in essay: *1,* Toltec; *2,* Carden Bottoms; *3,* Wild Violet; *4,* Aikman; *5,* Dragover; *6,* Washita; *7,* Adair, Poole; *8,* Kelly Creek; *9,* Winding Stair; *10,* Standridge; *11,* Powell; *12,* Jones Mill; *13,* Denham, Helm, Hedges; *14,* Means; *15,* Cooper; *16,* Caddo Valley Mound; *17,* Bayou Sel, Hardman, Freeman; *18,* Elledge; *19,* Copeland Ridge; *20,* 3CL391; *21,* East; *22,* Hays, Kirkham; *23,* Ferguson; *24,* Washington; *25,* Kidd; *26,* Mineral Springs (base map: Tom Patterson, Physical Map of the Coterminous United States).

The Setting

The Ouachita Mountains are situated between the Arkansas River to the north and the Red River to the south. In Arkansas, the east-west trending mountain ridges peak at Rich Mountain at an elevation of 817 meters (2,681 feet) AMSL in Queen Wilhelmina State Park, located in Polk County. The headwaters of the Ouachita River begin at the foot of Rich Mountain. The Ouachita River flows east and south, passing from the Ouachita Mountains onto the coastal plain near Malvern in Hot Spring County. The Caddo and Little Missouri Rivers also flow southeast out of the mountains, joining the Ouachita River in Clark County. To the east, the Saline River drains from the mountains and flows into the Ouachita River at Felsenthal, near the modern border with Louisiana.

This essay focuses on the middle and upper Ouachita River drainages north of the Felsenthal region. This is part of the Trans-Mississippi South, an area of oak-hickory forests Frank Schambach (1998:8) characterized as "a long tongue of Eastern Woodlands on the 'wrong' side of the Mississippi River." This is an ecological designation rather than a cultural area or areas, but ecology had effects on human communities living here. While diverse in climate, soils, geology, and terrain, the Trans-Mississippi South shared similarities in plant and animal communities to the eastern woodlands, but differed culturally from both the Lower Mississippi Valley to the east and the plains to the west.

Key Sites, Excavations, and Collections

Our understanding of Caddo ceramics in the Ouachita River basin comes from large collections of vessels as well as from excavations at sites in both the coastal plain and Ouachita Mountains in southwestern Arkansas. Archaeological research in the Ouachita River valley began with the work of amateurs in the early twentieth century (see Early [1983] for a historical overview). Robert Proctor, Vere Huddleston, Thomas and Charlotte Hodges, and Harry Lemley visited archaeological sites, dug graves, and amassed collections of pottery vessels, as well as provided assistance to the few professionals researching this region. Their collections and records, now held by institutions such as Henderson State University (HSU Museum/Proctor collection), the Joint Educational Consortium (Hodges/Huddleston collection), and the Gilcrease Museum (Lemley collection), continue to serve as a research resource (e.g., Early 1986 and 2012; Trubitt 2017 and 2019a; Trubitt and Evans 2015). Documentation of vessels in these collections for research, exhibit, and Native American Graves Protection and Repatriation Act (NAGPRA) consultation has increased dialogue between archaeologists and members of the Caddo Nation in recent years. These collections also serve as an important resource for modern Caddo potters.

There were few professional archaeologists active in this region in the early twentieth century. Mark Harrington (1920) illustrated pottery vessels and other artifacts from his excavations at sites in the Ozan area and the Washington Mounds site (3HE35) in Hempstead County, as well as at Mineral Springs (3HO1) in Howard County and sites on the upper Ouachita River in Garland County. He explicitly linked his finds in Hempstead and Howard Counties with ancestors of the Caddo Indians. Works Progress Administration (WPA) projects in Arkansas were limited to excavations in 1939 at Adair (3GA1) and Poole (3GA3) on the upper Ouachita River in Garland County and Cooper (3HS1) and Means (3HS3) on the middle Ouachita River in Hot Spring County. Later, collections from three of the four projects were analyzed and published (Schambach 1998; Wood 1981); recently, pottery from Adair has seen new analysis (Starr 2017).

Archaeological investigations in the region have increased since the mid-twentieth century, with many projects involving the University of Arkansas Museum, or, after 1967, the Arkansas Archeological Survey. Some of these were initiated as salvage projects, such as at Denham (3HS15; Wood 1963), Hays (3CL6; Weber 1973), Powell (3CL9; Scholtz 1986), and Hardman (3CL418; Early ed. 1993). Others were research projects accomplished with university archaeological field schools and/or Arkansas Archeological Society training programs, such as the excavations at Standridge (3MN53; Early 1988), Winding Stair (3MN496; Early ed. 2000), and Dragover (3MN298; Trubitt et al. 2016). The early explorations yielded whole vessels with little detail about the sites and contexts of the finds; these modern investigations have provided radiocarbon dates (see Perttula et al. 2011:tables 2 and 3; Trubitt 2009:fig. 5) and contexts to ceramic assemblages, leading to a defined chronological framework (table 4.1). Radiocarbon dates provided in this essay have been recalculated as 2-sigma calibrated ranges with IntCal13 using Calib 7.10, based on data in the Arkansas Archeological Survey's AMASDA radiocarbon database and in the original published references.

Methods of Analysis

While some of the early amateur archaeologists published their findings (e.g., Hodges and Hodges 1963), it was the inclusion of pottery as type specimens in the initial 1954 edition of the "Texas Handbook" that brought greater professional awareness to these Arkansas collections. Both Philip Phillips of Harvard University and Alex Krieger of the University of Texas photographed vessels in the Proctor, Huddleston, and Hodges collections from southwestern Arkansas sites in 1939 and in the mid-1940s. Krieger's photographs of pottery from these collections illustrate several vessel types in the *Handbook of Texas Archeology: Type Descriptions* (Suhm and Jelks 1962:41–42, 159–60).

The *Handbook of Texas Archeology* included pottery type descriptions with

Table 4.1. Chronological Framework Used in the Ouachita River Basin

Period	Phase (Middle/Upper Ouachita)	Dates
Caddo, Late	Deceiper / undefined	AD 1600–1700
	Social Hill / unnamed	AD 1500–1600
	Mid-Ouachita / Buckville	AD 1350–1500
Caddo, Middle	East / undefined	AD 1100–1350
Caddo, Early	undefined	
Caddo, Formative		
Woodland	Dutchman's Garden	AD 300–900
	Oak Grove	200 BC–AD 300
	Lost Bayou	1100–200 BC

paste, temper, surface treatment, vessel form, and decoration characteristics, as well as known distributions in space and time. This distributional information was important, for "a type is not just a descriptive category, but must have cultural and historical meaning if it is to be employed successfully as a tool for archeological interpretation" (Suhm and Jelks 1962:viii). While decorative treatment was not seen as the primary characteristic for type differentiation, most of the types in the *Handbook* are engraved, incised, brushed, and punctated rather than plain wares. While most of the examples come from sites in Texas, examples from Arkansas drawn from the Proctor, Huddleston, Hodges, Lemley, and University of Arkansas Museum collections are featured for certain types.

Alongside the type or type-variety system, archaeologists working in southern Arkansas have described ceramic rim and body decorations using the "collegiate system" or "descriptive classification" (see Essay 1). Initially developed during analysis of ceramic assemblages from borderland areas such as the Felsenthal region, the descriptive system has been used to characterize designs on Caddo ceramics in the Red River valley (Kelley 1997; Trubowitz 1984), the middle Ouachita River valley (Early ed. 1993; Lafferty et al. 2000), the Ouachita Mountains (Early 1988), and the Saline River valley (Trubitt 2012). The descriptive classification considers decoration only; temper and vessel shape do not factor in, although Caddo ceramics do have clear links between decorative treatment and vessel form for utilitarian and fine wares. Rims and bodies are described separately, so while it works best for

describing whole vessels, it can be used on sherds too. The system is hierarchical, with decorative "classes" identifying the method of decoration (incising, punctating, brushing, engraving, stamping, slipping, and appliqueing, etc.), each of which includes named rim and body "patterns" with numbered "designs" describing variations in decoration. Using this system, archaeologists can make fine-grained comparisons between assemblages and between designs found in different localities. For example, Ann Early (2012) showed how close examination of Friendship Engraved designs can yield the "grammar" or cultural rules behind their production. Details of designs may distinguish the work of specific potters or potter communities, as Early (in Lafferty et al. 2000:111) has suggested for two Keno Trailed bottles with the same incised design (Belhaven 28) found at the Helm site (3HS449).

Woodland Period Antecedents

The earliest pottery in this region is found on Woodland period sites. Based on sherds, there were similarities with Fourche Maline vessels from the northern Ouachita Mountains in Oklahoma, as well as with Tchefuncte, Marksville, Baytown, and Coles Creek vessels in the Lower Mississippi Valley. The Fourche Maline culture was initially defined from sites in the Wister valley of eastern Oklahoma but has been redefined to include sites in the Ouachita River basin in Arkansas, specifically Poole, Cooper, and Means (Schambach 1998 and 2001; Wood 1981). Based on sherd analysis, vessels were predominantly plain, grog, grit, or bone-tempered, flat-bottomed jars or bowls. Woodland period pottery shows variation in temper recipes across space, as seen from recently excavated and analyzed examples from the Dragover, Jones Mill (3HS28), and Wild Violet (3LO226; Porter et al. 2016) sites in the Ouachita Mountains of Arkansas.

KEY WOODLAND PERIOD CERAMIC TYPES

Cooper Boneware is an unusual type tempered with varying amounts of coarse fragments of calcined animal bone (fig. 4.2). Schambach (1998 and 2001) suspected this was the earliest of the Woodland period ceramic types and used it as a diagnostic type for the Lost Bayou phase (ca. 1100–200 BC). As defined from Cooper and Means assemblages, Cooper Boneware has fragments of bone, large enough to see the cell structure, in a sandy paste (Schambach 1998:21–23). The bone temper sometimes leaches from sherds, leaving large angular voids. Some of the bone-tempered sherds at the Cooper site were incised or incised and punctated (identified as Marksville Incised or Churupa Punctated on Cooper Boneware paste). At the Dragover site, the highest proportion of Cooper Boneware sherds came from an area (Area IV) that also had the earliest radiocarbon dates (Trubitt et al. 2016). An AMS date (accelerator mass spectrometry dating) was obtained from an Area IV fire-cracked rock cluster (Feature 67) containing Cooper Boneware sherds, and

Figure 4.2. Cooper Boneware sherds with coarse fragments of bone as temper; *upper,* rims from Elledge (3CL75) and Kirkham (3CL29), *lower,* body sherds from Kirkham (Arkansas Archeological Survey accession 1969-39, 1969-413).

the resulting 2-sigma date range of cal. 1050–895 BC (2810 ± 30 B.P.; Beta-506322; carbonized nutshell; δ^{13}C = −25.2‰) supports an Early Woodland period age for Cooper Boneware.

Several grit-tempered types have been identified in Fourche Maline assemblages. As defined by Schambach (1998:26–27, 88–89) from assemblages at Cooper and Means, Ouachita Ironware is tempered with crushed rock that includes mica, hematite, quartz, and novaculite grit. Examples from Clark, Hot Spring, and Saline Counties characteristically show coarse copper-colored mica and chunks of a black mineral that appears to be magnetite, along with hematite, quartz, and novaculite. The inclusion of magnetite seems to be a regional variation on sites in the Magnet Cove vicinity in Hot Spring County. While plain vessels are the norm, incised and punctated decorations are occasionally found on Ouachita Ironware paste (fig. 4.3).

Another grit-tempered type, found on Late Woodland period (Dutchman's Garden phase, ca. AD 300–900) sites in the middle Ouachita River valley and adjacent Ouachita Mountains, is LeFlore Plain (a.k.a. Ouachita Plain, see Schambach 2001:29). This type is distinguished from Ouachita Ironware by its temper recipe (quartz, novaculite, and hematite pebbles) and burnished, dark-colored exterior surfaces (Early 1988:64; Schambach 1998:90–92). Rim sherds indicate some changes in vessel shape through the Woodland period, with flared rim jars more common in later assemblages (fig. 4.4).

Ann M. Early and Mary Beth D. Trubitt

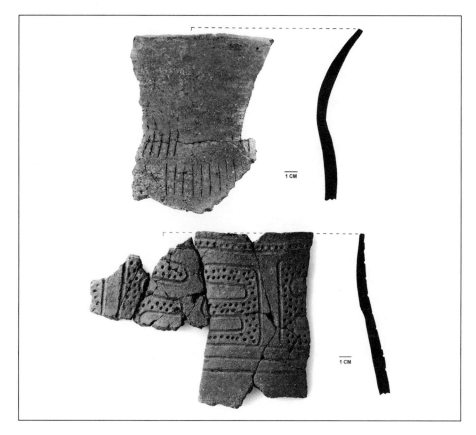

The Williams Plain type is characterized by thick-walled vessels with thick circular or square flat bases. Temper consists of clay particles or crushed sherds/grog and may be coarse and easily visible or worked into the paste. Varying amounts of sand (quartz and novaculite grit) are often present, especially at sites in the Ouachita Mountains. Base sherds are especially thick, typically between 1 and 2 centimeters. The square base vessel form, and circular disc bases with "heeled" or "stilt" profiles, are found on bone, grog, and grit-tempered forms during the Woodland period, but were discontinued by the Caddo period. It may only be possible to distinguish Williams Plain sherds from later plain grog-tempered Caddo ceramics by thickness (and it may be impossible to sort Williams Plain from Baytown Plain; see Schambach 2001:27–28).

A minority of vessels represented by sherds at Fourche Maline sites like Poole, Cooper, and Means had incised decorations on rim or upper body, leading to the definition of the Williams Incised type (Wood 1981); two new varieties of Williams Incised have been defined based on materials from the Wild Violet site (Porter 2016).

Larto Red is a minor type on Late Woodland period (Dutchman's Garden) phase) sites in the middle Ouachita River valley and adjacent Ouachita Moun-

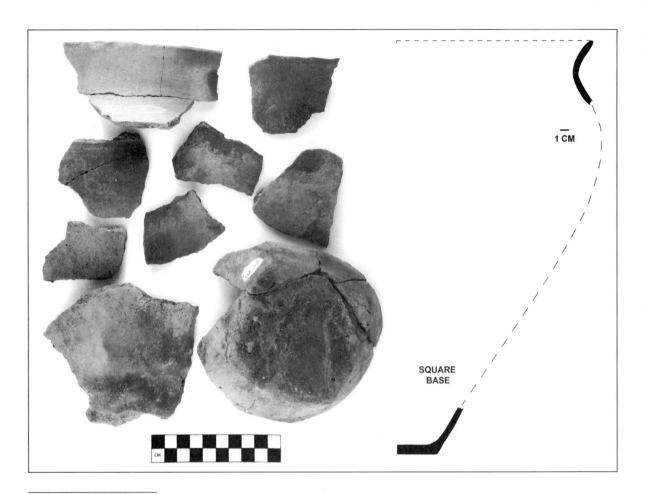

Figure 4.4. LeFlore Plain vessel fragments: *left*, jar rims, bodies, and square flat-base fragments from Kelly Creek site (3GA17); *right*, composite profile (Arkansas Archeological Survey accession 2015-647).

1 CM

SQUARE
BASE

tains (fig. 4.5). Sherds are tempered with grog and surfaces are red-slipped, with rim sherds indicating large shallow bowl forms (Schambach 1998:31, 92–93). While a minor presence, this type may indicate some connections with Toltec (3LN42; Rolingson 1998:46–48); paste and form suggest they were trade vessels, not locally made. However, the use of a red slip foreshadows the later local Caddo type East Incised.

Mill Creek Plain, defined by Early (1988:64–65) based on sherds from the Standridge site, is tempered with grog, grit, and some organic material that leaches out leaving voids in weathered sherds. The grit includes shale pebbles, a regional variation in the Ouachita Mountains (examples are seen on sites in Montgomery and Garland Counties, as well as in Oklahoma [Brown 1996:350]). While defined as a plain type, decorated sherds with the characteristic Mill Creek paste (with shale inclusions) are found as well (fig. 4.6). Based on examples from Dragover and Adair, shale pebbles may continue to be a regional paste variation into Caddo times.

Multiple tempers combined in the same vessel seem to be common at this time.

Woodland period temper recipes also vary across the region. Ouachita Ironware has grit temper that includes distinctive coarse mica and magnetite particles in the vicinity of Magnet Cove in Hot Spring County, while the later LeFlore Plain lacks those minerals. Mill Creek Plain includes grog and shale pebbles in the Ouachita Mountains near Mount Ida in Montgomery County. These distinctive temper recipes make these types more "diagnostic" of a local region and time period than the grog-tempered Williams Plain type with its wider spatial and temporal distribution. Because of the variety of grit used to temper Woodland period types in the Ouachita River basin, we encourage analysts to describe the specific rocks and minerals used as grit rather than using "grit-tempered" as a monolithic category. The type of grit and the combinations of tempers appear to have specific distributions in time and space.

Figure 4.5. Larto Red rim sherd and profile from Kelly Creek site with red slipping (2.5YR4/6) on interior and exterior surfaces (Arkansas Archeological Survey accession 2015-647).

Figure 4.6. Incised decoration on Mill Creek Plain paste, rim (*upper right*) and body sherds from Washita (3MN3) (Arkansas Archeological Survey accession 2015-651).

Woodland-Caddo Transition

The transition from Woodland to Caddo traditions as marked by changes in ceramics appears to have taken place over no more than a century between about AD 900 and AD 1000 throughout the Ouachita River basin. Settlements from this time period are not well documented, but this is likely a factor of the few sites studied thus far and the difficulty in identifying key sites for this short time span using assemblages composed largely of undecorated ceramics.

Two pottery types, French Fork Incised and Coles Creek Incised, found in small amounts in largely plain-ware assemblages, mark transitional occupations. Although they are currently rare in Ouachita River basin assemblages, their distribution indicates that Caddo tradition genesis took place throughout the region at roughly the same time, as it did in the Red River valley. The French Fork Incised items may originate from communities well outside the region.

One rim sherd of French Fork Incised and one of Coles Creek Incised were found beneath the Powell Mound, on the lower Caddo River in 1963 (Scholtz 1986:fig. 13e–f; items are reversed on the plate). They were found immediately beneath the burned timbers and daub piles of a circular structure with four

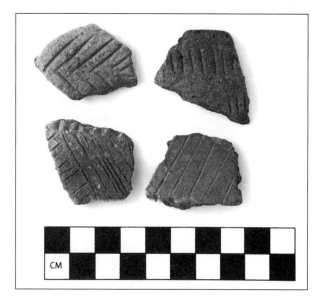

internal support posts and within a grey sandy pre-mound surface that also contained Middle Woodland and earlier Archaic middens. A single ^{14}C date (Tx-110; Scholtz 1986:38) on a timber from the building has a 2-sigma range of cal. AD 1030–1290. The mound fill contains later East and Mid-Ouachita phase ceramics.

The Coles Creek rim sherd is *var. Knapp* (Rolingson 1998:41). To date, this type has been found at the Toltec site only in surface collections and in the Mound D D-1 overbank midden, the latest dated feature at the site. Rolingson's ^{14}C assays for that feature have overlapping 2-sigma calibrated ranges between cal. AD 890 and AD 1190 (Rolingson 1998:24–25). *Var. Knapp* was not found in the earlier Mound S or in other mound contexts tested thus far on the site.

On the west edge of the Ouachita River basin, Mark Harrington (1920:plate LXVII*b*) unearthed a French Fork Incised jar at Washington Mounds in the uplands overlooking the headwaters of the Little Missouri River but he did not record its provenience. There are no other French Fork Incised vessels in his collection, but a local digger unearthed two Coles Creek bowls at the site subsequent to Harrington's visit (Arkansas Archeological Survey negative nos. 804269 and 804271). The same collector also unearthed four Coles Creek vessels at the Kidd site (3PI1), about 24 kilometers north on the Little Missouri River itself. One is Coles Creek Incised, *var. Knapp* and a second fits Rolingson's (1998:40) Coles Creek Incised, *var. Keo*. A French Fork Incised rim sherd was also found along the Ouachita River below the confluence with the Little Missouri.

Caddo Ceramic Sequences

Shortly after AD 1000, ceramic assemblages in the Ouachita River basin take on a different character with the appearance of new vessel forms and decoration protocols. Discovery contexts include graves, structures associated with pre- and early platform mound deposits, initial midden deposits at one salt-making site, and non-mound midden deposits that appear to represent small domestic sites. These assemblages share three notable characteristics. New vessel shapes appear, including bottles and jars with necks (independent restricted vessels [Shepard 1956]). New protocols for decorating ceramics are in place that differ for different vessel shapes. This is the start of a dual trajectory ceramic-making tradition that continued until the late seventeenth century as a hallmark of Caddo ceramic manufacture in the Ouachita River basin and elsewhere in the Caddo Area (Early 2012). One trajectory produces bowls, beakers, and bottles with burnished or polished surfaces. Decorative techniques include red-slipped surfaces, firm paste fine line incising, and dry paste engraving and excising. The second trajectory produces jars in several shapes and bowls with matte surfaces. Decoration techniques, including punctation, wet paste incising, stamping, and brushing were used alone or in combinations to produce high-relief plastic treatments.

This tradition is in place across all regions of the Caddo world, although communities in each region developed and continued to produce individually distinct variations of pan-Caddo vessel types. Collectively understood fabrication and decorative rules included a limited number of decorative elements appropriate for particular motifs; the application of specific motifs only with either wet paste or dry paste techniques; the association of specific motifs only with particular vessel shapes; and a limited number of options for combining particular rim and body motifs on specific vessel shapes. Pottery makers in each region of the Caddo world, primarily a river basin or major drainage segment, produced local variations within the broad shared tradition.

In the Ouachita River basin, at least three regional subtraditions emerged and persisted until abandonment around AD 1700. Potters in the upper Ouachita River valley above Hot Springs, the middle Ouachita River valley south of the Ouachita Mountains, and the Little Missouri River valley made vessels that were distinguishable in form, design elements, and motifs from those made in neighboring communities that shared the same general themes. There may be a fourth subtradition in the eastern Saline River drainage as well (Trubitt 2012 and 2019b), but Caddo tradition settlements in that valley need further study.

In the middle Ouachita region, Military Road Incised jars were made with punctated and incised meandering or banded decorations on rim and body, while in the upper Ouachita River valley, jars had punctated and incised rims with plain bodies, or with herringbone incising on bodies similar to Pease Brushed-Incised (fig. 4.7). At the same time, jars with castellated rims, stylized handles, and complex punctated and incised geometric motifs accentuated with appliqued nodes and fillets in the Little Missouri valley typically carry Haley Complicated Incised decorations.

The boundaries of each pottery-making community are imperfectly defined and shift through time. For instance, Middle Caddo period ceramics in the upper Caddo River valley share form and decoration details with Little Missouri River valley communities, but Late Caddo period ceramics in the same locality bear shape and decorative details found in the Arkansas River valley and in the downstream part of the Ouachita River valley. Vessel types also have different "use lives"; constituent types in assemblages that are associated with particular phases or subdivisions of the Caddo tradition are not replaced at the same time.

It is also evident that Ouachita River basin Caddo settlements do not constitute the northeastern boundary of the Caddo tradition throughout its history. The second largest pyramidal mound in the Caddo Area (at the Aikman or Bluffton Mound site, 3YE15) is in the Fourche LaFave River valley, north of the Ouachita River basin (see fig. 4.1), and Caddo ceramics have been recovered from both the Fourche LaFave and Poteau River valleys.

More than 600 pottery types and varieties have been proposed in the litera-

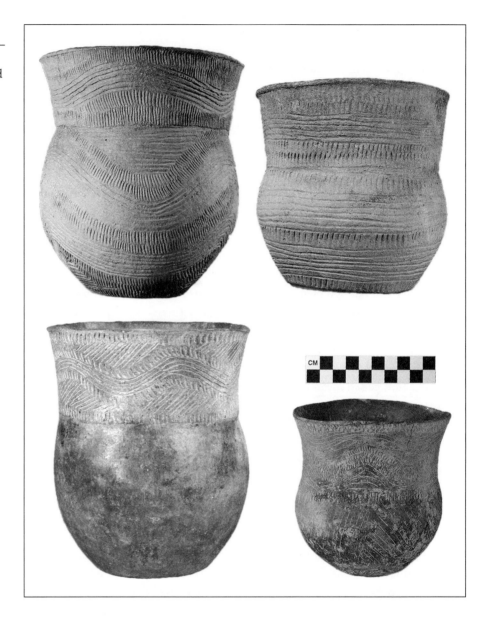

Figure 4.7. Regional variation in Military Road Incised: *upper,* Freeman (3CL40, JEC Hodges Collection); *lower,* Adair (University of Arkansas Museum Collections).

ture for Arkansas Native ceramics over the last seventy-five years. What follows is only the briefest review of the best-documented representatives marking the major phases of the Caddo tradition in the Ouachita River basin.

EAST PHASE CERAMIC TYPES

The earliest phase in the Ouachita River basin is the East phase from ca. AD 1100 to 1350 (Early ed. 1993:223–24; Early 2002a; Trubitt and Evans 2015:73–145), marked by East Incised vessels that are associated with a variety of other fine-ware types including Arkadelphia Engraved (Brown 1996:376; Weber 1973), Smithport Plain,

some varieties of Crockett Curvilinear Incised, and Holly/Spiro Engraved. East Incised vessels are primarily red-slipped beakers and bowls with a band of horizontal incised lines on the rims or upper bodies (fig. 4.8). Associated utilitarian wares are largely untyped but include jars with flaring rims and incised and punctated bodies that may be early varieties of Karnack Brushed-Incised and Pease Brushed-Incised types. Some vessels of various shapes are undecorated, including late specimens of Williams Plain, and there seem to be some late varieties of Coles Creek Incised present as well. East Incised and associated vessels are known mainly from cemetery excavations carried out at the East site and neighboring sites in the Antoine and Little Missouri River valleys by a group of local amateurs. Trubitt and Evans (2015) provide a history of this work and an inventory of surviving grave associations in the JEC Hodges/Huddleston collection.

Despite their widespread recognition, there is limited information about the chronological placement, social context, and geographic distribution of East Incised ceramics. The index specimens came from graves but the East site has not been investigated with modern excavations. East Incised sherds, along with plain wares and other elements of the East phase assemblage, have been reported at a number of sites. Although this information is fragmentary, it indicates a widespread appearance at the time of the initial development of mounds and other types of Caddo settlement components. These include the lowest level in the stratified midden at the Bayou Sel (3CL27) salt-making site, the sub-mound midden at Caddo Valley Mound (3CL593) near the confluence of the Caddo and Ouachita Rivers, and the first three stages of mound construction at the Hays site on the Little Missouri River. Radiocarbon dates for these contexts have 2-sigma ranges between cal. AD 890 and 1470 (median probabilities between AD 1000 and 1370) (Perttula et al. 2011:table 2; Reynolds 2007:fig. 43; Trubitt 2009:234–37; Weber 1973). In addition, Wolfman (1982) and Trubitt and Evans (2015:82) published two dates (AD 1270 ± 20 and 1400 ± 25) from burned floors in mounds at the East site. It is worth noting that the "use life" of East Incised ceramics and associated types overlaps both Early Caddo and Middle Caddo time brackets used elsewhere (cf. Girard et al. 2014) and fall roughly into the alternative Caddo II or Middle Caddo time frame (AD 1200–1400; Schambach and

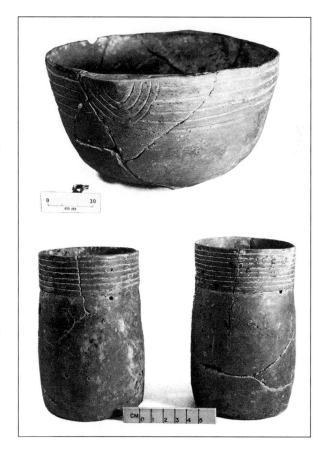

Figure 4.8. East Incised bowl and beakers, East site, HSU Museum Collection.

Early 1982:SW99, 106). This suggests the possible time-transgressive nature of the East phase and subsequent social developments in relation to those elsewhere in the Caddo Area, particularly along the main stem of the Red River. To clarify the matter, we need new radiocarbon dates on curated samples, along with new analyses of ceramic assemblages from key sites such as Bayou Sel and Hays.

East Incised ceramics and companion types found together in the middle Ouachita River valley are also found in contemporary contexts in the Little Missouri River valley. Vessels from graves 3 and 11 at the Mineral Springs site are essentially the same as key East site grave lots (Bohannon 1973; Trubitt and Evans 2015) and were assigned to Mineral Springs II and III periods, estimated to predate early fifteenth century AD developments at the site. Bohannon (1973:13) equated these periods with Hoffman's (1971:765) Graves Chapel phase in the nearby Little River region, estimated to date from AD 1000 to 1300. Three radiocarbon dates from a rectangular structure on stage 3 of Mound 8, believed to be Mineral Springs IV or V in age, yielded dates with wide calibrated 2-sigma ranges of between cal. AD 1220 and 1630 (median probabilities between AD 1350 and 1420) (Bohannon 1973:70).

East Incised ceramics are found in several collections in the upper Ouachita River valley, indicating that Early Caddo settlement contemporary with communities elsewhere in the basin was present (e.g., Early 1988; Early ed. 2000; Starr 2017; Wood 1981), but no work has provided a clear look at the character or material signature of initial Caddo developments.

Mid-Ouachita and Buckville Phase Ceramic Types

In the middle Ouachita region, the East phase is followed by the Mid-Ouachita phase, dating from ca. AD 1350–1500, long mentioned but only recently defined (Early ed. 1993; Early 2002b). Ceramic indicators first suggested by Dr. and Mrs. T. L. Hodges (Hodges and Hodges 1963; Suhm and Jelks 1962) included Friendship Engraved (now *vars. Freeman* and *Meador*) carinated bowls, Military Road Incised jars, Watermelon Island style seed jars with plain matte surfaces, and Blakely Engraved bottles. This last type may be associated with the last century of the phase and may continue into the succeeding Social Hill phase. New types and varieties established from this initial group include Garland Engraved bowls, Adair Engraved bottles, and Blakely Engraved, *vars. Blakely* and *Witherspoon* (Early ed. 1993). Means Engraved bowls and bottles also may belong to this assemblage.

The Mid-Ouachita phase marks the rapid expansion of Caddo populations and the development of dozens of small- and medium-sized pyramidal mound centers throughout the valley. Few components are well dated and published, however. Limited salvage at the Denham Mound site provided an initial description of a Mid-Ouachita phase mound (then referred to as the Mid-Ouachita focus [Wood 1963]) and three radiocarbon dates with calibrated 2-sigma ranges between cal. AD 1270 and AD 1640 (median probabilities between AD 1360 and 1450). For decades,

Mid-Ouachita was characterized as the only Caddo tradition phase in the middle Ouachita Valley with a 300-year age estimate (cf. Perttula 1992). Decades of work and a reformulation of the regional chronology have refined the time span to about a century, between ca. AD 1400 and 1500, and reassigned many pottery types to the subsequent Social Hill and Deceiper phases (Early ed. 1993:112–16, 224–25). The transition from grog to shell tempering occurred during the Mid-Ouachita phase in the cal. AD 1400s in the middle Ouachita River valley (Perttula et al. 2011:245–46).

The other regions of the Ouachita River basin also saw greatly expanded populations and the construction of pyramidal mound centers at roughly this time, beginning perhaps in the later 1300s. Identified variously as the Haley or Mineral Springs phases in the Little Missouri valley, ceramic indicators are primarily Haley Engraved, Handy Engraved, Hatchel Engraved, Glassell Engraved, and Hempstead Engraved fine wares, and Haley Complicated Incised and Pease Brushed-Incised utilitarian wares. Friendship Engraved, *vars. Antoine* and *Trigg* (Early 1988) and Sinner Linear Punctated are also present. Close comparison of the vessels with others of the same types in the Red River valley proper, though, disclose that Little Missouri valley potters made their own distinctive vessel shapes and motifs. Some fall outside current type definitions, such as jars with Pease Brushed-Incised body treatments and Military Road Incised rim treatments. Typical assemblages are found at the Mineral Springs site (Bohannon 1973), at Washington Mounds site in the Ozan Creek valley (Harrington 1920; Wilson 2018), and at the Ferguson site (3HE63) in the Terre Rouge Creek valley (Chowdhury 2018), to name a few.

Caddo settlement and mound site development in the upper Ouachita River basin is termed the Buckville phase, proposed first to encompass artifacts from a Caddo cemetery found at the Poole site in 1939 (Early in Wood 1981). Provisionally established with the expectation that additional better contextualized discoveries would partition the phase and better define its content and character, the ceramics itemized in the Poole site collection include Friendship Engraved, *var. Freeman* and *Antoine* carinated bowls, jars with Military Road Incised rim treatments and undecorated or Pease Brushed-Incised bodies, Blakely Engraved tripod bottles, Sandford Punctated bowls, and a large number of grog-tempered plain wares named Poole Plain. The thirty-one Caddo graves at the Poole site held small numbers of vessels known to be present in earlier and later phases elsewhere in the Ouachita River basin, suggesting that occupation at the site extended for more than one phase of development over a ca. 300-year period. Although the types listed for the phase are comparable to the core types for the Mid-Ouachita phase, local variation in form and decorative theme are evident in varieties, many yet to be named in print. For instance, seed jars in the upper Ouachita River region have strongly tapering upper bodies and paired pierced applique fillets serving as suspension elements. The time estimate for the Buckville phase is from about AD 1350 to AD 1500.

Ceramics from the Feature 9 grave at the Standridge site (Early 1988), collections from the Norman site (3MN386; Early and Trubitt 2003), and from the Winding Stair site (Early ed. 2000) provide evidence of assemblages that follow the original Buckville phase collections. Military Road Incised and grog-tempered Poole Plain types are replaced with shell-tempered Woodward Plain and Poteau Plain jars and bowls, Foster Trailed-Incised jars, and Ashdown Engraved and Keno Trailed, *var. Curtis* (Early ed. 1993) bottles. Friendship Engraved fine ware is no longer made, although *vars. Antoine* and *Trigg* were present in the earlier features at the Standridge site. Additional vessels untyped in the original publication can now be identified as local varieties of Means Engraved and Belcher Engraved, Taylor Engraved, and Nash Neck Banded (Early 1988). Comparisons with Arkansas River valley and other regions indicate that this assemblage was created after AD 1450 and more likely about AD 1500.

At about this same time, Mid-Ouachita phase pottery types are being replaced in the middle Ouachita River valley. Two graves, Features 13 and 18, at the Hardman site near Arkadelphia display assemblages that represent this transition (Early ed. 1993). Shell temper is ubiquitous. Military Road Incised vessels are absent, replaced by Foster Trailed-Incised and Caney Punctated jars. A single seed jar is a polished sphere, and the only Blakely Engraved vessel is *var. Witherspoon*. Fine-ware carinated bowls are the new Cook Engraved type along with Friendship Engraved, *var. Tisdale*, and a few Freeman Engraved and Garland Engraved vessels that lack many of the normal decorative elements and motifs. Deep Hardman Engraved bowls—a new vessel shape—are present along with a local Belcher Engraved bottle variety (Early ed. 1993). Undecorated and untyped black polished bottles and cylindrical engraved seed jars are present in contemporary collections and are also useful phase markers.

Social Hill and Deceiper Phase Ceramic Types

Most of these pottery types continue to be markers of the succeeding Social Hill phase between AD 1500 and 1600 (fig. 4.9). Midden deposits and a cemetery at the Hedges site (3HS60; see Early 1974, Trubitt 2019b) and a cemetery excavated by collectors at the Copeland Ridge site (3CL195; Early 2002c) have the same ceramic assemblage, and additional examples of the key types and varieties are present in museum collections.

The Social Hill phase appears to bracket the regionally transformative appearance of the De Soto expedition in the Caddo world. Scattered archaeomagnetic and radiocarbon dates (Wolfman 1982:277–300; 1990:237–60) indicate that this is also the century when mound building and use of pyramidal mound centers ceased, although there is no clear evidence of significant population loss in the Ouachita River basin. If there were social disruptions, the population recovered and the Caddo ways of life continued for nearly another century.

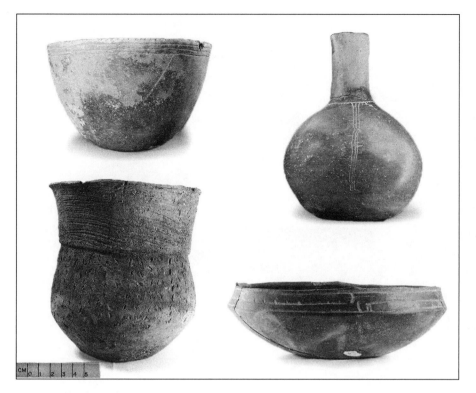

Figure 4.9. Social Hill phase vessels: (*upper left*), Hardman Engraved bowl; (*upper right*), Blakely Engraved, *var. Witherspoon* bottle; (*lower left*), Caney Punctated jar; and (*lower right*), Cook Engraved carinated bowl (JEC Hodges and HSU Museum collections).

The final Caddo occupation in the middle Ouachita River basin is the Deceiper phase, marked by the appearance of a new suite of fine wares and utilitarian vessels (Early ed. 1993; Early 2002d) that replace most of the vessels made during the Social Hill phase. The time estimate for this last resident occupation is between AD 1600 and 1700. The best-documented examples of these new vessel types are in grave lots from the Hardman and Helm sites. The Joint Educational Consortium Hodges and Henderson State University collections contain additional examples from several sites in both the Ouachita and Little Missouri River valleys (e.g., Trubitt 2019a), many of which are index specimens in long-established pottery types. Chief among the fine wares are Hodges Engraved, Hudson Engraved, and Keno Trailed bottles and bowls in a number of different varieties (fig. 4.10). Utilitarian vessels include Karnack Brushed-Incised and De Roche Incised (Early ed. 1993) jars and may include some Foster Trailed-Incised and Caney Punctated varieties, although neither were present in the Deceiper phase graves at Hardman and Helm. All ceramics continue to be shell-tempered. No Deceiper phase habitation sites have been excavated, so it is not possible to determine whether these grave assemblages reflect the same kinds and frequencies of pottery types used in domestic settings.

The Deceiper phase assemblage shows close comparison with that of Schambach's Chakanina phase in the Red River (Trubowitz 1984), and Hodges Engraved

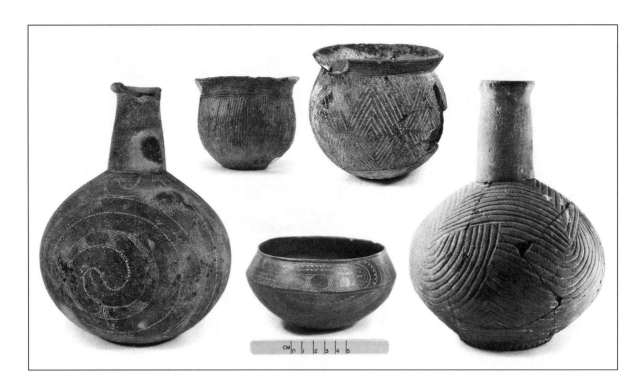

Figure 4.10. Deceiper phase vessels: (*left*), Hodges Engraved bottle; Karnack Brushed-Incised jar; De Roche Incised jar; Hodges Engraved carinated bowl; (*right*), Keno Trailed bottle (JEC Hodges and HSU Museum collections).

and Keno Trailed vessels are present in seventeenth century sites along the Arkansas River between Carden Bottoms and the Arkansas Post vicinity (Wiewel 2014). Both of these distributions support a seventeenth-century age estimate for the phase and its associated ceramics.

Deceiper phase vessel types also are present in the upper Ouachita and Little Missouri River valleys and mark post-Buckville and Mineral Springs phase occupations, respectively. Keno Trailed, Karnack Brushed-Incised, Moore Noded, and Nash Neck Banded vessels appear in small numbers in late period graves at the East site (Trubitt and Evans 2015), the Washington Mounds site (Wilson 2018), Dragover (Perttula 2009a), and Adair (Starr 2017), among other sites, indicating that early seventeenth-century settlement may have continued throughout the river basin. Late occupations in the northern and western part of the river basin have not received enough research attention to clarify the material signature, age, and extent of the Caddo occupation, however. Hoffman identified a Saratoga phase that postdates the Haley/Mineral Springs phases in the Ozan and Little River regions based on the appearance of Hodges Engraved and Nash Neck Banded vessels at the Mineral Springs site and offered a long list of associated types that may or may not be contemporaries (Hoffman 1971:776–81). With several decades of new data compiled since his monumental work, an update of his ceramic research is in order, but the current information is sufficient to indicate a reduced but still resident Caddo population at this time in the upper Little Missouri River valley.

The Caddo tradition residence in the Ouachita River basin appears to have ended abruptly around AD 1700. No European trade goods have been recovered from sites in the river basin in Arkansas except for a single unprovenienced nineteenth-century cuprous metal projectile point found at the Adair site in the 1930s, and a single nondiagnostic red seed bead in grave fill at the Hardman site (Early 2000:135). If Henri Joutel's small refugee group stopped briefly in a Caddo village in the middle Ouachita River valley on their way to Arkansas Post in 1687, an encounter yet to be confirmed, the date of abandonment may be within the decade before sustained European presence in Louisiana began (Foster 1998).

New Approaches and Future Directions

Finally, we highlight new approaches to understanding community identity, social boundaries, emulation, and exchange and interaction by examining technological and stylistic attributes of ceramic sherds and vessel collections from the Ouachita River basin and neighboring areas. We end the essay with suggestions for future work.

COMMUNITIES OF PRACTICE

Recent research on several sites in the Ouachita and Arkansas River drainages uses stylistic analysis of decoration and shape and technological analysis of temper, firing conditions, and paste to characterize local pottery communities of practice, propose social boundaries, and distinguish emulation from the movement of pots or potters. For example, excavations at the Dragover site in 2013–14, co-directed by Meeks Etchieson and Mary Beth Trubitt, were designed to investigate relationships between communities in the Ouachita Mountains, those in the Arkansas River valley further north, and those in the Red River valley to the south. Using a practice-theory approach similar to that employed by Elsbeth Dowd (2012) for the Mountain Fork drainage in the Oklahoma Ouachitas, analysis has focused on architecture, foodways, and material culture to interpret patterns of daily life in the communities that lived at the site (Hanvey 2014; Trubitt et al. 2016). The ceramic analysis is underway. Technological attributes such as paste composition, temper recipes, and firing conditions reflect how potters learned their craft and may distinguish networks of potters or communities of practice. Pottery decoration may have been intentional signaling of family status or other social identity, so stylistic analysis may be used to interpret broader communities of identity (see Eckert et al. 2015; Worth 2017).

Identifying the chemical signatures of local clays and pottery from Caddo sites using instrumental neutron activation analysis (INNA) is a first step. Using INAA, Rebecca Wiewel (2014) analyzed a large sample of sherds from Carden Bottoms (3YE25) in the Arkansas River valley to evaluate questions of local production, em-

ulation, and regional trade of pots. She included a sample of sherds from several sites in the middle Ouachita River valley (a smaller sample from several of these sites was included in Trubitt, Perttula, and Selden's [2016] INAA study of Caddo fine wares). With funding from the USDA Forest Service, Ouachita National Forest, and the University of Missouri Research Reactor Center (MURR), Trubitt has new INAA results from MURR on a sample of thirty-five sherds from Adair and Dragover in the upper Ouachita River valley. These studies show much overlap in the chemical composition of sherds from the Arkansas, middle Ouachita, and upper Ouachita valleys but also some regional chemical differentiation. Higher chromium values have been noted for the middle Ouachita River valley (Trubitt, Perttula, and Selden 2016; Wiewel 2014). Higher sodium, potassium, and arsenic values can be seen in the Carden Bottoms sample, and the upper Ouachita River valley sample shows lower values for many of the elements (fig. 4.11). This pattern is especially evident in the sherds from Adair and Dragover with shale grit in the temper, perhaps a local signature. Building the INAA database for Arkansas ceramics has the potential to identify local communities of pottery production, a first step to identifying movements of pots or potters across social boundaries.

Future Work

The richly complex variety of vessel shapes and decorative themes that Caddo potters produced over 700 years in the Ouachita River basin is only imperfectly captured in current typologies; dozens of variations on hundreds of examples are untyped or undocumented. Using a standardized and comprehensive coding protocol, we are documenting vessel collections left by the early twentieth-century amateur archaeologists. Some of these data have been published and can be incorporated into larger digital vessel databases. The collections of Caddo pottery curated at universities and museums serve as an important resource for modern Caddo potters and prompt continued dialogue between archaeologists and descendant community members.

Type definitions from the mid twentieth century need review and refinement. In particular, the ceramic assemblages from excavations at Hays and Bayou Sel need a modern reanalysis. Both sites have multiple radiocarbon dates, but new radiocarbon dates are needed on features with specific ceramic types (dating soot residues on typed sherds from features would be ideal). These sites have the potential to fill gaps in our understanding of Early Caddo developments in the Ouachita River basin.

We have several projects "in the works." One is completing the ceramic analysis from the Dragover site, including refining/redefining the Buckville phase and Late Caddo period manifestations in the Ouachita Mountains. Another is publication of the descriptive system "pattern book." There are several potential uses of the descriptive classification that have not been explored fully. With such a detailed

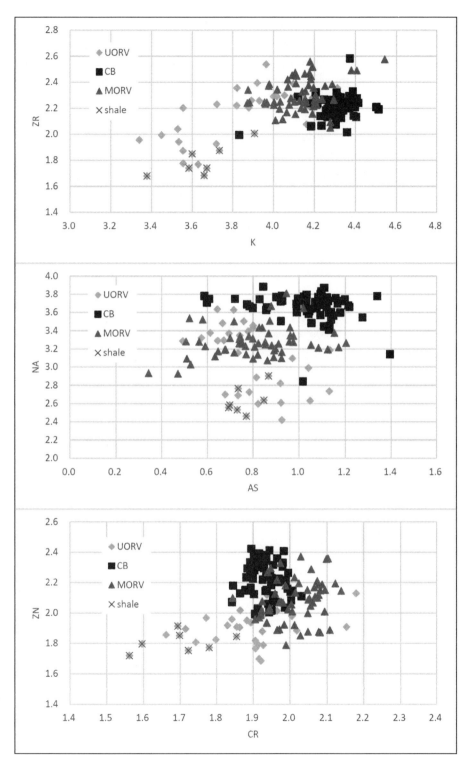

Figure 4.11. Biplots comparing zirconium and potassium (*upper*), sodium and arsenic (*middle*), and zinc and chromium (*lower*) values from Upper Ouachita River valley, Carden Bottoms, and Middle Ouachita River valley samples (shell and bone-tempered sherds corrected for calcium, all values transformed to log base 10).

system, we can do fine-grained design analysis, map the distribution of particular patterns in space, and we may be able to differentiate individual artisans or potter communities. As the descriptive system is published and used more broadly beyond the region, there is potential for extending Caddo vocabulary to ancient motifs, as well as inviting modern Caddo perspectives on possible meanings of ceramic motifs and designs.

The Ouachita River basin was one of the heartlands for ancestral Caddo tradition development and fluorescence. Caddo communities flourished in all parts of the basin for more than 500 years, and the physical evidence of their presence, in the form of mounds, settlements, and material culture, remain at archaeological sites and in museums and other repositories. Pottery vessels are among the most abundant, accomplished, and information-rich evidence of these Caddo societies. Continuing study and appreciation of these ceramics will continue to enrich and expand the story of Caddo people in southwestern Arkansas in years to come.

5

Caddo Ceramics in the Arkansas River Basin in Eastern Oklahoma

Scott W. Hammerstedt and Sheila Bobalik Savage

In this essay, we explore the ceramic tradition of the aboriginal peoples that lived in the Arkansas River basin of east-central and northeastern Oklahoma (fig. 5.1). Northeastern Oklahoma includes the Ozark highlands as well as the Illinois, Grand/Neosho, and Verdigris Rivers and their tributaries, all of which drain southward into the Arkansas River, while east-central Oklahoma includes the Poteau River and its tributaries, which drain northward into the Arkansas River (Albert and Wyckoff 1984). We separate these two areas largely because of differences in ceramic assemblages during the Woodland period and, to some degree, the late precontact Neosho and Fort Coffee phases. These two areas share many, if not all, ceramic characteristics during the Harlan, Norman, and Spiro phases (Regnier et al. 2019). We recognize that these cultural traditions extend into neighboring states (e.g., Harrington 1971; Ray 2018; Ray and Lopinot 2008; Sabo et al. 1990; Schambach 1982a and 2002; Stein 2012; Thomas and Ray 2002; Vehik 1984) but limit ourselves to discussing sites in eastern Oklahoma.

While many of the ceramic types present in the region have been previously defined, largely based upon collections from Spiro, recent work indicates that many key types were not locally manufactured and were imported from elsewhere, likely the Red River drainage to the south (Lambert 2017 and Essay 8). This necessitates a reevaluation of what constituted a "local" type, so we identify what are likely locally made ceramics from the Middle Woodland to the late precontact period.

Northeastern Oklahoma

The earliest known archaeological work that produced ceramics in the Arkansas River basin of eastern Oklahoma was conducted under the direction of Joseph Thoburn of the Oklahoma Historical Society. Thoburn (1931:54–55), working primarily in rock shelters, described what he termed the "Ozark Cave-Dwelling

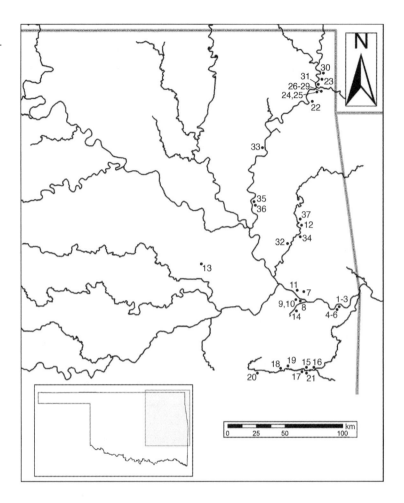

Figure 5.1. Map of eastern Oklahoma showing sites discussed in this essay: 1, Spiro; 2, Choates-Holt, 3, Jones; 4, Lymon Moore; 5, Skidgel; 6, Garrett Ainsworth; 7, Harvey; 8, Robinson-Solesbee; 9, Tyler; 10, Tyler-Rose; 11, Fine; 12, Vanderpool; 13, Plantation; 14, Otter Creek; 15, Williams I; 16, Akers; 17, Wann; 18, Copeland (34LF20); 19, Scott; 20, McCutcheon-McLaughlin; 21, Sam; 22, Cooper 1, 5–6; 23, Huffaker; 24, Evans 1–3; 25, Smith 1–2; 26, Guffy 4; 27, Guffy 5; 28, Copeland 1–2, (34DL30); 29, Caudill 1; 30, Reed; 31, Mode 1; 32, Cookson; 33, Jug Hill; 34, Morris; 35, Norman; 36, Harlan; 37, Brackett.

stock" who produced ". . . well burned pottery (in some cases sufficiently numerous to make possible the restoration of entire utensils)." Thoburn (1931:56–60) also excavated into the burial mound at the Reed site (34DL4) and reported the presence of pottery (Regnier et al. 2019).

The next major round of excavations occurred under the auspices of the Works Progress Administration (WPA) and the University of Oklahoma Department of Anthropology in the 1930s and early 1940s (Regnier et al. 2019). Many of the sites that were excavated by the WPA remain unanalyzed. However, David A. Baerreis and his graduate students at the University of Wisconsin produced a number of theses, dissertations, and articles on a series of sites from Delaware County in northeastern Oklahoma (e.g., Baerreis 1939, 1941, 1953; Baerreis and Freeman 1961; Baerreis et al. 1956; Freeman 1959, 1962; Freeman and Buck 1960; Hall 1951; Hall 1954; McHugh 1964; Purrington 1971; Wittry 1952). Further survey and testing were carried out by Oklahoma River Basin Survey crews in the 1960s and 1970s

ahead of dam and lake construction (e.g., Bell et al. 1969; Wyckoff 1964; Wyckoff and Barr 1964; Wyckoff et al. 1963). Since the 1970s, however, there have been few large-scale survey and excavation projects that have produced extensive ceramic analyses. Over the past decade, we have conducted an ongoing study of the later Spiroan occupations in northeastern Oklahoma, but this research has been limited to collections-based projects rather than new fieldwork (e.g., Hammerstedt and Savage 2014, 2016; Regnier et al. 2019).

Woodland Beginnings

The discussion below relies on summaries by Purrington (1971) and Vehik (1984) of Woodland ceramics that are primarily based on data generated by WPA crews. While surveys and test excavations in northeastern Oklahoma have recovered small amounts of what may be Woodland pottery (e.g., Bybee et al. 2016; Bybee, Warner, Bradley, Warner and Critz 2014; Bybee, Warner, Bradley, Warner and Dulle 2014; Kerr and Wyckoff 1967; Wyckoff and Barr 1964; Wyckoff et al. 1963), there have been few data recovery projects and no attempts to produce a new synthesis for the region in the intervening decades.

Purrington (1971:240–90) originally categorized ceramic types into four groups: Woodward, Caddoan, Delaware, and Cooper. To some extent, we follow this distinction with the Delaware and Cooper series. However, we eschew the Woodward and Caddoan descriptive labels in favor of a chronological approach for two reasons. First, recent work by Lambert (Lambert 2017 and Essay 8) has shown that Formative to Early Caddo fine wares were not locally made but were southern imports. Second, the Woodward group has been shown to extend throughout the later parts of the sequence and into the later Neosho and Fort Coffee phases.

DELAWARE A

The earliest ceramics identified in northeastern Oklahoma appeared during Delaware A, which is thought to be an Early to Middle Woodland focus that gradually emerged from the Late Archaic Grove C focus (Purrington 1971:531; Vehik 1984) or the Lawrence phase (Wyckoff 1984) around 2000 BP (table 5.1).[1] This distinction is based on the introduction of contracting stem projectile points and superposition (Purrington 1971:531) since no Delaware A radiocarbon dates are available. Sites (or site components) classified as Delaware A are Cooper 6 (34DL49); Huffaker 2 (34DL13); Evans 2 (34DL29, Zone 4); Smith 1 and 2 (34DL55 and 34DL42, Zones 1 and 2); Guffy 4 (34DL80, Levels 3–5); Guffy 5 (34DL81, Levels 2–4); and Reed 6 (34DL6). These are the sites listed in the description of the various Woodland foci in Purrington (1971) and Vehik

Table 5.1. Northeastern Oklahoma Chronology

Date	Phase/Focus
AD 1450	Neosho
AD 1350	Spiro
AD 1250	Norman
AD 1100	Harlan
	Delaware B
	Cooper
AD 1	Delaware A

(1984). However, Delaware and Cooper ceramics are found in small quantities at several other sites. These are equally distributed between open-air and rock shelter sites and many of the sites are multicomponent in nature.

Sherds are relatively rare in Delaware A contexts, but Purrington (1971:272–79) defined two types: Delaware Plain and Delaware Cord Marked. The definition of these types is somewhat vague, but both are tempered with crushed sandstone and shell (occasionally in large amounts): the "grit-shell ratio varies, with roughly equal amounts of grit and shell, predominately grit, and predominately shell occurring in order of importance" (Purrington 1971:272). Further, they often have "significant amounts of chert and occasional inclusions of hematite, quartz, and limestone" (Purrington 1971:272). Vessel forms include both jars and bowls with conoidal or flat-disk bases. Delaware Plain has undecorated rims (fig. 5.2), while incised chevrons, cord-wrapped stick impressions, and barrel-shaped punctations sometimes occur on Delaware Cord Marked rims (fig. 5.3).

COOPER

While not ancestral to the Caddo, we include Cooper as a comparison because sherds have been found at sites that also have later Spiroan components. Baerreis (1939, 1941, 1953, n.d.) first defined Cooper as an intrusion by Middle Woodland Kansas City Hopewell people. Purrington (1971:536) lists four Delaware County sites belonging to the Cooper focus. The Cooper 1 and 5 sites (34DL33, 34DL48) were open-air sites that likely were single component while Copeland 2 (34DL47, Zone 3) and Evans 2 (Zone 3) were rock shelters that had Cooper components along with both earlier and later occupations. However, Cooper 6, Smith 1, Guffy 4 and 5, and Copeland 1 (34DL30) also had a Cooper component (Lentz 2015; Purrington 1971:274, 499), and small numbers of Cooper sherds have also been found at nearby sites to the southwest in the Markham Ferry Reservoir (now Lake Hudson) and to the west in the Copan Reservoir and Kaw Lake regions (e.g., Bastian 1969:33–36, 48–58; Neal 1974; Reid and Artz 1984:193–95; Vehik and Pailes 1979:19, 43, 90–91, 240; Wyckoff and Barr 1964:14).

Baerreis's (1953) definition of the Cooper ceramic series was based exclusively on sherds from Cooper 1 and 5, which were located approximately 500 meters apart near the confluence of Grand River and Honey Creek. He defined four types: Cooper Zoned Stamped, Ozark Zoned Stamped, Cowskin Dentate Stamped, and Honey Creek Plain. These are grit-, clay-, clay-grit-, or grit/shell-tempered wares; the decorated types have a variety of stamped, punctated, incised, or embossed designs. Honey Creek Plain body sherds are likely indistinguishable from Delaware Plain and undecorated body sherds of Cowskin Dentate (Vehik 1984). Based on broad patterns of superposition, Baerreis (1953) argued that Cooper Zoned is the earliest of these types, followed by Ozark Zoned, with Cowskin Dentate the most

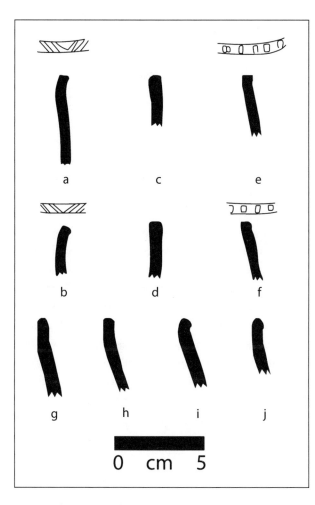

Figure 5.2. Delaware Plain rim profiles: *a*, Reed (34DL10); *b*, Cooper Shelter (34DL48). Redrawn from Purrington 1971:plates 3 and 18.

Figure 5.3. Delaware Cord-Marked, Cooper Shelter (34DL48): *a–b*, incised·lips; *c–d*, cord-impressed lips; *e–f*, lips with barrel-shaped punctates; *g–j*, undecorated lips. Redrawn from Purrington 1971:plate 16.

recent; decoration became more restricted to rims through time. Honey Creek Plain was regarded as spanning the entire sequence.

There are several radiocarbon dates available for Cooper sites (table 5.2). Some of these, particularly the Wisconsin dates, are problematic. The samples in some cases were stored in original field bags and may have been contaminated (Cook 2001:20–21). Further, we have recently redated older samples from WPA collections at the Reed and Lillie Creek sites, and the results from two assays of the same sample sometimes vary by more than 100 years (Regnier et al. 2019:286–87 and table 8.3). Problematic radiocarbon dates have also been noted from WPA collections in southeastern Oklahoma (Hammerstedt et al. 2010). We therefore view these older dates with suspicion but recalibrated them using OxCal 4.3 (Bronk Ramsey 2009). However, the recently obtained Cooper 6 dates (Lentz 2015:table 2.1) seem reliable and place the Middle Woodland component of the site from AD 200 to the mid-fifth century.

Table 5.2. Radiocarbon Dates from Cooper Sites (Bender et al. 1968; Lentz 2015)

Lab #	Context	Intercept (BP)	+/-	OxCal 4.3 Calibration (AD)		
				from	to	%
WIS-307	Cooper 1	980	55	908	1264	95.4
WIS-309	Cooper 5	680	55	1249	1405	95.4
WIS-313	Cooper 5	1840	60	52	335	95.4
WIS-379	Cooper 6	700	50	1223	1394	95.4
AA94713	Cooper 6	607	37	1294	1408	95.4
AA94714	Cooper 6	1680	38	251	427	95.4

The pottery from Cooper 1 and 5 was reanalyzed by Cook (2001) and compared with sherds from Quarry Creek, a contemporaneous Hopewell site at Fort Leavenworth, Kansas. She noted that recreating the types described above was problematic owing to overlaps in tempering agents and decorative techniques. Therefore, she abandoned them and focused primarily on differences in decorative traits. Her analysis suggested that there was an increase in ceramic decoration over time at the Cooper and Quarry Creek sites and that the elements used on rims were basically the same as those seen in other Kansas City Hopewell assemblages (Cook 2001:109–10). While microstyles at each site showed variation, the broad patterns suggest that these sites were closely related and that some sherds from Cooper 1 were possibly made in Kansas (Baerreis 1953; Cook 2001:38, 111). Trace element and/or petrographic analyses should be able to address this issue, as would analysis of the nonceramic artifacts from Cooper sites.

Delaware B

Delaware B may represent a terminal Late Woodland focus. According to Purrington (1971:539–40), Delaware B is distinguished from Delaware A by the appearance of some Caddo-like materials such as small-stemmed and notched arrow points, ear spools, and other items. There is no difference between the Delaware A and B ceramic assemblages; Delaware Plain and Cord Marked are predominant, albeit still in low quantities. Vehik (1984) states that Delaware B likely lasted from roughly AD 900 to 1300, although there are few available radiocarbon dates to substantiate this. Sites with Delaware B components include Guffy 4 (Levels 1 and 2), Guffy 5 (Level 1), Smith 1 Shelter (Zones 1 and 2), Cooper 6 (Zone 2), and Evans 2 (Zones 1 and 2). Purrington (1971:362) and Vehik (1984:185) suggest that there is a Delaware B component at Reed 6, but if so, this is based solely on projectile points since no sherds were recovered from that locality.

McHugh (1964:209–22) described shell-tempered cord-marked ceramics from Guffy 4, along with grit-, sand-, and limestone-tempered plain and/or cord-marked types that are part of the Cooper or Delaware series. However, Purrington

(1971:540) considered these shell-tempered sherds to be Delaware B since "the only difference between McHugh's (1964:216) shell tempered (nearly all of which has sparse to moderate grit inclusions), predominately cord-marked pottery (which we are assigning to the Delaware B focus) and the grit- and grit-shell tempered cord-marked and plain pottery (which comes from all levels of the site) is in temper."

The Delaware series as a whole is poorly defined and in need of revision. It was defined for a relatively small area and was, out of necessity, based on somewhat poorly provenienced collections. Delaware B is essentially a continuation of Delaware A with the addition of a few Caddo nonceramic characteristics. There are no known Caddo ceramics in Delaware B components and the same few pottery types persist in very low frequencies in both Delaware A and B. In other words, it seems that little pottery was in this area before ca. AD 1100. Further, while Delaware B is argued to extend to AD 1300 based on two older, potentially problematic, radiocarbon dates from Copeland 2 (Vehik 1984:table 8.1), elsewhere we have noted that sites that postdate ca. AD 1100 in northeastern Oklahoma (including some of the same sites described by Purrington) have assemblages that fit well into the Spiro sequence (Hammerstedt and Savage 2014 and 2016; Regnier et al. 2019). We suggest that, at a minimum, eliminating the "A" and "B" distinction in favor of a broader "Delaware" nomenclature may reduce confusion until further taxonomic revision can be done. We further argue that using the Spiro sequence for "Delaware" occupations after AD 1100 allows for a more useful chronology.

Spiroan

This time period extends from roughly AD 1100 to 1450. It has been much more extensively studied and is better known than the Delaware and Cooper foci. Purrington used the term Caddoan to define this unit, but we prefer the term Spiroan because it more accurately indicates the regional archaeological differences between the Arkansas and Red River drainages. Researchers have long recognized that, while these regions shared a common cultural core, there were also noticeable differences between them, particularly with respect to burial practices, house shape, and ceramics (Brown et al. 1978; Perttula 1992; Regnier et al. 2019; Schambach 1982b; Wyckoff and Baugh 1980).

Purrington (1971:250–56, 544–45) marks the transition from Delaware into Spiroan by the introduction of large amounts of shell-tempered pottery and Caddo fine wares such as Hickory Engraved, Spiro Engraved, Pennington Punctated-Incised, and Crockett Curvilinear Incised, along with ear spools, polished celts, ovate knives, and square buildings with four center posts. However, with the exception of the burial mounds at Norman (34WG2), Harlan (34CK6), and Reed (34DL4), and the cemeteries at Brackett (34CK43) and possibly Huffaker (34DL13), which have intact fine-ware vessels in burials (Regnier et al. 2019), these

fine wares are represented by only a handful of sherds (Purrington lists a total of twenty-five from all sites). Lambert (2017; Essay 8) demonstrated that these early fine wares were likely produced in the Red River region and imported as finished objects and placed primarily, if not solely, in specialized ritual contexts at mound sites in the Arkansas drainage. These types have been described elsewhere in detail (e.g., Brown 1996; Suhm and Jelks 1962); therefore, we focus on ceramic types more likely to have been locally manufactured. Similarly, we exclude types such as Sanders Plain (now called either Bois d'Arc Plain or Sanders Slipped in the Red River drainage [Perttula, Walters, and Nelson 2016:87]) that occur in exceedingly small numbers, are clearly imports to both northeastern and east-central Oklahoma, have primarily been recovered from special contexts at Spiro itself, and have been previously compiled by Brown (1971, 1996).[2]

Grog-Tempered Types

Williams Plain was first described (but not named) by Newkumet (1940a) and was later referred to as the Spiro 1 type by Orr (1946). It was more formally defined and eventually named in the early 1950s (Bell 1953a; Bell and Dale 1953; Proctor 1953 and 1957). It is a plain, coarse grog-tempered type with thick walls (a mean of 1 centimeter in some assemblages) and both smoothed and unsmoothed surfaces. Rims are primarily everted with very diverse lip forms. Bases are flat or rounded, with rounded bases occurring only on bowls (Brown 1971:55–58 and 1996:343–46). There is also a grog-and-shell-tempered variety called Williams Plain, var. Craig (Brown 1996:346).

LeFlore Plain was originally defined as a grit-tempered plain ware with a dark paste and an uneven and burnished surface (Brown 1971:58–59 and 1996:346). Subsequent refinements have added grog and grog-bone tempered (Rogers 1980, 1982a) and grit-tempered plain wares (Early 1988:64; Schambach 1982a) to the type. A wide variety of vessel colors are represented, ranging from black to gray to red. LeFlore Plain vessels include bowls, jars, and bottles. Brown (1996:346–48) noted the wide variety encompassed within this type and suggested that it is no longer useful as presently defined.

Shell-Tempered Types

The most common shell-tempered pottery type found in northeastern Oklahoma collections is Woodward Plain. This type was first defined by Hall (1951:19–21) to include both plain and decorated coarse shell-tempered pottery with tapered and incurving, flattened, or recurved rims; flattened or rounded lips; and shallow bowls and globular vessels with flat disk bases (fig. 5.4). Brown (1996:158) also included handle peaks (ears or peaks atop the handle) as Woodward Plain diagnostics in Norman phase burials. Using sherds from the Reed site, Woodward Plain was later split into two varieties (Woodward Plain, var. Reed and Woodward Plain, var.

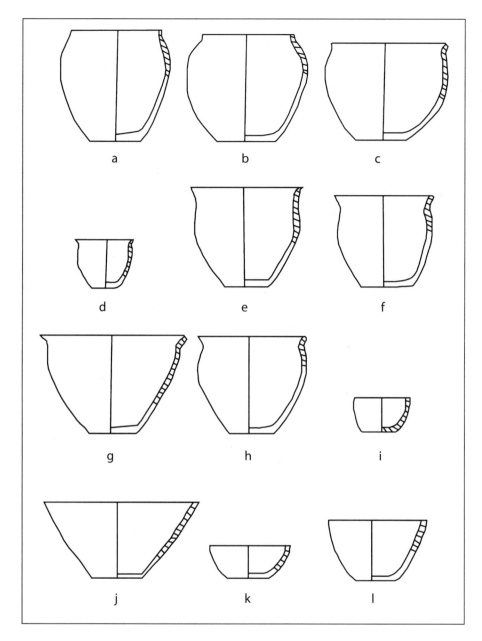

Figure 5.4. Woodward Plain vessel forms: *a–h*, jars; *i–l*, bowls. Redrawn from Freeman and Buck 1960:fig. 1.

Neosho) by Freeman and Buck (1960) based on vessel form. Based on collections from the Harlan site, Bell (1972:247–50) later argued that an additional difference between these varieties was that Woodward Plain, *var. Reed* had badly leached temper and Woodward Plain, *var. Neosho* did not. Later studies showed that neither leaching nor vessel forms were useful distinctions (e.g., Brown 1971:145 and 1996:390; Israel 1979:153; Rohrbaugh 1983); these varieties have largely been dropped from use. Freeman and Buck also split decorated sherds from the Woodward Plain

assemblage and recast them as a new type called Neosho Punctate, which we discuss further below. Body sherds of Woodward Plain are virtually indistinguishable from Mississippi Plain (Phillips 1970:130–35), but most vessel forms of the latter found at Spiro have rounded rather than flat bases (Brown 1996:391–92). The type Woodward Applique is simply Woodward Plain with notched applique strips or nodes on the upper body (Brown 1971:154–56 and 1996:393–94).

Poteau Plain is a coarse shell-tempered ware with a slipped surface (Bell et al. 1969:32; Brown 1996:405–6). The slip is most often black, but red and brown versions also exist. Vessel forms include bowls, bottles, and jars. Another type, Poteau Engraved, is essentially the same as Poteau Plain with the addition of engraved lines. This type is exceedingly rare (Brown 1996:406).

Neosho

The Neosho focus/phase, dating from AD 1450 to 1660 (Rogers 2006), was first defined primarily on the basis of distinctive pottery (Baerreis 1939, 1940, 1941); the phase was later modified to include other traits such as projectile point forms (Freeman 1959, 1962). The majority of the ceramics found at Neosho sites are Woodward Plain, demonstrating some degree of continuity with the preceding Spiroan assemblages, although the rare but distinctive Caddo fine wares are not present in Neosho contexts. Woodward Applique sherds also continue into the Neosho phase.

Figure 5.5. Neosho rim profiles. Inner surface to left. Not to scale. Redrawn from Baerreis 1939.

The key type that defines Neosho assemblages is Neosho Punctate (Freeman and Buck 1960). Neosho Punctate vessels have a coarse shell-tempered paste that is identical to Woodward Plain and the two types also share the same vessel forms (figs. 5.4 and 5.5). However, Neosho Punctate sherds are punctated, incised, or have applique nodes (fig. 5.6). Punctations are generally wedge-shaped but round examples do occur. Lips can be plain or have round, triangular, oval, or barrel-shaped punctations (figs. 5.7 and 5.8).

The original definition of the Neosho phase was based on the examination of WPA-excavated material from rock shelter sites Copeland 1 and 2, Evans 1 and 2, and Smith 1 and 2, and open-air sites Evans 3 (34DL28), Mode 1 (34DL39), and Caudill 1 (34DL59) (Freeman 1959, 1962). More sites have been identified in the intervening years (e.g., Wyckoff 1964 and 1980:324–43; Wyckoff et al. 1963).

East-Central Oklahoma

As in the northeastern part of Oklahoma, the earliest excavations that produced ceramics in east-central Oklahoma were by Joseph Thoburn (1931), who excavated in the Ward 1 Mound at Spiro and took valuable photos of the Craig Mound before its destruction (Brown 1996:41). However, WPA crews once again carried out

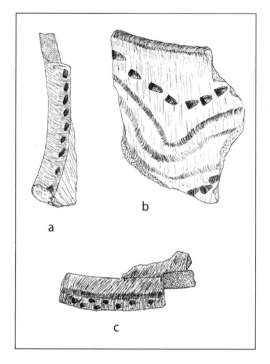

Figure 5.6. Neosho Punctate sherd from Evans 1: *a*, side view; *b*, front view; *c*, top view. Not to scale. Courtesy of Sam Noble Oklahoma Museum of Natural History, the University of Oklahoma, WPA files.

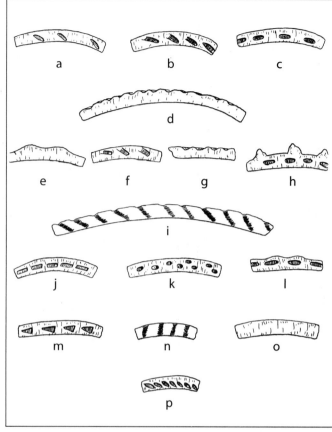

Figure 5.7. Neosho lip designs: *a–l*, Evans 2; *m–o*, Evans 1; *p*, Copeland 1. Courtesy of Sam Noble Oklahoma Museum of Natural History, the University of Oklahoma, WPA files.

the bulk of early work in the late 1930s and early 1940s. These excavations included large-scale work at Spiro and related sites in the Arkansas River valley (Regnier et al. 2019), although many sites dating to the earlier Fourche Maline and later Fort Coffee phases were also tested. Analysis of aspects of these sites continued in the 1940s and 1950s as archaeologists used WPA data to create trait lists and cultural chronologies (e.g., Bell 1953a, 1953b; Bell and Baerreis 1951; Krieger 1947a; Newkumet 1940b; Orr 1946).

From the 1960s through the 1980s, the Oklahoma River Basin Survey, Stovall Museum (now Sam Noble Oklahoma Museum of Natural History), University of Oklahoma (OU) Department of Anthropology, Oklahoma Archeological Survey, and the OU Archaeological Research and Management Center conducted considerable survey, excavation, and collections work in east-central Oklahoma. These included excavations and collections work at Spiro and nearby sites (e.g., Brown 1966a, 1966b, 1971, 1976, 1996; Peterson et al. 1993; Rogers 1980, 1982a, 1982b; Rohrbaugh 1982, 1985, 2012; Wyckoff 1968b, 1970b), work in the Wister valley to the south (e.g., Clark 1987; Galm 1978a, 1978b; Galm and Flynn 1978; Guilinger

Figure 5.8. Neosho Punctate designs. Redrawn from Freeman and Buck 1960:fig. 4.

1971; Powell and Rogers 1980), and exploration of sites to the north and northwest of Spiro (e.g., Harden and Robinson 1975; Wyckoff 1970c; Wyckoff and Barr 1967). These and other projects provided much-needed chronological context through more rigorous field and laboratory methods than the earlier WPA work, culminating in the eventual publication of a thorough statewide synthesis (Bell 1984).

More recently, archaeologists have embarked on a series of projects directed at both collections-based and field-based research at and near Spiro and contemporaneous sites (Cranford 2007; Erickson 2018; Hammerstedt and Galloway 2009; Hammerstedt et al. 2018; Hammerstedt et al. 2017; Kusnierz 2016; Lambert 2017; Regnier et al. 2019) and on the Fourche Maline period in the Wister valley (Fauchier 2009; Leith 2011; Rowe 2014). These projects continue to refine our knowledge of this portion of the Arkansas River drainage.

FOURCHE MALINE

Fourche Maline is the first ceramic-bearing culture in this portion of the Arkansas River drainage and has since been found in Arkansas, Louisiana, and Texas. It was initially described by Newkumet at the first Symposium on the Caddoan Archaeological Area (later the Caddo Conference) (Krieger 1947a) and was de-

fined more formally in the 1950s (Bell 1953a; Bell and Baerreis 1951) and 1980s (Bell 1980; Galm 1984). Fourche Maline was originally thought to last from 300 BC to AD 800 in part because it was difficult to separate Archaic and Woodland traits. However, Wood (1981) identified Fourche Maline artifacts at the Poole site in Arkansas, where Woodland period assemblages could be separated in subsequent work. Using seriation of ceramics, points, and stone tools, Leith (2011) subdivided Fourche Maline into four phases that, taken together, span the Woodland period; we use his ceramic chronology here.

Fourche Maline pottery types include Williams Plain, Williams Boneware, Williams Incised, LeFlore Plain, and Woodward Plain, along with a number of residual categories. Williams Plain, LeFlore Plain, and Woodward Plain were defined above. Williams Boneware is a variant of Williams Plain that is bone- and grog-tempered. This type was first described many years ago (Bell 1953a; Brown 1971, 1996; Galm 1984; Irvine 1980; Proctor 1957; Sharrock 1960) but was not formally named until 2011 (Leith 2011).

Williams Incised is a decorated version of Williams Plain that is sometimes referred to as Williams Decorated or Canton Incised (Brown 1984:fig. 5 and 1996:355; Proctor 1957). It is rare at Spiro but is found in small amounts at sites with Fourche Maline components such as Sam, Fine, Otter Creek, Vanderpool, and possibly Plantation (Briscoe 1977; Eighmy 1969; Harden and Robinson 1975; Picarella 1999; Proctor 1957). Newkumet (1940a) illustrated a number of sherds that resemble Williams Incised from the Williams I site (see also Irvine 1980:35–39). Decorations usually consist of sloppily executed incised chevrons, concentric circles, horizontal lines, or vertical parallel lines. There are, however, two sherds from the Copeland site that have circular punctations; one of these also has an applique strip (Guilinger 1971:plate 23). These incisions are restricted to the area near the lip.

Fourche Maline vessel forms separate these grog-tempered types from their northeastern Oklahoma versions of Williams Plain. The most common shape is a "flower pot" with very thick bases (fig. 5.9) and mostly straight rims, although some flared rims are present (Bell 1953b). Both bowls and jars occur (Fauchier 2009).

As mentioned above, Leith (2011:180–86) used seriations to subdivide Fourche Maline into several

Figure 5.9. Fourche Maline Williams Plain showing thickened base. Redrawn from Newkumet 1940a.

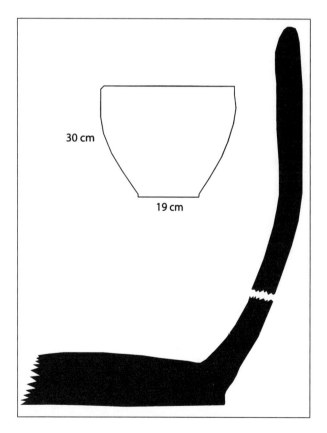

30 cm

19 cm

Table 5.3. Fourche Maline Chronology (after Leith 2011)

Date	Phase	Culture
AD 1000		Fourche
AD 900	Evans	Maline IV
AD 800		Fourche
AD 600	Akers	Maline III
AD 500		Fourche
	Scott	Maline II
AD 1		
		Fourche
300 BC	Williams	Maline I
300–1500 BC	Wister	

phases (table 5.3). He used ceramic, axe, and projectile point data in his work but we only summarize his ceramic data here. Fourche Maline I (Williams phase) lasts from roughly 300 BC to sometime in the first century AD and is marked by the first use of pottery technology in the area. Thick, coarse, Williams Plain pottery is present during this phase. Fourche Maline II (Scott phase) extends from AD 1 to AD 600. Williams Plain was still in use, and Williams Incised and LeFlore Plain were introduced. During Fourche Maline III (Akers phase), Williams Plain, Williams Incised, and LeFlore Plain were all still present but Williams Boneware was added to the assemblage. Decorated grit- and grit-grog-tempered vessels also occurred in small numbers (Fauchier 2009). Fourche Maline IV is the previously defined Evans phase (Brown 1996; Orr 1952), which marks a Woodland-Spiroan transition. The preceding pottery types remained in use, but Coles Creek Incised and French Fork Incised as well as shell-tempered Woodward Plain ceramics were introduced at late Fourche Maline sites.

Spiro

The Spiro sequence has been developed and refined since the 1940s. Here, we use the most recent version primarily defined by Brown with slight revisions by Rogers (fig. 5.10) (Brown 1996; Rogers 2011). It is based on the contents of individual grave lots at Spiro, primarily in the Craig Mound, but also from Brown Mound and the Ward Mounds. The discussion that follows is based on a careful parsing of the ceramic data presented in Brown's (1996) Spiro volumes. We do not provide full descriptions of fine-ware types in this section since, as mentioned above, they are imports, are only found in important ritual contexts, and are described elsewhere in this volume. We do, however, note their presence since they serve as key chronological markers.

Spiro IA

Spiro IA (Evans phase) is the earliest cultural period at Spiro and comprises thirty-three Spiro I and Spiro IA grave lots, all in Craig Mound and Ward Mounds 1 and 2 (Brown 1996:138, 141, 164). Williams Plain and LeFlore Plain are represented by simple bowls and barrel-shaped jars. Agee Incised, Coles Creek Incised, and Coles Creek Incised, *vars. Plum Bayou* and *Keo* bowls are found in Spiro IA grave lots at Craig Mound, and a Crockett Curvilinear Incised sherd was recovered from pre-mound deposits at Brown Mound (Brown 1996:133, 141–42, 194, 340–41).

Spiro IB

Brown (1996:138, 164, 341) suggests that the Spiro IB grave lots from Craig Mound's north primary mound area could represent an early component of the Harlan phase, which is associated with the Spiro II grave period. Williams Plain and LeFlore Plain are the only plain-ware vessels found in the Spiro IB grave lots (Brown 1996:340). Red-slipped sherds first appear at Spiro in this period (Brown 1996:158, 194). LeFlore Plain, Williams Plain, and Coles Creek Incised, var. *Keo* sherds and vessels continue to be represented in the Spiro IB grave lots.

Spiro II

The first classic Spiroan traits occur in the Harlan phase (AD 1050/1100 through AD 1250), which correlates with the Spiro II grave lots from Craig Mound and from the Brown and Ward 1 Mounds. The entire constructional sequence for Brown Mound is within the Spiro II grave period. Dated Harlan phase assemblages at Spiro include Copple Mound, Stage 1, and House Mounds 1 and 2 (Brown 1996:133, 141, 164–67). Most Spiro II ceramics from the Craig and Brown Mounds are sherds; vessels are infrequent. Bottles appear for the first time. Utilitarian wares found in Spiro Ib and II contexts are Williams Plain, LeFlore Plain, and Smithport Plain (Brown 1996:133, 340).

Harlan phase ceramic decorations include infrequent incising, finger-pinching, and punctations. Applique nodes and strips are absent. Low-waisted, straight-walled bowls are common and simple carinated bowls are present. Bottles with corners placed at the vessel's maximum circumference are recorded and bottle necks are tapering cones. Coarse wares are usually jars tempered with grog, grit, or bone. Thin-walled sherds are most common (Brown 1996:133, 158, 194). Vessels with extended/pedestal bases are found in both Spiro II and Spiro III grave lots, albeit in small numbers (Brown 1996:158). Handles are uncommon for the Spiro II grave period and only the loop form is present (Brown 1996:194).

Spiro II is defined by the appearance of Crockett Curvilinear Incised, Hickory Engraved, and Spiro Engraved. These three types span the Spiro II and Spiro III

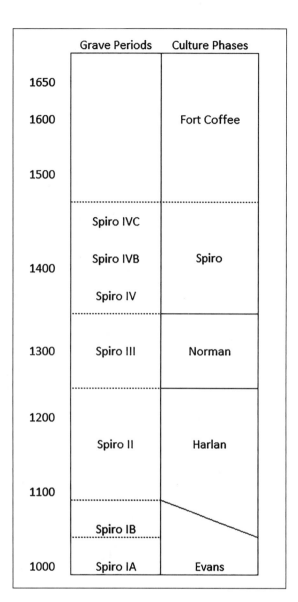

Figure 5.10. Spiro cultural chronology. After Brown 1996; Rogers 2011.

grave periods. Arkadelphia Engraved is believed to be a marker type for Spiro II (Brown 1996:142, 341).

Spiro Engraved and Hickory Engraved bottles and Arkadelphia Engraved and East Incised bowls are from a Spiro II Craig Mound artifact group. Spiro Engraved sherds are also present in a Spiro II burial. Davis Incised bowls and sherds are found in Spiro IB and Spiro II grave lots. A Crockett Curvilinear Incised bowl is from a Craig Mound Spiro II burial and a sherd is from the pre-mound structure at Brown Mound (Brown 1996:112, 141, 166, 232). Sherds from the dated assemblages at Copple Mound, Stage 1, and House Mounds 1 and 2 include Williams Plain, LeFlore Plain, Crockett Curvilinear Incised, Woodward Plain, Sanders Slipped, and Hollyknowe Ridge Pinched (Brown 1996:165–66).

Spiro III

The Norman phase (AD 1250–1350) is transitional between the earlier Harlan phase and the later Spiro phase. It is based on the Spiro III grave lots from Craig Mound (Brown 1996:134, 163). A small amount of the material collected by Thoburn from the Ward 1 Mound is contemporary with Spiro III (Brown 1996:166).

Spiro III has some ceramic features similar to the preceding Spiro II grave period (Brown 1996:158, 194). Ceramic types that span both Spiro II and Spiro III are Hickory Engraved, Spiro Engraved, and Crockett Curvilinear Incised (Brown 1996:341). Additionally, grog-grit tempered extended base bottles are found in both Spiro II and Spiro III (Brown 1996:158, 194). At Craig Mound, however, extended base bottles (Woodward Plain and Undesignated Plain) are only found in one Spiro III context.

Norman phase (Spiro III grave lots) ceramic attributes include the following: jars are larger compared with vessels from the previous Evans and Harlan phases (Brown 1996:196) and strap handles on jars and bowls frequently have handle peaks (Brown 1996:164, 194, 340). Pedestal jars with footed bases/pedestal legs and strap handles are restricted to Spiro III (Brown 1996:28,134, 340).

Hooded effigy bottles appear in Spiro III (Brown 1996:340). Bottle shape is gourd-like and there are pumpkin-shaped jars with restricted openings (Brown 1996:164, 194, 340). Bottle necks are usually conical or tapering (Brown 1996:142), although Brown (1996:340) also states that bottle necks are more cylindrical in the Spiro III grave period.

Shell-tempered coarse ware is predominant and jars are exclusively shell-tempered in Spiro III. Shell-tempered bowls and bottles are also present (Brown 1996:28, 163, 194, 196). Red- and black-slipped surfaces are found on shell-tempered ceramics such as Poteau Plain for the first time during the Spiro III grave period (Brown 1996:194).

Spiro III bowls are flat-bottomed and have broad openings; bowls have incised rim collars on shouldered, carinated profiles (Brown 1996:194, 340). Applique

nodes and strips occur on jar shoulders in Spiro III grave lots (Norman phase) and in subsequent Spiro IV grave lots (Spiro phase; Brown 1996:158).

Ward Incised is a marker for Spiro III (Brown 1996:341). This type is a clay-grit tempered ware. Thoburn reportedly recovered a bowl from the Ward 1 Mound. There is also a sherd from a Spiro III grave lot in Craig Mound (Brown 1996:166, 361). Shell-tempered Bell Plain and Barton Incised are Lower Mississippi Valley types that are found in Spiro III grave lots at Craig Mound (Brown 1996:694, 708).

Three key ceramic types first appear in Spiro III. These shell-tempered types are Poteau Plain, Braden Punctated, and possibly Woodward Applique (Brown 1996:134–35, 194, 341, 393–94, 405–6). Poteau Plain sherds are found in Craig Mound Spiro III grave lots. Fill from Ward Mound 1 and House Mound 1 also have Poteau Plain sherds. Complete vessels of this type are only found in the Spiro IV grave period at Spiro. Braden Punctated is an uncommon type at both Spiro and Norman but is absent from the Reed and Harlan sites. The only example of Braden Punctated from Spiro is a jar with handles from a Spiro III grave lot. Woodward Applique is diagnostic of Craig Mound's later (Spiro IV) grave lots and is found in Spiro phase habitation sites in the Fort Coffee Archaeological Area. Brown (1996:135, 393–94) states that Woodward Applique occurs in the Spiro phase and possibly the Norman phase. However, Woodward Applique jars and sherds were only found in Spiro IV burials in Craig Mound. But Woodward Applique sherds and possibly a jar were found in Spiro III grave lots at Norman (Cranford 2007).

Sanders Slipped and Sanders Engraved are earlier slipped wares that persist into the Spiro III grave period. Poteau Plain and Maxey Noded Redware are slipped types that first appear in Spiro III grave lots (Brown 1996:341).

A distinctive feature in the Spiro III grave period is the appearance of handle peaks on the strap or loop handles of Woodward Plain and Woodward Applique jars. One to three handle peaks are possible but they usually occur in pairs (Brown 1996:158, 165).

SPIRO IV

The Spiro phase (AD 1350–1450) is based on the Spiro IV grave period at Craig Mound. Spiro IV is contemporaneous with or predates the Great Mortuary (designated Spiro IVB) at Craig Mound. Spiro IVB is not a temporal unit. Rather, it refers to burials and objects placed within the Great Mortuary, which was in use for several hundred years (Brown 2012; Brown and Rogers 1999). Extended burials of multiple individuals are common in the Spiro IV grave lots (Brown 1996:139, 153, 156, 164). In at least two instances, sherds from Spiro IV interments refit sherds from Spiro IVB burials. This suggests that at least some Spiro IV and Spiro IVB grave lots are contemporaneous but spatially separated burial programs at Craig Mound.

Vessels are not common in Spiro IVB grave lots. Ceramic types include Po-

teau Plain, Woodward Applique, Woodward Plain, Nashville Negative Painted, Sanders Engraved, Sanders Slipped, Spiro Engraved, Hickory Engraved, Haley Engraved, Handy Engraved, Glassell Engraved, Crockett Curvilinear Incised, Le-Flore Plain, Smithport Plain, Williams Plain, *var. Craig*, and Williams Plain. This combination of both Early and Middle Caddo period ceramics in Spiro IVB grave lots suggests considerable chronological mixing, which is unsurprising given that the Great Mortuary was in use for several hundred years (Brown and Rogers 1999).

Spiro IVC postdates the Great Mortuary (Spiro IVB) and the Spiro IV grave period. Spiro IVC coincides with the construction of Craig Mound's main cone. There is a major shift in Spiro IVC burial treatments; grave goods are infrequent and usually consist of sherds. As a result, it is uncertain whether Spiro IVC is transitional between the Spiro phase and the later Fort Coffee phase or if Spiro IVC burials belong to the subsequent Fort Coffee phase (Brown 1996:134, 139, 153, 156, 164–66, 195).

Forty-seven Spiro IVC burials are from the Mound Summit Zone that overlies the Great Mortuary. All are non-pit burials. Grave goods are reported for twenty of these burials. Sherds are infrequent but represent a variety of types: Woodward Plain, Woodward Applique, Woodward Incised (a Fort Coffee type we define below), Maxey Noded Redware, Spiro Engraved, Sanders Slipped, LeFlore Plain, Coles Creek Polished Plain, Williams Plain, Hickory Engraved, Crockett Curvilinear Incised, Williams Plain, *var. Craig*, Poteau Plain, Poteau Engraved, Parkin Punctated, an unidentified plain, and an unidentified applique. This again shows an apparent mixing of Early and Middle Caddo types. These could be heirlooms or perhaps a reuse of fill from earlier contexts.

The Spiro IV grave period (excluding Spiro IVB and IVC grave lots) features a large number of ceramic types and a noticeable increase in vessels as opposed to sherds. Poteau Plain and Woodward Applique vessels are typical (Brown 1996:134–35, 142, 164, 194–95, 340–41, 394). Woodward Applique is a style marker for the Spiro phase (Spiro IV) grave lots and possibly for the earlier Norman phase (Spiro III) grave lots (Brown 1996:394). Other local types found in Craig Spiro IV burials include Paris Plain, Woodward Plain, Sanders Slipped, and Sanders Engraved.

Braden Punctated is not found in the Spiro IV grave lots from Craig and Brown mounds. Sherds and a vessel are present in the Spiro phase assemblage at the Edgar Moore cemetery (Rohrbaugh 2012:table A.5).

Exotic types found in the Craig Spiro IV assemblages include Nash Neck Banded, Friendship Engraved, *var. Trigg*, Adair Engraved, *vars. Adair* and *Neal*, Haley Engraved, *var. Caruse*, and Redland Engraved. Many of these types are from the Ouachita Mountain region to the southeast of Spiro (Brown 1996:194, 341).

Mississippi Plain is a generally plain-surfaced type tempered with coarse shell. This type is very similar to Woodward Plain (Brown 1996:391). Vessels classified as Mississippi Plain have been recovered from Spiro IV burials in Craig Mound and

Brown Mound. The drawing of one missing bottle classified as Mississippi Plain (oddly, since it is decorated) from Brown Mound shows what appears to be a row of engraved, crown-shaped figures on the vessel's shoulder (Brown 1996:figs. 2–34). This motif is similar to the crown-shaped/mace head bone ornaments found in a Craig Mound Spiro II grave lot. Crown-shaped/mace head ornaments (spangles) made of shell are also found in a Spiro IVB burial.

Spiro IV ceramics are distinguished by high-rimmed jars (Nash Neck Banded); bowls with broad shoulders that slant inward; and bowls with incised, scalloped, or notched rims. Goblet jars are also common (Brown 1996:134, 142, 158, 195, 199, 340–41). Bottle neck forms are usually cylindrical or straight, but the earlier conical and ovoid neck forms are still present (Brown 1996:142). Neckless bottles (seed jars) and beakers now make an appearance (Brown 1996:340). Grit-tempered Paris Plain vessels include bowl and goblet forms (Brown 1996:349).

Paris Plain goblets and a single Ouachita seed jar have been recovered from Craig Mound. Handles, legs/feet, and hooded effigy bottles are nearly absent from Spiro IV grave lots (Brown 1996:194, 340). There is one pedestal base (legged/footed) Woodward Applique vessel with handles and handle peaks from a Craig Mound Spiro IV grave lot.

Spiro Summary

The Spiro ceramic sequence, along with its nonceramic components, has proven to be robust and useful in both east-central and northeastern Oklahoma. We have employed it elsewhere to refine our knowledge of a number of Spiroan mound sites including Reed, Norman, and Harlan (Hammerstedt and Savage 2014 and 2016; Regnier et al. 2019). As noted above, we believe that this ceramic sequence should replace the Delaware focus in northeastern Oklahoma for sites occupied between ca. AD 1100 and 1450.

Vessel type and decoration became more diverse over time. During the Harlan phase (Spiro II), some Fourche Maline traits persisted, such as Williams Plain and flat-bottomed jars, although diversity increased during the Norman (Spiro III) and Spiro (Spiro IV) phases. Williams Plain and Woodward Plain utilitarian wares were found throughout the sequence. The use of shell temper increased over time, but grog-tempered wares continued to be produced. The presence of Early and Middle Caddo vessels in Spiro IV contexts, both mortuary and nonmortuary, suggest a long duration of use for the Great Mortuary and perhaps the presence of heirlooms (or reused fill) in Spiro IVC contexts.

Fort Coffee Phase

This phase was originally defined based on traits from fifteen sites in the Fort Coffee region near Spiro (Bell and Baerreis 1951; Orr 1946). However, subsequent

work by Rohrbaugh (1982, 1984, 2012) trimmed this list to two sites (Lymon Moore [34LF31] and Skidgel [34LF70] cemeteries) with pure Fort Coffee components and three with multicomponent Spiro and Fort Coffee occupations (Choates-Holt [34LF97/34], Jones [34LF75], and Garrett Ainsworth [34LF80]). Five additional sites from outside the core area also have been assigned to the Fort Coffee phase: Harvey (34SQ18), Robinson-Solesbee (34HS9), Tyler (34HS11), Tyler-Rose (34HS24), and Wybark (34MS76) (Bell et al. 1969; Burton 1971; Burton et al. 1969; Cartledge 1970; Lopez 1973).[3] Recent work by Rogers (2006) dates the Fort Coffee phase to AD 1450–1660.

Type markers for the Fort Coffee phase are Braden Incised and Braden Punctate.[4] Braden Incised, defined by Rohrbaugh (2012:171–73), is shell-tempered with paste identical to Woodward Plain and Braden Punctate. It is smoothed and sometimes burnished. Bases are round or flat, and jars are most common (figs. 5.11 and 5.12). Decorations occur from the shoulder to the rim and consist of incised lines forming triangles. This type is distinguished from Canton Incised based on differences in vessel form and temper.

Braden Punctate was originally defined by Brown (1971:153 and 1996:393). It is similar to Braden Incised in both paste and vessel form, although its decorative motif consists of punctations from the shoulder to the

Figure 5.11. Braden Incised sherd and rim profile. Rohrbaugh 2012:fig. B.19.

Figure 5.12. Braden Incised and Braden Punctate vessel forms. Rohrbaugh 2012:fig. B.20.

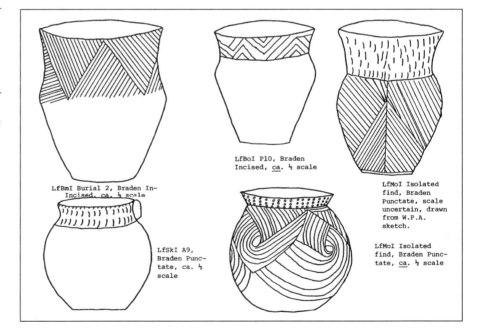

LfBmI Burial 2, Braden In-Incised, ca. ½ scale

LfBoI P10, Braden Incised, ca. ½ scale

LfSkI A9, Braden Punctate, ca. ½ scale

LfMoI Isolated find, Braden Punctate, scale uncertain, drawn from W.P.A. sketch.

LfMoI Isolated find, Braden Punctate, ca. ½ scale

rim (fig. 5.13), but on rare occasions the body is also incised (Rohrbaugh 2012:173).

There are a number of new exotic types that first appear in the Fort Coffee phase. Rohrbaugh (2012:tables A.2 and A.8) identified Avery Engraved, Chickachae Combed, Emory Punctated-Incised, Hempstead Engraved, Hudson Engraved, Mound Place Incised, Nash Neck Banded, Simms Engraved, and Womack Engraved, although Chickachae Combed and Womack Engraved are likely intrusive from a later occupation as the former is a historic Choctaw type and the latter well postdates AD 1600. Fort Coffee phase assemblages also contain a number of types that were originally introduced during previous phases and may be heirlooms. These include Bell Plain, Friendship Engraved, Maxey Noded Redware, Spiro Engraved, Woodward Applique, and Woodward Plain (Rohrbaugh 2012:tables A.2 and A.8). The presence of exotic wares suggests that external relations with the Red River drainage and northern parts of the Arkansas River drainage in Kansas (e.g., Perttula et al. 2001; Stein 2012:296–99, 283–85, 317 and table 11.1) remained important even after Spiro ceased to be a major site.

Figure 5.13. Braden Punctate sherds and rim profiles. Rohrbaugh 2012:fig. B.22.

Conclusions

The earliest ceramics in eastern Oklahoma appeared in east-central Oklahoma during the Fourche Maline I period around 300 BC, roughly 300 years before the advent of Delaware pottery in the northeast. This coarse, thick, grog-tempered Williams Plain from the Wister valley is easily distinguished from both Delaware pottery (as defined by Purrington) and Williams Plain found further north. The Delaware varieties are thinner and have finer pastes and northern examples of Williams Plain do not seem to have the flower-pot shape with thick bases that are found in the south. Williams Plain may have appeared later in the Ozarks, possibly as late as AD 1100 as currently defined. However, we suggest that this is merely a result of sampling bias and that further study of collections will not only deepen the time depth of Williams Plain in northern Oklahoma but strengthen the early parts of the chronology (which is not as robust as the later sections).

Sometime around AD 200, and possibly until as late as AD 900, the Cooper focus, with its distinctive Kansas City Hopewell-like stamped pottery, appeared at a handful of sites in Delaware County. It is unclear whether this involved a movement of people from the north into this area or simply a local adoption of new ideas, since all but a few sherds seem to have a paste similar, if not identical, to

Delaware. These aberrant sherds may be from the Kansas City area (Baerreis 1953; Cook 2001). Motifs suggest that the Cooper variant of Hopewell was stylistically distinct from the Kansas City variant. Future sourcing projects may help to resolve this question. It is clear, however, that Cooper and Delaware traditions are contemporaneous since Delaware pottery continued to be used at other sites during this period. Currently, the Delaware foci are thought to last until AD 1300. However, we argue that the Delaware sequence is poorly defined and is in need of revision, especially when compared with that of Leith's (2011) Fourche Maline chronology.

As we noted above, the Spiro ceramic sequence as defined by Brown (1996) works just as well for northern sites that postdate AD 1100, such as Reed, Norman, Harlan, and Lillie Creek, as it does for the area around Spiro in east-central Oklahoma. A recent study has shown, however, that the decorative fine-ware types that are found in Spiroan assemblages were not locally made (Lambert 2017 and Essay 8). This does not minimize their importance, since these wares were moved over long distances and were found in important ritual contexts. Excavations at off-mound areas at Spiro produced far more grog-tempered Williams Plain and LeFlore Plain sherds than any other type (Hammerstedt et al. 2018; Rogers 1980, 1982a, 1982b), perhaps suggesting that these were the more common wares used for daily life. If so, this situation differs somewhat from the north as recent analyses of ceramics from the Reed site and both the mound and off-mound areas of Lillie Creek have far more shell-tempered Woodward Plain, although the sample sizes are small (Regnier et al. 2019).

It is unclear to what extent the Fort Coffee and Neosho phases are related. In both cases it is clear that there is cultural continuity with previous occupations. Neosho sites are dominated by Woodward Plain, while Fort Coffee sites have continuity with imported fine wares. After defining the Braden Punctate and Braden Incised types, Rohrbaugh (1982 and 2012) reanalyzed the ceramic assemblages from four Arkansas River sites upstream from Spiro that had been described in the 1960s as having Neosho Punctate sherds. His analysis showed that these sherds were actually Braden Punctate. It is not clear at this time whether Neosho Punctate sherds found further north in the Ozarks could also be reclassified. Other artifact classes and the layout of structures are similar between the two areas, although bison scapula hoes and Harahey knives are generally found on Fort Coffee sites rather than in Neosho sites. Ford (2019) argued that Neosho research has lagged behind the rest of the state because of its relative isolation. There has been considerably less archaeological work done in the north, and most of it has been conducted along the Grand and Illinois Rivers; many tributaries remain unsurveyed.

While much more research is needed, it appears that the precontact inhabitants of northeastern and east-central Oklahoma interacted with each other with varying levels of intensity over time. During the Woodland period, there does not ap-

pear to have been much interaction. During the Spiro phases, these regions were clearly linked, although there was less variety in fine wares to the north. During the Fort Coffee and Neosho phases, there were similarities in ceramic technology but the nature of the relationship between the two regions remains unclear.

Notes

1. We use the term *focus/foci* to describe Delaware and Cooper because that is how they were defined by Purrington and no work has been done to redefine them. We use the term *phase* to refer to Lawrence because that is how it was defined by Wyckoff (1984).

2. Brown (1971:164 and 1996:401) and Rohrbaugh (2012:161) only included slipped wares in their definition of Sanders Plain; therefore, we will adopt Sanders Slipped here.

3. The Harvey, Robinson-Solesbee, Tyler, and Tyler-Rose sites were assigned to the Neosho focus by their excavators, but Rohrbaugh (2012:53–54, 63) subsequently reexamined the "Neosho" pottery and reclassified it as Braden Punctate.

4. Brown (1971:153, 1996:393) used the term Braden Punctated to refer to ceramics from Spiro, while Rohrbaugh (2012:173) referred to the same type as Braden Punctate.

6

East Texas Caddo Ceramic Traditions

Timothy K. Perttula

Introduction

The distinctive Caddo Indian pottery from sites in East Texas developed from local Woodland period ceramic antecedents about ca. AD 800/850. This is well after the first pottery was made in the region beginning perhaps about 2,500 years ago by ancestral Caddo hunter-gatherers. The technological and stylistic practices that came to characterize the East Texas Caddo ceramic traditions found in habitation and mortuary contexts, namely their styles, vessel forms, and functional character, are employed in several respects, namely to examine in the archaeological record the importance of ceramics in the cooking and serving of foodstuffs, in the lives of agricultural peoples, as mortuary offerings, and as a means to establish and maintain the social identity of contemporaneous Caddo groups.

Ceramic vessels and vessel sherds are abundant on East Texas Caddo Indian sites, part of the southern Caddo Area (fig. 6.1), that date from as early as ca. AD 800/850 to the early nineteenth century. These ceramics are very diverse in decorative styles, methods of manufacture, surface treatment, firing, and chemical composition (see Essay 1) and this has led to the acquisition of information on the stylistic and technological character of geographically distinctive ancestral Caddo ceramic assemblages and how they have changed through time. These temporally and geographically distinctive ceramic assemblages have been recognized as phases in the East Texas archaeological record, but are best viewed as distinct ceramic style zones and specific communities of practice and identity across the landscape (see Worth 2017:150–51 and fig. 7.5).

From the archaeological contexts in which Caddo ceramics have been found, as well as inferences about their manufacture and use, it is evident that ceramics were important in several ways. This includes in the cooking and serving of foods and beverages, for the storage of foodstuffs, as personal possessions, and as in-

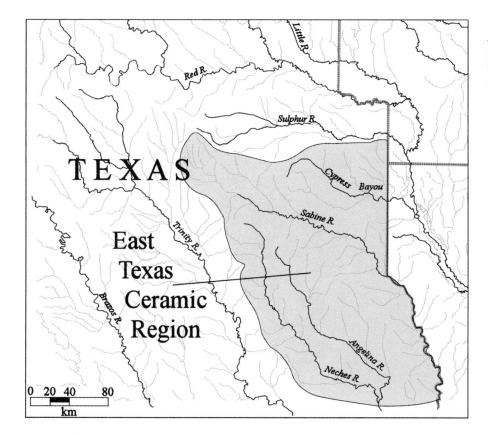

Figure 6.1. The East Texas Caddo ceramic region.

cense burners (see Lankford 2012). Other ceramics were created as works of art and craftsmanship that were clearly made to never be used in domestic contexts. Cross-cutting these categories, vessels were used as social identifiers; that is, certain shared and distinctive stylistic motifs and decorative patterns on ceramic vessels marked closely related communities and constituent groups.

Recent investigations at the Timber Hill site (41MR211) (fig. 6.2) indicate that the aboriginal Caddo ceramic tradition continued in East Texas until the late 1830s (Parsons et al. 2002:35). The ceramics at Timber Hill were made and used for cooking, reheating, serving, and storage of foodstuffs, and they probably had the same range in vessel form and size as earlier Caddo ceramics in East Texas. Even after extensive contact with Europeans, presumably more than a century after the introduction of metal cookware (i.e., iron kettles), the Caddo continued to maintain their long-established ceramic traditions. In another example of Caddo ceramic manufacture and use/culinary continuity, several mid-1830s Caddo vessels apparently collected from Caddo peoples living in northwestern Louisiana are similar in vessel shape to eighteenth-century vessel forms and they have recognizable Historic Caddo engraved motifs (Lee 2001:33–34; Perttula 2001) (fig. 6.3a–c).

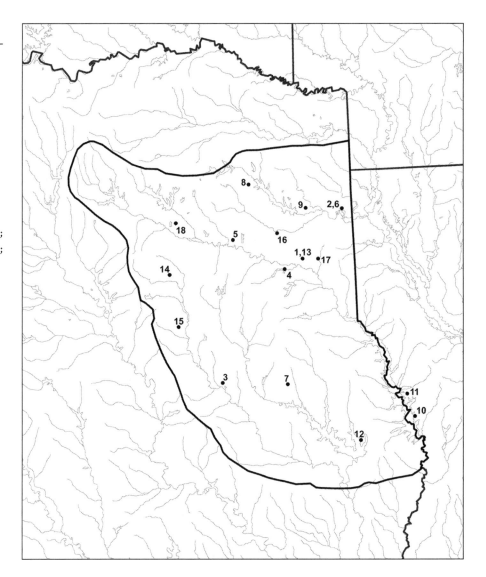

Figure 6.2. Key sites mentioned in the text: *1*, Resch; *2*, Timber Hill; *3*, George C. Davis; *4*, Hudnall-Pirtle; *5*, Boxed Springs; *6*, Mound Pond; *7*, Washington Square Mound; *8*, Tuck Carpenter; *9*, H. R. Taylor; *10*, Salt Lick; *11*, Bison, Area B; *12*, Lake Sam Rayburn sites; *13*, Pine Tree Mound; *14*, Lang Pasture; *15*, Allen; *16*, Little Cypress sites; *17*, Nadaco sites; *18*, Gilbert.

Woodland Period Ceramics in East Texas

Woodland period ceramics in East Texas are not especially abundant in sites across the region. The earliest Woodland period ceramics date to perhaps as early as ca. 500 BC and are also found on sites that date as late as the ninth century AD in parts of the Sabine River basin (cf. Dockall et al. 2008). The ceramics are primarily plain grog- and bone-tempered Fourche Maline culture wares (i.e., Williams Plain) with flat bases and very thick vessel walls (Ellis 2013:139–40). Woodland period ceramics in other parts of the Sabine River basin as well as in the Big Cypress Creek basin are also primarily plain grog-tempered wares (Rogers et al. 2001:124–30 and table 21), but there are also plain sherds with laminated and contorted pastes and

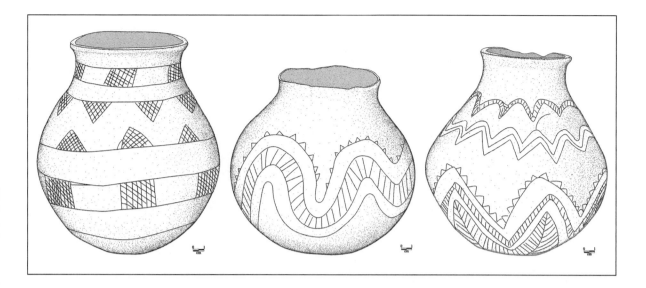

Figure 6.3. Decorative elements on Caddo vessels collected in northwest Louisiana in the 1830s by Dr. Nathan Sturges Jarvis, a surgeon in the U.S. Army. Vessels are in the collections of the Brooklyn Museum.

no temper, similar to Lower Mississippi Valley Tchefuncte wares. However, these vessels were made between ca. 400 BC and AD 200; that is, in the early Marksville period. At sites such as the Resch site (41HS16) in the Sabine River basin (Webb et al. 1969), there are also relatively thick, bone-tempered sherds, as well as sherds with grog temper and a sandy paste, bone temper with a sandy paste, and non-tempered sandy paste sherds (fig. 6.4). Decorated ceramics with lower Mississippi valley stylistic similarities are present in these assemblages, including Coles Creek Incised, Chevalier Stamped, and Marksville Stamped, which belong to the Mill Creek culture (Ellis 2013) (fig. 6.5).

Woodland period ceramics in the Neches-Angelina River basins of East Texas are sandy paste wares, primarily undecorated Goose Creek Plain, *var. unspecified* (Aten and Bollich 2002; Story 1990a), a common ceramic type also on the upper Texas coast. Lip-notched sandy paste ceramics (Goose Creek Plain, *var. Burris*) are characteristic of Mossy Grove pottery in East Texas sites; this distinctive lip-decorated type appears to have been most commonly made prior to ca. AD 300. Other kinds of decorated sandy paste pottery (with incised, punctated, and incised-punctated elements) have been documented in a late seventh to eighth century ceramic assemblage in the Attoyac Bayou basin (Perttula ed. 2008).

Caddo Ceramic Wares

Basic distinctions are recognized in Caddo ceramic assemblages between plain wares, utility wares, and fine wares. The same range of basic forms was made by Caddo potters in all three wares: carinated bowls, bottles, bowls, and jars (see Essay 1). The particular shape and form of these vessels is a hallmark of the tech-

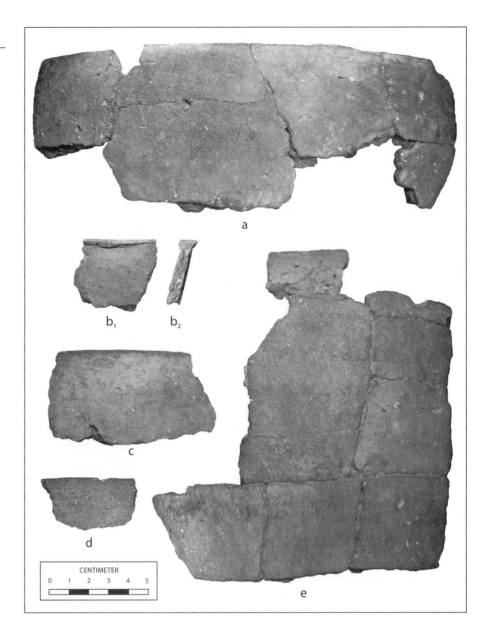

Figure 6.4. Plain rim sherds from the Resch site (from Ellis 2013:fig. 11, courtesy of the Texas Archeological Society).

nology and style of Caddo vessels in East Texas, and these shapes and specific vessel forms would have been immediately recognizable to other Caddo as belonging to particular East Texas social groups.

Utility ware vessels were used for cooking, storage, and probably other culinary activities; they tended to have a coarse paste, thick body walls, smoothed interior surfaces, and were decorated with wet-paste designs (i.e., decorations were made with tools and fingers prior to the vessel being fired, when the vessel had a "wet" or malleable exterior surface). Typical utility vessel shapes included small to large

Figure 6.5. Woodland period cultures in East Texas.

jars, as well as conical and simple bowl and bottle forms. Most of the bottles in the earlier Caddo ceramics (and the historic Caddo ceramics) were plain and unpolished wares. The utility-ware vessels have carbon encrustations, food residues, and soot stains, suggesting they were employed over open fires. However, some of these kinds of vessels were used primarily for storage (those with large orifice diameters and vessel volumes) of foodstuffs and liquids.

Incised and punctated utility vessels were commonly used before ca. AD 1300–1400, but these vessels were also decorated in a variety of other ways. Brushing of vessel bodies is a form of surface treatment on utility wares that is notable after ca. AD 1250 in the Big Cypress Creek basin and the Neches-Angelina River basins and in sites in the middle reaches of the Sabine River (fig. 6.6). Other types

Figure 6.6. Distribution of Caddo site ceramic assemblages where brushed sherds constitute more than 60 percent of the decorated sherds.

of decorations and/or surface treatments on later Caddo utility vessels included neck-banding, brushing, ridging, and applique, along with combinations of zoned or diagonal incised and punctated designs on the rim and body of jars. In historic Caddo times, dating after ca. AD 1680/1700, rows of fingernail punctations on the rim of everted-rim Emory Punctated-Incised jars are also a common decorative treatment in sites in the upper Sabine River basin (Story et al. 1967). Handles and lugs were present on some of the utility vessels, especially on Caddo sites dating after ca. AD 1250.

Fine wares are engraved and red-slipped vessels that were used for food service and to hold liquids, as well as for other purposes, such as holding pigments or tobacco. They tend to have fine pastes, with finely crushed tempers, typically grog but also burned bone. They are frequently burnished on the interior and/or exterior vessel surfaces (except the bottles, which were burnished on exterior surfaces only) and have relatively thin body walls compared to the utility wares. Vessel forms among the Caddo fine wares include carinated bowls, deep compound bowls with upper and lower rim panels, bottles, double and triple vessels (conjoined or fused bowls and bottles), ollas, zoomorphic and anthropomorphic effigy bowls and bottles, ladles, platters, rim-peaked jars, gourd and box-shaped bowls, and chalices.

Plain wares have technological attributes common to both utility wares and fine wares. The frequent occurrence of plain-ware bowls and bottles in East Texas Caddo assemblages suggests that they were mainly used for food service and to hold liquids, as were the fine wares.

The East Texas Caddo made ceramic wares that were tempered with grog or bone, although burned and crushed shells were used as temper after ca. AD 1300 among McCurtain phase Caddo groups in the Kiamichi-Red River confluence area and on later Caddo sites in the lower and upper Sulphur River basin (see Essay 3). The high frequency of grog tempering in East Texas Caddo ceramic assemblages represents a specific attempt by potters to slow the oxidation process of the ceramic vessels during firing. This would have allowed them to be fired longer, producing a harder ceramic vessel (see Rice 1987). The use of bone temper by Caddo potters varied significantly by region as well as temporally (fig. 6.7).

After adding the temper to the clay, the kneaded clay was formed into clay coils that were added to flat disk bases to form the vessel, and the coils were apparently smoothed with a round river pebble to create the finished vessel form. Coiling is a technique especially suited to the construction of large, sturdy vessels, such as storage jars (Rice 1987:128), but in the case of Caddo potters, coiling of plastic clays

Figure 6.7. The distribution of post-AD 1400 bone-tempered ceramics (greater than 40 percent in assemblages) in East Texas.

led to the manufacture of a wide variety of vessel forms of varying sizes. The majority of the vessels and sherds from Caddo sites have a clayey to silty paste. Clays used for vessel manufacture were probably gathered from nearby alluvial settings. Potters were likely to select lower quality clays for vessel manufacture than high quality clays if the latter were farther away (Arnold 2000).

Decorations and slips were added before, as well as after, baking in an open fire, and commonly the vessels were then burnished and/or polished in a leather-hard state (e.g, Rice 1987:138). Red ochre and white kaolinite clay pigments were often added to the engraved decorations on bottles, compound bowls, and carinated bowls.

The orifice diameters of Caddo vessels ranged in size from those suited for individual use (less than 1–2 liters in volume) versus large to very large vessels (with volumes greater than 5–6 liters) intended to be used by multiple individuals, probably in the context of feasting activities. As the vessels from East Texas Caddo sites are hollow wares (i.e., jars, bowls, and carinated bowls), it seems likely that the Caddo diet was based almost entirely on liquid-based foods cooked in jars, including stews, corn and bean dishes, and gruels.

Mortuary vessels on Caddo sites held liquids and foodstuffs for the deceased to use on the six-day journey to the House of Death. The very large size of some of the carinated bowls and compound bowls from many cemeteries suggests that they may have been intended to serve multiple purposes in mortuary rituals, including use of the vessels in graveside rituals and food offerings by the relatives of the deceased, after which they were placed in the graves as a final accompaniment once the "Sixth Day Feast" had been concluded (see Gonzalez et al. 2005:57–58). The character of the ceramic vessels from burials reflect closely shared beliefs, rituals, and cultural practices among East Texas Caddo groups in what adult males and females, as well as children, needed in life and "needed in the other life" (Swanton 1942:205).

Stylistic Distinctions and Caddo Ceramic Sets

The stylistic analysis of Caddo ceramics from sites in East Texas focuses on the definition of recognizable decorative elements, patterns, and motifs on the rim and/or body of the fine wares (i.e., the engraved and red-slipped vessels, including carinated bowls and bottles) and utility wares. These distinctions have both temporal and geographical distributions across East Texas, and in some cases, across the broader Caddo Area, and thus the recognition and unraveling of those distributions has been key to the reconstruction of settlement and regional histories of different Caddo communities as well as their ceramic practices.

The stylistic distinctions that have been recognized in East Texas Caddo ceramics are based primarily on the pioneering typological research done by Alex D.

Krieger, Clarence Webb, Dee Ann Suhm (Story) and Edward B. Jelks in the 1950s and early 1960s (Suhm and Krieger 1954; Suhm and Jelks 1962). Suhm and Jelks (1962) presented descriptions of sixty Caddo ceramic types that had been identified in Caddo sites in East Texas and the Caddo archaeological area up to that time. Perttula and Selden (2014) have more recently noted thirty-eight new Caddo ceramic types in East Texas archaeological sites defined since the mid-1960s. Some new varieties have also been identified among several of the well-known types, including Poynor Engraved, Patton Engraved, Hume Engraved, Ripley Engraved, and Wilder Engraved, and these varieties appear to have more discrete temporal and geographic boundaries. Table 6.1 partitions the known ancestral Caddo ceramic sets in East Texas. The distribution of these ceramic sets can be linked with the identification of culturally specific Caddo vessel assemblages, groups, communities, and phases in the East Texas archaeological record.

The pottery types identified in the decorated sherds and vessels known to come from ca. AD 800/850–1200 East Texas Caddo sites such as George C. Davis (41CE19) include: (a) the engraved fine ware types Hickory Engraved (fig. 6.8a), Holly Fine Engraved (fig. 6.8b), and Spiro Engraved (fig. 6.8c–d); and (b) the utility ware types Coles Creek Incised, Davis Incised, Dunkin Incised (fig. 6.8e), Weches Fingernail Impressed (fig. 6.8f), Kiam Incised, East Incised, Hollyknowe Ridge Pinched (fig. 6.8g), Crockett Curvilinear Incised (fig. 6.8h), Pennington Punctated-Incised (fig. 6.8i), Duren Neck Banded (fig. 6.8j), and Crenshaw Fluted. All of these types would be expected to be present in ca. AD 800/850–1200 Caddo sites in East Texas, along with several other types (see table 6.1), but the relative proportions of the different ceramic types vary from site to site and through time across the region. Fine-ware engraved vessels dominate the vessel collections at both the Boxed Springs (41UR30) and George C. Davis sites, particularly Hickory Engraved and Holly Fine Engraved, as well as Spiro Engraved. In these Early Caddo sherd assemblages, engraved fine wares constitute between 16.5 and 30.8 percent of all the decorated sherds; red-slipped sherds are rare.

East Texas Caddo fine wares dating before ca. AD 1200 have curvilinear, rectilinear, and horizontal decorative elements and motifs, with dominant geometric patterns as well as scrolls, and the engraving frequently covers the entire vessel surface; other fine-ware designs simply are placed on the rim or sometimes on the interior rim surface. The earlier Caddo fine wares are quite uniform in style and form, suggesting that a broad and extensive social interaction existed between Caddo groups across East Texas (and other parts of the Caddo Area), in concert with an extensive trade and exchange of vessels.

The most common decorative methods on ca. AD 800/850–1200 East Texas Caddo utility-ware vessels, and on sherds from vessels, are incised (especially horizontal incised elements), punctated, and incised-punctated designs. Crockett Curvilinear Incised (see fig. 6.8h) and Pennington Punctated-Incised (see fig. 6.8i)

Table 6.1. East Texas Ceramic Sets

Formative to Early Caddo set, ca. AD 850–1200
Bowles Creek Plain
Canton Incised
Coles Creek Incised
Crockett Curvilinear Incised
Davis Incised
Dunkin Incised
Duren Neck Banded
Hickory Engraved, including Hickory Engraved, *var. Chapman*
Holly Engraved
Hollyknowe Pinched
Kiam Incised
Pennington Punctated-Incised
Spiro Engraved
Weches Fingernail Impressed

Middle Caddo set, ca. AD 1200–1400, in parts of East Texas
Canton Incised
Leaning Rock Engraved
Maxey Noded Redware
Monkstown Fingernail Impressed
Sanders Engraved
Sanders Slipped
Spoonbill Engraved
Spoonbill Plain

Middle Caddo set, ca. AD 1200–1400, Angelina River basin in East Texas
Broaddus Brushed
Nacogdoches Engraved
Pineland Punctated-Incised
Reavely Brushed-Incised
Tyson Engraved
Washington Square Paneled

Titus phase set, ca. AD 1430–1680
Anglin Corn Cob Impressed
Bailey Engraved
Bullard Brushed
Cass Applique
Gardener Punctated
Gilmer Engraved
Harleton Applique
Johns Engraved
Karnack Brushed-Incised
Killough Pinched
La Rue Neck Banded

Titus phase set, ca. AD 1430–1680 (*cont.*)
Maydelle Incised
Mockingbird Punctated
Pease Brushed-Incised
Ripley Engraved, multiple varieties
Taylor Engraved
Turner Engraved, multiple varieties
Wilder Engraved, multiple varieties

Frankston phase set, ca. AD 1400–1680
Bullard Brushed
Fair Plain
Hood Engraved (effigy bowls)
Hume Engraved, several varieties
Hume Plain
Killough Pinched
La Rue Neck Banded
Maydelle Incised
Poynor Brushed
Poynor Engraved, multiple varieties

Allen phase, ca. post-AD 1680
Bullard Brushed
Constricted Neck Punctated
Hood Engraved (effigy bowls)
Hume Engraved
Hume Plain
Killough Pinched
King Engraved
La Rue Neck Banded
Lindsey Grooved
Mayhew Rectilinear
Patton Engraved, several varieties
Spradley Brushed-Incised

Kinsloe phase, post-AD 1680–1830
Darco Engraved
Emory Punctated-Incised
Henderson Plain
Keno Trailed
Natchitoches Engraved
Patton Engraved
Simms Engraved

Post-AD 1680, Upper Sabine River basin
Ebarb Incised
Emory Punctated-Incised
Natchitoches Engraved
Simms Engraved
Womack Engraved
Womack Plain

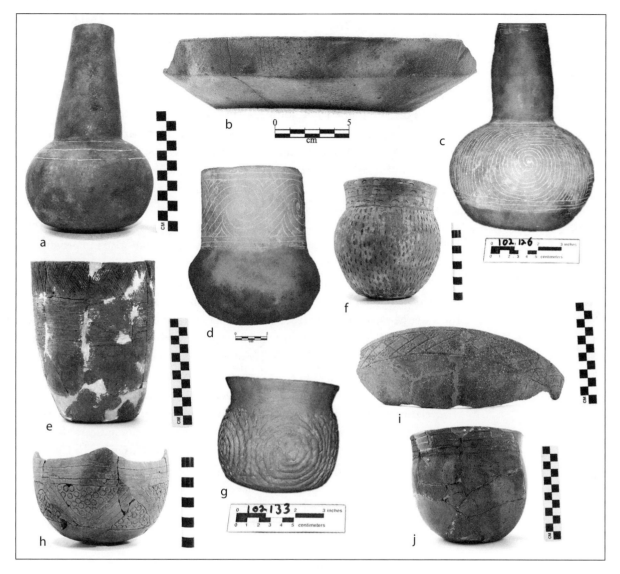

Figure 6.8. Formative and Early Caddo period fine-ware and utility-ware ceramic vessels: *a*, Hickory Engraved; *b*, Holly Fine Engraved; *c–d*, Spiro Engraved; *e*, Dunkin Incised; *f*, Weches Fingernail Impressed; *g*, Hollyknowe Ridge Pinched; *h*, Crockett Curvilinear Incised; *i*, Pennington Punctated-Incised; *j*, Duren Neck Banded.

sherds and vessels are present in pre-AD 1200 ceramic assemblages but occur in considerable frequencies only at the George C. Davis site. An analysis of the ceramic assemblages from well-dated unit excavations at the site (see Stokes and Woodring 1981:table 26), suggests that both types are present in unit excavations that date from between cal. AD 897 and 1276, virtually the entire span of the ancestral Caddo occupation there (see Story 2000), with Crockett Curvilinear Incised most common between cal. AD 1027 and 1223 and Pennington Punctated-Incised most common throughout the occupation at the site.

Some vessels have horizontal incised lines above rows of vertically oriented punctations and have straight or parallel incised lines adjacent to a zone of tool punctations. Rows of tool punctations also occur between the incised lines.

This decorative element is noted in ceramic assemblages at Early Caddo sites like Hudnall-Pirtle (41RK4) and George C. Davis in East Texas (Newell and Krieger 1949:fig. 38*m–n*; Bruseth and Perttula 2006:fig. 26*d*; Perttula ed. 2011:figs. 35*b* and 36*a*) and northwestern Louisiana (see Webb 1963:fig. 9*r–s, u*).

Coles Creek Incised sherds and vessels are present in very low frequencies in several Formative to Early Caddo sites in East Texas. At the George C. Davis site, for example, there are only nine Coles Creek Incised sherds in an assemblage of more than 100,000 sherds and fifteen whole vessels (Story 1990b:746). The occurrence and relative proportion of Coles Creek Incised pottery in ceramic assemblages from the Early Caddo Mound Pond site (41HS12) near Caddo Lake is considerable, however, dwarfing its use on most East Texas Caddo sites of the same age (Goode et al. 2015). The most common variety is *var. Coles Creek* (Phillips 1970), and this variety apparently dates from ca. AD 900–1050 in Formative to Early Caddo contexts (Girard 2009:52). The Coles Creek Incised vessels and sherds from sites in the Caddo Area are similar "in decorative designs and sometimes in vessel form, but not usually in details of paste" (Story 1990b:736) to vessel sherds in the lower Mississippi valley. They do not represent settlement of the area by lower Mississippi valley peoples. Girard (2009:52) suggests there was a period of strong lower Mississippi valley Coles Creek contact and social interaction among Caddo peoples in parts of the Caddo Area between ca. AD 900 and 1050.

Early Caddo plain-ware vessels include bottles, bowls, carinated bowls, and jars. The relatively high frequency of plain rims (47.6 percent) among all the rim sherds in habitation deposits at the Early Caddo Boxed Springs site indicate that plain vessels constitute a substantial part of the vessels made and used by the Caddo inhabitants of the site. More than 42 percent of the 169 vessels in the Boxed Springs cemetery were also plain wares (Perttula ed. 2011:table 11).

The Middle Caddo period (ca. AD 1200–1400) in East Texas is marked by a considerable stylistic heterogeneity in the decorated Caddo ceramic wares (Hart and Perttula 2010:203–4). This appears to be related to the fact that Caddo communities at this time "became economically, as well as socially and politically, more autonomous" (Girard 2010:205), and this autonomy led to innovations in ceramic traditions, both in new styles of decoration as well as new vessel forms and attributes (i.e., strap handles on both fine wares and utility wares, vessel pedestal legs, distinctive rim modes, etc.). The use of a red hematite slip on interior and/or exterior surfaces of carinated bowls and bottles occurs with some regularity in ca. AD 1200–1400 ceramic assemblages in various parts of the region (particularly in the upper Sabine and Big Cypress drainage basins) (see also Essay 3).

There are distinctive engraved motifs in this East Texas Caddo style zone and ceramic tradition. These include engraved rattlesnake motifs (see Walters 2006; Hart and Perttula 2010), hatched or cross-hatched curvilinear and vertical ladders, narrow panels, as well as hatched and cross-hatched circles and ovals (fig. 6.9*b*),

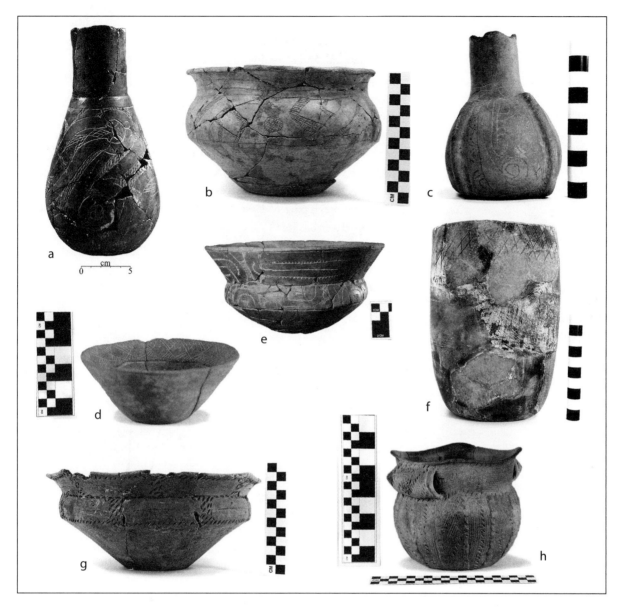

triangles (fig. 6.9d), pendant triangles, or rectangular panels with engraved triangles. The engraved rattlesnake motif on Nacogdoches Engraved vessels from the Washington Square Mound site (41NA49) (fig. 6.9a) represents a local expression of Beneath World creatures. In some instances, there are engraved vessels with vertical and triangular panels filled with concentric circles, or panels made by appliqued elements (fig. 6.9c). A number of the engraved fine-ware vessels have horizontal interlocking, slanting, and vertical scrolls—including negative S-shaped scrolls—as their principal motif (fig. 6.9e). There are also rayed circles/sun elements and the swastika cross-in-circle.

Figure 6.9. Fine-ware and utility-ware vessels from selected Middle Caddo period sites in East Texas: *a–b*, Nacogdoches Engraved; *c*, engraved-appliqued bottle; *d*, Spoonbill Engraved; *e*, Tyson Engraved; *f*, Canton Incised; *g*, Washington Square Paneled; *h*, Reavely Brushed-Incised.

Decorated utility wares in East Texas Middle Caddo ceramic traditions have a similar broad range of common elements and motifs. This includes diagonal, diagonal opposed, horizontal, and cross-hatched incised lines (fig. 6.9*f*) on vessel rims; rows of tool, fingernail, and cane punctations on utility-ware rims and/or bodies, including interlocking rows (fig. 6.9*g*); triangular and circular incised zones filled with punctations; appliqued nodes, ridges, and fillets as decorative elements and design dividers; and brushing, either as the sole decoration on the rim and the vessel body, or on the rim or body in combination with incised, punctated, and appliqued decorative elements (fig. 6.9*h*). Brushed utility wares are more abundant in the eastern part of the region after ca. AD 1250 but only a minor part of ceramic assemblages in the western part of East Texas (especially the upper parts of the Sabine and Sulphur River basins).

Figure 6.10. Defined Late Caddo and Historic Caddo period phases in East Texas.

Timothy K. Perttula

Late Caddo period (ca. AD 1400–1680) ceramics retain their stylistic heterogeneity, but these assemblages of fine-ware, utility-ware, and plain-ware vessels are part of and associated with recognizable and relatively geographically coherent sociopolitical entities that arose out of earlier and distinctive archaeological traditions of the Caddo peoples. Caddo groups of varying sizes, complexity, and local history were widely distributed across both major and minor streams in the area. Subtle population and territorial readjustments, coupled with continued mound building in some major valleys (including the Sabine and Big Cypress basins), trade activities (salt and bow wood), and other pursuits suggests these were prosperous farmers with sustainable social and political organizations. For want of a better term, these sociopolitical entities are recognized as phases in the regional archaeological record, including the Titus phase in the Big Cypress and Sabine River basins (as well as parts of the Sulphur River basin, see Essay 3), the Frankston, Allen, and Angelina phases in the Neches-Angelina River basins, and the Salt Lick phase in the lower reaches of the Sabine River basin (fig. 6.10).

The later Caddo fine-ware designs in East Texas include scrolls, scrolls with ticked lines, scrolls and circles, negative ovals and circles, pendant triangles, diagonal lines and ladders, and S-shaped motifs. These kinds of decorative elements continued in use in historic Caddo ceramics (that is, until about AD 1800 or later). The latter are best exemplified by the scrolls and tick marks on Patton Engraved vessels among Hasinai Caddo groups in the Neches River basin and the pendant triangles and engraved scrolls on Womack Engraved bowls on Caddo sites in the upper Sabine River and Red River basins.

Fine-wares in Titus phase sites such as the Tuck Carpenter (41CP5) and H. R. Taylor (41HS3) sites, especially vessels in cemeteries where they were placed as funerary offerings, are dominated by several recently defined varieties of Ripley Engraved (fig. 6.11a–k; see also Fields et al. 2014:table 8-6; also Essay 10), including carinated bowls, compound bowls, simple bowls, bottles, jars, and ollas. These have a diverse range of vessel motifs, most of them featuring scrolls, continuous scrolls, scrolls and circles, circles and nested triangles, or pendant triangles on rim panels (fig. 6.12), as well as scroll arms with excised brackets, negative ovals, S- or SZ-shaped elements (see Essay 11), and triangles; red

Figure 6.11. Defined varieties of Ripley Engraved and other engraved motifs on carinated bowls and compound bowls: a, *var. McKinney*; b, *var. Gandy*; c, *var. Galt*; d, *var. Caldwell*; e, *var. Cash*; f, *var. Carpenter*; g, *var. Pilgrims*; h, *var. Williams*; i, *var. Reed*; j, *var. Dry Creek* (horizontal diamond); k, *var. Dragoo* (interlocking diamond).

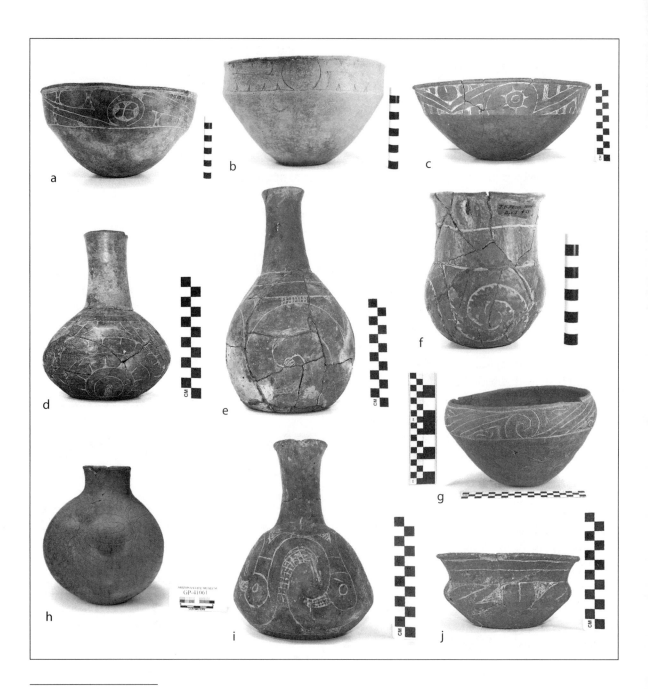

Figure 6.12. Titus phase fine wares: *a–d*, Ripley Engraved; *e–f*, Wilder Engraved; *g*, Taylor Engraved; *h*, Bailey Engraved; *i*, Johns Engraved; *j*, Turner Engraved.

and white clay pigments were commonly applied to the engraved designs on many of the vessels. A sample of over 2,000 vessels from seventeen Titus phase cemeteries in the Big Cypress Creek basin (Perttula and Sherman 2009:table 17-4) indicate that Ripley Engraved vessels account for approximately 50 percent of the entire vessel sample, especially carinated bowls, compound bowls, and bottles.

Other important fine wares from Titus phase sites include Wilder Engraved

bottles (fig. 6.12e), jars (fig. 6.12f), and ollas, Taylor Engraved carinated bowls (fig. 6.12g) and bottles, Bailey Engraved bottles and ollas (fig. 6.12h), and Simms Engraved carinated bowls and deep bowls. Johns Engraved bottles have engraved bird head elements (fig. 6.12i), and Turner Engraved compound bowls (fig. 6.12j) have pendant triangle and large hatched and cross-hatched triangle engraved elements, and rim peaks with ovals, negative ovals, and negative S-shaped elements.

Womack Engraved vessels and their ancestral stylistic forms (i.e., Taylor Engraved inverted rim carinated bowls and Womack Engraved, *var. Gum Creek*, fig. 6.13) in burials on late Titus phase sites that lack trade goods indicate that certain Caddo groups were living in parts of the Sabine, White Oak, and Little Cypress Creek basins after ca. AD 1680. These Caddo groups developed this distinctive vessel form and its constellation of stylistic elements and motifs that reached their full stylistic maturation by the early eighteenth century on sites on the Red River (see Essay 3) and by the middle eighteenth century at the Gilbert site in the upper Sabine River basin.

Titus phase utility-ware vessels in the same sample of vessels from Titus phase cemetery contexts primarily include Harleton Applique jars with intricate appli-

Figure 6.13. Womack Engraved, *var. Gum Creek* from the Enis Smith site (41UR317), Upshur County, Texas.

Figure 6.14. Utility wares in Titus phase sites.

qued elements on the vessel body (fig. 6.14*a–b*), Bullard Brushed vessels, La Rue Neck Banded (fig. 6.14*c*), Mockingbird Punctated (fig. 6.14*d*), Maydelle Incised, Karnack Brushed-Incised, Pease Brushed-Incised, and utility ware jars decorated with combinations of incised, punctated, and/or brushed elements, including rows of punctations. Jars regularly had rim peaks, where the vessels were divided into quarters, which may be symbolic of the Caddo's view of the world. Plain bowls often held pigments used in graveside rituals. Titus phase ceramic assemblages also have appliqued noded rattle bowls (fig. 6.14*e*).

In the upper Neches River basin after ca. AD 1450, the principal fine wares in Frankston phase contexts are several varieties of Poynor Engraved bowls and carinated bowls (see Perttula 2011:figs. 6-64 and 6-65) (fig. 6.15*a–c*), followed by Poynor Engraved bottles of various forms, Patton Engraved (dating mainly after ca. AD 1680, in Allen phase contexts), Hood Engraved effigy-ware vessels (fig. 6.15*d*), with or without tail riders, and beaker-shaped Hume Engraved bottles (fig. 6.15*e*). More than 460 vessels documented from post-AD 1400 Caddo sites in the upper Neches

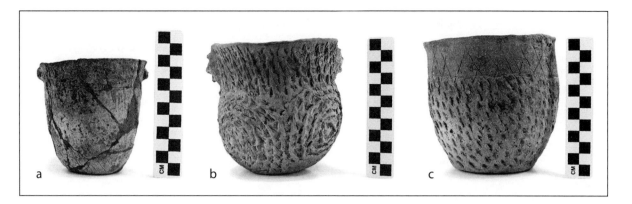

Figure 6.16. Frankston phase utility-ware vessels.

(Perttula 2011:table 6-35) are primarily fine wares (73 percent), followed by utility wares (14.9 percent), and plain wares (11.8 percent).

Among the utility wares in Frankston phase contexts, the major types include Bullard Brushed (fig. 6.16a), Killough Pinched (fig. 6.16b), Maydelle Incised (fig. 6.16c), punctated jars, and brushed-punctated jars of unidentified types. Most of the plain wares are simple bowls, carinated bowls, and several forms of bottles.

The distinctive Caddo ceramic vessels and sherds from the lower Sabine (i.e., Toledo Bend Reservoir, see McClurkan et al. 1966; Woodall 1969) and Neches-Angelina (i.e., Lake Sam Rayburn, see Jelks 1965) river basins remain poorly defined assemblages. Sites in these areas were included in the Angelina focus by Jelks (1965), which was a "broadly defined unit encompassing the entire Caddoan [sic] sequence in the Lake Sam Rayburn locality; needs reevaluation in light of larger sample of sites which are known in the area" (Story 1990a:table 43). Perttula (2017b) used the terms Angelina phase and Salt Lick phase to refer to sites in these two different localities that date after ca. AD 1400.

Sites at Toledo Bend Reservoir that have both ceramic vessels and decorated sherd assemblages include Salt Lick (16SA37a) and Bison, Area B (16SA30). On the basis of the whole vessels from these sites, affiliations may be said to exist with the Titus phase, given the popularity of Ripley Engraved, Taylor Engraved, Karnack Brushed-Incised, and Wilder Engraved vessels in the burials (table 6.2); Belcher Ridged vessels from Belcher phase sites are also included as funerary objects. However, it remains to be determined how many of these vessels were locally manufactured or were instead vessels traded or gifted to a local Caddo community that lived in this part of the Sabine River basin (see Kelley 2006; Kelley et al. 2010).

The sherds from domestic contexts at these sites, as well as at the nearby Burnitt site (16SA204; Kelley et al. 2010), are dominated by typologically unidentifiable fine ware and utility ware sherds as well as Belcher Ridged, incised, brushed, and Pineland Punctated-Incised sherds (see table 6.2); the proportion of ridged utility wares is suggestive of a cultural connection with Belcher phase Caddo groups on the Red River (cf. Webb 1959).

Table 6.2. Ceramic Vessels and Sherds from Selected Sites at Toledo Bend Reservoir

Ceramics	Salt Lick		Bison, Area B	
	vessels	sherds	vessels	sherds
Briarfield Plain olla	1	—	—	—
Unidentified Plain ware	2	—	6	—
Subtotal	3	—	6	—
Avery Engraved	—	—	1	—
Glassell Engraved	1	6	1	—
Keno Trailed	—	25	—	—
Natchitoches Engraved	—	4	—	—
cf. Patton Engraved	1	—	—	—
cf. Ripley Engraved	4	—	20	—
Taylor Engraved	6	5	12	—
Wilder Engraved	—	—	7	—
Unidentified Engraved	4	216	10	264
Subtotal	16	256	51	264
Belcher Ridged	—	48	7	194
Bullard Brushed	—	6	—	—
Cass Applique	—	—	1	—
Cowhide Stamped	—	1	—	—
Harleton Applique	3	4	1	—
Karnack Brushed-Incised	5	13	6	—
Kiam Incised	—	6	—	—
Pease Brushed-Incised	1	5	1	—
Pineland Punctated-Incised	—	39	2	—
Unidentified Applique	—	—	—	13
Unidentified Brushed	—	295	1	349
Unidentified Incised	—	462	4	393
Unidentified Incised-Punctuated	—	17	—	—
Unidentified Punctated	—	58	1	50
Subtotal	9	954	24	999
Totals	28	1210	81	1263

Few of the vessels recovered from burials at the Walter Bell and Wylie Price sites at Lake Sam Rayburn have been typologically identified (table 6.3). The decorated sherds are dominated by Broaddus Brushed and Pineland Punctated-Incised sherds (fig. 6.17), along with considerable numbers of unidentifiable brushed, incised, and punctated utility wares and unidentified engraved fine wares.

The rarity of ridged sherds in the Lake Sam Rayburn sites when compared with their frequency in Toledo Bend Reservoir sites appears to indicate that the ancestral Caddo groups that once occupied these two areas had distinctly different

Table 6.3. Ceramic Vessels and Sherds from Selected Sites at Lake Sam Rayburn

Ceramics	Walter bell		Wylie Price		Print Bell	
	vessels	sherds	vessels	sherds	vessels	sherds
Unidentified Plain ware	1	—	2	—	1	—
Belcher Ridged	—	8	—	—	—	—
Broaddus Brushed	1	2,112	—	570	—	53
Davis Incised	—	7	—	—	—	—
Dunkin Incised	—	45	—	—	—	—
Pineland Punctated-Incised	1	203	—	73	—	40
Unidentified Brushed	2	—	—	—	—	—
Unidentified Incised	—	1,740	2	119	—	337
Unidentified Incised-Punctated	—	—	1	—	—	—
Unidentified Punctated	1	166	—	87	—	46
Glassell Engraved	1	—	—	—	—	—
Unidentified Engraved	1	200	1	152	—	61
Totals	8	4,281	6	1,001	1	530

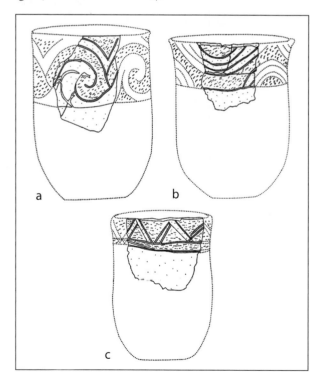

Figure 6.17. Pineland Punctated-Incised vessel decorative elements from sites at Lake Sam Rayburn.

utility-ware traditions. Furthermore, stylistically related Titus phase and Belcher phase engraved fine wares are absent in the Lake Sam Rayburn sites, much different from the Toledo Bend Reservoir ceramic assemblages (see tables 6.2 and 6.3), a trend which may be indicative of the existence of different populations of Caddo peoples.

In historic times, Caddo ceramic vessels held liquids and foods. They were used for cooking and serving foods, such as atole, a corn gruel pounded into a flour and mixed with water or milk (Chapa and Foster 1997:149, fn 6), and tamales (see Swanton 1942:157–58; Chapa and Foster 1997:149). In 1690, Alonso de Leon noted the use of "pots and casserole dishes," filled with beans, corn, and pinole, made of powdered corn and sugar (Chapa and Foster 1997:150, fn 1). Other vessels held incense, body paints/pigments, and corn-meal offerings.

After ca. AD 1680 to the early 1800s, the archaeology of the Hasinai Caddo groups is associated with the Allen phase (ca. AD 1680–early 1800s). The groups who occupied the Neches, Angelina, and parts of the Sabine River basins were direct ancestors of the Hasinai tribes who were already living in or near the Spanish missions periodically

established and maintained in the region between ca. AD 1690 and 1731, and they continued to live there until the 1830s (see Jackson 1999:plate 98).

The most distinctive of the fine-ware ceramics from Allen phase sites are Patton Engraved bowls and carinated bowls. The decorations consist primarily of a series of simple horizontal or curvilinear engraved lines with tick marks on the vessel rim and/or body (fig. 6.18a–c). Other fine wares include Hume Engraved, *var. Allen* vessels with rows of larger (i.e., larger than tick marks) engraved triangles that are pendant to a straight line (fig. 6.18d), Hood Engraved, *var. Allen* effigy bowls (fig. 6.18e), and Natchitoches Engraved bowls (fig. 6.18f).

The compilation of utility-ware metrics from East Texas Historic Caddo ceramic assemblages in the upper Neches, Nabedache, Neche, and Nadaco areas (fig. 6.19) has identified specific groups/communities of ceramic practice that can be linked confidently to specific Caddo groups known from ethnographic and historic records (Perttula 2017c). The differences in the proportions of brushed

Figure 6.18. Allen phase fine-ware and utility-ware vessels.

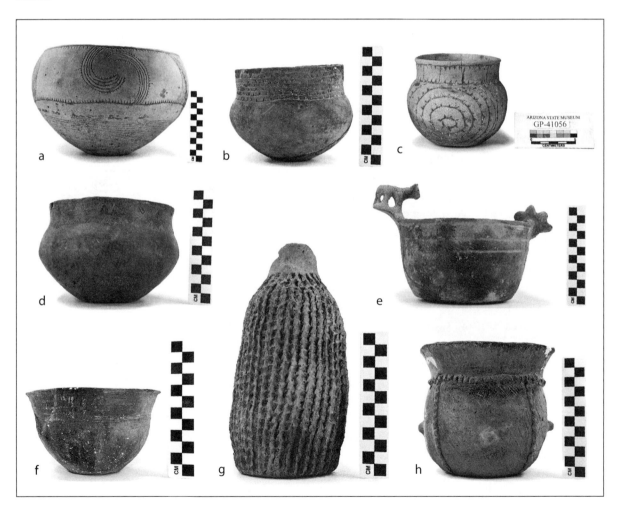

sherds among all decorated sherds in Historic Caddo assemblages in fifteen different parts of the Sabine, Neches, Angelina, and Attoyac stream basins; the ratio of brushed to other wet-paste utility-ware sherds; and the differential use of bone temper in vessel manufacture indicate that the character of utility ware vessel sherd assemblages among Hasinai Caddo groups was diverse in the post-AD 1680 era, such that assemblage-level distinctions can be associated, in some cases, with specific post-AD 1680 Caddo tribal groups. Examples of Allen phase utility-ware vessels with pinched (Killough Pinched, *var. Allen*) and brushed-appliqued decorative elements are shown in fig. 6.18*g–h*.

The most common vessel types on Historic Nadaco Caddo sites are a grog-tempered plain ware (Henderson Plain), Simms Engraved (fig. 6.20*a*), including Simms Engraved, *var. Darco* (fig. 6.20*b*), Natchitoches Engraved (fig. 6.20*c*), and a punctated-incised utility-ware jar that closely resembles Emory Punctated-Incised (Perttula 2007a:table 1). Bowls, jars, and bottles are the most common vessel forms,

Figure 6.19. Historic Hasinai Caddo ceramic clusters in East Texas.

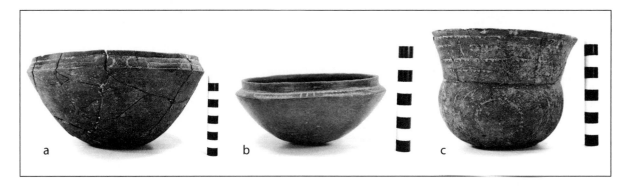

Figure 6.20. Simms Engraved and Natchitoches Engraved vessels from Nadaco Caddo sites.

with only a few carinated bowls. The utility wares are primarily jars, with a few bottles, bowls, and ollas. All of the carinated bowls, 70 percent of the bottles and 86 percent of the bowls have engraved or trailed decorations or are specialized forms such as effigies or rattle bowls. The presence of Patton Engraved vessels in Nadaco Caddo burials points to contacts between the Nadaco and Hasinai Caddo groups in the Neches-Angelina River basin, while Taylor Engraved and Hudson Engraved vessels suggest interaction between the Nadaco and Caddo groups living in the Big Cypress and Red River basins to the north. That Womack Engraved vessels are present in Kinsloe phase vessel assemblages suggests northern and western contact with Caddo groups living in the upper Sabine, Sulphur, and Red River basins, as this distinctive engraved type is found and likely made primarily in these areas.

The mid-eighteenth-century component at the Gilbert site (41RA13) in the upper Sabine River basin has Womack Engraved and Natchitoches Engraved fine wares, as well as Emory Punctated-Incised and brushed jars (see Story et al. 1967). The principal temper-paste groups include shell-tempered, bone-tempered, grog-tempered, and fine sandy paste. Instrumental neutron activation analysis of sherds from the Gilbert site indicate that they came from vessels made with local subregion 5 clays (see Essay 1) in the upper Sabine River basin.

Summary and Conclusions

The Caddo ceramics found in domestic and mortuary contexts at ancestral Caddo sites in East Texas include fine wares, utility wares, and plain wares of different forms. There are technological and stylistic differences between the wares at sites and between different Caddo groups living in East Texas, and the female Caddo potters that made these vessels had a considerable range in choices and practices in how they were made and decorated. The differences were not substantial in technological practices, but much more so in the case of decorative and stylistic elements, as there is a great diversity in East Texas Caddo decorated wares. This stylistic diversity has led to the recognition of stylistic motifs and types that have unique

spatial and temporal distributions, and these distributions have been linked with culturally specific Caddo groups, phases, and vessel assemblages in the East Texas archaeological record.

There is a consistent sequence to the production of handmade earthenware vessels by ancestral Caddo peoples living in East Texas, as is also discussed in Essay 1. These steps included, from first to last: procurement of materials such as the clay and temper, as well as fuel; preparation of materials, including the crushing, cleaning, size sorting, or mixing of clays and tempers to prepare the paste; construction of the vessel, beginning with the base, and then building the walls, along with finishing treatments; decoration of the vessel (at least wet-paste utility wares), including occasionally adding a hematite-rich slip; drying and firing; and post-firing treatments that included the engraving of certain fine-ware vessels, as well as surface burnishing. Clays used for vessel manufacture were likely gathered from nearby alluvial settings, particularly the more easily processed alluvial clays. Depending on the site and the type of ware, clay, temper, and paste, recipes were diverse, with Caddo potters using particular recipes to make particular kinds of fine-ware, utility-ware, and plain-ware vessels.

Stylistic expressions, and variations in that expression, in material culture, dress, body ornamentation, food practices, etc. are measures of social identity. Patterns of style in the archaeological record reflect variability in both individual choices as well as social group membership, and the existence and pervasiveness of styles in material culture reflect the strength of interaction between individuals (individual potters), the form of cultural transmission (i.e., from parent to child; from a teacher to a pupil; etc.), and the ability of styles to be inherited from one generation to the next.

Styles of decoration on Caddo pottery vessels seem to have changed rapidly after ca. AD 1200, more rapidly than functional forms of tools and pottery vessels. This interpretation follows from the idea that stylistic traits have a relatively rapid turnover because of their use in generating and reinforcing cultural identity, their selectively neutral character (i.e., stylistic elements have no differential effect on survival), and the potential high variation between individuals and groups in learning and replicating specific shared styles, particularly if Caddo potters were producing vessels largely in community settings as part of a ceramic tradition.

The decorative, technological, and formal attributes of ceramic vessels chosen by a potter or group of potters when they made them represent a ceramic practice within a distinctive social community or network of socially related individuals. The particular choices and tendencies exhibited in the manufacture and decoration of ceramics by East Texas Caddo potters between ca. AD 800/850 and the early nineteenth century indicate that temporally (and socially) related group of Caddo sites identified in the archaeological record are a means to recognize socially defined groups that closely interacted and transmitted knowledge between potters

as a means of social learning, and this knowledge of manufacture and decoration choices was inherited by other descendant potters in that group. In this context, then, ceramic practices shared by women potters reflect the learning of their craft from other women in a Caddo community, and that "patterns in local pottery styles, both technological and decorative, result from potters making different decisions throughout the production process but using a similar set of tools and techniques available to other potters within an area" (Eckert 2008:2).

7

Caddo Salt Making Ceramic Wares

Paul N. Eubanks

Introduction

The Caddo Homelands are well known for their numerous above-ground salt deposits. It is for this reason, in part, that the Caddo were famous for their role in the historic period salt trade (Brain 1977, 1979, 1988, 1990; Brown 2004; Eubanks 2016a; Gregory 1973; Hofman 1984; Kidder 1998; McWilliams 1981:146–49; Swanton 1911:78, 1928, 1929, 1942, 1946; Webb and Gregory 1986; Wentowski 1970). At salt working sites in East Texas and southwestern Arkansas, there is evidence that the Caddo were processing brine in ceramic containers as early as AD 1300 or 1400 and that this activity lasted until about 1700. Conversely, in places like northwestern Louisiana, the Caddo did not make salt on a large scale until after the initial arrival of Europeans in the Southern United States (Eubanks 2018). Like other salt makers from around the world, the Caddo probably first harvested salt without the aid of ceramic vessels and well before the first signs of large-scale processing. This could be accomplished by scooping up salt directly from a dry "lick" or by collecting small amounts of brine from natural springs and seeps and letting natural evaporation run its course. However, in order to make larger quantities of salt, especially for trade, it would have been necessary to heat and evaporate brine in ceramic containers. In this essay, these containers, which include pans, jars, and bowls, are discussed as they relate to the various regions of the Caddo Homelands in which they were utilized.

Making Salt

There are two techniques that the indigenous occupants of North America used to evaporate brine. The first of these involved concentrating the brine so that it could be heated using solar energy. Salt made using this technique is often difficult to detect archaeologically as it does not require hearths or kilns, and it does not produce large quantities of broken pottery vessels. The second method, which

is much more visible archaeologically, is sometimes referred to as "*sal cocida*," or "cooked salt" (Andrews 1983:108–13). *Sal cocida* can take place directly over a fire or indirectly through the use of heated stones. Although using solar energy requires no fuel (other than that used by the sun), it is usually only practiced in coastal regions where there is an abundant supply of seawater, warm temperatures, a steady breeze, and a predictable dry season. *Sal cocida* is not bound by such limitations and, thus, this method was often more heavily utilized in noncoastal or temperate areas. In addition, *sal cocida* can be made in a matter of minutes or hours whereas solar evaporation can take up to several weeks or months (Akridge 2008).

As the ceramic vessels for *sal cocida* would have been subjected to frequent and rapid heating, they were prone to breakage, and as a result, the salt workers often had to make large numbers of these containers (Eubanks and Brown 2015; Kenmotsu 2005:121–23; O'Brien 1990). Consequently, the vast majority of salt making pottery from around the world and from the Caddo Homelands was designed to be functional, serving its purpose until no longer usable. In many instances, care was taken to produce durable vessels that could withstand multiple, prolonged episodes of heating, whereas in other cases, "disposable" mass-produced vessels were preferred.

Figure 7.1. Salt-working sites discussed in the chapter.

Caddo Salt Making Sites and Localities

The information presented in this essay is derived largely from three major studies of Caddo salt production (fig. 7.1). The first of these was conducted at the Hardman site (3CL418) in the Ouachita River valley of southwestern Arkansas. This site was excavated extensively in 1987 by the Arkansas Archeological Survey as part of a road construction project. The results of this work were assembled in a report edited by Ann M. Early (ed. 1993). The Salt Well Slough site (41RR204), located along the middle Red River valley of East Texas, was investigated by the Texas Archeological Society Field School a few years after the Hardman excavation. Nancy Kenmotsu (2005) summarized the findings from this field school in a report published by the Texas Historical Commission. The final salt making locality to be discussed in this essay is the Red River valley of northwestern Louisiana where I worked while conducting my doctoral dissertation research (Eubanks 2016a).

Southwestern Arkansas

Southwestern Arkansas is home to an unknown number of Caddo salt production sites. During the Arkansas Archeological Survey's work at Hardman, twelve 2 × 2 m units were excavated and a large portion of the site was exposed using a mechanical excavator (Williams 1993). Nearly 1,000 features were identified, and of these, 900 were postholes, with the remaining features being pits (n = 40), hearths (n = 11), and burials (n = 17). A handful of radiocarbon and archaeomagnetic samples were analyzed to assess the site's chronology, but most of the results were unreliable (Williams 1993:47–48). However, the majority of the site's chronologically diagnostic pottery indicated that it was occupied from ca. AD 1300/1400 until 1700 (Early ed. 1993). The Caddo who lived at Hardman appear to have done so on a permanent or semipermanent basis, as is evidenced by several residential structures and a large, partially encircling, compound fence (Early ed. 1993:233–34; Williams 1993:42–46). Unlike many other salines in eastern North America, this site yielded numerous artifacts and features unrelated to the salt making process, suggesting that the occupants of Hardman engaged in a range of domestic and agricultural activities. This may have been necessary given that the salt makers do not appear to have been able to make a living by producing salt and trading it on a regional scale (Early ed. 1993:233–34).

A short distance from Hardman is the Bayou Sel site (3CL27). This site was visited in the first decade of the 1800s by George Hunter and William Dunbar and, later, in the 1880s by Edward Palmer and the Smithsonian Institution's Mound Exploration Division (Early 1983:1–2; Jeter 1990:291–312; McDermott 1963; Palmer 1917:393, 416). In addition, Philip Phillips of Harvard University's Peabody Museum and Frank Schambach of the Arkansas Archeological Survey excavated here in the 1930s and 1960s, respectively. Although their excavations were limited in scope, they produced numerous archaeological materials, especially plain saltpan sherds, but, unfortunately, these materials have yet to be analyzed.

In 1985 and 1986, the Arkansas Archeological Society conducted test excavations as part of a training program at the Holman Springs site (3SV29) (Davis 1986). The 1985 portion of this project produced a massive amount of ceramic debris and, as a result, the motto for the 1986 training program was "more sherds than dirt." Similar to Bayou Sel, the materials from these excavations remained largely untouched for decades, but recently there has been an effort to catalog and analyze at least some of the artifacts and features from this site (Drexler 2018; Drexler and Taylor 2017).

East Texas

Along with the Hardman site, the Salt Well Slough site in East Texas is one of the best documented salines in the Caddo Homelands. The site was used from ca. AD

1300 until 1700, and, although it was not home to a permanent settlement, it is located just to the south of the contemporaneous Sam Kaufman mound and village site (41RR16). As a result, the salt workers who practiced their craft at Salt Well Slough most likely lived at Sam Kaufman or perhaps at one of several other nearby villages in the middle Red River valley (Kenmotsu 2005, 2017).

During their excavations at this site, the Texas Archeological Society's field school excavated twenty 1 × 1 m test units and three 50 × 50 cm units. These units yielded eleven features, most of which were isolated clusters of sherds and patches of burned soil. As is often the case at salt making sites, the most abundant artifact classes were burned earth and pottery sherds from evaporation vessels. There is little that distinguishes Salt Well Slough's ceramic assemblage from the utilitarian assemblage at Sam Kaufman. This suggests that the same vessel forms (if not the same vessels) used for cooking or storage were also deemed suitable for making salt. The lack of semispecialized vessels may be expected given that the salt production operation was not a full-time or intensive activity. Furthermore, as the site is located in a prairie where fuel is scarce, the producers may have considered it impractical to evaporate brine on a large scale. Thus, it is likely that the salt produced at Salt Well Slough was intended primarily for local consumption; it is possible, however, that a few producers traded some of their salt to people living in nearby villages (Kenmotsu 2005:119 and 2017).

Northwestern Louisiana

There are at least three major salt licks in northwestern Louisiana that were used around the time of initial European contact. One of these is Potter's Pond (16WE76) in Webster Parish. In the 1980s, the site was recorded by members of the Louisiana Archaeological Society, and more recently in 2005–2006, it was revisited and mapped by Jeffrey S. Girard (2006) of Northwestern State University. The other two salines are the Upper Lick (16WN30) and the Little Lick (16NA11) in Winn and Natchitoches Parishes. These two licks, separated by Saline Creek, are located less than a kilometer from each other, and they are part of the Drake's Salt Works Site Complex. Both licks, along with four others at the site complex, were investigated by the Alabama Museum of Natural History's Gulf Coast Survey and the U.S. Forest Service between 2011 and 2014 (Eubanks 2016a).

Although the salt making operations at Potter's Pond and the Upper and Little Licks generated large quantities of debris, mostly in the form of pottery sherds, burned earth, and charcoal, there is little evidence to suggest that the producers were living or working at the salt licks on a full-time basis (Eubanks 2016b). Most of the chronologically diagnostic pottery from these sites supports a post-AD 1600 usage, and a handful of AMS radiocarbon samples taken from the base of salt making middens at the Upper and Little Licks support this estimate (Eubanks 2018:table 1). The possible ca. AD 1600 beginning date for salt making in this region

falls just after initial European contact but prior to sustained settlement. Despite the absence of European settlements in northwestern Louisiana before the early eighteenth century, the influx of salt-hungry horses and livestock into the southern plains and East Texas in the late seventeenth century could have created a regional demand for salt that was met, in part, by producers in northwestern Louisiana (Burton and Smith 2014:148–49 and table 7.1; Eubanks 2018). After the establishment of Natchitoches in 1714, much of the salt made in northwestern Louisiana was likely used to preserve meat and animal hides (Eubanks 2014, 2016a). At Drake's Salt Works, indigenous salt making continued until sometime during or shortly before the first decade of the nineteenth century, when the saline was taken over by American settlers (Eubanks 2016a:75; Sibley 1805:49–65; Veatch 1902:55–56).

Salt Making Vessels

Throughout much of eastern North America, large, basin-shaped pans are typically associated with salt production (Brown 1980, 2004; Bushnell 1907, 1908, 1914; Dumas 2007; Early ed. 1993; Eubanks 2013; Eubanks and Smith 2018; Guidry and McKee 2014; Keslin 1964; Muller 1984, 1986, 1997; Muller and Renken 1989). These vessel forms are often referred to as "saltpans." This term, at least in some cases, may be misleading given that saltpans likely served a variety of functions unrelated to making salt, including but not limited to the serving and preparation of food and the processing of minerals (Eubanks and Smith 2018). In addition, these vessel forms are sometimes present at sites without a nearby salt source, but they tend to occur in much lower frequencies relative to salt making sites (Brown 2004). Given that pans were occasionally used in activities unrelated to salt production, they may be considered "semispecialized" vessel forms.

Although pans were commonly used to evaporate brine, in certain parts of the southeastern United States, smaller, more portable, vessels were also used (Eubanks and Brown 2015). For instance, between AD 1550 and 1650 in southern Louisiana, groups of migrating salt producers working at Salt Mine Valley (16IB23) made thin-walled bowls and jars to process brine obtained from a salt spring (Brown 1999, 2015). Similarly, small or medium-sized non-pan vessels were employed during the Late Prehistoric period at the Stimpson site (1CK29) in southern Alabama (Dumas 2007; Eubanks 2013) and at several salines in northwest Louisiana (Eubanks 2014; Girard 2006:58–60; McCrocklin 1985).

Caddo salt makers employed a variety of vessel forms, including pans, jars, and bowls to make salt. Despite this range of vessel forms, almost all of their salt-making wares were tempered predominantly with mussel shell. This temper is usually coarsely ground, and on occasion, inclusions such as sand, gravel, and plant materials are present in the paste. Compared with other tempering agents such as

sand and grog, shell has a greater resistance to thermal shock, thus making it ideal for *sal cocida* (Feathers 1989; Steponaitis 2009:37–45). It is for this reason that some have argued that salt workers who relied primarily on artificial heating to make salt were often the first to introduce shell-tempered pottery into a particular region (Perttula et al. 2011; Weinstein and Dumas 2008).

What follows below is a discussion of the various salt-making wares used by the Caddo in southwestern Arkansas, East Texas, and northwestern Louisiana. This discussion includes descriptions of vessel form, surface treatment (or lack thereof), size, temper, and any associated decorated wares. In addition, the seasonality and the scale of the salt-making operations in these locales are considered, as these variables appear to have had an effect on the kind of vessel(s) the salt producers preferred.

SOUTHWESTERN ARKANSAS

The majority of the ceramic artifacts from Hardman and the nearby Bayou Sel site are sherds from plain pans with wall thicknesses often in excess of one centimeter (fig. 7.2) (Early ed. 1993:table 9). These pans tend to have widely flaring rims, but platters with short incurving rims are also present (Early ed. 1993:fig. 57). Many of the pan sherds display evidence of spalling and erosion resulting from repeated use. At Hardman, most of the recovered sherds are fairly small, but at Holman Springs, the average sherd size is noticeably larger. While there are several possible explanations, this difference could be a product of how the sites were used. At residential occupations like Hardman, there would have been more opportunities for people to step on and break sherds as compared with sites like Holman Springs that were used only seasonally or occasionally for the primary purpose of making salt (Early ed. 1993).

The pans from Hardman are tempered with a mix of coarse and finely ground shell. Although this tempering material was used in the Ozark Highlands of northern Arkansas as early as the seventh century, there is little evidence that it was used prior to AD 1300 or 1400 in the southwestern part of the state (Pert-

Figure 7.2. Saltpan from Southwest Arkansas, provenience unknown. Photograph courtesy of the Joint Educational Consortium's Hodges Collection; used with permission of the Arkansas Archeological Survey.

tula et al. 2011:246). Perhaps not coincidentally, some of the first occurrences of shell-tempered pottery in this region are at salt making sites like Bayou Sel and Hardman.

No complete pans were recovered from Hardman, but a mostly intact pan from Barkman (3CL7), a nearby Caddo salt working site located just upstream, had a rim diameter of forty-eight centimeters. Pans found elsewhere in eastern North America can be larger, sometimes with diameters in excess of one meter, but this measurement is still well within the range for a "typical" saltpan. Along with pans, it is also possible that thin-walled jars were used in the salt production process as sherds from small globular jars and tall jars were both common at Hardman (Early ed. 1993:101–5; Early 2017). If this idea is correct, then perhaps once the brine had been partially or mostly evaporated in a saltpan using solar energy or direct heat it could have been transferred to a jar to finish drying (Early 2017). Alternatively, if there was a wood fuel shortage at Hardman (Fritz 1993:162), then a more fuel-efficient production technology could have been developed, as heating the contents of a thin jar requires less fuel as compared to that required for a large, thick-walled pan (Akridge 2008).

Unlike the other salt making sites discussed later in this essay, Hardman and Bayou Sel produced a considerable range of decorated wares owing to the fact that these two sites are associated with a semipermanent occupation. Although the decorated materials from Bayou Sel have not yet been formally quantified, many of the pottery types from Hardman are also present in the Bayou Sel ceramic assemblage. Approximately 85 percent of the total sherd assemblage from Hardman was pan fragments; however, among the remaining sherds, the following types were represented: Belcher Engraved, Blakely Engraved, Caney Punctated, Cook Engraved, De Roche Incised, East Incised, Foster Trailed-Incised, Friendship Engraved, Hodges Engraved, Garland Engraved, Glassell Engraved, Hardman Engraved, Hudson Engraved, Karnack Brushed-Incised, Keno Trailed, Old Town Red, Simms Engraved, and Wallace Incised (Early ed. 1993). Shell was the preferred tempering agent for the decorated sherds, but 19 percent of the decorated assemblage was tempered with grog, bone, or grit (Early ed. 1993:97).

East Texas

Based on the recovered materials from Salt Well Slough and from initial observations at other potential salines nearby (e.g., 41RR248, 41RR256, and 41RR257), it seems that the thin-walled utilitarian jar is the most common salt-making vessel form in East Texas (Kenmotsu 2005:83–85; Perttula 2008a:240–45). No complete or nearly complete vessels were recovered during Kenmotsu's work at Salt Well Slough, but several large sherds could be pieced together (Kenmotsu 2005:fig. 27). In addition, a handful of in situ clusters of stacked sherds from separate vessels

were found, possibly indicating that sherds from broken jars were placed on top of each other in order to elevate brine-filled salt jars above a fire.

The lack of classic pan sherds at Salt Well Slough and in East Texas is curious given that this vessel form was used in the Ouachita River valley of southwestern Arkansas. In southern Louisiana and Alabama, smaller, more portable vessels that would not be out of place in a typical domestic assemblage were used to evaporate brine (Brown 1999; Dumas 2007:297–302; Eubanks 2013). In these latter instances, however, the producers did not live within walking distance of the saline like those at Salt Well Slough and Sam Kaufman. Assuming that the producers at Salt Well Slough knew about saltpan technology, they may have reasoned that the relatively small scale of their salt making operation did not warrant the use of a semispecialized salt-producing vessel.

No complete vessels were recovered from Salt Well Slough, but the salt-making vessels from this site would have looked similar to the flaring rim jar from the nearby Sam Kaufman site pictured in fig. 7.3. This jar has an approximate height of 21 centimeters, a maximum rim diameter of 15 centimeters, and a shoulder diameter of just under 13 centimeters. These vessels are made by coiling and are not as thick as the saltpans from southwestern Arkansas. Aside from perhaps an increased rate of deterioration resulting from the salt production process, there is very little that distinguishes the jars at Salt Well Slough from other utilitarian jars found at nearby habitation sites.

Almost all of the jars from Salt Well Slough are tempered with coarsely ground shell. Less than 1 percent of the sherds from this site are tempered with grog, and even in these cases, shell was used as a secondary tempering agent (Kenmotsu 2005:83). Although shell temper was used in the Red River valley of East Texas prior to Salt Well Slough (ca. AD 1300) and at the Sam Kaufman site, shell was not a dominant tempering material in this region until after AD 1300 (Perttula et al. 2011:251–52).

Most of the salt jars from East Texas are undecorated, but it is not uncommon for some to have neck-banded rims (see fig. 7.3). These vessels tend to have smoothed interiors and exteriors, but beyond this, they display little evidence of surface treatment or decoration. Aside from the Nash Neck Banded sherds, less than 5 percent of Salt Well Slough's pottery is decorated. Among these sherds, the most commonly represented types are Avery Engraved and Emory Punctated-Incised (Kenmotsu 2005:88–89, 127–29).

Figure 7.3. Flaring rim Nash Neck Banded jar from Arnold Roitsch/Sam Kaufman. Photograph courtesy of Timothy K. Perttula.

Northwestern Louisiana

The hemispherical bowl, by far, is the most abundant vessel form found at Potter's Pond and the Upper and Little Licks at Drake's Salt Works (fig. 7.4). The majority of these bowls are about 10 to 15 centimeters high with rim diameters ranging between 20 and 25 centimeters. On occasion, their exteriors have shallow, haphazard impressions from brushing or scraping, but aside from this, these bowls have no visible surface treatment. It is apparent from breakage patterns that the bowls were made by coiling. Usually, coil-made vessels, even those intended to be of a similar size, exhibit at least a minimal range of variation, but this is not the case for the salt bowls from northwestern Louisiana. This lack of variation is particularly noticeable at the Little Lick and at Potter's Pond where almost all of the salt bowls are nearly identical to those in fig. 7.4 (Eubanks 2016b). Given the high degree of standardization, it would not be surprising if some sort of mold (e.g., an upside-down salt bowl, a small clay-lined pit, or wooden bowl) was used to aid in the coiling process.

The vast majority, if not all, of the salt bowls in northwestern Louisiana are tempered with coarsely ground shell. The use of shell as a tempering agent first appears in this region around AD 1600 (Perttula et al. 2011:249–51). Perhaps not coincidentally, this is also when large-scale salt production first started to occur. Despite a preference for using shell temper, the salt bowl potters do not appear to have been overly concerned about inclusions as sand and plant matter are often found in the pastes of these vessels. As most of the salt bowls range in thickness between five and six millimeters and since the vessel walls were prone to spalling, they could likely only be used once or a few times before breaking apart anyway; thus, it may not have mattered if various types of debris found their way into the potting clay.

Although these smaller and thinner vessels are prone to breakage, they would have provided the salt producers several advantages. First, standardized bowls are stackable, meaning that it would have been relatively easy to transport them to the

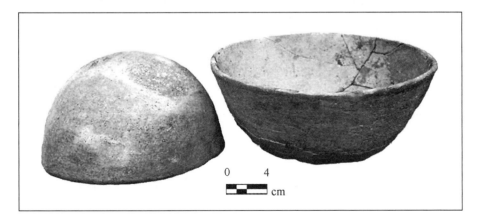

Figure 7.4. Nested salt bowls from Potter's Pond. Photograph by Claude McCrocklin, Williamson Museum, Northwestern State University.

salines. Second, they are lightweight, which would again aid in transportation, as there is currently no evidence of a long-term occupation at any of northwestern Louisiana's salines. Finally, using standardized salt bowls would have produced standardized salt cakes, which could then be traded for known or standard quantities of other commodities.

As the salt producers of northwestern Louisiana tended to favor less durable vessels that could be mass produced, the salines in this region are littered with fragments of these "disposable" salt bowls. For a salt producer (or archaeologist), attempting to walk at these salines without stepping on broken pottery sherds would have been nearly impossible. At the Little Lick, this problem was mitigated to some extent by consolidating most of the salt production debris along the edge of the salt flat. Eventually, this activity produced a low mound composed almost exclusively of pottery sherds, charcoal, burned earth, and filtered soil. Similar mounds have been documented at some Mesoamerican salines and at other salt production sites around the world (e.g., Watson 2015). Today, the mound at the Little Lick stands just under one meter in height and is about twenty-five meters in diameter. At the Upper Lick, salt making was concentrated on a natural landform on the salt flat known as "Widdish" Island after the Caddo word for salt. It appears that parts of Widdish Island were also swept clean of debris from time to time, as the primary salt working portion of the island is surrounded by a dense ring of salt making debris.

Decorated pottery at salines in northwestern Louisiana is rare, constituting 0.4 percent and 1 percent at the Little and Upper Licks, respectively (Eubanks 2016a:table 7.2). Decorated wares also make up only a small percentage of the Potter's Pond ceramic assemblage, but sizeable fragments of Foster Trailed-Incised or Keno Trailed and Fatherland Incised vessels were recovered from a pit feature in the 1980s (Girard 2006:58–60; McCrocklin 1985). Sherds from Foster Trailed-Incised or Keno Trailed vessels have also been found at the Upper Lick along with examples of Natchitoches Engraved, Karnack Brushed-Incised, Barton Incised, and Belcher Ridged (Eubanks 2016a:fig. 4.1). Although located less than a kilometer from the Upper Lick, the decorated sherds from the Little Lick appear to be more at home in the Lower Mississippi Valley some 100 kilometers to the east. Included among these sherds are unspecified varieties of Cracker Road Incised, Maddox Engraved, Natchitoches Engraved, Barton Incised, Owens Punctated, Grace Brushed, and Winterville Incised (Eubanks 2016a:fig. 4.2).

The presence of these apparent nonlocal types has led to the argument that the Little Lick, located on the southeastern fringe of the Caddo Homelands, was used by a group of traveling producers from the lower Mississippi valley (Eubanks and Brown 2015:237). The Taensa, for instance, seem to have known of the location of some salines in northwestern Louisiana, and it could be the case that the use of this or another nearby salt site was mentioned in the 1690 treaty between the Taensa

and the local Natchitoches Indians (Eubanks 2018; John 1975:186). At one East Texas saline, and perhaps more, raiding and territorial encroachment from hostile groups seems to have been a concern for the local producers (Sibley 1922:22–23; Swanton 1942:82). It is not unreasonable to think that these threats would have also been on the minds of the Louisiana salt makers. In view of this, it could be that the Caddo at the Upper Lick and their lower Mississippi valley counterparts chose to work close to each other in an effort to discourage raiding (Eubanks 2018). Lending some support to this notion is the fact that there would have been many other salt licks in northwestern Louisiana aside from those at Drake's Salt Works with stronger or purer brine that the nonlocal producers could have utilized but did not (Eubanks 2014; Veatch 1902:tables 1 and 2).

Conclusions

Large basin-shaped pans are most often associated with salt production in eastern North America, but bowls and jars were sometimes used either by themselves or in tandem with pans (Brown 2015; Dumas 2007; Eubanks 2013). The Caddo Homelands, in some ways, are a microcosm of eastern North American salt making vessel technology as pans, jars, and bowls were all used in the salt making process. Curiously, fabric impressed pans, which are common elsewhere, are absent from the Caddo repertoire of salt making ceramic technologies. It is generally thought that large pans were molded in pits lined with fabric and that potters used the fabric to help lift the vessel out of the pit once it was ready to be fired (Brown 1980:31–32), but, for smaller saltpans, this step may not have been necessary (Muller and Renken 1989). The Caddo of the Ouachita River valley of southwestern Arkansas either did not find it necessary to rely on fabric-lined pits, or they systematically smoothed over every pan's exterior to remove the fabric impressions. Given that this process would be time-consuming with no apparent benefit, the former scenario seems much more likely.

The plain saltpans found in the Ouachita River valley, while smaller than some of their fabric-impressed counterparts, would have been relatively durable. However, given that these vessels are bulkier than jars and bowls, it would have been difficult to transport them over long distances. This does not seem to have concerned the producers who used these vessels as they lived adjacent to the place or places where they were making salt. At Salt Well Slough in East Texas, the producers lived near, but not at, the saline, and thus, transportation would have been more of an issue. In addition, it may not have been worth the effort for them to make larger, semispecialized vessels, since it is doubtful that there would have been enough fuel for a large-scale salt making operation (Kenmotsu 2005, 2017).

In northwestern Louisiana, there is no evidence of a permanent occupation near Potter's Pond or at the Upper and Little Licks. This means that the producers

would have needed to bring their salt-making vessels with them or make them at the site. If they elected to do the former in order to conserve time and fuel at the saline, then it would make sense to use disposable, lightweight bowls. This would have been especially applicable at the Little Lick, where the producers likely had to travel in excess of 100 kilometers up the Red River from the Lower Mississippi Valley. This could also be part of the reason why these vessels exhibit such a high degree of standardization: if they were all made to be of the same size, they could be stacked not unlike the nested bowls found at Potter's Pond (see fig. 7.4). Furthermore, making salt in standardized bowls would have also made it easier to create standardized salt cakes, which could then be traded for known quantities of other goods. This would have been particularly advantageous after the French established a trading post at Natchitoches in 1714, and it is likely no coincidence that this settlement was within a day's walk or canoe ride from the Upper and Little Licks.

There is some historical evidence to suggest that the Caddo were making salt in East Texas in the 1810s (Sibley 1922:22–23; Swanton 1942:82), but by 1700, salt production had more or less ceased at Salt Well Slough, Hardman, and Bayou Sel. Despite a lack of salt making throughout most of the Caddo Homelands, it was during the early eighteenth century that the salt trade flourished in northwestern Louisiana. This was largely due to the presence of European traders and settlers and their demand for salt and salt-treated commodities. The salt producers who profited from this demand were a mix of Caddo and Caddo-allied people from the east. However, by the first decade of the nineteenth century, the Caddo were no longer making salt in Louisiana, and not long thereafter, indigenous salt production in the Caddo Homelands ceased altogether, ending a tradition that dated back at least half a millennium. Nevertheless, the importance of salt making to Caddo history and culture is not lost thanks in large part to the oral traditions of the Caddo and to the efforts of the archaeologists who have worked at, or with materials from, Caddo salt making sites.

II

Ceramic Variation and Social Interaction

8

A Provenance and Stylistic Study of Early Caddo Vessels

Implications for Specialized Craft Production and Long-Distance Exchange

Shawn P. Lambert

Introduction

Archaeologists are increasingly recognizing the important role of long-distance interactions and exchange relationships that stimulated and directed cultural change in small-scale communities (Alt 2006; Gilmore 2015; Sassaman 2010; Spielmann 2002, 2004; Wallis et al. 2010). At multiple times and locations, pre-Columbian groups with an increased organizational complexity developed ritually charged places that continually promoted social and material interaction that brought together diverse people, things, and ideas into spaces of mutual engagement (Gilmore 2015; Randall 2011). The objects made, used, exchanged, and deposited within a myriad of contexts produced new types of social formations and affected the historical trajectories of entire regions (Wright 2014). In fact, the emergence of fine-ware pottery used as a primary medium of symbolic expression appears to coincide with increased variation in ritual practices on a regional scale (Gadus 2013a; Muller 1989).

In this essay, I present the results of a stylistic investigation and instrumental neutron activation analysis (INAA) of Formative to Early Caddo (ca. AD 850–1200) fine-ware pottery from nine ceremonial mound centers in two diverse parts of the Caddo Area (fig. 8.1). Recent research into the emergence and widespread distribution of early Caddo fine wares have led some to hypothesize a more homogenous cultural and ritual landscape, or at least similar types of human practice through time and space (e.g., Girard et al. 2014; Perttula and Walker 2012). However, numerous factors—including significant variations in early Caddo use and deposition, more nuanced understanding of stylistic variation, and locating production locales—have yet to be used to question their significance beyond matters of cultural homogeneity and unilineal evolutionary processes.

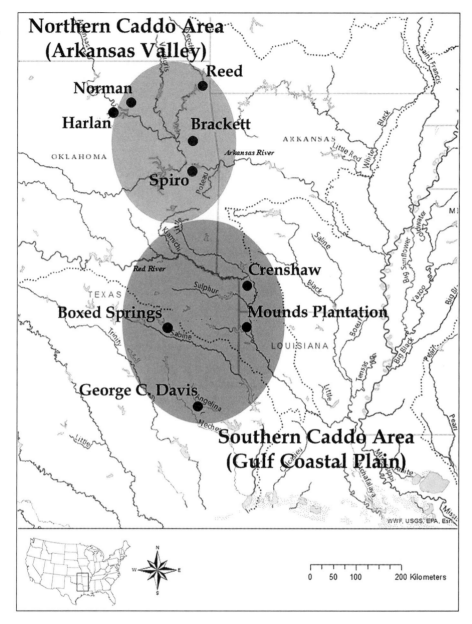

Figure 8.1. Caddo sites selected for INAA and stylistic research in eastern Oklahoma with locations of other ceremonial centers in the southern Caddo Area.

I consider how early Caddo communities transformed their historical trajectories and ritual practices through the construction, distribution, and use of four fine-ware types: Spiro Engraved, Holly Fine Engraved, Hickory Engraved, and Crockett Curvilinear Incised (fig. 8.2). I examine early Caddo interactions and variations in ritual practices using a fundamentally different conception of history and practice than those typically applied to early Caddo contexts, one that imagines the emergence and widespread use of fine wares as products of localized histories punctuated by innumerable long-distance exchange events.

While the widespread use of early Caddo fine wares shows significant social connectivity, the different ways in which northern and southern Caddo communities utilized the wares demonstrate they transformed their worlds in distinct historically constituted acts through which the pottery was made meaningful. Such acts no doubt shaped early Caddo histories and variations in ritual practices. Therefore, I first focus on the organization of depositional practices of these fine wares throughout the Caddo Area, showing they were used for different practices between the northern and southern Caddo areas (fig. 8.3). Then, I discuss the results of the stylistic variation analysis, which demonstrates very little variation existed among the fine wares recovered from the nine ceremonial mound centers. Last, I detail the INNA sampling methods and results, challenging previous assumptions that potters throughout the Caddo Area locally produced these fine wares.

General Observations of Early Caddo Pottery

This essay focuses on the Formative to Early Caddo period (ca. AD 850–1200) of eastern Oklahoma. This period was marked by dramatic material and ritual changes, culminating in the construction of aggregated villages and ceremonial centers within the Arkansas valley (northern Caddo Area) and the West Gulf coastal plain region (southern Caddo Area) (see fig. 8.3). The most noticeable object of Early Caddo ceremonialism is pottery. The widespread distribution of fine wares is the result of a more formalized regional interaction and exchange of objects between separate groups of the Caddo that lasted for almost three centuries (Perttula 2002, 2017b). Early fine wares can be broken down into two basic design categories: (1) vessels with evenly spaced engraved horizontal lines finely executed on bowls, jars, and bottles; and (2) vessels with a more highly embellished mixture of curvilinear and rectilinear motifs, many of which have excised, feathered, and punctated elements. The vessels primarily contain a fine grog-tempered paste with thin walls and highly burnished exteriors.

Girard (2009:57) suggested early fine-ware vessels were important display items and "were limited to specific groups within communities . . . probably involving feasts or ritual consumption of food." Perttula and Ferguson (2010) have shown

Figure 8.2. Early Caddo ceramic types selected for study: *a*, Spiro Engraved vessel from the Spiro site; *b*, Holly Fine Engraved from George C. Davis; *c*, Hickory Engraved from Harlan; *d*, Crockett Curvilinear Incised from the Spiro site.

Figure 8.3. Point density map showing the widespread distribution of all four Early Caddo fineware types in this study. The points that are unlabeled are domestic sites in the Southern Caddo region.

that early fine wares were important items of exchange among distant Caddo communities and other groups in the eastern woodlands and plains. Girard et al. (2014:54–55) proposed that early fine wares served as accoutrements of wealth, power, and status and became important exchange items among emerging elites who not only resided within the Caddo Area, but also at Cahokia in the American Bottom during the eleventh and twelfth centuries. They further assumed that the localization of ceramic production and large-scale distribution did not develop in the Caddo world until after AD 1200.

I, and others, have argued that based on their frequency distribution, highly formalized workmanship, degree of technical difficulty, and limited design choices, early fine wares were produced by a few ceramic specialists at centralized southern Caddo locations, such as the George C. Davis mound site in the Neches River drainage and the Crenshaw site along the Great Bend of the Red River (Girard 2009:57–58; Lambert 2018). For instance, compositional and petrographic analyses have been completed on several early fine-ware specimens from George C. Davis. The results have shown that most, if not all, were locally produced (Selden 2013; Perttula and Ferguson 2010; Perttula, Robinson, and MURR 2017; Selden, Perttula, and Carlson 2014).

Ritual Mode of Production and Distribution

It is my argument that the production, use, and deposition of these fine wares were fundamental to the ongoing creation of Caddo social histories. As Randall (2011:122–23) points out, "this view requires shifting our analytical lens away from presuming that spatial patterning of past practices reflect inevitable outcomes." When pre-Columbian people interact with the same object through time and space it becomes contingent and relational to specific experiences and places. As a result, the meaning of the same object can be transformed when used in different historical circumstances.

Rather than reify becoming "Caddo" by attempting to reconcile its definition, it is more fruitful to consider this period of history as constantly changing and becoming (Ingold 1993, 2006). Transformations in traditional practices, like the emergence of Early Caddo fine wares, resulted in the continuous reworking of relationships between people and places. Following Spielmann's (2002, 2008) use of ritual mode of production and distribution in small-scale societies, it seems more useful to understand *how* people invested considerable labor to produce objects and spaces for communal rituals.

Previous research indicates there was not a significant degree of ritual craft specialization during the Early Caddo period (Girard et al. 2014). Traditionally, the idea of specialization for ritual use and distribution was thought to be present only in more developed or ranked societies (Van Keuren 2006). In fact, any degree of craft specialization in societies with an emerging organizational complexity have been primarily attributed to economic or political factors, such as risk avoidance, population increase, or aspiring charismatic leaders (Bell 1984; Blitz 1999; Wilson 1999). An alternative to a prestige goods model is that of the ritual mode of production in small-scale societies (Spielmann 2002, 2008). This approach argues that intensified craft production and distribution in small-scale groups is a social response to an amplified demand by individuals and communal ceremonial obligations (Spielmann 2002:195). Intensified craft specialization in small-scale groups is

not so much about meeting the demands of subsistence but is instead about meeting the demand for "socially valued goods" used for ritual purposes. Central to this premise is an emphasis on the community in which these socially valued goods were produced and then used and distributed "as they fulfill ritual obligations and create and sustain social relations" (Spielmann 2002:196–67).

When examining the origins and spread of pottery in Native North America, Sassaman (2004:39) reasoned that the ritual demand for pottery for ceremonial and mortuary purposes led potters to produce many more vessels. Saunders and Wrenn (2014) studied the ritual modes of production and distribution of a Late Archaic Orange pottery in northeast Florida. Their findings suggested potters may have produced this early pottery strictly for ritual use and distribution across different drainages. Moreover, Miller (2014) investigated the ritual economy of bladelet production from Hopewell earthworks. Miller's findings suggested only a few craft specialists may have been responsible for the moderate production and distribution of the stone blades.

Motivated by this research, I use multiple lines of evidence to investigate our current understandings of emerging social networks in the Caddo world as a means to show that a mode of ritual production and distribution was an integral way in which Early Caddo groups created ceremonial obligations and maintained long-distance relationships with one another. To understand relationships between different Early Caddo communities in time and space, one must first have a clear understanding of the social and ritual contexts of ceramic production and distribution (Fenn et al. 2006). At the moment, archaeologists have a clearer understanding of the organization of pottery production and distribution in the southern Caddo Area (Selden 2013) but still lack the ceramic data necessary to understand pottery production and distribution in the northern Caddo Area.

Before more fine-grained scales of pottery production and distribution can be recognized in the Caddo Area, such as household and community scales of production (Abbott 2009; Costin 2007), it is necessary to untangle the roles of ritual production and distribution by considering the northern and southern cultural areas as a whole (Renfrew 2001). Southeastern archaeologists have not only shown the major implications of such a perspective by highlighting contextual differences in ceramic use and the ritual motivations for production and exchange in a region with small-scale societies (Pluckhahn 2007; Wallis 2007; Wilson 1999), but they have also shown the power of using style and INAA as a way in which to understand the organization of production and distribution that emphasized unique perspectives of social interaction and ritual practices (Lynott et al. 2000; Pevarnik 2007; Wallis et al. 2010). Thus, this contribution seeks to understand the ritual mode of early Caddo fine-ware production through a detailed INAA and stylistic study that will distinguish which communities of potters produced these fine wares across this region.

Establishing Early Fine Ware Contexts

Here, I address the complex history of Early Caddo pottery and show how its emergence constructed multiple histories of the people who participated in their production, distribution, and use. While it has been shown that Early Caddo fine wares were locally produced in the Red River valley and surrounding coastal plain drainages (Girard et al. 2014:27–28), many archaeologists have assumed Caddo people living in the Arkansas valley and Ozark plateau also produced them locally (Bell 1984:236). However, there is reason to question this assumption, and this starts with the observation that fine wares are not recovered from the same contexts across both Caddo areas. Early Caddo pottery is commonly found in both domestic and ritual contexts at coastal plain sites in southeastern Oklahoma (Bell et al. 1969; Bohannon 1973; Burton 1970; Rohrbaugh 1972, 1973; Wyckoff 1965b, 1967b, 1968a) but is restricted to ritual contexts at ceremonial centers on the Ozark Plateau (Bell 1972; Brown 1996; Schambach 1982b, 1988, 1990a, 1993). The ritual contexts in which early Caddo ceramics are recovered are also quite different. At coastal plain ceremonial centers, such as the George C. Davis site in Texas and the Crenshaw site in Arkansas, Early Caddo ceramics have been deposited in off-mound, on-mound, and mortuary contexts. Yet, at northern Caddo ceremonial centers, such as the Spiro, Harlan, and Brackett sites in eastern Oklahoma, Early Caddo ceramics have been deposited exclusively in mortuary contexts.

The contexts of these fine wares demonstrate a much more complex history of practice than previously realized. The various ways in which peoples deposited and distributed fine-ware pottery may suggest they had multiple meanings, value, and power when used by different Early Caddo communities and their exchange networks. The social life of this pottery as it journeyed through multiple hands and social boundaries was interpreted and reinterpreted within different cultural contexts.

Sampling

My sampling strategy for northern Caddo ceremonial sites focused on pottery types most commonly associated with Early Caddo contexts such as Spiro Engraved, Holly Fine Engraved, Hickory Engraved, and Crockett Curvilinear Incised. To create an Arkansas valley reference group to compare with the fine wares, I chose specimens from very large grog-tempered Williams Plain and LeFlore Plain jars (table 8.1). It is likely that the high relative abundance of Williams Plain and LeFlore Plain vessels as compared with fine wares at Arkansas valley sites indicates these jars were locally made. This method has been an effective way to generate a robust geochemical reference group (Selden 2013).

A total of ninety INAA fine-ware specimens, which represents the complete available research assemblage, came from Arkansas River valley ceremonial sites:

Table 8.1. Sherd Samples Selected for INAA

Context	Site No.	Sample Description
Eastern Oklahoma Northern Caddo Area	Spiro (34LF40)	27 fine wares 32 utility wares for Arkansas Valley reference group
	Harlan (34CK6)	28 fine wares 20 utility wares for Arkansas Valley reference group
	Brackett (34CK43)	14 fine wares 26 utility wares for Arkansas Valley reference group
	Norman (34WG2)	17 fine wares 21 utility wares for Arkansas Valley reference group
	Reed (34DL1)	4 fine wares 17 utility wares for Arkansas Valley reference group
Northeastern Texas Southern Caddo Area	41FK107	5 sherds for Southern Caddo reference group
	41LR2	7 sherds for Southern Caddo reference group
	41WD51	7 sherds for Southern Caddo reference group
	41WD575	3 sherds for Southern Caddo reference group
	41WD573	2 sherds for Southern Caddo reference group
	41WD577	10 sherds for Southern Caddo reference group
	41UR30	3 sherds for Southern Caddo reference group
	41BW171	6 sherds for Southern Caddo reference group
	41TT650	5 sherds for Southern Caddo reference group
	41HS407	4 sherds for Southern Caddo reference group
	41HS240	4 sherds for Southern Caddo reference group
	41CP25	5 sherds for Southern Caddo reference group
	41CP525	10 sherds for Southern Caddo reference group
	41WD46	8 sherds for Southern Caddo reference group
	41CE19	80 sherds for Southern Caddo reference group
	41SM273	21 sherds for Southern Caddo reference group
Northwestern Louisiana Southern Caddo Area	16CD12	6 sherds for Southern Caddo reference group
	16NA587	5 sherds for Southern Caddo reference group
	16BO327	5 sherds for Southern Caddo reference group
	16CD218	5 sherds for Southern Caddo reference group
	16DS268	11 sherds for Southern Caddo reference group
Total	**418**	

Spiro ($n = 27$), Harlan ($n = 28$), Norman ($n = 17$), Brackett ($n = 14$), and Reed ($n = 4$). To produce the Arkansas valley baseline group, 116 utility ware specimens were selected for INAA (table 8.2). Additionally, I drew on the INAA results of 212 samples from twenty-one southern Caddo sites analyzed during previous projects to generate a southern Caddo baseline group (Perttula and Ferguson 2010;

Table 8.2. Northern Caddo Fine-Ware Sherds Selected for INAA

Site Name	Vessel Type	No. of Sherds Selected for INAA
Spiro	Spiro Engraved	19
	Holly Fine Engraved	1
	Hickory Engraved	3
	Crockett Curvilinear	4
Harlan	Spiro Engraved	13
	Holly Fine Engraved	1
	Hickory Engraved	3
	Crockett Curvilinear	11
Norman	Spiro Engraved	12
	Holly Fine Engraved	0
	Hickory Engraved	5
	Crockett Curvilinear	0
Brackett	Spiro Engraved	10
	Holly Fine Engraved	0
	Hickory Engraved	1
	Crockett Curvilinear	3
Reed	Spiro Engraved	3
	Holly Fine Engraved	0
	Hickory Engraved	1
	Crockett Curvilinear	0
Total INAA Samples		**90**

Perttula, Robinson, and MURR 2017) (table 8.3). The southern Caddo ceramic samples were chosen because they are (1) grog-tempered, (2) contemporaneous with the Arkansas River valley sites, and (3) chemically verified as locally made wares. Overall, eleven chemical groups have been identified in the East Texas region of the southern Caddo Area (fig. 8.4). A recent study comparing Central Arkansas River valley pottery with southern Caddo sourcing data to locate precise production locales has proved it is "impossible to assign unknown samples to a particular southern Caddo production region with confidence since each core group overlaps with oth-

Table 8.3. Northern Caddo Utility Wares Selected for INAA

Site Name	Vessel Type	No. of Sherds Selected for INAA
Spiro	Williams Plain	32
Harlan	Williams Plain	20
Brackett	Williams Plain	26
Norman	Williams Plain	11
	LeFlore Plain	10
Reed	Williams Plain	17
Total INAA Samples		**116**

ers" (Wiewel 2014:84). However, Perttula and Selden (2013) argue that production locales can be established in the southern Caddo Area. Despite these differing perspectives about production locales, I was able to broadly infer whether Arkansas

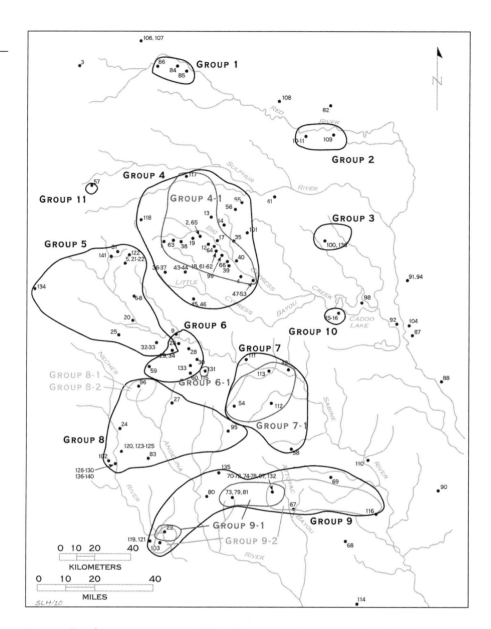

Figure 8.4. INAA compositional groups in the southern Caddo Area (adapted from Perttula and Selden 2013:fig. 1).

River valley fine wares were made locally or produced somewhere in the southern Caddo Area.

Results

Instrumental neutron activation analysis (INAA) was performed to locate geochemical signatures of northern and southern Caddo fine-ware pottery and multivariate statistics were employed to observe patterns in the compositional data. Specifically, I wanted to broadly understand if the early fine wares were produced locally in the northern and/or southern Caddo regions. INAA was performed

at the University of Missouri Research Reactor (MURR) and each sample consisted of two irradiations and three gamma counts. Combined, the two irradiations and gamma counts detected thirty-three major and minor elements. Following the methodology of Wallis et al. (2010) when studying prehistoric pottery in North America, Nickel (Ni) was omitted due to low detections rates. Additionally, Calcium (Ca) and Strontium (Sr) were also omitted because detection is likely due to postdepositional processes.

First, the raw elemental data was converted to base-10 logarithms to compensate for the differences between major and minor elements in performing a principal component analysis and in evaluating group membership using Mahalanobis distances. Principal component analysis comparing the variation between northern and southern Caddo baselines produced two distinct groups, showing that they are chemically distinguishable from one another (fig. 8.5). The elements that contribute the most meaningful variation between northern and southern Caddo clay pastes include Sodium (Na) and Potassium (K). The chemical variation among these two compositional groups is fundamental for understanding the provenance of Arkansas River valley early fine wares. While the southern Caddo reference group shows a relatively uniform composition, the Arkansas River valley reference group has much greater chemical diversity in its composition and appears to be site specific, especially regarding the chemical data from the Reed and Brackett sites. This is likely capturing variability in the clays used to make utility wares at each Arkansas River valley site. This may also indicate that future compositional analyses would detect variability in the clay pastes of pottery at and between Arkansas River valley sites.

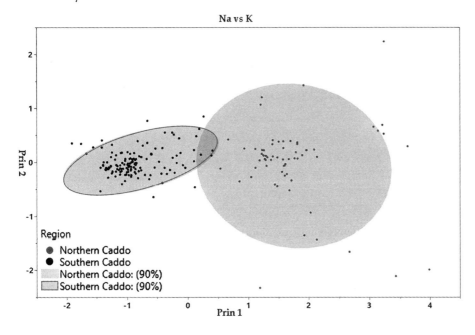

Figure 8.5. PCA bivariate plot of sodium and potassium showing regional variation among Arkansas Valley and Gulf Coastal Plain locally made specimens. Ellipses represent 90% confidence levels of group membership.

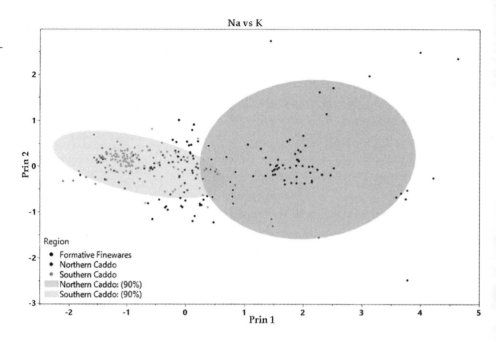

Figure 8.6. Biplot of the first two principal components of sodium (Na) and potassium (K) to show Arkansas Valley fine ware relationships with the southern Caddo reference group. Ellipses represent 90% confidence level for group membership.

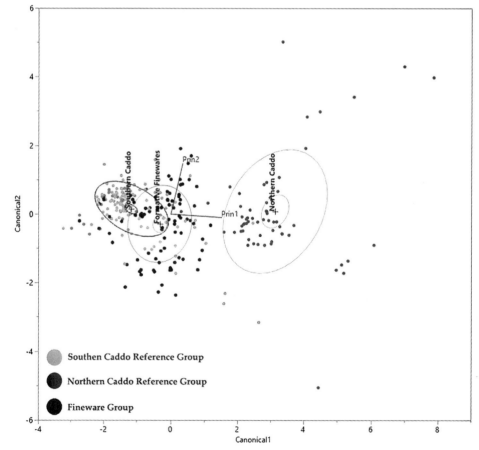

Figure 8.7. Discriminant bivariate plot showing Early Caddo fine ware group membership with the southern Caddo reference group.

In order to determine the provenance of the Arkansas River valley fine wares, I compared the studied samples with the two known baseline groups (fig. 8.6). The results of the principal component analysis illustrate that the Arkansas River valley fine-ware group has a significant chemical relationship with the southern Caddo reference group. None of the Arkansas River valley fine-ware specimens overlap with the Arkansas River valley reference group. To verify the probability of group membership for each Arkansas River valley fine-ware sample, I calculated the Mahalanobis distance by performing a discriminant analysis (fig. 8.7). Plotted on the first two canonical discriminant functions of the two known reference groups, the Arkansas River valley fine wares show group membership with the southern Caddo reference group. None of the Arkansas River valley fine wares grouped with the Arkansas River valley utility wares baseline group.

Stylistic Analysis of Fine Wares

A stylistic analysis of 200 whole fine-ware vessels from both northern and southern Caddo ceremonial centers argues for fewer highly specialized potters and more centralized areas of production than previously acknowledged. For the stylistic study, I used a hierarchical stylistic analysis (Plog 2008) and a design grammar analysis (Early 2012) to understand technological and design attributes. Attributes studied included vessel size, form, thickness, temper, and design elements and motifs. This list of attributes allowed me to observe the degree of design choice, organization, construction, and overall regional variability between northern and southern Caddo ceremonial centers. In this essay, I discuss only the stylistic analysis results of Spiro Engraved vessels (Lambert 2017).

The stylistic results indicate very few potters had the knowledge and skill to produce Spiro Engraved vessels. To understand the style of Early Caddo fine wares, I first developed a method I call "design stratigraphy" to analyze the depth and overlap of lines to reveal the sequence of design construction (fig. 8.8). From there, I was able to reconstruct the sequence of steps of each Spiro Engraved vessel to understand design pathway variability. The results indicated that all Spiro Engraved design elements were placed in the same order (fig. 8.9). This suggests Early Caddo potters were not only concerned with copying the overall design, but it was also important to learn the exact order in which the designs should be made, which implies personal tutelage in designing the pots. Although the sequential order seems like the most efficient way to lay out design fields, research has

Figure 8.8. Example of the design stratigraphy process showing how Early Caddo fine ware lines overlap in the motif. Step 1 (*black lines*), Step 2 (*dark gray lines*), Step 3 (*light gray lines*), and Step 4 (*gray circle punctation*).

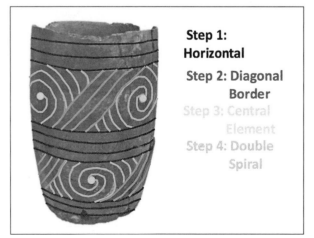

Step 1: Horizontal

Step 2: Diagonal Border

Step 3: Central Element

Step 4: Double Spiral

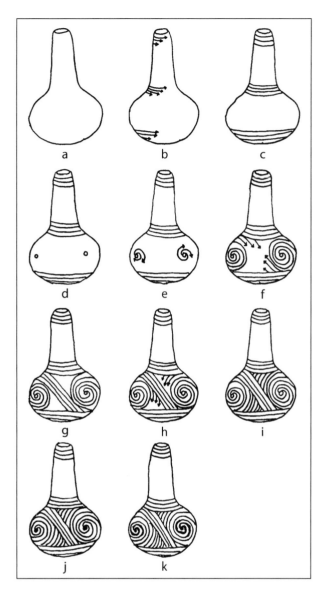

shown there is significant variation in design layout in post AD 1200 Caddo contexts (Early 2012; Girard et al. 2014).

In addition, the hierarchical stylistic analysis showed that Spiro Engraved vessels had a very limited set of design choices from which potters could choose to complete a vessel. I produced a hierarchical tree diagram for Spiro Engraved vessels to visually display the range of stylistic variability (fig. 8.10). Each element added onto the primary forms are considered secondary elements, or finishing options. For Spiro Engraved vessels, there are only five primary design forms, all of which are stylistically related to one another. Early Caddo potters restricted themselves to only three secondary design choices, which included excising, feathering, and punctating. This is true for fine wares at both northern and southern Caddo ceremonial centers. In fact, identical Spiro Engraved motifs and vessel forms are repeatedly found in both Caddo regions, although most are from southern Caddo ceremonial centers. If several potters were making these vessels throughout the entire Caddo region, I would expect much more stylistic variation than is shown here. These findings are in concert with the INAA results and indicate the emergence of ceramic specialization in the southern Caddo Area involving only a few craft specialists.

Discussion: Alternative Pathways to Ritual Complexity

Figure 8.9. Overall design pathway sequence to create a Spiro Engraved motif.

The analysis confirms that the fine wares found in the Arkansas River valley in eastern Oklahoma were produced at distant locales somewhere within the southern Caddo region. The nonlocal vessels may have derived from major sites, such as George C. Davis and Crenshaw, but at the moment, this is speculative until more archaeometric data can be gathered. Nevertheless, this study has emphasized that the early Caddo ritual landscape was much more complex and dynamic than previously recognized. Although early fine wares are distributed throughout the northern and southern Caddo areas with relatively little stylistic variation, they exhibit considerable variability in how they were used and deposited. The dichotomy of these practices reflects differences in how ritual identity was expressed and negoti-

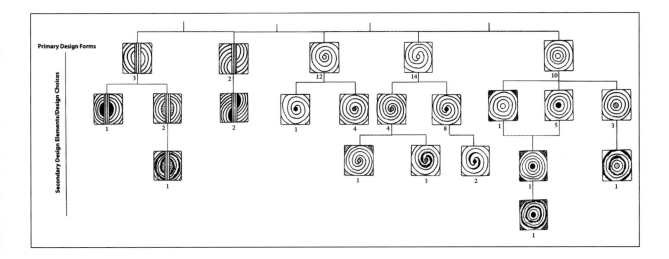

Figure 8.10. Spiro Engraved Hierarchical Tree Diagram showing the limited number of design choices in 100 whole vessels recovered from northern and southern Caddo mound sites.

ated. There are also a number of other points of divergence between northern and southern Caddo ceremonial centers that may have had significant consequences to their historical trajectories. For example, northern Caddo ceremonial centers had completely different mortuary programs, special-purpose structures, and burial mound construction from southern Caddo ceremonial centers (Regnier 2017).

Early Caddo fine-ware vessels were brought to Arkansas River valley ceremonial centers from afar, and the route of vessel transport was likely from south to north. Because they were nonlocal vessels, they were significantly valued and perhaps the reason why northern Caddo communities restricted them to mortuary contexts at northern Caddo centers. Such contextual boundaries are characteristic of the emergence of a ritual economy, in which "ritual and belief define the rules, practices, and consumption" (Spielmann 2002:203). Previous research into northern Caddo ceremonial centers has shown that ritual elites or specialists held the primary residences (Kay and Sabo 2006; Kusnierz 2016). Perhaps these individuals were the ones who obtained these early fine wares at the moments of exchange and controlled their access since there are no examples of them being distributed outside Spiro and other Arkansas River valley ceremonial centers. However, I believe it is more reasonable to suggest that the broader community was responsible for the construction of these ceremonial centers and obtaining and distributing the fine wares. The creation of ceremonial centers in the Caddo Area may have involved the need to craft such objects. Spielmann (2008:38) argued that crafting objects specifically for use in ceremonial spaces maintained a social network of "complementary and competitive relations." In other words, the use of these vessels at ceremonial centers brought people and ideas together, thus materializing and maintaining a sense of group identity.

I propose that the diverse provenance and deposition of Early Caddo fine wares reflects not only a new habitus of pottery production but also the emergence of two distinct ritual horizons. The difference in the context and use of this pottery cre-

ated and maintained northern and southern Caddo ritual structures. Intensified ritual production in small-scale societies is about meeting the demand for "socially valued goods" that were used for ritual purposes.

Conclusions

This study sought to problematize the concept of ritual mode of production and large-scale distribution in Early Caddo groups by examining how the organization of production and distribution of fine wares used in ceremonial places influence community construction. Early Caddo fine wares do not represent cultural homogeneity due to redundancy in site use. Rather, the findings in this essay demonstrate that, contrary to the assumption of decades of archaeological interpretation, these fine wares were not made at Spiro or even in the surrounding Arkansas River valley mound sites but were made and imported from communities hundreds of kilometers to the south.

The production and exchange of fine wares may emphasize a social response to a demand by northern and southern Caddo communities as a way to maintain their own ritual practices, traditions, and communal ceremonial obligations (Spielmann 2002:195). The key artifact classes used in the most important mortuary ceremonies at Spiro and other Arkansas River valley ceremonial centers for three centuries are now understood as imports. This means because they were imported from great distances, northern Caddo people imbued them with different meanings and connotations. It also indicates that skilled artisans and the broader southern Caddo community invested significant time and labor in the production and transportation of hundreds of whole vessels from their source of production. Finally, it demonstrates that we should not only reevaluate northern Caddo belief systems, we should also reconsider the ritual complexity of other small-scale societies in the pre-Columbian Southeast, as archaeologists have begun to do (Pluckhahn et al. 2017; Wallis et al. 2017).

As a final point, the evidence presented here suggests Early Caddo groups developed a dynamic social landscape integrated through the ritual production and exchange of their fine wares. Specialization has been defined as the "production for use by others" (Costin 2007:50). I assert that Early Caddo potters were at least part-time specialists "in the sense of highly skilled production and not simply a task to be taken up periodically by anyone when mortuary obligations demanded" (Wallis et al. 2017:140). Now that we understand separate Caddo communities produced, exchanged, and used their fine wares for a variety of domestic and ritual practices, it will have profound implications for Caddo research, or any archaeological research, that considers topics of ritual practices, long-distance interactions, and exchange relationships in regions with an emerging organizational complexity.

9

Ceramic Variation as an Indicator of Interregional Interaction and Community

Duncan P. McKinnon

Introduction

Historically, distributional analyses of ceramic variation in the Caddo Archaeological Area have focused on local or intraregional examination, but the studies were constrained by non-Caddo, modern state boundaries. While there have been numerous intraregional analyses, as evidenced in the highly comprehensive *Caddo Bibliography* (Perttula 2018c), there have been few syntheses of material culture distributions aimed at the multistate or interregional scale (see Girard et al. 2014 and Essay 8 for exceptions). Obviously, the Caddo peoples who occupied the vast region now defined within the localities of southwestern Arkansas, northwestern Louisiana, East Texas, and southeastern Oklahoma did not evaluate their landscape with current state political boundaries in mind.

The Caddo people who occupied their ancestral landscape (ca. AD 800–1830s) lived in numerous communities spread across a roughly 200,000 square kilometer area that is a diverse ecological combination of flora, fauna, climate, and terrain very similar to the Woodlands ecology east of the Mississippi River (Perttula 1992; Schambach 1998:8). Individuals residing within Caddo communities expressed their membership through a variety of multiscalar interactions that could be considered cultural spaces made up of an integrated yet diverse web of social, economic, and political places, ideas, people, material culture, and natural surroundings (Harris 2014:79). On an interregional scale, large multi-mound sites represent the loci of distinctive community assemblages. These communities were loosely affiliated by kinship relations whose members were socially and politically integrated into a heterogeneous network of broad interregional trade and interaction throughout the Caddo Area (Perttula 2012a:8).

Thus, an evaluation of the Caddo Archaeological Area landscape on an interregional scale is important to consider for a variety of reasons. If nothing more, the archaeological boundaries that attempt to define the Caddo Area are not fully

agreed upon. For example, a recent survey of Caddo specialists in the four-state region reveals a lack of consensus on the spatial extent of the Caddo Archaeological Area, particularly toward the eastern extent (Perttula 2012b:fig. 1). The survey emphasizes the need to move toward multistate interregional evaluations of economic and ideological interaction, connection, influence, identity, and exchange through a study of the distribution of Caddo material culture among communities situated throughout the Caddo landscape and to neighboring cultural groups (Girard 2018; Girard et al. 2014; Perttula 2017b). This essay offers an example of how Caddo archaeological research is attempting to move beyond intraregional analyses tied to constructed state or presumed archaeological boundaries (see Perttula 2016b).

The emphasis herein is on the examination of ceramic variation across the Caddo landscape as an indicator of interregional interaction and community. I begin by describing the contents of a multistate Caddo ceramic database and offer an initial analysis of the distribution of several well-represented ceramic types. This is followed by three case studies of defined ceramic types and motifs that build on earlier studies of ceramic interregional interaction and community and further highlight a broad distributional approach (McKinnon 2011, 2015). Such an effort illustrates the value of this type of analysis in developing research questions based on visualized patterning at an interregional scale.

Caddo Ceramic Database

Over the past several years, I have been synthesizing, with the help of numerous Caddo archaeological researchers, a comprehensive multistate material culture database as a mechanism to evaluate variation as an indicator of interregional interaction and community (McKinnon 2018). The database is primarily composed of whole Caddo vessels documented from readily accessible published excavation summaries, less-accessible archaeological reports or "grey literature" housed in state archives, and various photographs taken of private collections by archaeologists over the last sixty years. Material culture is also being compiled on several other media, such as ceramic vessel sherds, worked shell (pendants, gorgets, cups), and lithic arrow point types and styles. For example, using data on worked shell zoomorphic pendants, a distributional analysis revealed north-south stylistic differences within the Caddo landscape that are likely tied to artistic expression and community identity at multiple scales of social, political, and economic interaction (McKinnon 2015:128).

While the database project is ongoing and far from complete, it is comprehensive enough to evaluate distributional relationships and develop hypotheses to test and refine at multiple scales. The ceramic database currently contains 11,434 whole vessels from 447 documented archaeological sites (fig. 9.1). The sites are mostly located within a region known broadly as the Caddo Archaeological Area and are

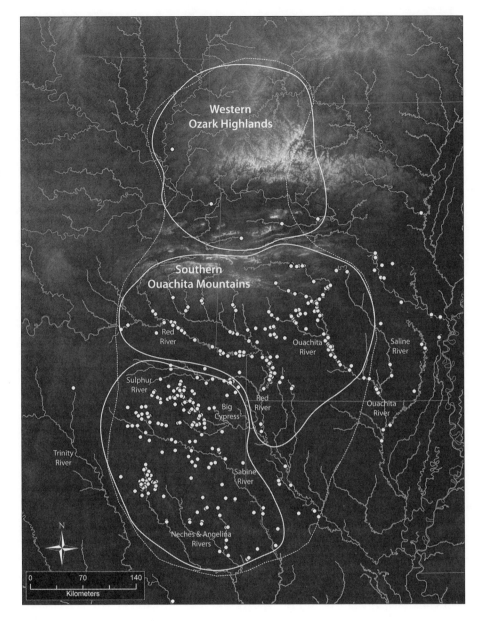

Figure 9.1. The current distribution of sites containing whole ceramic vessels. The dashed line represents the rough extent of the Caddo Archaeological Area.

situated within a biogeographical region defined as the Trans-Mississippi South. The Trans-Mississippi South is bordered by the Missouri River to the north and stretches southwest across the Ozark Plateau and Ouachita Mountains. The southern border is along the western edges of the west Gulf coastal plain and the foothills of the Edwards Plateau at the Colorado River (Schambach 1998:8).

Generally, the Caddo Archaeological Area has been divided into three subareas: northern Caddo (Arkansas River basin, western Ozark highlands), western Caddo (western Gulf coastal plain) and central Caddo (Red and Ouachita River valleys).

While the extent of these areas is debated, or if each of the subareas should even be considered part of the Caddo Archaeological Area (see Schambach 1990b), sites containing Caddo archaeological materials have been identified throughout southwestern Arkansas, eastern Oklahoma, northwestern Louisiana, and East Texas. The materials used to define this region have largely been the distinctive ceramic vessels made as part of a long tradition of Caddo ceramic production and design, and they stand in marked contrast in style and design from ceramic expressions by contemporaneous "Mississippian" cultural groups to the east (Townsend and Walker 2004). At present, the database largely contains vessels from the western and central subareas. The northern Caddo subarea is not well represented at this time.

The quantity of vessels at each site within the current ceramic database ranges from a single vessel to hundreds of examples. Variability of the intensity of use and occupation at sites as well as the frequency of burials and cemeteries, such as at farmsteads or mound centers, can likely explain the differences in frequency at each site. However, the range of ceramic occurrences is also largely a factor of the lack of publications (or limited amount of excavations) at many sites and a lack of regional sampling programs in many places that go beyond those done by a small number of professional, avocational, and nonprofessional (looters) investigators (Schambach 1982b:11). Thus, sites with hundreds of vessels are the result of biases toward large published syntheses of work offering detailed catalogs of ceramic photographs and descriptions. For example, sites such as Harlan (Bell 1972), Belcher (Webb 1959), Poole (Wood 1981), Mineral Springs (Bohannon 1973), Tuck Carpenter (Perttula, Walters, Stingley, and Middlebrook 2017), Sam Kaufman (Perttula 2016c; Perttula, Walters, and Nelson 2012a), Sanders (Jackson et al. 2000), George C. Davis (Newell and Krieger 1949), and others are well represented in the database.

A large number of the whole vessels from Arkansas sites come from unpublished private collections that were originally recorded on orange index cards housed at the Arkansas Archeological Survey (ARAS). Each card has a black and white photograph of the ceramic vessel, site trinomial, collector information, ceramic attributes, and intrasite provenience information, if available. The vessels on the index cards were photographed from private collections in the mid-twentieth century by several ARAS station archaeologists, station assistants, and students. Over the last several years they have been scanned and the information entered into the multistate ceramic database. Around 3,000 of the 11,434 vessels in the database come from this collection of index cards.

An obvious concern with the use of private collections is the authenticity of information and the accuracy of typed vessels from known sites. Wood (1981:27) considers this issue with his inclusion of vessels of questionable provenience in

his Poole site analysis. He includes these vessels to "provide a greater range" of types that are "homogeneous enough that they . . . appear to be contemporaneous with the material excavated [with provenience information]." The information on the ARAS orange index cards were compiled by archaeologists with over thirty years of regional archaeological familiarity and the information on each card was obtained by directly interviewing private collectors, who in many cases cataloged their collections and were very familiar with the sites in which they dug. Often these sites were within close proximity because individual collectors usually operated within a circumscribed and specific river valley or tributary. Thus, I have included such vessels from the cards in the database.

Furthermore, many sites are only represented in the ceramic database by ceramics recorded from private collections. For example, the large multi-mound Bowman site (3LR50) along the Red River only has vessels acquired from collector diggings conducted in the 1940s and 1960s; some are housed at the University of Arkansas Museum, some are housed at the ARAS Station in Magnolia, and others remain in private collections. There has been no systematic excavation at the Bowman site, although Hoffman (1970:168) suggested almost fifty years ago "the importance of [the temporal span at] the site would justify large-scale investigation." Despite its importance as a likely community center of exchange and influence, none of the excavated Bowman vessels have been published in catalog form but are nevertheless important to include in the database. Recent research of the Bowman vessels highlights that these types are present at contemporaneous sites along the Red River in the region and thus "provide a greater range" of types (McKinnon et al. 2018).

In addition to the 11,434 vessels, around 1,600 whole vessels from undocumented or unrecorded sites are also included in the database. While they allow for regional comparative analyses on ceramic form and decorative treatment, they lack site proveniences and associated UTM coordinates. Many of these ceramics are recorded with only regional site vernacular names or previous landowner names that are not associated with current landowners. In some instances, there is a site trinomial, which can assign the site to a regional county locale, but the specific site geographic location (UTM) is not recorded in state repositories or is recorded as a general area too broad for this type of analysis. This is primarily because numerous sites have been destroyed as a result of river meandering or historic land modification prior to their addition into a statewide repository. For example, only a portion of the sites Clarence B. Moore visited along the Red River in southwestern Arkansas in the early twentieth century have been relocated (Schambach 1982b:11; Weinstein et al. 2003). While some have been assigned trinomials, the exact locations of these former sites are unknown. Since there is a lack of site provenience on these 1,600 vessels, they are not included in this distribution analysis.

Since its beginning, the ceramic database has evolved to contain, where appli-

cable, attribute fields on type, variety, motif designs (largely using the Glossary of Motifs published in the Spiro shell engravings [Phillips and Brown 1978–84:145–56] and by others [Gadus 2013a:219]), descriptive "collegiate" assignment of both the rim and the body (Rolingson and Schambach 1981:114; see also Essay 1), vessel form, temper, decorative method (incised, brushed, engraved, punctated, stamped, etc.), context (burial #, feature #, mound #, house #, etc.), pigment, archaeological phase, cultural period, collector, repository, associated photographs or figures, and reference citations. The database is managed using Microsoft Access where data are imported into ESRI ArcGIS and spatial analyses can be conducted.

At present, eighty-three archaeological ceramic types are represented in the vessel database. They range from a single example to at least several hundred vessels. Types are recorded in the database as they are noted and documented in publications and by the research of regional scholars' familiar with types and varieties in each of the Caddo subareas. There has been little analysis, or reanalysis, of types in published reports, despite methodological concerns with the occasional assignment of different type names to similar designs that extend across state boundaries. Twenty-seven types are well represented (> 100) in the database. They include Avery Engraved (n = 314), Belcher Engraved (n = 235), Bullard Brushed (n = 160), Clark Punctated-Incised (n = 197), Crockett Curvilinear Incised (n = 190), East Incised (n = 124), Emory Punctated-Incised (n = 112), Foster Trailed-Incised (n = 318), Haley Engraved (n = 293), Handy Engraved (n = 119), Harleton Applique (n = 118), Hempstead Engraved (n = 152), Hickory Engraved (n = 210), Hodges Engraved (n = 232), Karnack Brushed-Incised (n = 113), Keno Trailed (n = 185), La Rue Neck Banded (n = 106), Maydelle Incised (n = 118), Mockingbird Punctated (n = 102), Nash Neck Banded (n = 205), Pease Brushed-Incised (n = 183), Poynor Engraved (n = 274), Ripley Engraved (n = 1542), Simms Engraved (n = 241), Spiro Engraved (n = 103), Taylor Engraved (n = 244), and Wilder Engraved (n = 166).

Many of the twenty-seven types were originally described and illustrated in the *An Introductory Handbook of Texas Archeology* (Suhm and Krieger 1954) and *Handbook of Texas Archeology: Type Descriptions* (Suhm and Jelks 1962) or elsewhere (Krieger 1946; Newell and Krieger 1949) and represent some of the more common and recognizable types still in use today. While there have been a few attempts at updating ceramic classificatory approaches with some success (see Dowd 2011b; Early 1988; Early ed. 1993; Rolingson and Schambach 1981; Schambach and Miller 1984; Essay 1), these attempts have mostly been site- or regionally specific (largely applied to Arkansas) and lack a comprehensive published "glossary" of design terms to apply to interregional applications. Thus, they lack large-scale comparative data to examine in a broad distributional approach. An in-depth analysis of the pros and cons of the type-variety ceramic system (see Phillips 1958; Gifford 1960; Wheat et al. 1958) is beyond the scope of this essay. However, at present, it represents the primary form of a well-established and well-published system of ce-

ramic classification that can be utilized in a multiscalar broad distribution analysis; thus, I rely on it here.

Using the twenty-seven high-frequency ceramic types in the database, I will briefly illustrate the value of this approach to developing exploratory research questions that can be pursued and tested at multiple scales. Borrowing the multiscalar spatial organizational framework proposed by Lockhart (2007:1), I organize the twenty-seven types into three distributional classifications: macroscale, mesoscale, and microscale. Lockhart uses the macroscale to apply to "all known Caddo mounds sites in Arkansas," the mesoscale to apply to the "regional subset of the Caddo mound sites [in Arkansas]," and the microscale to apply to a "site-specific level to examine intra-site organization." For this analysis, the macroscale will refer to the entire Caddo (and neighboring) Archaeological Area, the mesoscale will refer to regional ecological subsets of the Caddo Archaeological Area, such as neighboring river drainages or watersheds, and the microscale will refer to specific river drainages or cultural landscapes or communities with high-density ceramic clusters.

Several of the twenty-seven types are widely distributed throughout the western and central Caddo regions (fig. 9.2a–b). I designate a widely distributed type as those on a macroscale with numerous occurrences in multiple river valleys and drainages across the broad cultural area. These include the types Crockett Curvilinear Incised, Foster Trailed-Incised, Hickory Engraved, Hodges Engraved, Karnack Brushed-Incised, Keno Trailed, Pease-Brushed Incised, and to some extent Spiro Engraved. These types occur in all the major river drainages across several

Figure 9.2. Ceramic types with macroscale distributions: a, Crockett Curvilinear Incised, Foster Trailed-Incised, Hickory Engraved, and Hodges Engraved; b, Karnack Brushed-Incised, Keno Trailed, Pease Brushed-Incised, and Spiro Engraved.

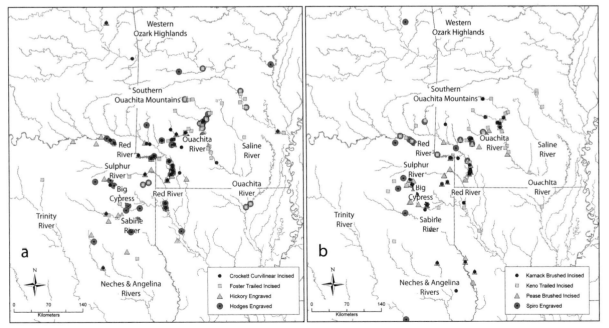

different time periods. This may suggest broad interregional similarities, or perhaps underlying cultural or ideological homogeneity, in certain designs or, more important, the meanings that the designs convey.

Types such as Avery Engraved, Belcher Engraved, East Incised, Emory Punctated-Incised, Haley Engraved, Handy Engraved, Nash Neck Banded, Simms Engraved, and Taylor Engraved are seemingly more limited and regional in distribution (fig. 9. 3a–b). Types with a more limited distribution are considered on a mesoscale. They occur within the western and central areas, but are not as widely represented across those regions. For example, Simms Engraved is present at several sites along the Red River and further west along Big Cypress Creek, and in the Sulphur, Sabine, Neches, and Angelina Rivers. However, there is only one Simms Engraved example (in the present database) along the upper Ouachita. Similarly, Belcher Engraved is very prevalent along the Red River and Ouachita River drainages (and further east), but is not well represented to the west in East Texas river drainages.

Types such as Bullard Brushed, Clark Punctated-Incised, Hempstead Engraved, La Rue Neck Banded, Maydelle Incised, Mockingbird Punctated, Poynor Engraved, and Ripley Engraved are microscale in their relative distribution. They occur only within one river drainage or at proximate sites in adjoining river valleys (fig. 9.4a–b). Types such as Clark Punctated-Incised and Hempstead Engraved are frequent in the adjoining Ouachita and Red River valleys. As Early (2012:30) notes in her analysis of Friendship Engraved, the Ouachita and Red River drainages were easily accessible using feeder tributaries, suggesting intraregional ex-

Figure 9.3. Ceramic types in the database with mesoscale distributions: *a*, Avery Engraved, Belcher Engraved, East Incised, and Emory Punctated-Incised; *b*, Haley Engraved, Handy Engraved, Nash Neck Banded, Simms Engraved, and Taylor Engraved.

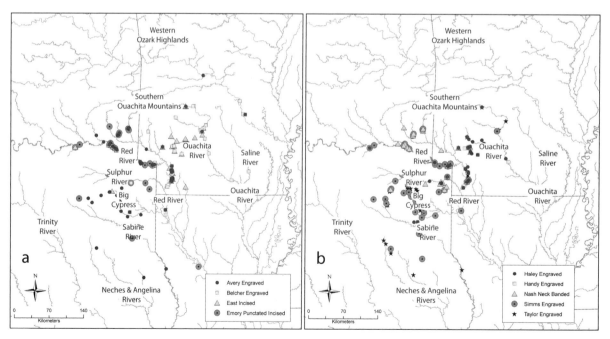

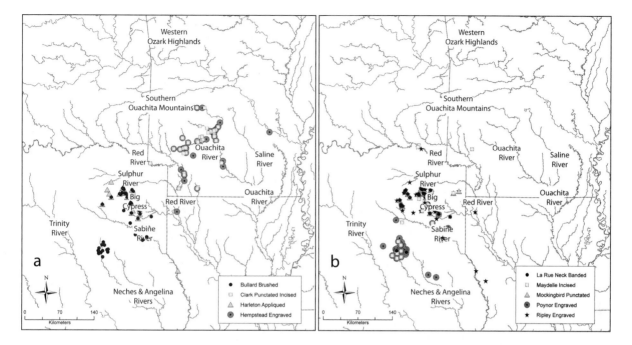

change of vessels. A second example is with Bullard Brushed (fig. 9.4*a*), which occurs in the adjoining Big Cypress and Sabine drainages. Notably, a separate cluster of Bullard Brushed vessels is restricted to the Upper Neches, which also suggests social, economic, or political connections to communities in the Big Cypress and Sabine localities. In contrast, types such as Harleton Applique, La Rue Neck Banded, Mockingbird Punctated, Ripley Engraved, and Poynor Engraved are located largely within one river drainage. Ripley Engraved is frequent in the Big Cypress drainage whereas Poyner Engraved is present in the Upper Neches and these types further represent examples of microscale clustering of a ceramic type.

I suggest that the multiscalar differences in the distribution of a select number of ceramic types, and, importantly, the suite of designs and vessel forms that define these types, represent multilevel cultural assemblages of interaction. The distributions illustrate the participation and maintenance of distinctive ceramic elements and designs related to membership identity and interaction at the local (micro), intraregional (meso), and interregional (macro) community scales (Layton 1991:34). Types distributed on the microscale suggest localized community identities where examples that exist outside of the local drainage reflect exchange with neighboring communities or perhaps exogamous marriage practices and kinship affinities. Examples on the mesoscale suggest the presence of distinct stylistic forms that are linked to regionally shared political, social, or economic themes that extend beyond specific communities (McKinnon 2015). Examples on the macroscale suggest broader traditional cultural designs or narratives that are associated with complex ideas, shared among many communities, and manifested throughout the interre-

Figure 9.4. Ceramic types in the database with microscale distributions: *a*, Bullard Brushed, Clark Punctated-Incised, Harleton Applique, and Hempstead Engraved; *b*, La Rue Neck Banded, Maydelle Incised, Mockingbird Punctated, Poynor Engraved, and Ripley Engraved.

gional landscape. This multiscalar line of thought mirrors that offered by Girard et al. (2014:55); they suggest that distributional studies of decorative elements to evaluate regional styles can shed light on questions related to variation between regions [macro and meso] and within regions [micro].

Case Studies

The following case studies consider the distribution of the ceramic types Crockett Curvilinear Incised and Foster Trailed-Incised. The selection of these two types is based on three primary criteria. First, while variation exists within these types (see Schambach and Miller 1984), overall the similar execution of decorative motifs and elements suggests that potters creating these designs were limited in their decorative choices (see also Essay 8). As such, the overall design on each type is fairly consistent and readily identifiable using the type-variety system. This consistency in design offers a high degree of confidence with regard to type assignments in the literature. Second, the two types "bookend" the current established Caddo chronology. Crockett is prominent mostly during the Early Caddo period (ca. AD 1000–1200) whereas Foster is in wide use during the Late Caddo (ca. AD 1400–1680) period. Finally, both of these types are distributed on the macroscale, which allows for evaluations beyond independent river drainages as indicators of interregional interaction and community across a broader cultural landscape.

Also included is a case study of a ceramic design that is present on multiple archaeological types that largely occur within Middle and Late Caddo period contexts. I define this design as the rayed circle motif (McKinnon 2016) and it is selected in order to examine the cultural dispersal of a specific motif and possible associated ideological influences. The design is present on varieties of Avery Engraved, Belcher Engraved, Hempstead Engraved, and Ripley Engraved types, as well as others. The purpose is to consider the distributional relationship of commonly applied themes or motifs and the feasibility of examining ceramic design beyond archaeologically assigned types.

CROCKETT CURVILINEAR INCISED

A total of 190 Crockett Curvilinear Incised whole vessels are currently in the Caddo ceramic database. The type is considered an Early Caddo (AD 1000–1200) type that has historically been understood as being widely distributed in East Texas and southwestern Arkansas (Suhm and Krieger 1954:262). The current distribution expands occurrences in northwestern Louisiana and northward to sites in Oklahoma (fig. 9.5a). The type is present at several large mound centers, such as George C. Davis (Newell and Krieger 1949:98–104), Harlan (Bell 1972), Bowman (Hoffman 1970; McKinnon et al. 2018), and Spiro (Brown 1996).

The Crockett type is first illustrated by Krieger (1946:227–28 and fig. 19) and

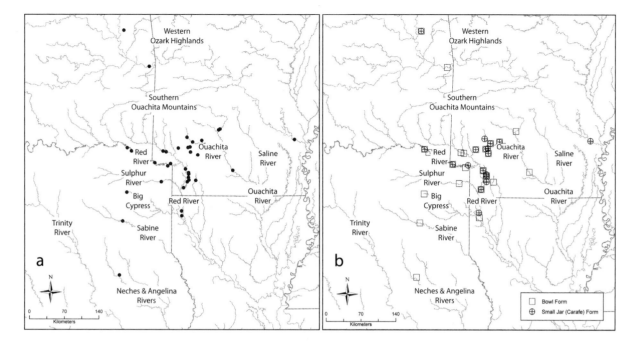

Figure 9.5. Crockett
Curvilinear Incised: *a*, the
current distribution; *b*,
the current distribution of
vessel forms of Crockett
Curvilinear Incised.

used as a comparative sample in his evaluation of variation in vessel body and rim
forms in East Texas Alto focus (phase) types. He offers no description of the type,
but mentions in a footnote that the type was named by Perry Newell and was based
on work at George C. Davis. Newell and Krieger (1949:98–104) formally describe
the design as largely reserved for carinated bowl forms and as highly variable in
execution. Common elements conform to a similar motif with a scroll and a cen-
tralized circle. The scroll is frequently offset with a series of incised lines that run
diagonally within a triangle zone from the bottom to the top of each circle. How-
ever, there are also numerous examples with the triangle zone filled with puncta-
tions rather than incised lines. While the overall design is maintained with a "strict
adherence to the vessel forms and scroll motif, there was much individualism in the
manner of filling and spacing the units" (Newell and Krieger 1949:100).

The description from Suhm and Krieger (1954:262) is based largely on the
George C. Davis report. They elaborate that the form consists of several differ-
ent bowl forms, such as carinated bowls, globular bowls, "simple" bowls with rim
peaks, cylindrical bowls, and "square" bowls. Punctations, when present, are de-
scribed as being plain (without embellishment), possibly made using reed stems,
and with "hemi-conical" shapes. Several design units are illustrated (Suhm and
Krieger 1954:plates 15 and 16) that often occur in a series of four around the bowl,
"but repetitions up to 15 or more [related to the size of the vessel]" are also present.
They add that similar designs are present at the Chupek (41ML44) site along the
Brazos River in central Texas and at the Greenhouse (16AV2) site within the lower
Red River drainage in central Louisiana.

Ford (1951:62–66), in his description and illustration of the type French Fork Incised at Greenhouse, suggests connections between Crockett designs and the French Fork Incised type. He suggests "French Fork will undoubtedly be found to change imperceptibly into Crockett Curvilinear Incised, an Alto Focus type that Krieger has set up in the material from the Davis Site" (Ford 1951:65). He also highlights the distinction made by Suhm and Krieger (1954:262) between vessel forms where Crockett Curvilinear designs are on "carinated bowls, a shape not found with French Fork decoration."

At the Chupek site, Watt (1953:figs. 21–22) suggests connections to Alto focus (phase) ceramics found at George C. Davis with several decorated sherds assigned to types such as Pennington Punctated-Incised, Hickory Engraved, and Weches Fingernail Impressed. However, a few sherds (Watt 1953:figs. 21A1 and 22A1, A3, A14) assigned to Pennington Punctated-Incised more closely resemble Crockett Curvilinear Incised. This is especially the case if the stylistic differentiation between the two suggested by Newell and Krieger (1949:98) is applied: "All sherds with the usual characteristics of resident pottery and a clear-cut scroll motif were referred to the *Crockett* type; those with clearly geometric straight-line elements were referred to as *Pennington*."

While Crockett designs are largely found on bowls, Bohannon (1973:fig. 16a–b) proposed a "tentative" new variety (*var. Ozan*) based on two vessels found at the Mineral Springs site, and compared those with examples from the Ozan (Harrington 1920:plate LXV) and Belcher (Webb 1959:fig. 77a) sites. The vessels contain the standard incised scroll motif and central circles used on bowls, but at the site they are present on small jars with "squat globular bodies and high straight rims" (Bohannon 1973:44). He noted that this variety is well represented in Arkansas, but limited elsewhere. The distribution of Crockett Curvilinear Incised vessel forms demonstrates Bohannon's observation that bowls are found throughout the region and small jars (sometimes referred to as carafes) are mostly limited to southwestern Arkansas sites with one example at the Jones site (3AR14) along the Arkansas River just above the confluence with the Mississippi River (fig. 9.5b). Several sites in southwestern Arkansas have both vessel forms, as does the Spiro site in Oklahoma.

FOSTER TRAILED-INCISED

A total of 318 Foster Trailed-Incised vessels are currently in the Caddo ceramic database (fig. 9.6a). The type is considered a Late Caddo (AD 1400–1680) type that has historically been associated with Caddo occupations in the Ouachita and Red River drainages (Krieger 1946; Suhm and Krieger 1954; Suhm and Jelks 1962; Webb and Dodd 1941; Webb 1959; Schambach and Miller 1984; Early 1988; Early ed. 1993; Kelley 1997). Distributional data demonstrate that this type is also pres-

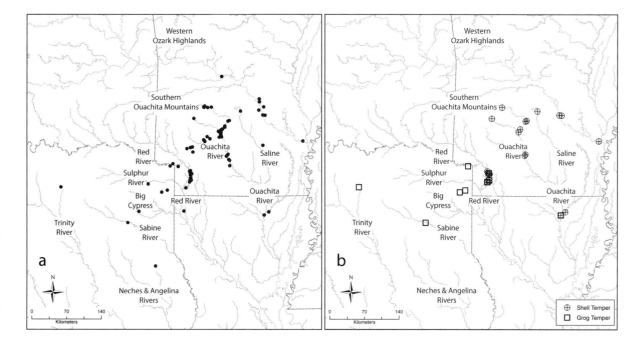

Figure 9.6. Foster Trailed-Incised: *a*, the current distribution; *b*, the current shell and grog temper distributions for Foster Trailed-Incised vessels.

ent in the Saline, Arkansas, and Little Missouri Rivers, along the lower Ouachita River in northeastern Louisiana (Kidder 1988), and along several river basins in northeastern and north-central Texas (Crook and Perttula 2008; Perttula 2005a; Walters 1997).

Webb and Dodd (1941:96) are the first to describe criteria associated with Foster Trailed-Incised using vessels found at the Belcher site in northwestern Louisiana. They describe the type as having body decorations of trailed and heavily incised U-shaped incisions and shallower, wider, trailed lines that form concentric circles. Small "teat-like" appliqued nodes are located in the center of concentric circles. Vessels with tall rims often contain lightly incised lines or punctations. They described vessel temper generally as clay (no temper or possibly grog?) with occasional shell, but do not identify tempers of specific vessels. Later, Webb (1959:131) elaborated by stating that the temper is "preponderantly clay-tempered" with "occasional sand or tuff, presumably accidental," and shell or bone temper is rare.

In Texas, Krieger (1946), Suhm and Krieger (1954:272), and Suhm and Jelks (1962:43) describe the decorative treatment similarly, with "incising, trailing (incising with a broad, round-tipped tool), punctating, and applique" elements. They classify Foster Trailed-Incised vessels as having clay-grit or finely pulverized shell temper and consider the distribution as primarily localized in the Red River valley.

In Arkansas, the most comprehensive discussion of Foster Trailed-Incised concerns the Cedar Grove (3LA97) vessels found along the Red River in the southwestern corner of the state. Schambach and Miller (1984:121 and fig. 11–10) present

a chronology of Foster Trailed-Incised vessels that are divided into seven varieties based on differences in design and decorative treatment. This begins with a concentric circle motif on the body and multiple bands of zoned diagonal lines on a tall rim (*var. Foster*). The design evolves through a series of variations, and the latest Foster varieties have designs that contain vertically oriented interlocking scroll designs on the body with unzoned punctations on the tall rim (*var. Shaw*) and a single row of diagonal incised lines on the short rim (*var. Finley*). In contrast to vessels recovered from the Belcher site and in East Texas, the Cedar Grove vessels are all shell-tempered (Schambach and Miller 1984). Elsewhere in Arkansas, a single vessel recovered by Early (1988:74) at the Standridge site (3MN53) along the Caddo River is described as containing "liberal quantities of finely pulverized shell." However, at the Poole (3GA3) site in the upper Ouachita River basin, seven Foster Trailed-Incised vessels had "finely crushed clay-grit [temper] in five vessels; two of them are shell-tempered" (Wood 1981:37).

Variations in the dominant temper used are likely related to the distribution of localized resources and regional adherence to cultural "rules" associated with vessel construction. This is not to imply an absence of a resource, but rather that there were regional approaches in the utilization of particular resources. Of the Foster Trailed-Incised vessel entries in the database, temper is only recorded in 30 percent (*n* = 91) of the vessels. Of these 91 vessels, shell temper occurs in 72.5 percent (*n* = 66) and grog temper in 27.5 percent (*n* = 25). Bone temper is not recorded. Although preliminary, the distribution of the 91 vessels with recorded temper suggests a distinctive type of temper usage between sites within the Gulf coastal plain (grog) and those in the Ouachita River drainage (shell). A mixture of grog and shell temper is present along the Great Bend of the Red River at several important sites (fig. 9.6*b*).

A second pattern of interregional interaction and community is the presence of vessels that fall within the Foster Trailed-Incised design criteria but are located at sites outside of their general distribution. These include the Joe Little, Henry Williams (41UR318), Langford (41SM197), and Sister Grove Creek (41COL36) sites in Texas and the Glendora (16OU32) and Keno (16OU31) sites in northeastern Louisiana (fig. 9.7). A single vessel at the Joe Little site along Attoyac Bayou in northeastern Nacogdoches County in East Texas is globular in form with a short, out-flaring rim. The body is decorated with incised scroll designs and appliqued nodes are present. The rim design consists of annular punctations (Tom Middlebrook, 2009 personal communication). Found at the Langford site in Smith County was a vessel with broad concentric appliqued or pinched circles and two rows of punctations on the rim that divide sets of narrow and interlocking incised lines (Walters 1997). At the Sister Grove Creek site in Collin County, a single Foster Trailed-Incised vessel was recovered. The vessel represents the first known occurrence of this type

along the East Fork of the Trinity River (Crook and Perttula 2008). The form is globular with an out-flaring rim. The rim design contains four horizontal panels of diagonal lines. The designs on the body are concentric semicircles although there are no appliqued nodes.

In northeastern Louisiana near the confluence of Bayou Bartholomew and the Ouachita River at the Glendora and Keno sites, Kidder (1988:fig. 51) classifies four vessels as Foster Trailed-Incised. A vessel from the Keno site is assigned to *var. Finley*, a single vessel from the Glendora site is assigned to *var. Shaw*, and two additional vessels from the Glendora site are classified as *var. unspecified*. One of the *var. unspecified* vessels resembles the form and design of Foster Trailed-Incised vessels from the Ouachita River drainage. It has a series of concentric circles with appliqued nodes on the

vessel body. The primary rim design has rows of punctations with two incised lines above the rim-body juncture. Similarities in form and design to vessels in the Ouachita River drainage suggest interregional interaction with Caddo groups to the north along the Ouachita River. Additionally, the identification of *var. Finley* and *var. Shaw* at the Glendora and Keno sites suggests interregional interaction with Late Caddo groups along the Red River in southwestern Arkansas (see Schambach and Miller 1984:121).

Figure 9.7. Location of Foster Trailed-Incised vessel outliers.

Rayed Circle Motif

Another approach toward considerations of interregional interaction is an analysis of design motifs that are present on several defined ceramic types. Ceramic types, while established in the literature, can be limiting when attempting to understand the origin of design varieties and how these may be represented differently in design treatment and vessel form. This is especially true when there are types that are very similar in their overall motif representation. For example, Crockett Curvilinear Incised vessels contain the emblematic scroll motif that is also present on Haley Engraved, Hodges Engraved, Ripley Engraved, Avery Engraved, and other types, with possible variants in Holly Fine Engraved or Pennington Punctated-Incised types (see Essay 11; Newell and Krieger 1949:98–104). Similarly, Foster Trailed-Incised vessels contain the definitive concentric circle design on the body that is also apparent on types such as Keno Trailed, Cowhide Stamped, and Killough Pinched.

To consider ceramic distributions beyond the type-variety system and evaluate the versatility of such an approach, the interregional relationship between two rayed circle motif varieties is examined at sites throughout central and southwestern Arkansas and nearby areas. The rayed circle motif is defined in the Phillips and Brown (1978–84:plate 36) engraved shell Glossary of Motifs and is considered an elaboration on the barred oval motif where "rays or scallops" are added to a half oval containing two or more concentric lines. Here, the rayed circle motif is used for ceramic vessels that have a series of engraved or incised concentric circles with one or more ray-like tics emanating from the center. Some ceramic type equivalents are Belcher Engraved vessels, where a series of concentric circles surrounds a "flower or star-like" element in the center (Suhm and Krieger 1954:244); Avery Engraved, where concentric semicircles contain ticked lines (Suhm and Krieger 1954:236); and Ripley Engraved, where concentric circles have "ticking or pendant triangles on lines" (Suhm and Krieger 1954:346). A more abstract representation occurs on Hempstead Engraved vessels where concentric circles are situated around the rim of bowls or the neck of bottles and contain "hatched or cross-hatched triangles" that point downward (Suhm and Krieger 1954:292).

Rayed Circle Burst Motif

The "burst" variety is defined by the presence of a central element, or burst, as a circle containing a series of small triangles or rays emanating outward from the center. The presence of at least one burst is sufficient to be included in the distribution, although variability is present in their use, as some vessels have multiple bursts organized with two or four on opposing sides. The primary vessel forms are bottles with the burst motif on the body. Eighty-five vessels containing the motif are identified in this study and were found at sites with Middle and Late Caddo period (ca. AD 1200–1680) components.

Vessels with the rayed circle burst have been found at sites located along the Red River, Caddo River, Little Missouri River and tributaries, Little River tributaries, Ozan Creek, and with single examples on the lower Ouachita and Sulphur Rivers in southwestern Arkansas and East Texas (fig. 9.8). The rayed circle burst vessels are clustered within two Arkansas regions. Cluster 1 (45 percent of the vessels at eight sites) is situated along the Red River in southwestern Arkansas whereas Cluster 2 (32 percent of the vessels at thirteen sites) is northeast of the Red River along the Caddo, Little Missouri, Saline, and Ozan Creek drainages in southwestern Arkansas. The Red River Cluster contains a greater number of rayed circle burst vessels that are concentrated at fewer sites. For example, the total number of vessels found at the Battle Mound and Haley sites constitute 49 percent of the vessels within the cluster and 25 percent of the rayed circle burst corpus, which may suggest the importance of this design at, and relationships between, these two mound centers (e.g., Steponaitis and Knight 2004).

Figure 9.8. Distribution of rayed circle burst.

RAYED CIRCLE OVERHEAD MOTIF

The rayed circle overhead motif is present on both bottle and bowl forms. Both vessel forms have a series of triangles filled with engraved cross-hatching and are pointed downward from a circular engraving, often with an accompanying set of nested concentric circles. On bottles, the design is at the base of the neck as it transitions to the body. With bowls, the overhead motif is not fully visible from overhead. It is present around the side of the rim and above the body. There are sixty-five representations of the overhead motif in the current vessel corpus and all are associated with Middle and Late Caddo period sites.

The rayed circle overhead motif is more dispersed than the rayed circle burst motif. There are no visible site clusters and the motif is well represented at sites throughout the major rivers and associated tributaries, although occurrences are more prevalent at sites northeast of the Red River along the Caddo, Little Missouri, Ouachita, Saline tributary, and Ozan Creek drainages (fig. 9.9). Of note are two vessels that fall outside of a 2-standard deviation distance analysis (see Wheatley and Gillings 2002). First, the Noble Lake (3JE19) site is part of the Menard Complex along the lower Arkansas River and dates to AD 1400–1700 (House 1995). The Noble Lake vessel, along with surface collections and excavated material containing Caddo ceramic styles, indicate interregional association with groups to the west in the Caddo Archaeological Area (House 1995:90; see also House 1997; Walker 2014). The second outlier is at the Poole site in southwestern Arkansas where archaeological investigations document a long history of Fourche Maline and Caddo occupations (Wood 1981).

Figure 9.9. Distribution of rayed circle overhead.

Rayed Circle Burst and Overhead Motif Relationships

When examined together, the combination of both motifs at certain sites has identified a possible corridor of sites in the proximity of the Little Missouri River, Ozan Creek drainage, and Caruse Creek (fig. 9.10). These observations hint at two possible interactions and the movement of ceramic vessels and their associated meanings. Independently, the rayed circle overhead motif is prominent at sites in the Ouachita River basin whereas the rayed circle burst motif is more common at sites in the Red River basin. Sites containing both motifs occur within a possible cultural "isoline" or corridor of interregional influence and exchange. Sites such as Murf Davis (3PI13), Stokes Mound (3PI17), and Hayes Mound along the Little Missouri drainage, Mineral Springs, Flowers, Jim Cole (3HE59), and Washington Mound along the Ozan Creek drainage, and the Ferguson site along Caruse Creek contain both motifs and occur in this corridor. To the south of the corridor, the Lester (3LA38) and Battle Mound sites along the Red River also contain both motif varieties, where the Battle Mound site has been suggested to represent an important community center where elaborate celebrations were held that served to reaffirm community membership and establish linkages to neighboring groups (McKinnon 2017:142–45).

Conclusions

This essay demonstrates the value of distributional analyses that move beyond contemporary state boundaries in order to develop broader questions related to inter-

Figure 9.10. Distribution of both rayed circle burst and rayed circle overhead motifs and their spatial relationships. Note the possible corridor of sites in proximity to the Little Missouri, Ozan Drainage, and Caruse Creek.

Legend:
- ● Overhead Motif
- ○ (gray) Burst Motif
- ○ Burst and Overhead Motif

Map labels: Southern Ouachita Mountains, Red River, Ouachita River, Saline River, Ouachita River, Red River, Sabine River, N, 0 70 140 Kilometers

regional interaction. Certainly, the database at present does not represent the full suite of ceramic material culture and sites across the Caddo landscape. As such, distribution analyses of larger data sets will provide additional insights. Nonetheless, the database in its present form is sufficiently comprehensive to evaluate relationships, visualize patterns, and develop hypotheses to test and refine at macro, meso, and micro scales. These can then be compared with other distributional sets for evaluation and comparison.

For example, the north and south differences in Foster Trailed-Incised temper and Crockett Curvilinear Incised vessel form mirror distinct regional expressions related to architecture, iconography, and mortuary practices (Perttula 2009b; McKinnon 2015; Sullivan and McKinnon 2013). Similarly, the distribution of the "rayed circle" design types reveals that the overhead motif occurs at sites to the north whereas the burst motif occurs at sites to the south. This distribution is similar to the northern use of shell tempering by Caddo potters of Foster Trailed-Incised vessels and grog tempering in vessels to the south with the co-occurrence of both temper types at Red River sites spatially between them. It is also similar to the use of Crockett Curvilinear Incised bowls to the south and both bowls and jar (carafe) forms to the north.

The distribution of ceramic types demonstrates the presence of clusters at different scales. Microscale distributions suggest strong community identities imbued in certain ceramic designs that are emblematic of a type. Mesoscale distributions may indicate economic exchange with proximate communities, or perhaps social exchange through exogamous marriage practices and kinship affinities. Last, mac-

roscale distributions suggest interconnectedness with broader traditional cultural designs that are shared among many broadly defined Caddo communities.

While not as developed as ceramic data, additional technological characteristics, such as instrumental neutron activation analysis (INAA) and petrographic studies, offer quantitative approaches to evaluate the technological basis of interregional interaction. Certainly, these kinds of data are being used more frequently and are likely to provide valuable insights into the origin, distributions, and exchange of manufacturing practices and their corresponding meanings. The current challenge is similar to the implementation of divergent ceramic classificatory approaches and their lack of interstate comparative data. At present, results from INAA and petrographic studies are not widely distributed or comprehensive enough to apply to interregional applications.

The Caddo material culture database will continue to grow and hypotheses will be confirmed or rejected as new data are considered. The database began with 360 vessels, of which 284 Foster Trailed-Incised vessels, largely from Arkansas, were analyzed (McKinnon 2011). Over the last seven years, the database has grown to include 13,034 whole vessels spread across all four states, of which 11,434 have provenience information. That is a significant increase, and as it continues to expand, as categories become refined, and qualitative datasets are added, the vessel database will continue to shed light on interregional interaction and community identity throughout the Caddo Archaeological Area.

10

Spatial Variation in Ripley Engraved Bowls among the Titus Phase Caddo of Northeastern Texas and Communities of Identity

Ross C. Fields

There is a long history of asking what spatial variation in pottery among the Titus phase Caddo of northeastern Texas means. This essay explains why that is and updates one recent attempt to explore the topic. To set the stage, I begin with a brief history of how our understanding of the Titus phase has evolved. Then I present the methods and results of an analysis of the distributions of varieties of the main fine-ware type that the Titus phase Caddo used: Ripley Engraved. This is followed by a cautionary case study looking at pottery from just one of the better-understood sites in the area, the Pine Tree Mound site (41HS15; see Fields and Gadus 2012a).

At the heart of this study is the notion that the abundant variation in the Ripley Engraved type may convey something about distinctions between the many social groups who made up the Titus phase and thus this variation may be informative about communities of identity, i.e., "social networks in which potters share a group identity . . . based in a shared language, migration history, religion, kinship, or some other social process" (Eckert 2008:3, cited in Worth 2017:139). Also relevant to the general topic of spatial variation in pottery is the concept of community of practice, which is "the geographically bounded aggregate of craftspeople with a common *chaîne opératoire* resulting from shared histories of learning and practice" (Worth 2017:151). The study presented here does not go down that path, however, since it focuses on a single nontechnological attribute, design variability.

What Is the Titus Phase?

The Titus phase is among the most intensively researched places and times in Caddo history, with synthetic treatments by Thurmond (1985, 1990), Perttula (1992, 2004), Perttula (2005, ed.), Perttula and Sherman (2009), Fields and Gadus

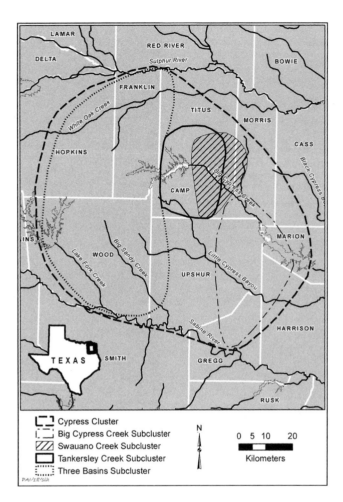

Cypress Cluster
Big Cypress Creek Subcluster
Swauano Creek Subcluster
Tankersley Creek Subcluster
Three Basins Subcluster

N

0 5 10 20

Kilometers

Figure 10.1. Map of Thurmond's (1990) Cypress cluster showing extents of hypothesized Titus phase subclusters.

(2012a), Fields (2014), and Fields et al. (2014). Although first defined decades earlier, it was Thurmond's work in the 1980s, building on that by Turner (1978), that planted the seeds for how we interpret the phase today. Thurmond (1990:229, 232) related the Titus phase to sites he assigned to the Cypress cluster, which was centered on the upper Cypress Creek, White Oak Bayou, and Lake Fork Creek basins in northeastern Texas (fig. 10.1) and appeared to span the period from ca. AD 1400 to 1600. He, and others, suggested that the phase represented the remains of Caddo groups equivalent to the well-known and ethnohistorically documented confederacies of the Hasinai in the Neches-Angelina basin to the south and the Kadohadacho in the Red River valley to the north. These groups lacked seventeenth- and eighteenth-century documentation because they were too fragmented by that time and most of their territory was off the beaten path.

Based on burial assemblage variability in this area, which was approximately 100 kilometers across both east-west and north-south axes, Thurmond (1985:191–96) saw four spatial subclusters of sites—which he named Three Basins, Tankersley Creek, Swauano Creek, and Big Cypress Creek—and proposed that they represented contemporaneous and sociopolitically integrated tribes or subtribes. The Three Basins and Big Cypress Creek sites were in the western and eastern parts of the area, respectively, and the Tankersley Creek and Swauano Creek sites had overlapping distributions in the central part of the region. Part of his analysis focused on differences between ceramics in these areas and, in particular, the use of various motifs on carinated bowls typed as Ripley Engraved, the predominant engraved ware across the whole region. As Thurmond (1990:214) well knew, the limitations of the data made his interpretations speculative, and he was not able to take his analysis further than just suggesting that the spatial differences in ceramic vessels in burial assemblages related to different Titus groups.

Since then, we have gained a better understanding of the archaeology of the region as a result of acquisition of new data and new synthetic studies. The spatial limits have been amended with Fields and Gadus's (2012a) work pushing the boundary of the phase south of the Sabine River in places. And the temporal pa-

rameters have changed because many more ra-
diocarbon dates are available today. The phase
commonly is seen as dating to ca. AD 1430–1680,
but there is good evidence for continuities back
into the AD 1300s and lasting into the AD 1700s.

Recent researchers have not found Thur-
mond's spatial subclusters to be very useful, in
part because they are too coarse-grained. For
example, Perttula (2005 ed.:357–64; Perttula
and Sherman 2009:375–77) scarcely mentions
them in some analyses, preferring instead to
talk about a string of proposed Late Caddo com-
munities along Big Cypress Creek in the Titus
phase heartland. Three of these communities,
in the southeastern part, are within the north-
ern section of Thurmond's Big Cypress Creek
subcluster, and two cross-cut both the Swauano
Creek and Tankersley Creek subclusters (fig.
10.2). More recently, a sixth community has been
suggested at the upstream end of the heartland,
in the area of the central part of the Tankersley
Creek subcluster (Perttula, Marceaux, and Nel-
son 2012:6–7)[1]. None of these communities is in
the area of the Three Basins subcluster, as it is
almost entirely outside the heartland.

According to Perttula and Sherman
(2009:375–77), these heartland communities

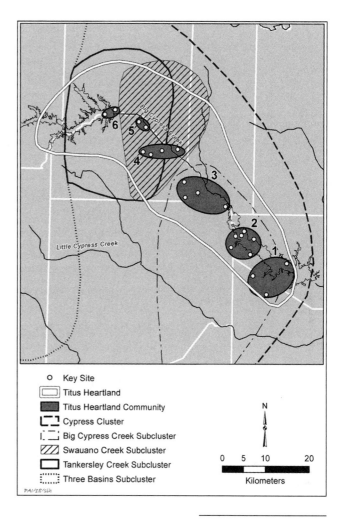

Figure 10.2. Map of the
Titus phase heartland
showing the extents of the
key sites for the six hy-
pothesized communities
there and Cypress sub-
clusters (key site extents
do not equate to the likely
extents of the communi-
ties themselves).

consisted of dispersed farmsteads and villages affiliated with key sites that con-
tained public architecture (mounds and ritual buildings) or large community cem-
eteries (as opposed to the smaller, more-ubiquitous family cemeteries), i.e., places
that were reserved for activities that integrated the community and bound its parts
together. They identify key sites for these six communities as follows, moving from
southeast to northwest: (1) one site with four mounds and two sites with more
than 150 graves; (2) seven mounds at two sites and four cemeteries with more than
500 graves; (3) three sites with three mounds and two sites containing more than
250 graves; (4) one site with a single mound and three community cemeteries with
284 graves; (5) two sites with single mounds; and (6) two cemeteries with at least
185 graves. Perhaps associated with the last of these, but not depicted in fig. 10.2,
are three sites with single mounds or probable mounds (Fields 2014:117, 134). The
proposed associations between sites within each of these groups are based solely
on physical proximity, rather than analyses of their contents, since what we know

about many of them comes from digging by looters. This limits what we can say confidently about them as communities, but it does not detract from the value of this as a model for how groups who inhabited this part of the Titus phase area may have arranged themselves geographically.

The community cemeteries are spatially distributed more equably than the mound sites, and hence, they may have served more universally to integrate communities, sometimes in the absence of ceremonial landscapes defined concretely by mounds and plazas. Three of the cemeteries are known to have contained large shaft graves, which surely held elite members of the society, and they are in separate groups of key sites, arguing that at least some of these truly were distinct communities occupied by groups of people who, although related, considered themselves different from their neighbors.

A case can be made that these six communities belonged to two larger and temporally persistent core communities with a dichotomy of "belief and cultural practices" within the heartland. One encompasses the three downstream groups of key sites listed above, and the other contains the three upstream ones. Perttula and Sherman (2009:397–401) see a split in ceramic traditions between these core communities. Trade wares such as Avery Engraved from McCurtain phase sites on the Red River to the north (see Essay 3) are more common in burial assemblages of the northwestern core community, along with more La Rue Neck Banded and untyped utility-ware jars and plain vessels overall. In the southeastern core community, Taylor Engraved, Bailey Engraved, and Simms Engraved appear as important secondary fine-ware types along with trade wares from the Belcher phase on the Red River to the east (see Essay 2). Utility wares for the southeastern sites include more Harleton Applique, Bullard Brushed, and Karnack Brushed-Incised jars. Ripley Engraved dominates the fine wares of both subtraditions (Perttula and Sherman 2009:400).

Another recent synthetic treatment of Titus phase spatial organization arose from work at the Pine Tree Mound site, which is outside the Big Cypress Creek heartland in the Sabine River basin. Its main contribution to this topic is that it hypothesizes a third Titus phase core community, centered on Pine Tree Mound (fig. 10.3), comparable with the two in the heartland (Fields and Gadus 2012a:673–77). One difference is that it does not identify any constituent local communities like those on Big Cypress Creek, although this probably relates mostly to a scarcity of data that would make such communities evident. Another contribution of the Pine Tree Mound project is that it emphasizes how important it is to look beyond the Big Cypress Creek heartland to gain a fuller understanding of what the Titus phase is all about. The maximum extent of the phase as shown by Perttula (2005 ed.:358) encompasses about 6,240 km² beyond the 1,350 km² heartland (i.e., 4.6 times larger), and Fields and Gadus's analysis suggests that in some areas this maximum boundary should be pushed even farther out (see fig. 10.3). These other

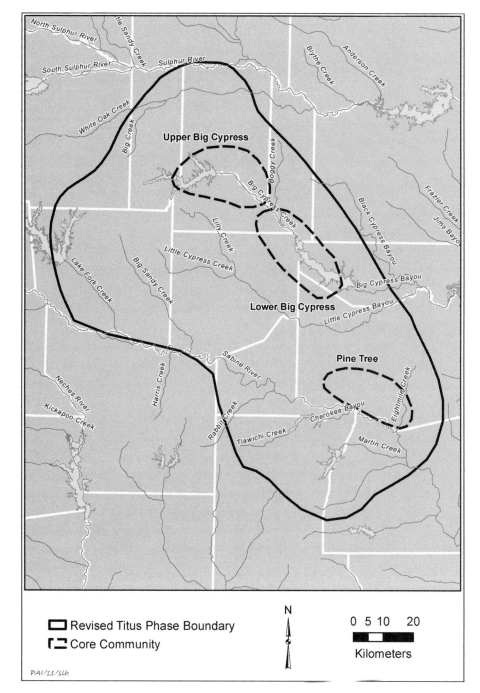

Figure 10.3. Map showing Fields and Gadus's (2012a) revised greater Titus phase boundary and the three known core communities.

nonheartland areas, including the entire Little Cypress Creek valley and those of north-side Sabine River tributaries west of Pine Tree Mound to Lake Fork Creek and the White Oak Creek basin along the northwestern margin of the region, may contain few or no communities like that around Pine Tree Mound, with its well-

Figure 10.4. Examples of Titus phase bottles, bowls, and jars (from the Pine Tree Mound site in the Sabine River basin).

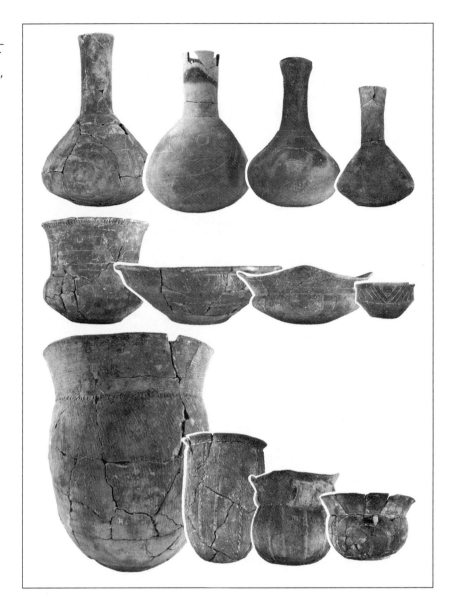

defined ceremonial space (multiple mounds around a plaza) and elite community cemetery all in one place, but they surely contain Titus communities of one sort or another. As appears to be the case in the heartland itself, these likely vary in terms of social complexity and how connected they were to other nearby communities.

The Current Study

The Titus phase Caddo produced a rich and varied assemblage of ceramic containers consisting of bottles, bowls, and jars (fig. 10.4). This study looks at only a

subset of the pottery, i.e., the primary fine-ware type throughout the area, Ripley Engraved bowls and carinated bowls. There are three main reasons for focusing on Ripley Engraved bowls and carinated bowls. First, its prevalence across the region implies that the engraved images it incorporates were central to Titus phase belief systems. But it is extremely varied, suggesting that there was no strong adherence to a single template and that there was a great deal of opportunity for potters to use those images in ways that distinguished one group from another, whether those groups were defined by social or other differences. Second, there are historical precedents for this kind of study; Ripley Engraved motif variation was an important part of what Thurmond used to define his Cypress subclusters but a less important part of what Perttula and Sherman used to distinguish ceramic subtraditions. Third, Perttula and his colleagues (Perttula, Walters, and Nelson 2012b) (and subsequently Gadus [see Fields and Gadus 2012a; Fields et al. 2014]) have codified some of the Ripley Engraved bowl and carinated bowl variation by defining named varieties of the type, and they are using this system in their ongoing efforts to document vessel collections from the region.

Sites Included in the Analysis

This study includes vessel assemblages from twenty-nine individual sites, plus one assemblage likely from one or more of four nearby sites on Caney Creek in Wood County (table 10.1 and fig. 10.5). This is not an exhaustive list of documented assemblages with Ripley Engraved bowls and carinated bowls as it excludes ones with very small samples; all of those in table 10.1 have at least five bowls or carinated bowls. These sites are distributed widely across the Titus phase area, extending approximately 120 kilometers from the Pine Tree Mound site on the southeast to the W. A. Ford, Atkinson, and Culpepper sites on the northwest (see fig. 10.5). Most sites ($n = 23$) are in the Cypress Creek basin, with fifteen on Big Cypress and eight on Little Cypress or their tributaries. Four assemblages are from sites in the Sabine River basin, one (Pine Tree Mound) far downstream from the others. The three northwestern-most sites are in the Sulphur River basin.

Half ($n = 15$) of the sites are within or close to the bounds of the three hypothesized core communities discussed above. Almost all of the others are far enough away that it seems likely they belong with other core communities, and a possible reason for this distribution is offered later in this essay. Even fewer sites ($n = 9$) can be associated with any of the six communities proposed for the heartland on Big Cypress Creek, three (Pilgrim's Pride, Tuck Carpenter, and H. R. Taylor) because they are considered key sites and the other six based strictly on physical proximity. The extents of these communities as depicted on figs. 10.2, 10.3, and 10.5, both core and heartland, are more conceptual than data-based, however, and thus the assignments suggested here should be taken with a grain of salt. Further, there is no consideration of how these communities may have shifted over time.

Figure 10.5. Map showing the locations of the Titus phase cemetery sites used in this comparative study and the three known core communities. (Note the boundaries of the two core communities on Big Cypress Creek have been adjusted slightly compared with those of fig. 10.3 to make them more inclusive of the sites studied).

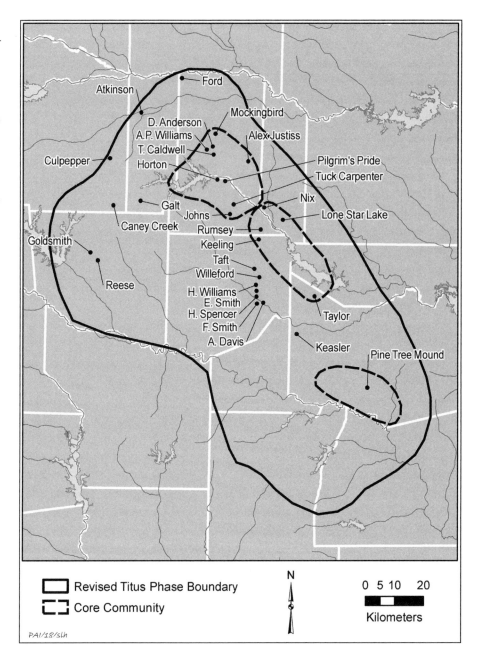

Some of the cemetery assemblages (e.g., Pilgrim's Pride, Mockingbird, and Pine Tree Mound) were acquired during recent investigations by professional archaeologists, and hence information on the numbers of graves and numbers of vessels recovered and analyzed is known with certainty. At the other end of the spectrum, essentially nothing is known about the sites that produced four of the assemblages (Rumsey, Lone Star Lake, Willeford, and Caney Creek), other than that

Table 10.1. Summary of Titus Phase Cemetery Sites Used in Comparative Study

Site	Local Drainage	Known Graves	Graves in Analyzed Sample	Analyzed/Total Vessels	Excavator	Core Community	Heartland Community	Cemetery Type	Reference
Big Cypress Creek (lower)									
H. R. Taylor (41HS3)	Copeland Creek	ca. 70	64	488/?	professional (UT, 1931)	Lower Big Cypress	1	community	Data on file with Perttula
Big Cypress Creek (middle)									
Rumsey (41CP3)	Greasy Creek	?	?	54/?	no excavation (collection purchased)	Lower Big Cypress	3	?	Perttula, Walters, and Nelson 2010a
Lone Star Lake (41MX65)	Ellison Creek	?	?	38/?	avocational	Lower Big Cypress	3	?	Perttula, Walters, and Nelson 2010a
Harold Nix (no trinomial; Marion Co.)	Boggy Creek	22?	9	78/120	avocational (Nicholas+, 1995–96)	Lower Big Cypress	3	family?	Perttula 2017b
Keeling (no trinomial; Upshur Co.)	Greasy Creek	15	?	34/?	avocational (Keeling)	Lower Big Cypress	3	family?	Perttula, Walters, and Nelson 2010a
Big Cypress Creek (upper)									
Johns (41CP12)	Prairie Creek	35	35	283/293	avocational (Johns and Turner, 1966–84)	Upper Big Cypress	4	family?	Perttula, Nelson, and Walters 2010; Perttula, Walters, and Nelson 2010a, 2010b
B. J. Horton (41CP20)	Big Cypress Creek	19+	11	83/?	avocational (Nicholas+, 1958, 1960s)	Upper Big Cypress	5	?	Perttula and Miller 2014; Perttula, Walters, and Nelson 2010a
Tuck Carpenter (41CP5)	Dry Creek	ca. 50	43	200/397	avocational (Turner and Walsh, 1963–67)	Upper Big Cypress	4	community	Perttula, Walters, and Nelson 2010a; Turner 1978
Pilgrim's Pride (41CP304)	Big Cypress Creek	19	19	137/137	professional (AEC, 1998–99)	Upper Big Cypress	5	family	Perttula, ed. 2005

Table 10.1. (*continued*)

Site	Local Drainage	Known Graves	Graves in Analyzed Sample	Analyzed/ Total Vessels	Excavator	Core Community	Heartland Community	Cemetery Type	Reference
Galt (41FK2)	Gum Creek	7?	6	53/52	professional (UT, 1931)	Headwaters	—	family	Data on file with Perttula
A. P. Williams (41TT4)	Tankersley Creek	10	10	88/87	professional (UT, 1934)	Upper Big Cypress	—	family	Fields et al. 2014
Thomas B. Caldwell (41TT6)	Tankersley Creek	10	10	90/95	professional (UT, 1934)	Upper Big Cypress	—	family	Fields et al. 2014
Alex Justiss (41TT13)	Swauano Creek	26	?	58/195	avocational (Nicholas+, 1950s); professional (TxDOT, 1973, 1975; PBS&J, 2001)	Upper Big Cypress	—	family	Bell 1981; Rogers et al. 2003
Duncan Anderson (41TT18)	Tankersley Creek	ca. 10	ca. 10?	77/?	avocational (Anderson, 1960s)	Upper Big Cypress	—	family	Fields et al. 2014; Perttula, Marceaux, and Nelson 2012
Mockingbird (41TT550)	Hayes Creek	11	11	89/89	professional (EHA, 1993–94)	Upper Big Cypress	—	family	Perttula et al. 1998
Little Cypress Creek (middle)									
Keasler (41HS235)	Little Creek	31+	?	69/?	avocational (1970s)	Lower Little Cypress	—	?	Perttula, Walters, and Nelson 2016
Willeford (41UR5)	Little Walnut Creek	?	?	15/?	avocational (UT purchased collection)	Middle Little Cypress	—	?	Perttula and Walters 2015
Henry Spencer (41UR315)	Gum Creek	43?	39	183/222w	avocational (Jones, 1957–58)	Middle Little Cypress	—	family?	Perttula, Nelson, and Walters 2012; Perttula, Walters, and Nelson 2012b
Enis Smith (41UR317)	Gum Creek	15	12	84/97?	avocational (Jones, 1958)	Middle Little Cypress	—	family?	Perttula, Nelson, and Walters 2012; Perttula, Walters, and Nelson 2012b

Site	Local Drainage	Known Graves	Graves in Analyzed Sample	Analyzed/ Total Vessels	Excavator	Core Community	Heartland Community	Cemetery Type	Reference
Henry Williams (41UR318)	Gum Creek	37	?	49/134+	avocational (Jones, 1954–55)	Middle Little Cypress	—	family?	Perttula, Nelson, and Walters 2012; Perttula, Walters, and Nelson 2012b
Taft (41UR320)	Gum Creek	6	6	41/42?	avocational (Jones 1958)	Middle Little Cypress	—	family?	Perttula, Walters, and Nelson 2012b
Frank Smith (41UR326)	Clear Creek	16	16?	77/67+	avocational (Jones, 1955–56, 1959)	Middle Little Cypress	—	family?	Perttula, Nelson, and Walters 2012; Perttula, Walters, and Nelson 2012b
A. Davis (no trinomial; Upshur Co.)	Clear Creek	11	1	7/?	avocational (Jones, 1961)	Middle Little Cypress	—	family?	Perttula and Nelson 2007
Sabine River (middle)									
Pine Tree Mound (41HS15)	Potters Creek	27	27	145/145	professional (PAI 2006–7)	Pine Tree	—	family	Fields and Gadus 2012
Sabine River (upper)									
J. H. Reese (41WD2)	Dry Creek	3	3	20/22?	professional (UT, 1930)	Dry Creek	—	?	Perttula and Walters 2016b
Goldsmith (41WD208)	Dry Creek	?	2	16/16	professional (Perttula and Skiles, 1985)	Dry Creek	—	family?	Perttula and Skiles 2014
Caney Creek (multiple? Wood Co.)	Caney Creek	?	?	58/?	avocational (Walters)	Headwaters	—	family?	Perttula, Marceaux, and Nelson 2009
Sulphur River									
Atkinson (41FK1)	White Oak Creek	6	6?	23/?	professional (UT, 1934)	Sulphur	—	family	Data on file with Perttula
Culpepper (41HP1)	Stouts Creek	19+	8	36/39	professional (UT, 1931)	Headwaters	—	family?	Perttula 2016d
W. A. Ford (41TT2)	Sanders Slough	12?	11	36/39	professional (UT, 1934)	Sulphur	—	family	Perttula 2016a

they contained graves that were excavated by avocational archaeologists; context is very poor for these. The rest of the sites lie between these extremes. Information is generally good for the eight cemeteries excavated by University of Texas personnel in the 1930s (H. R. Taylor, Galt, A. P. Williams, Thomas B. Caldwell, J. H. Reese, Atkinson, Culpepper, and W. A. Ford), even if it is not up to modern standards and some ambiguities remain. Also of generally good quality are the data from the Johns (Perttula, Nelson, and Walters 2010), Tuck Carpenter (Turner 1978; Perttula, Walters, Stingley, and Middlebrook 2017), and Alex Justiss (Bell 1981; Rogers et al. 2003) sites, which were excavated mostly or entirely by avocational archaeologists who recorded their work. However, for Alex Justiss, the vessels illustrated are not identified to specific graves, and for this site and Tuck Carpenter, significant numbers of the vessels recovered were not available for analysis.[2] Of the other eleven avocational-acquired assemblages, all but one (Taft) suffer from substantial data quality problems, including lack of information about the total vessel assemblage, lack of information about the graves from which the vessels came, and lack of information on significant portions of the assemblages recovered. For these (Harold Nix, Keeling, B. J. Horton, Duncan Anderson, Keasler, Henry Spencer, Enis Smith, Henry Williams, Frank Smith, and A. Davis), and the four noted above where context is poorest, the data gaps translate into uncertainty about how representative the documented vessel assemblages actually are. A lesser degree of uncertainty applies to the Alex Justiss (the analyzed assemblage constitutes just 30 percent of the vessels recovered from an unknown number of graves), Tuck Carpenter (the analyzed assemblage constitutes just over 50 percent of the vessels recovered, but from about 86 percent of the graves), H. R. Taylor (the total number of vessels recovered is unknown, although the analyzed sample represents more than 90 percent of the graves), and the Atkinson site (the total number of vessels recovered is unknown, although the analyzed sample appears to represent 100 percent of the graves).

The cemeteries also vary in terms of their functional interpretations, i.e., family vs. community. Previous analyses have suggested that only H. R. Taylor and Tuck Carpenter served whole communities (e.g., Fields et al. 2014:407–32; Perttula ed. 2005:379–80). Ten of the better-documented ones (Pilgrim's Pride, Galt, A. P. Williams, Thomas B. Caldwell, Alex Justiss, Duncan Anderson, Mockingbird, Pine Tree Mound, Atkinson, and W. A. Ford) can be interpreted with confidence as family burial grounds based on the small numbers of graves (see table 10.1; the two at Pine Tree Mound actually are small cemeteries in village areas at this mound center, which also has an unexcavated community cemetery). Another twelve (Harold Nix, Keeling, Johns, Henry Spencer, Enis Smith, Henry Williams, Taft, Frank Smith, A. Davis, Goldsmith, Caney Creek, and Culpepper) appear to be family cemeteries just based on the numbers of graves found, but this interpretation is weakened by the fact that they are not well documented. For the Rumsey,

Lone Star Lake, B. J. Horton, Keasler, Willeford, and J. H. Reese sites, the data are scant enough that it is best to not classify them in this regard.

Variability in terms of cemetery type could have important implications for this study. For example, it would be logical to think that different burial contexts could translate into differences in vessel assemblages, since several previous studies (e.g., Fields et al. 2014:405–33; Perttula ed. 2005:384–88; Perttula et al. 1998:381–92) have concluded that most graves of higher-status individuals are at community cemeteries. However, these same studies have shown this is not always the case. Some family cemeteries contain interments of higher-status people as well as commoners, and most of the graves at community cemeteries have no indications of high status, such as large and deep grave shafts, multiple individuals in single graves, especially numerous and varied offerings, highly visible offerings made non-locally of exotic materials, and inclusion of grave furniture like litters.

Also, the large cemeteries, which were used by multiple villages and likely represent "broad community-wide participation in ceremonial and mortuary rituals" (Perttula and Sherman 2009:394), clearly have specific histories reflecting growth over significant spans of time, whereas the smaller family cemeteries likely were used over shorter spans. Greater variety in ceramics in the former rather than the latter would be a logical outcome of this. Further complicating matters, Fields and Gadus (2012a:363) argue that the two family cemeteries at the Pine Tree Mound site were used for even shorter spans than their associated residential areas, with the early and late occupants having been buried elsewhere (e.g., in the community cemetery there or in other family cemeteries). How commonly this occurred across the greater Titus phase area is unknown.

In short, the cemetery assemblages vary in both data quality and context. It is hard to know how this affects the analysis below, but it would be naïve to think that it does not.

Ripley Engraved Bowl and Carinated Bowl Varieties

Eighteen varieties of Ripley Engraved bowls and carinated bowls are used in this analysis (table 10.2), following those used by Fields and Gadus (2014:473–75), but with some simplifying substitutions in variety names. These are based on differences in design elements selected and how they were combined to create motifs, and as such, this study excludes previously identified varieties (Walkers Creek and Xena) that are based on other characteristics (Perttula ed. 2005:245–55). Also excluded are several varieties (e.g., Dry Creek, Dragoo, and Nix) that have been defined or named very recently, since their presence/absence is known for only a few sites, as well as bowls classed as Ripley Engraved but unidentified as to variety.

Nine of the eighteen varieties (Enis Smith, Mockingbird, Diana, Richey, Starkey, Pine Tree, Spencer, Harvard, and Tiddle) were defined by Fields and Gadus (2014:473–75), and the others were defined by Timothy K. Perttula and colleagues

Table 10.2 Ripley Engraved Varieties Based on Bowls

Variety	Description
Galt	Scroll (generally slanted) with circle as primary element. Circle can be partial, but more than half is present. Circle can have small circle, cross, or diamond element within it. Circle may be defined by hatched surrounds. No other secondary elements factor into variety definition. Encompasses Thurmond's scroll and circle motif.
McKinney	Horizontal scroll with pendant triangles secondary element on upper and lower arms of scroll. Can have open circle, circle with cross, diamond, diamond with cross, or some combination of these as primary elements. Encompasses Thurmond's pendant triangle motif.
Enis Smith (formerly McKinney-Enis Smith)	Version of variety McKinney with simple bar or no primary element between the scroll arms. Rather, the arm is bent up or down to form rounded abutting scroll ends. Retains the straight scroll and pendant triangles of McKinney.
Carpenter	Slanted scroll with no primary element between the scroll arms. Secondary elements within scroll arm do not factor into variety definition. Encompasses Thurmond's continuous scroll motif.
Gandy	Horizontal or slanted scroll with arms making a bisected simple scroll. No primary element or only a simple line between the scroll arms, which have rounded ends. This is Thurmond's scroll motif minus the SZ primary element.
Mockingbird (formerly Gandy-Mockingbird)	Version of variety Gandy with crosshatched zones between and around the scroll arms.

Variety	Description
Diana (formerly Gandy-Pine Tree)	Version of variety Gandy with SZ primary element and slanted or horizontal scroll arms. This is true to Thurmond's original scroll motif. Version of variety Gandy with SZ primary element and slanted or horizontal scroll arms. This is true to Thurmond's original scroll motif.
Cash	Slanted scroll with two opposed scroll arms that form triangular areas often filled with secondary circular element, curl, or simple hatching. Secondary element is not a factor in variety definition, but primary element between the scroll arms is generally some form of circle. May encompass Thurmond's circle and nested triangle motif.
Caldwell	Slanted scroll with half-circle primary element. No secondary elements factor into variety definition. May encompass Thurmond's scroll and semicircle motif.
Richey	Generally horizontal scroll with arm ends curled back on themselves. Engraved lines of an arm end in a small excised or hatched triangle. May have SZ, simple bar, or no primary element between the arms.
Reed	Band motif with triangular elements alternating with bars, curls, or other elements. May encompass Thurmond's bisected diamond motif.
Williams	Band motif with the three repeating slanted lines alternating with a circle, curl, or other element. May encompass Thurmond's alternating nested triangle motif.
Starkey	Band motif with alternating half circles and bar elements. Half circles may have central vertical line. Hatching or crosshatching may surround these elements.

Table 10.2 (*continued*)

Variety	Description
Pine Tree	Band motif with alternating SZ, circle, or half circle elements. Hatching or crosshatching may surround these elements.
Spencer	Band motif of nested semicircles emerging from lowest carination line and that may repeat or alternate with straight bars, slanted bars, or semicircle extending down from upper carination line. Hatching or crosshatching may surround these elements.
Pilgrim (formerly Pilgrim's)	Horizontal scroll with interlocking arms that may have simple bisecting line. No primary element between scroll arms. Similar to variety Gandy but more rectilinear. Similar to Thurmond's interlocking horizontal scroll.
Harvard	Sinuous slanted scroll arms that are not broken by primary element, i.e., a continuous scroll. Scroll arms may be bisected by central line.
Tiddle	Rectilinear horizontal scroll with or without hatched line bisecting the scroll arms. Arms interlock to form a series of elongated and nested Zs.

(Perttula, Nelson, and Walters 2012; Perttula, Walters, and Nelson 2010a, 2010b, 2012b), with motifs illustrated by Thurmond (1990:fig. 6) as the starting point. Perttula's group has been using these varieties in their efforts to document vessels in various private collections from the region for almost two decades, and it is because of their studies that an analysis such as this one is possible.

The variety definitions in table 10.2 were derived from inspection of many vessel photographs (usually one per vessel), some drawings, and accompanying descriptions; they are an attempt to verbalize what the published classifications appear to be based on. They are general in that they rely on basic decorative elements and

their arrangements and exclude other potentially important information, such as secondary elements or how a motif plays out around a vessel, because the latter could not be consistently discerned. Most of the variety classifications made by Perttula and colleagues were consistent with the descriptions in table 10.2, but some were not, and in those cases the identifications made by Fields and Gadus are used. For sites with published reports containing vessel drawings as well as photographs (e.g., Mockingbird, Pilgrim's Pride, and Tuck Carpenter), there is ample information for assigning vessels to varieties. This also is the case for the collections to which Fields and Gadus had direct access, i.e., the Thomas B. Caldwell, A. P. Williams, and Pine Tree Mound sites, as well as a small part of the Duncan Anderson site collection.

Because not all the varieties have been clearly and fully described, it sometimes was hard to determine what design elements were considered important when the varieties were first defined. Lack of guiding definitions can lead to overly broad or extremely narrow varieties. One example of an overly broad variety is *var. Galt*, defined as a slanted scroll with a circle for a primary element based on Thurmond's Motif C (Perttula, Nelson, and Walters 2012:10–11). The kind of circle is not specified, although a cross-in-circle is shown in Thurmond's original figure. Even though there is considerable variation in the treatment of circles within this motif, no attempt was made here to account for that variation because it was not consistently discernible for all the vessels considered.

In contrast, differences within *var. Gandy* could be separated reliably because they were observable within the basic motifs. *Var. Gandy* originally was defined as Thurmond's Motif B (Perttula, Nelson, and Walters 2012:10–11), which is a horizontal or slanted, bisected, simple scroll with rounded arm ends and no primary element or only a simple line between the scroll arms. In addition to this, two other versions could be defined: one with an SZ as a primary element within a scroll, here called *var. Diana*; and one with cross-hatched zones between and around the scroll arms, here called *var. Mockingbird*. In addition, varieties *Harvard* and *Tiddle* were separated out of *var. Pilgrim*, and a variation of *var. McKinney* was separated out as *var. Enis Smith* (see table 10.2).

Among the newer varieties, *var. Starkey* is a basic band motif with alternating half-circles and bar primary elements, *var. Pine Tree* is a band motif with alternating SZ, circle, or half-circle elements, and *var. Spencer* is a band motif of repeating nested semi-circles (see table 10.2). Band motifs are almost as common on Ripley Engraved bowls as scroll motifs. A band motif is composed of alternating or repeating primary elements that are not connected, except by proximity, as they encircle the design field. Thurmond's (1985, 1990) Motifs H, J, K, and I are all band motifs. Band and scroll motifs share common elements, some of which, such as the cross-in-circle and SZ, are found alone on other vessels, suggesting that they have intrinsic meaning that does not rely on their position within either a band or a scroll.

DISTRIBUTIONS

Table 10.3 shows the breakdown of 870 Ripley Engraved bowls in the thirty ana-lyzed collections by variety. It is difficult to see obviously meaningful patterns in these site-by-site data, in part because some samples are so small, although some patterns are evident. Just three varieties (*Galt*, *McKinney*, and *Carpenter*) over-whelm the others, accounting for 54 percent of the collection. Of these, *var. Galt* is almost ubiquitous, as it is present at all but one site. As noted, this variety as used here is probably overly inclusive, so its common occurrence is not surprising. *Var. McKinney* and *var. Carpenter* are only slightly less numerous, with the former being almost as widespread (twenty-three assemblages) and the latter less so (seventeen assemblages). *Var. Galt* is especially common in the small assemblages from the J. H. Reese and Goldsmith (63 percent for each) sites, both in the middle Sabine River basin, and it is especially infrequent at Harold Nix (2 percent) in the mid-dle Big Cypress basin and the very small collection from Willeford (0 percent) in the Little Cypress basin. Otherwise, it varies gradually from 9 to 38 percent. *Var. Carpenter* is especially frequent (75 percent) in the small collection from the W. A. Ford site and least common (where it occurs at all) at Enis Smith and Frank Smith (2 and 4 percent) in the Little Cypress basin and Pine Tree Mound (5 percent) in the Sabine River basin. The seven sites where it is missing are in the middle Big Cypress basin, the Little Cypress basin, and the upper Sabine River basin. Apart from these, it varies, mostly gradually, from 8 to 39 percent. *Var. McKinney* is most common at the A. Davis (60 percent) site in the Little Cypress valley and at the Harold Nix (54 percent) site in the upper Big Cypress valley, and least common (0–3 percent) at fourteen sites in the upper Big Cypress basin ($n = 6$), Little Cypress basin ($n = 2$), Sabine River basin ($n = 3$), and Sulphur River basin ($n = 3$). Other-wise, it varies moderately from 10 to 44 percent.

Not surprisingly, some varieties with especially small samples have more re-stricted distributions. For example, the five vessels classed as *var. Mockingbird* all come from the upper Big Cypress basin, albeit from three sites, and the five *var. Starkey* vessels are all from one site in the middle Sabine River valley. Others are more widespread. The six *var. Tiddle* vessels are from four sites in the upper Big Cypress, Little Cypress, and middle Sabine River basins; the seven *var. Pine Tree* vessels are from three sites in the upper Big Cypress and middle Sabine basins; and the eight *var. Harvard* vessels are from four sites in the upper Big Cypress Creek and upper Sabine River basins.

The ten varieties with moderate sample sizes ($n = 14$–77) are distributed in various ways. None occurs at fewer than five sites, and one (*var. Gandy*) is present in twenty-two assemblages. Most widespread are *var. Gandy*, *var. Caldwell*, *var. Williams*, and *var. Pilgrim*, as each occurs in all but one of the seven drainage basin segments under consideration here (*var. Gandy* is missing only in the lower Sabine; *var. Caldwell* is missing only in the upper Sabine; *var. Williams* is missing only in

Table 10.3. Breakdown of Ripley Engraved Bowl Varieties by Site

Site	Galt	Mc-Kinney	Car-penter	Enis Smith	Gandy	Mock-ingbird	Diana	Cash	Cald-well	Richey	Reed	Wil-liams	Star-key	Pine Tree	Spencer	Pilgrim	Harvard	Tiddle	Totals
H. R. Taylor	10	47	9	6	4			6	2		1	11				11			107
Rumsey	1	3	2	1	1											2			10
Lone Star Lake	3	1		3	1							1							9
Harold Nix	1	22		15	1			1								1			41
Keeling	1	4	1	1	1			1	1			1							11
Johns	25	13	15	2	9		2	13	2		5	7				1			94
B. J. Horton	2		3					1			2	1							9
Tuck Carpenter	27	21	53	1	5	1	8	8	7		4	7							142
Pilgrim's Pride	3		2					1			1	2			5	1	4	3	22
Galt	4		2		10		5					3							24
A. P. Williams	8		7		2	1		4	4		1	2		3	1		1		34
Thomas B. Caldwell	5	3	12		1			2	1	5		1		1					31
Alex Justiss	1	6	2		3			1		5		1			1	1			21
Duncan Anderson	6		4				2				1	3					1	1	17
Mockingbird	5		8		3	3	2	1	3							1			26
Keasler	7	2	2	1	2				1			4				1		1	21
Willeford		1		4															5
Henry Spencer	5	1	6		3		3	1		2	2	5			6	1			35
Enis Smith	6	11	1	11	5			3		2		2							41
Henry Williams	4			7	4		2	2		1									20
Taft	2	7	2	2	1				2										16
Frank Smith	3	9	1	3	3			2	1						1				23
A. Davis	1	3														1			5
Pine Tree Mound	10		2				4	3	3		1	6	5	3				1	38
J. H. Reese	5	1			2														8
Goldsmith	6		1									1							8
Caney Creek	8				8				2			1				1	2		22
Atkinson	6		4		1														11
Culpepper	2		1		7											1			11
W. A. Ford	1		6				1												8
Totals	168	155	146	57	77	5	29	50	29	15	18	58	5	7	14	23	8	6	870

the Sulphur; and *var. Pilgrim* is missing only in the lower Sabine). *Vars. Richey* and *Spencer* have the most restricted distributions. Both occur only in the upper Big Cypress and Little Cypress Creek basins. The other four varieties (*var. Cash, var. Enis Smith, var. Diana,* and *var. Reed*) fall in the middle; each has been found in four or five of the drainage basin segments. The fact that there is a strong positive correlation ($r = 0.88$) between a variety's sample size and its ubiquity argues strongly that some of what we are seeing in the distributions is related to numbers of vessels and thus is not necessarily meaningful culturally.

A logical approach to investigating whether the Ripley Engraved bowl varieties are informative about communities of identity would involve looking at their distributions in relation to proposed spatial subdivisions of the Titus phase defined on other grounds, i.e., the three core and six heartland communities discussed above. As noted, however, these spatial systematics (especially the proposed heartland communities) can be applied to no more than half the sites. The study below starts with the more-inclusive of the two schema, i.e., the three previously defined core communities. Fifteen sites are assigned to these, as follows: (1) Lower Big Cypress—H. R. Taylor, Rumsey, Lone Star Lake, Harold Nix, and Keeling; (2) Upper Big Cypress—Johns, B. J. Horton, Tuck Carpenter, Pilgrim's Pride, A. P. Williams, Thomas B. Caldwell, Alex Justiss, Duncan Anderson, and Mockingbird; and (3) Pine Tree—Pine Tree Mound. The remaining fifteen sites are put into five other groups based on their locations: (1) Lower Little Cypress—Keasler; (2) Middle Little Cypress—Willeford, Henry Spencer, Enis Smith, Henry Williams, Taft, Frank Smith, and A. Davis; (3) Dry Creek—J. H. Reese and Goldsmith; (4) Sulphur—Atkinson and W. A. Ford; and (5) Headwaters—Caney Creek, Galt, and Culpepper (fig. 10.6). For the Middle Little Cypress and Dry Creek groups, the sites are close enough to one another that lumping is an obvious thing to do. The Sulphur and Headwaters sites are more dispersed, however, as the areas they encompass are no larger than those covered by each of the three previously proposed core communities. The Headwaters group is different than the others in that it is not restricted to a single drainage basin. The rationale for grouping these three sites is that all are in the upper parts of their respective basins (Big Cypress, Sabine, and Sulphur), well removed from sites downstream. For the purposes of this analysis, these five spatial groupings are considered to represent parts of provisional core communities, albeit ones even less understood and more hypothetical than the three previously defined ones.

As above, *var. Galt* and *var. Carpenter* are most widespread, occurring in all eight groups, and *var. Gandy* and *var. Williams* are not far behind in their occurrence in seven groups (table 10.4). Most restricted are *var. Mockingbird* (only in Upper Big Cypress) and *var. Starkey* (only in Pine Tree), followed by *var. Richey* (Middle Little Cypress and Upper Big Cypress), *var. Pine Tree* (Pine Tree and Upper Big Cypress), *var. Spencer* (Middle Little Cypress and Upper Big Cypress), and *var.*

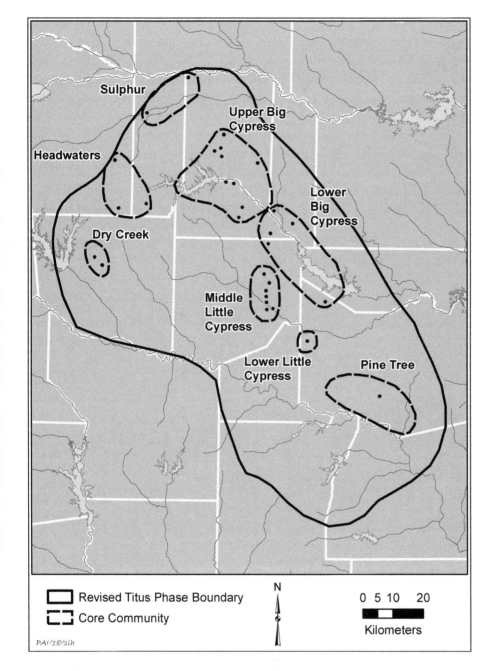

Figure 10.6. Map showing the locations of the Titus phase cemetery sites used in this comparative study and their spatial groupings.

Harvard (Upper Big Cypress and Headwaters). The other eight varieties are represented in three to six groups. As with the site-by-site comparison, there is a strong positive correlation ($r = 0.88$) between sample size and group representation, suggesting that ubiquity is at least partly a function of the number of vessels.

Var. Galt ranks first or second in six of the eight groups (all but the Lower Big Cypress and Middle Little Cypress), *var. McKinney* and *var. Carpenter* each rank

first in two (Lower Big Cypress and Middle Little Cypress, and Upper Big Cypress and Sulphur, respectively), *var. Gandy* ranks first or second in two (Headwaters and Dry Creek), and *var. Enis Smith* and *var. Williams* each rank second in two (Lower Big Cypress and Middle Little Cypress, and Pine Tree and Lower Little Cypress, respectively). The Lower Big Cypress group is dominated by *var. McKinney* and *var. Enis Smith*. The Upper Big Cypress group is mostly *var. Carpenter* and *var. Galt* vessels. The Pine Tree assemblage is mostly *var. Galt, var. Williams, var. Starkey,* and *var. Diana*. The Lower Little Cypress assemblage is similar in that *var. Galt* and *var. Williams* vessels predominate, but *var. McKinney, var. Carpenter,* and *var. Gandy* vessels also are well represented. The Middle Little Cypress cemeteries have mostly *var. McKinney, var. Enis Smith,* and *var. Galt*. The Dry Creek group is dom-

Table 10.4. Distribution of Ripley Engraved Bowl Varieties by Core Community

Variety	Lower Big Cypress		Upper Big Cypress		Pine Tree		Lower Little Cypress		Middle Little Cypress		Dry Creek		Sulphur		Headwaters	
	No.	%	No.	%	No.	%	No.	%	No.	%	No.	%	No.	%	No.	%
Galt	16	9	80	20	10	26	7	33	23	16	10	63	5	26	17	30
McKinney	77	43	43	11	0	0	2	10	32	22	1	6	0	0	0	0
Carpenter	12	7	106	27	2	5	2	10	10	7	1	6	10	53	3	5
Enis Smith	26	15	3	1	0	0	1	5	27	19	0	0	0	0	0	0
Gandy	8	4	23	6	0	0	2	10	16	11	2	13	1	5	25	44
Mockingbird	0	0	5	1	0	0	0	0	0	0	0	0	0	0	0	0
Diana	0	0	14	4	4	11	0	0	5	3	0	0	1	5	5	9
Cash	8	4	31	8	3	8	0	0	8	6	0	0	0	0	0	0
Caldwell	3	2	17	4	3	8	1	5	3	2	0	0	2	11	0	0
Richey	0	0	12	3	0	0	0	0	3	2	0	0	0	0	0	0
Reed	1	1	14	4	1	3	0	0	2	1	0	0	0	0	0	0
Williams	13	7	23	6	6	16	4	19	7	5	1	6	0	0	4	7
Starkey	0	0	0	0	5	13	0	0	0	0	0	0	0	0	0	0
Pine Tree	0	0	4	1	3	8	0	0	0	0	0	0	0	0	0	0
Spencer	0	0	7	2	0	0	0	0	7	5	0	0	0	0	0	0
Pilgrim	14	8	4	1	0	0	1	5	2	1	1	6	0	0	1	2
Harvard	0	0	6	2	0	0	0	0	0	0	0	0	0	0	2	4
Tiddle	0	0	4	1	1	3	1	5	0	0	0	0	0	0	0	0
Totals	178		396		38		21		145		16		19		57	
No. of varieties	10		17		10		9		13		6		5		7	

inated heavily by *var. Galt*. The Sulphur River group is mostly *var. Carpenter* and *var. Galt*. Finally, the Headwaters group is mostly *var. Gandy* and *var. Galt* vessels.

The eight spatial groupings can be boiled down to four as follows: (1) Lower Big Cypress and Middle Little Cypress groups are similar because of the predominance of *var. McKinney* and *var. Enis Smith*; (2) Upper Big Cypress and Sulphur groups share *var. Carpenter* and *var. Galt* as predominant varieties; (3) the Pine Tree and Lower Little Cypress groups are similar in the predominance of *var. Galt* and *var. Williams*; and (4) Dry Creek and Headwaters groups share *var. Galt* and *var. Gandy* as predominant varieties. It may not be a coincidence that each member of these pairs is spatially proximate to one another, but it is hard to interpret this in any detail. There are at least two main reasons for this. First, *var. Galt*, clearly an inclusive variety, plays an important role in three of the four groups. Second, within each pair, there are distinct differences in the representation of minor varieties. It is uncertain how these similarities and differences relate to things like the subjectivity of the analytical scheme and sample size inadequacies, to say nothing of other potential complicating factors, including problems with understanding some of the contexts that the vessels came from, variability in cemetery function, variable cemetery use histories, movement of potters between communities, and relocation of communities over time.

In a more positive vein, some of the patterning above supports Perttula and Sherman's (2009:397–401) conclusion that there was a split in ceramic traditions between the lower and upper parts of the Big Cypress basins. They saw this somewhat in the decorations on fine wares, but also in trade wares and local utility wares, and it formed part of the basis for defining the two core communities, which they believe represent persistent differences in "belief and cultural practices" there. The information presented above argues that continued dissection of ceramic assemblage data could lead to more insights about Titus phase spatial organization at the core community level over a much larger area, even if it is not clear what that means. Community of identity (at some level) is certainly one possibility. Spatial aggregations of sites akin to the core communities may well turn out to be the best way to look for subdivisions relating to Titus phase subgroups, but the similarities in Ripley Engraved motifs across the region suggest a larger pattern reflecting overall unity. On these grounds, the Titus phase as a whole stands its ground as a community of identity distinct from contemporaneous neighboring Caddo groups to the north, east, and south.

The Pine Tree Mound Site Example

Data from the Pine Tree Mound site, the southeastern-most Titus phase site considered in this study (see fig. 10.6), provides some instructive lessons for using ceramic assemblages to address group identity, offering an opportunity to look for

signs of both unity and discreteness in a fully analyzed assemblage (Gadus and Fields 2012:387–467). It is well suited to this because the assemblage comes from two contemporaneous (mostly AD 1400s), small (thirteen clustered graves in Area 2 and eight clustered graves in Area 8, with three scattered graves in each) family burial plots associated with residential areas about 350 meters apart at the edge of the main Pine Tree Mound village, approximately 400 meters from the ceremonial precinct defined by a plaza central to three mounds and a probable but unexcavated community cemetery.

The cemeteries appear to represent households that were separate and distinct parts of an integrated community. The roles in the community of the people buried there likely were similar in that they were among those who lived close to, but not within, the ceremonial precinct rather than in outlying hamlets. Most graves in both areas apparently were those of commoners, but each cemetery had higher-status people too. Both plots were used for shorter spans of time than the associated residential areas and were not large enough to accommodate all who lived and died there; the missing individuals may have been buried in the nearby community cemetery or perhaps in small cemeteries elsewhere as these families abandoned Areas 2 and 8 and then reoccupied other parts of the village.

The Area 2 graves contained ninety-eight vessels, and the Area 8 graves contained forty-seven. Not surprisingly, the assemblages are similar in some ways and different in others (table 10.5). Grog, sometimes in combination with bone, is the most common tempering agent in both but is more predominant in Area 8 than in Area 2. This is true for all three main vessel forms (bottles, bowls, and jars), which as noted below, occur in similar percentages in the two assemblages. This implies manufacture by different groups of potters who sometimes made different technological choices. The fact that the vessels are similar in terms of both core color and exterior color suggests the use of similar firing techniques, however, with the latter also reflecting similar desired ultimate vessel colors. Another color-related attribute, pigment additions in engraved lines, also has a very similar distribution for both areas.

Vessel forms have nearly identical representations in both areas. The only differences in this respect are that three of the bottles from Area 2 are a form with four distinct corners, one of the bowls from Area 8 is a pedestaled form, carinated and compound bowls have equal representation in Area 8 but compound forms are slightly more common in Area 2, and the only olla is from Area 2. Other form-related differences are that more vessels from Area 2 have peaked rims while scalloped rims are more common in Area 8.

Typologically, the bottles from both areas are mostly Ripley Engraved followed by Wilder Engraved. One bottle from Area 2 is typed as Hodges Engraved. Of the jars, 25 percent of those from Area 2 and 42 percent from Area 8 are typed as Pease Brushed-Incised. Also common are untyped brushed jars, some with punctations

(38 percent in Area 2 and 33 percent in Area 8). Area 2 also produced single examples of Cass Applique, Cowhide Stamped, Karnack Brushed-Incised, and La Rue or Nash Neck Banded jars and two Harleton Applique jars, while Area 8 had only single Harleton Applique, Maydelle Incised, and possible Taylor Engraved jars as minor types. Given the small sample sizes, it probably would be a mistake to make much of the differences in the bottle and jar types, although the greater variety of nonlocal vessels, especially the Hodges Engraved bottle and the Cass Applique and Cowhide Stamped jars, in Area 2 suggests differences in access to goods from far-flung places. Further, the Ripley Engraved bottles vary some in terms of motif composition, with Area 2 bottles having scrolls or circular elements decorated with pendant triangles and Area 8 bottles more commonly having decorated concentric bands with pendant triangles around the body.

Apart from a single imported Poynor Engraved vessel from Area 8, all of the typed bowls are Ripley Engraved (56 percent of the bowls from Area 2 and 67 percent from Area 8). Untyped plain bowls are more common in Area 2 than Area 8 (26 percent vs. 17 percent), as are untyped decorated bowls (18 percent vs. 13 percent). In terms of Ripley Engraved bowl varieties, the Area 2 assemblage is mostly *var. Galt, var. Diana, var. Caldwell,* and *var. Williams,* while the predominant varieties from Area 8 are *var. Starkey, var. Galt, var. Williams,* and *var. Pine Tree.* The larger Area 2 assemblage has a longer list of minor varieties (*var. Carpenter, var. Cash, var. Pine Tree, var. Reed,* and *var. Starkey*) than the Area 8 assemblage (*var. Cash* and *var. Tiddle*). Considering the main varieties only, *var. Galt* and *var. Williams* unite Areas 2 and 8, and *var. Diana, var. Caldwell, var. Starkey,* and *var. Pine Tree* separate them.

Gadus and Fields (2012:379–82) concluded that some of the differences noted above "could relate to the maintenance of group or family identity." Further, they posited the following: (1) "differences between the common vessel motifs from Areas 2 and 8 appear . . . not in the use of one element or the other, but in the ways that similar elements were combined, [which] suggests the potters, and by extension the families or clans they belonged to, could control the way meaning was expressed"; (2) "the motifs and elements used on the vessels included as grave offerings may have served to mark or display the strength of an individual's social ties within the community"; and (3) "the offerings are an accumulation of specific symbols from an overarching Caddo cosmology that reflects an individual's choices or achievements over a lifetime of participation within a particular community." The Pine Tree Mound site evidence suggests that a variety of factors affected how and why potters selected and composed images on fine-ware vessels, ranging from association with both smaller and larger social groups and the status and role of the user. "This may explain both the similarities in theme and the great variation in design structure that is so prevalent in Ripley Engraved ceramic vessels and in Middle to Late Caddo ceramics in general" (Gadus and Fields 2012:383).

Table 10.5. Comparison of the Vessel Assemblages from Areas 2 and 8 at the Pine Tree Mound Site

	Area 2		Area 8		Total
	No.	**%**	**No.**	**%**	
Temper					
Grog	25	26	15	32	40
Grog/bone	28	29	17	36	45
Bone	43	44	14	30	57
Sand	2	2	1	2	3
Total	*98*		*47*		*145*
Core Color					
Black	55	56	26	55	81
Dark brown	3	3	1	2	4
Gray	34	35	12	26	46
Light brown	4	4	2	4	6
Yellow	0	0	3	6	3
Unknown	2	2	3	6	5
Total	*98*		*47*		*145*
Exterior Color					
Black	4	4	6	13	10
Dark brown	49	50	18	38	67
Gray	2	2	5	11	7
Light brown	21	21	9	19	30
Red	8	8	5	11	13
Yellow	14	14	4	9	18
Total	*98*		*47*		*145*
Pigment Color					
Green	1	1	2	4	3
Red	14	14	7	15	21
White	17	17	7	15	24
None	66	67	31	66	97
Total	*98*		*47*		*145*
Vessel Form					
Bottle	20	20	11	23	31
Bottle, 4-corner	3	3	0	0	3
Bowl, carinated	21	21	11	23	32
Bowl, compound	27	28	11	23	38
Bowl, pedestal	0	0	1	2	1
Bowl, simple	2	2	1	2	3
Jar	24	24	12	26	36
Olla	1	1	0	0	1
Total	*98*		*47*		*145*

	Area 2		Area 8		Total
	No.	%	No.	%	
Lip Elaboration					
Extended	2	7	0	0	2
Peaked	17	63	2	22	19
Punctated	2	7	0	0	2
Scalloped	6	22	7	78	13
Total	27		9		36
Type					
Cass Applique	1	1	0	0	1
Cowhide Stamped	1	1	0	0	1
Harleton Applique	2	2	1	2	3
Hodges Engraved	1	1	0	0	1
Karnack Brushed-Incised	1	1	0	0	1
La Rue or Nash Neck Banded	1	1	0	0	1
Maydelle Incised	0	0	1	2	1
Pease Brushed-Incised	6	6	5	11	11
Poynor Engraved	0	0	1	2	1
Ripley Engraved	40	41	20	43	60
Taylor Engraved	0	0	1	2	1
Wilder Engraved	3	3	2	4	5
Untyped, brushed	5	5	1	2	6
Untyped, brushed and punctated	4	4	3	6	7
Untyped, engraved	7	7	5	11	12
Untyped, incised	2	2	2	4	4
Untyped, incised and punctated	1	1	0	0	1
Untyped, plain	18	18	5	11	23
Untyped, plain, red slipped	1	1	0	0	1
Untyped, punctated	4	4	0	0	4
Total	98		47		145
Ripley Bowl Variety					
Caldwell	3	11	0	0	3
Carpenter	2	7	0	0	2
Cash	2	7	1	6	3
Galt	7	25	3	19	10
Diana	4	14	0	0	4
Pine Tree	1	4	2	13	3
Reed	1	4	0	0	1
Starkey	1	4	4	25	5
Tiddle	0	0	1	6	1
Williams	3	11	3	19	6
Unclassified	4	14	2	13	6
Total	28		16		44

At one level, the distributions of the Ripley Engraved bowl varieties could be seen as being consistent with the idea that the people who lived in Areas 2 and 8 were separate and distinct parts of an integrated community. Even if one accepts the notion that they used decoration on fine-ware bowls to convey this, however, it would seem they did not use that mechanism solely. Just within the pottery, there are both similarities and differences in other attributes that would have been readily visible and thus could have conveyed the same message. Among the former are the similarities in vessel and pigment colors and overall vessel forms. Among the latter are the presence of four-corner bottles only in Area 2, the differences in Ripley Engraved bottle motifs, and the contrasting percentages of peaked rims and scalloped rims in the two areas. This comparison does not even begin to address clues in other aspects of the archaeological record.

Further, the notable differences between the assemblages highlight the danger of using sitewide data to look at ceramic distributional patterns. Clearly, there was no single vessel assemblage that the people who lived in Areas 2 and 8, and presumably the rest of the site as well, used to represent themselves as a group. Looking at Areas 2 and 8 individually, the way that the assemblage as a whole is characterized above, i.e., mostly *var. Galt*, *var. Williams*, *var. Starkey*, and *var. Diana* vessels, does not fully hold for either, since *var. Starkey* is notably infrequent in Area 2 and *var. Diana* is absent in Area 8. This raises doubts about the reliability of the data from the other sites used in this study, most of which are far less understood than Pine Tree Mound.

Conclusions

Some of the defined varieties of Ripley Engraved bowls and carinated bowls have spatial distributions suggesting that they could be reflective of localized communities of identity. Most obvious are *var. Mockingbird* (at three sites in the upper Big Cypress Creek basin) and *var. Starkey* (only at the Pine Tree Mound site in the middle Sabine River basin). These two varieties account for only 1 percent of the vessels analyzed, however, and thus it appears that the variety schema as a whole is not a good indicator of local social groups. Of course, it would be naïve to expect that such a simple scheme based on single-attribute variability could ever do that. The images on Ripley Engraved bowls are varied, but the elements involved and the ways in which they could be combined are finite. Given the expansive size of the area, the large number of groups who made up the Titus phase, and the much larger number of family potters who were parts of those groups, it is not reasonable to expect that there were distinct "signature" varieties relating to individual social groups.

This is not to say that variability in designs on Caddo ceramic vessels has no chance of conveying this kind of information. I suspect that it could, if ceramic

classifications were refined and if it was coupled with other attributes, including ones relating to technology and image interpretation (see Essay 11). A persistent complicating factor, though, is that many of the mortuaries from which these pots came are very poorly understood, and there is no chance that will ever change. Of course, that does not prevent more-refined, more-comprehensive studies of assemblages from the better-documented sites and from cemeteries excavated in the future, albeit at the sacrifice of geographic coverage that is so important to a distributional study such as this.

Beyond variability suggestive of localized communities, the data presented here support the idea that larger core communities may be a productive way of looking at how Titus phase peoples organized themselves spatially. Further, based on Ripley Engraved bowl and carinated bowl varieties alone, some of the hypothesized core communities look more alike than others. Interpreting these patterns is fraught with difficulties, though, and one must suspect that this stems partly from the fluidity of the Titus phase groups (aside from the sampling problems mentioned). Some undoubtedly were long-term features on the landscape, but others may not have been, and movement of people between them, shifts in their boundaries, and group coalescence and splitting all likely play a role in making them difficult to deal with from an archaeological perspective. Perhaps these patterns relate to communities of identity at varying levels. Or maybe they relate to communities of practice based on social interaction, a potter's "current social and material environment," and physical proximity, as Worth (2017:145–46) discusses. In either case, to really understand what they mean, it likely will be necessary to look beyond ceramics and material culture.

Notes

1. Another recent version combines the fourth and fifth original communities into one, such that the sixth community referenced here becomes the fifth one (Perttula, Marceaux, and Nelson 2012:83).

2. A comprehensive accounting of all the materials from Tuck Carpenter has become partially available recently (Perttula, Walters, Singley, and Middlebrook 2017) but is not used in this study because it does not yet contain vessel illustrations.

II

The Origin and Development of the Caddo Scroll Motif

Eloise Frances Gadus

Perspectives on the ancestral Caddo people's response to their social and natural environment have been gained through new interpretations of the mythic-religious beliefs systems that were widely held across the prehistoric Southeast and midcontinent. How and what the Caddo incorporated from these belief systems as their own has been explicated to some degree through the study of Caddo ceremonial centers, burial rituals, and ceramic art (Girard et al. 2014: 54–57, 77–83). These studies have begun to outline a complex of social interactions on both the local and regional scales which undergird that acceptance (Girard et al. 2014:32). This essay looks again at Caddo ceramic art to identify some early correspondences that may explain the origin, meaning, and consistent use of the Caddo scroll motif and help to address the underlying basis of those interactions. To this end, and to understand why the scroll is ubiquitous in Caddo ceramic art, three themes are explored here. The first theme concerns the definition of the scroll motif and how it is presented on Early Caddo bottles and bowls, as well as its presentation in other media, such as the shell art of Spiro. The first theme is linked to the second though the correspondences between the scroll motif, the structure of Caddo vessels, and the iconography of a multilevel cosmos. The multilevel cosmos is an idea that is itself ubiquitous to the belief systems of prehistoric groups living across the Southeast and midcontinent (Lankford 2007a:18–20; Hudson 1976:122–38). Correspondences to the idea of the multilevel cosmos address the iconography of the scroll motif. The third theme concerns influences on the configuration of the scroll motif based on non-Caddo Woodland period iconography (Gadus 2013b). These influences worked to make the Caddo scroll motif unique.

An Early Caddo Ceramic Corpus

The Caddo scroll motif is examined here using a configurational approach through which the internal structures of the motif are isolated and compared across a body

of work (Knight 2012:85–129). That body of work is the motifs and vessels of the ceramic types attributable to the Formative Caddo (AD 850/900–1000/1050) and Early Caddo (AD 1000/1050–1200) periods (Girard et al. 2014:93). The ceramic types include Hickory Engraved, Holly Fine Engraved, Davis Incised, Spiro Engraved, Crockett Curvilinear Incised, Coles Creek Incised, and French Fork Incised. Examples of these types were taken from three Formative to Early Caddo ceremonial centers that crosscut the northern and southern areas of the Caddo Homeland (fig. 11.1). The sites are the George C. Davis site in Cherokee County, Texas; the Crenshaw site in Miller County, Arkansas; and the Spiro site in LeFlore County, Oklahoma. These sites are marked by large villages, specialized structures, group burials, earthen platforms, causeways, and multiple mounds demarcating plazas (Girard et al. 2014:40–53). Such features indicate that the sites functioned as nexuses for community-wide ritual activities.

The George C. Davis site, with three mounds and a village area, is on the Neches River at the southwestern edge of the southern Caddo Area (see fig. 11.1). The University of Texas undertook initial excavations in 1939–41 as part of a Works Projects Administration (WPA) project. Those excavations focused on part of Mound A and the adjacent village area, which produced many fine-ware ceramic sherds (Newell and Krieger 1949). Actual numbers of typed vessels from these early excavations are hard to quantify; however, vessels reconstructed and illustrated by Newell and Krieger (1949) are used here as a representative sample. They include the types Hickory Engraved, Holly Fine Engraved, Davis Incised, and Crockett Curvilinear Incised. Exploration of the site in 1968–70 by Dee Ann Story and her students from the University of Texas focused on Mound B, Mound C, and sections of village remains between the two mounds (Story 1997). Based on dating of these excavations, Story (1997:67–70) contends that the site represents Formative through Early Caddo period occupations dating from ca. AD 980 to 1270. Story's excavations (1997:28–59) found nine vessels from burial contexts in Mound C. Most of these vessels were typed as Holly Fine Engraved with two bowls and a bottle having a clear Early Caddo period association as they came from a burial in construction Stage 2 of the mound (Story 1997:table 2). Another Holly Fine Engraved bottle, from construction Stage 5, provides additional structural information on the type, as this bottle has two stacked bodies (Story 1997:fig. 29c). Neither Krieger nor Story found Woodland period ceramics in mound context at the Davis site. However, both noted the occurrence of Mossy Grove pottery at the site, which they considered to predate the Caddo occupation. The Davis site's long history of use and its southernmost location makes it a likely conduit for ceramic and iconographic influences coming from groups in the lower Mississippi valley and along the Gulf coast.

The Crenshaw site on the Great Bend of the Red River near the center of the southern Caddo Area (see fig. 11.1) contained six mounds and multiple cemeteries and village areas. The site saw numerous excavations, some of which were done

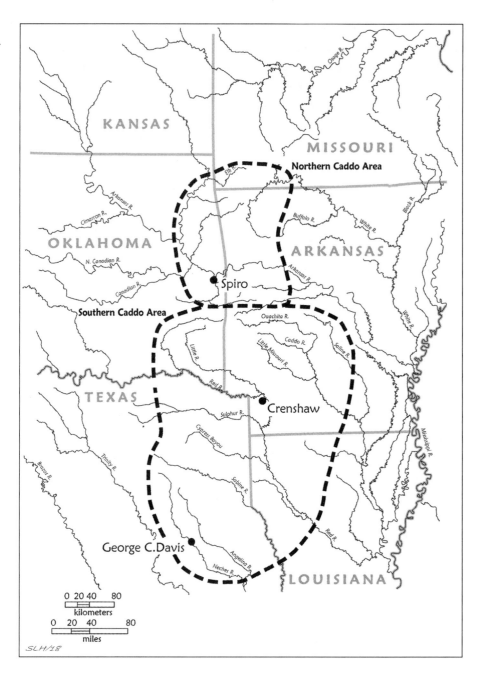

Figure 11.1. Map of the Caddo Homeland and the location of the George C. Davis site, the Crenshaw site, and the Spiro site.

by relic collectors. The first reported explorations were carried out by Clarence B. Moore (1912) and Judge H. J. Lemley (1936) with later excavations by J. H. Durham (1964) and Frank F. Schambach (1971). A recent compilation of vessels from the Crenshaw excavations, now housed at the Gilcrease Museum in Tulsa, Oklahoma, provides a readily accessible vessel corpus from which to draw comparisons (Perttula, Nelson, Walters, and Cast 2014). A total of thirty Early Caddo Hickory En-

graved bottles, fourteen Crockett Curvilinear Incised bowls, five Holly Fine Engraved bottles, and six Spiro Engraved bottles were documented in the Gilcrease Museum collection (Perttula Nelson, Walters, and Cast 2014:266–67). Vessel types associated with the Woodland or Formative Caddo periods in the collection include sixteen Williams Plain vessels (a Fourche Maline plain ware not discussed in this study) along with twenty-two Coles Creek Incised vessels and nine French Fork Incised vessels of various varieties. The latter two types indicate a strong connection to groups in the Lower Mississippi Valley (Perttula Nelson, Walters, and Cast 2014:265).

What is interesting about Crenshaw is the clear superposition of an Early Caddo occupation (AD 1000/1050–1200) on an extensive Late Woodland Fourche Maline/Formative Caddo occupation (AD 800/850–1000), as confirmed by recent radiocarbon dating from the site (Perttula Nelson, Walters, and Cast 2014:1). The Late Woodland/Formative Caddo occupation appears to have incorporated ceramic influences from the lower Mississippi valley as represented by the types Coles Creek Incised and French Fork Incised. It is likely that ideas and themes from cultures of the lower Mississippi valley were passed on to the Caddo occupants of the site with these vessels. Also present at Crenshaw are several vessels of the Early Caddo type Spiro Engraved that suggest ceramic influences extended to the Spiro site of east-central Oklahoma (see Essays 5 and 8). Early occupations at the Spiro site date to ca. AD 950–1000, suggesting the site was contemporaneous with the occupations at Crenshaw (Brown 1996:29).

The Spiro site is in east-central Oklahoma on the Arkansas River (see fig. 11.1). It is an enigma in that, in addition to marking a nexus of local ritual activity, its famous Great Mortuary covered by the Craig Mound is now considered to be a sacred accumulation of human remains and exotic objects from far removed communities. These objects were positioned to form a cosmogram reflecting a hierarchical social order that was in the process of change (Brown 1996, 2010, 2012). Shawn Lambert's work (Essay 8) also demonstrates that the Spiro Engraved vessels recovered from the Spiro site were made by southern Caddo potters, possibly at sites such as Crenshaw. The acceptance of these vessels at Spiro likely was due to the vessel forms and motifs that embodied the same mythic-religious motifs found on the many engraved shell cups recovered from the Great Mortuary and the Craig Mound. Those shell cups are known to encompass mythic-religious themes from across the midcontinent and southeastern United States (Phillips and Brown 1978–84).

The ceramic types from the Spiro, Crenshaw, and George C. Davis sites indicate that there were strong connections between Caddo communities during the Formative and Early Caddo periods. These connections were likely based partly on shared iconic and ritual ideas, which fostered a shared identity (Girard et al. 2014:57). The types Holly Fine Engraved, Hickory Engraved, Crockett Curvilinear

Incised, and Spiro Engraved have also been identified at the Cahokia site in the upper Mississippi valley (Kelly 1991; Pauketat 1994). Girard et al. (2014:59) suggest that interaction with early Caddo people may have played a significant role in the cultural florescence at Cahokia. Whichever way influences flowed within or beyond the Caddo Homeland, the scroll motif and the structure of the ceramic vessels on which it is found appear to have developed early as a symbol of a widely held cosmic theme. That theme blossomed in the Middle to Late Caddo periods into an array of ceramic types and type varieties that carried forward the same message.

The Form of the Caddo Scroll Motif

Found engraved or incised on Caddo bowls and bottles, a simple version of the scroll motif can be defined as a primary element, with lines attached to and between two or more primary elements (fig. 11.2). In this configuration, the primary element is defined here as the focus of the scroll motif, or that element of the motif which carries the most iconographic information. All other elements within the scroll are considered secondary as they may modify the meaning of the primary element. A primary element is often a simple circle, a circle-within-a-circle, concentric circles, a diamond, a bar-shape, a series of vertical lines, or even a single vertical line (see Gadus and Fields 2012:390). But, a circle or circle-within-a-circle with slanting lines or arm elements connecting these primary elements is most common to Early Caddo ceramic types such as Crockett Curvilinear Incised bowls and jars, Holly Fine Engraved bowls and bottles, and Spiro Engraved bottles. In addition, as on some Crockett Curvilinear Incised vessels, the primary element and the areas surrounding the scroll arms can be punctated or hatched (see fig. 11.2a–b). The scroll motif also repeats four or more times around the vessel body (Suhm and Jelks 1962:plate 16a).

The version of the scroll motif present on Holly Fine Engraved bottles displays concentric circles as the primary element with zones of slanting lines running between the circles and forming the arms of the scroll (fig. 11.3a–b). These scrolls repeat four times around the vessel body. Several Holly Fine Engraved bottles from the Crenshaw site also have a small cross-hatched or excised circle at the center of the concentric circles that reprises the circle-within-a-circle primary element on some Crockett Curvilinear Incised scrolls. A scroll motif also appears on Holly Fine Engraved bowls, but the concentric circle primary element seen on the bottles is replaced with a zone of vertical lines as the primary element with zones of slanting lines between the vertical lines forming the arms of the scroll (see fig. 11.2c). Excised triangles occur above and below the ends of these scroll arms. There is some variability in the size and direction of the linear elements of this version of the scroll motif, but overall the motif presents a Z-shaped configuration (Newell and Krieger 1949:fig. 30).

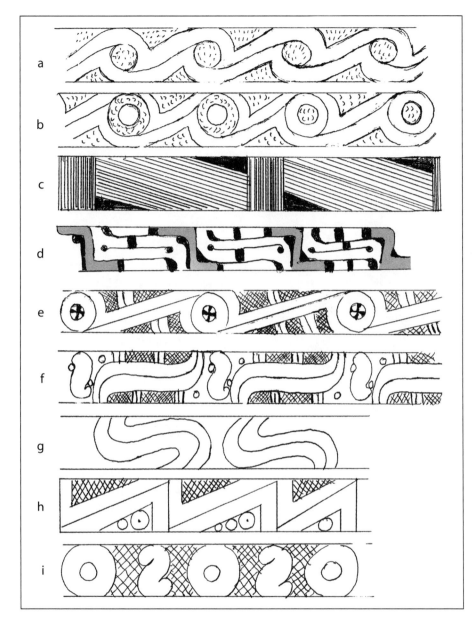

a

b

c

d

e

f

g

h

i

Figure 11.2. Variation of the scroll motif found on Early Caddo period bowl types: *a–b*, Crockett Curvilinear Incised; *c*, Holly Fine Engraved; *d*, the "Davis Rectangle" scroll from the George C. Davis site; *e–i*, Middle to Late Caddo period scrolls are represented here from bowls of the type Ripley Engraved.

The composition of elements that form the scroll motif on Early Caddo Crockett Curvilinear Incised bowls and Holly Fine Engraved bottles and bowls from the Crenshaw and George C. Davis sites are also similar to scroll motifs on Spiro Engraved bottles from the Spiro site, which would be expected if, as Lambert (Essay 8) contends, they were made by the southern Caddo. In fact, one Spiro Engraved vessel recovered from the Crenshaw site also has a square body that emphasizes the fourfold display of its scroll on the bottle (see fig. 11.3*c*).

Early Caddo ceramic scroll motifs also found their way onto the shell art, for

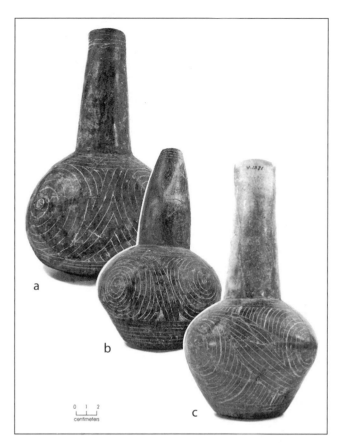

Figure 11.3. Holly Fine Engraved (*a–b*) and Spiro Engraved (*c*) bottles with scroll motifs from the Crenshaw Site collections at the Gilcrease Museum (from Perttula et.al. 2014:figs. 96, 101, and 118).

which the Spiro site is famous. The simple scroll is present on engraved shell cups associated with the Braden A style (Phillips and Brown 1978–84:plates 46–50). The similarity of these shell cup scrolls to those found on Spiro Engraved vessels has been noted by Phillips and Brown (1978–84:plate 47). More intriguing for the extent of the connections it may represent is a scroll motif found on shell cups, which has been called the "Davis Rectangle" (Phillips and Brown 1978–84:150). The motif appears on several Spiro shell cups associated with the Braden A style (Phillips and Brown 1978–84:plates 36–42), and it is present on bowls and bottles recovered from the George C. Davis site (Newell and Krieger 1949:fig. 33*g–h*). The primary element of the Davis Rectangle scroll, both on the shell cups from Spiro and the vessels from the Davis site, is the use of a Z-shaped primary element (see fig. 11.2*d*). This Z-shaped primary element may reprise the overall configuration of the scroll motif on Holly Fine Engraved bowls, which is also Z-shaped (see fig. 11.2*c*). The Z-shape continues in use in the overall structure of the slanted-scroll motif, as a primary element, and even as a secondary element into the Late Caddo period. It is particularly pronounced on Ripley Engraved vessels (see fig. 11.2*e–i*), where it has been referred to as an SZ element because it appears as an S-shape as well (Gadus and Fields 2012:fig. 6.1). The element will simply be referred to here as a Z-shape to provide continuity with earlier element forms discussed below.

During the Middle and Late Caddo periods the utilization of the scroll motif on Caddo fine-ware vessels becomes ubiquitous. The ceramic types that display the scroll motif include Barkman Engraved, Friendship Engraved, Glassell Engraved, Hodges Engraved, and Taylor Engraved (Suhm and Jelks 1962:plates 4, 23, 27, 37, 64, 65, and 75). These types are part of the archaeological complexes defined across the Caddo Homeland in northeastern Texas, southwestern Arkansas, northwestern Louisiana, and southeastern Oklahoma (see fig. 11.1). These ceramic types display the basic slanted-scroll and add much additional variation to the motif. For instance, on Ripley Engraved vessels the primary element of the scroll takes on all of the variation outlined above (see fig. 11.2*e–f*), and the primary element can be completely eliminated so that the arms of the scroll become the focus of the motif (see fig. 11.2*g–h*). Some of these arms-only scrolls also have a Z-shaped configura-

tion similar to that seen on the Holly Fine Engraved bowls described above. And for Taylor Engraved, the end of the arms interlock forming a spiral as the primary element (Suhm and Jelks 1962:plate 75). Going still further, the Caddo potters who made Ripley Engraved bowls disengaged some primary elements from the scroll and arranged them to form repeating elements within a band motif around a vessel body (see fig. 11.2*i*). These late variations suggest that the primary elements of the scroll retained certain importance for the Caddo potters even as they explored new or different ways to combine those elements to express long-held iconic themes.

The Caddo Scroll Motif as Cosmogram

The Middle to Late Caddo period Caddo potters who made Ripley Engraved vessels incorporated an array of additional elements into the scroll not seen on the early scrolls. These elements and their position within the overall motif help to explicate the iconography of the Caddo scroll, and iconography present in even earliest examples of the motif. The primary element and the connecting arms of the scroll on Ripley Engraved vessels were often elaborated with a swirl cross, small circles, bars, or cross-hatching (see fig. 11.2 *e–f, h*) (Fields and Gadus 2012a:fig. 6.1). Such elaboration is a step beyond the punctations and repeating lines decorating the Early Caddo scroll motifs. These additional elements may reference particular cosmic actors or locations and thus accentuate the underlying meaning of the scroll.

An iconographic study of Ripley Engraved ceramic bottles and bowls from the Pine Tree Mound site (41HS15) in Harrison County, Texas, associated Mississippian mythic actors or powers, such as the Birdman or the Great Serpent, and their placement in the cosmos based on the elements that elaborated the scroll arms (Gadus and Fields 2012:505–20). In that study, the scroll's primary element, such as a circle-within-a-circle, was considered emblematic of the axis mundi or cosmic center. Elaboration of the circle with a swirl cross (see fig. 11.2*e*) at its center may have emphasized the center by referencing a particular world level (Lankford 2011:251–75). Around this center, actors or powers represented by particular elements on the scroll arms moved or danced (Reilly 2010). This interpretation borrowed heavily from the work of F. Kent Reilly (2007:39–55) and George Lankford (2007a:8–38) that concerned their configurational analysis of some engraved shell cups from the Craig Mound at Spiro, as well as Cox Mound and Hixon-style shell gorgets known from sites in the Tennessee River valley.

Lankford's (2007a:8–29) work in particular explicates the structure of the Native cosmos as being multileveled, with an above, below, and middle world, and an axis mundi as represented by a pole, tree, sun, fire, or drum extending though all levels. The Middle World or earth level, which floats on the waters of the beneath world, is stabilized by four directional powers. Lankford (2007a:29–38) uses the

Figure 11.4. Hixon-style gorget (*a*), Cox Mound-style gorget (*b*), and Holly Fine Engraved bottle (*c*) from the George C. Davis site (Lankford 2007a:fig. 2.1; Newell and Krieger 1949:fig. 31a).

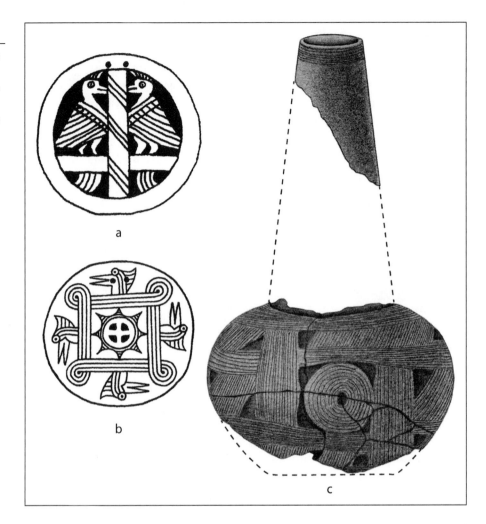

multilevel cosmos to interpret the structure of the motifs seen on the Hixon- and Cox Mound-style gorgets (fig. 11.4*a*–*b*). In short, Lankford interprets the gorget motifs as two different ways of representing the same idea of a multilayered cosmos. The Hixon-style gorgets show a profile view of what the Cox Mound-style gorget presents in plan view perspective. Specifically, Lankford (2007a) suggests that the four-looped square of the Cox Mound-style gorget may relate to the four cardinal directions of the Middle World with a cross within a rayed circle, as sun or fire, at its center representing the axis mundi that unites all world levels. The actors or powers, in this case the crested birds, move around the axis mundi in a counterclockwise fashion with their four heads and beaks forming the arms of a swirl cross that echo through the arms of the central rayed or petaled cross. On the Hixon-style gorget, the birds are set around a central striped pole that is in the same position as the rayed-cross and thus is another representation of the axis mundi (Lankford 2007a:29–32).

The scroll motifs seen on Early Caddo vessels may reprise the ways of representing the same mythic idea as displayed in the Hixon- and Cox Mound-style gorgets. The simple Z-shaped scroll on some Holly Fine Engraved bowls can be seen as a side view with the primary element as the axis mundi represented by a bar or pole composed of multiple vertical lines with slanting lines or excised triangles, the scroll arms moving around it (see fig. 11.2c). The scroll motif on Early Caddo bottles that incorporates the concentric circle element as the primary element is a top-down view with the same reference to the axis mundi or center (fig. 11.2e). One motif variation found on a Holly Fine Engraved bottle appears to present the same information in a top-down view, quite similar to that represented on the Cox gorget (fig. 11.4b–c). The motif on the Holly Fine Engraved bottle is composed of four sets of zoned lines forming a square surrounding a concentric circle primary element with a central circular excised area. Remove the crested birds and cross-in-circle from the gorgets, and a basic and likely old referential form appears on both the vessel motif and the gorget.

Lankford (2007a:15) interprets the Hixon- and Cox Mound-style gorgets as cosmograms. And because of their structural similarities to the Hixon and Cox Mound gorgets, the Early Caddo period scroll motif found on bottles and bowls and the Caddo scroll motif in general may also be considered a cosmogram representing the multilevel world theme with the axis mundi at the center surrounded by the representation of world powers or actors in the form of the scroll arms. It is also proposed here that the scroll motif is related to the form and structure of Early Caddo bottles, such as Hickory Engraved, Holly Fine Engraved, and Spiro Engraved. The design of these vessels that is their body, neck, and rim also appears to represent aspects of the multilevel world.

The Caddo Scroll Motif and the Symbolism of the Bottle

At first look, the simply decorated Hickory Engraved bottle seems to have no apparent association with the scroll motif. These bottles, with globular bodies and long tapering cylindrical necks, are decorated only with a series of four to eight horizontal lines encircling the rim and the base of the neck (fig. 11.5a). However, when viewed from the rim down, the lines around the neck appear as concentric circles around a central circle that is the vessel rim (fig. 11.5b). The central circle and the long neck represent the axis mundi. The concentric engraved lines around the base of the neck are similar to the concentric circles that form the primary element of the scroll motif seen on the body of Holly Fine Engraved bottles (fig. 11.5c). The concentric lines may represent multiple world levels or the four aspects of each world level. Thus, the Hickory Engraved bottle structure and decoration work together to form a cosmogram similar to the circular primary element of the early scroll. And from this top-down comparison, it is not hard to see a similarity to

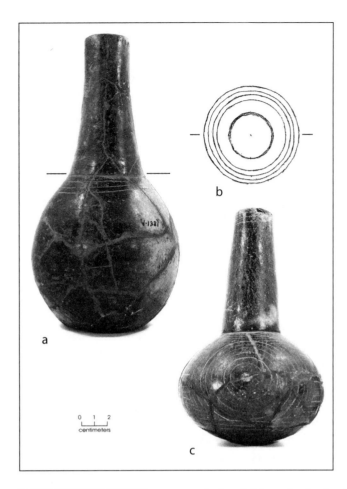

the primary elements of the scrolls on Crockett Curvilinear Incised bowls and later scroll motifs (see fig. 11.2a–b, and e). A similar connection between a rayed circle bottle motif and the associated bottle form has been noted for the Late Caddo period type Hempstead Engraved common to southwestern Arkansas Caddo sites (McKinnon 2016). This late example along with examples on Ripley Engraved bottles (Gadus 2013a) suggests that the idea of vessel form and engraved motif contributing to the overall design meaning was common in Caddo ceramic production. However, based on its presence in Early Caddo vessels, this alignment of vessel structure and motif appears to have emerged in the Early Caddo period.

The Hickory Engraved bottle structure is also reprised by the Holly Fine Engraved and Spiro Engraved bottles, which display similar globular bodies and long tapering cylindrical necks that are decorated with a series of four to eight horizontal lines encircling the rim, the neck-body juncture, and the base (see fig. 11.3). However, on the Holly Fine Engraved and Spiro Engraved bottles, these lines also demar-

Figure 11.5. Hickory Engraved bottle from the Crenshaw site (*a*), top-down view from the rim of the Hickory Engraved bottle (*b*), and Holly Fine Engraved bottle (*c*) with a concentric circle primary element from the Crenshaw site (from Perttula et al. 2014:figs. 78 and 103).

cate a design field on the body of the vessel where the elaborate scroll motifs described above are often repeated four times around the vessel. This repeating scroll may have served to emphasize the fourfold aspects of the multileveled world theme or cosmogram, which could also be embedded in the structure of the vessel itself. On a Spiro Engraved bottle, a four-part or square body again accentuates the repeating scroll (see fig. 11.3c).

The idea that early Caddo potters saw their vessels as an embodiment of an understanding of cosmic structure is strengthened by the unique structure of certain Caddo vessels. For instance, some Holly Fine Engraved bottles have two or more bodies stacked on top of each other with the characteristic cylindrical neck protruding from the multiple bodies. One such bottle is known from the Crenshaw site (Suhm and Jelks 1962:plate 36h), and a similar compound bottle was recovered from a Stage 5 burial pit in Mound C at the George C. Davis site (Story 1997:54). Although the George C. Davis site vessel was not associated with a particular ceramic type, Story stated that it was decorated with "concentric quartered circles" that suggested it had a "crude Holly Fine motif." Another possible Holly Fine En-

graved bottle with a three-level compound body was also found at the Crenshaw site (fig. 11.6). This vessel may have come from a grave in the area between Mounds C and D (Frank F. Schambach, personal communication 2018). The form of the neck and the multiple lines around the rim and the base of the neck are suggestive of both Hickory Engraved and Holly Fine Engraved vessels, but the decoration on the multiple bodies, which includes concentric circles, cross-hatching, and pendant triangles, is suggestive of Middle to Late Caddo period Ripley Engraved design elements (Gadus and Fields 2012:390). As such, this particular vessel may demonstrate the carryover of structural meaning from early to later Caddo vessel forms. Again, the multiple bodies or stacked segments on the bodies of these vessels and the concentric lines around the rim may be a reference to a multileveled world, while their long necks may represent the axis mundi at the center of these world levels (Lambert 2018; Gadus 2013a:226–30).

The multileveled cosmic symbolism continues in the structure of Middle to Late Caddo period vessels (Gadus 2010, 2013a, 2013b; Gadus and Fields 2012). For example, like the Hickory Engraved and Holly Fine Engraved bottles, Ripley Engraved bottles have an extended neck, which can sometimes be emphasized by the addition of a pedestal base, both representing the world center or axis mundi that connected all cosmic levels as it extends through and from the center of the body of the bottle. The bottle body may be enhanced with engraved motifs or constructed in such a way that they emphasize the cosmic levels and a four-part structure within each level, as is the case with some square Ripley Engraved bottle bodies (Gadus 2013a:216–18, 226–30). As noted above, the use of the four-part or square body is also found on some Spiro Engraved bottles (see fig. 11.3c).

A small Late Caddo bottle from a double grave at the Pine Tree Mound site graphically demonstrates the potter's understanding of the interconnection between the structure of the bottle body and the motif as a way of conveying meaning (fig. 11.7). The bottle is red slipped with wide engraved lines that are filled with white pigment. The motif has a four-part structure that, when opened out and viewed from the rim down, appears to be a cross with the central circle at the neck and lip of the bottle. There are also four U-shaped elements between the arms of the cross. Two of these elements are connected by engraved lines that run down from the body to the base. The two connected U-shaped elements have additional lines and ticking that give them a vegetal feeling, as if plants rooted to the lower cosmic level represented by the vessel base are shown sprouting in the middle level associated with everyday life on the body of the bottle.

A similar iconographic analysis of another uniquely decorated Caddo bottle

Figure 11.6. Untyped bottle with multiple body segments from the Rayburn collection at the Crenshaw site (photograph reproduced with the permission of the Arkansas Archeological Survey, Fayetteville).

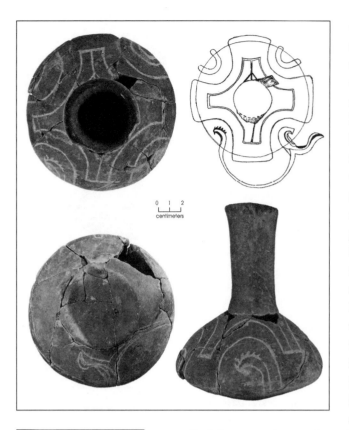

was done by Shawn Lambert (2018); that bottle was recovered from a Craig Mound burial at the Spiro site. The bottle is a composite vessel with multiple levels that Lambert attributes to the lower, middle, and upper worlds. The vessel levels were decorated, not overtly with scrolls, but with swirling motifs. Still, the design has a fourfold structure and an axis mundi linking all worlds. Lambert (2018:figs. 6 and 8) identified a repeating circle-and-bar motif on the vessel as representing the axis mundi based on a comparison with a Craig Mound shell gorget and Early Caddo Crocket Curvilinear Incised bowl motifs. The elements in this motif are scroll primary elements such as the circle-within-a-circle. In addition, a Z-shaped element is juxtaposed with a circle-within-a-circle and is repeated four times around the vessel center on the level that is designated as representing the upper world (Lambert 2018:fig. 7). This configuration is similar to an example of the Middle to Late Caddo deconstructed scroll motif (see fig. 11.2*i*).

Figure 11.7. Multiple views of an untyped Late Caddo bottle from the Pine Tree Mound site (Gadus and Fields 2012:fig. 6.13).

All of these vessel examples, whether elaborate or simple, indicate that Caddo potters linked the design of their ceramic vessels with their understanding of the order of the cosmos. And that understanding was emphasized again and again by the engraved and incised motifs, such as the scroll motif, that were emblazoned on the sides of those vessels.

Connections beyond the Caddo Homeland

Pauketat and Emerson (1991:919–41) were the first to recognize the symbolism of a vessel in their seminal analysis of Ramey Incised vessels associated with the polity centered at Cahokia. The design of the Ramey Incised vessels, just like the Caddo bottles and bowls discussed above, has been interpreted in relation to a multilayered, four-quartered cosmos with the incised motifs on the shoulders of the vessels associated with actors or attributes of those realms. Emerson (1989:63–67) argued that Ramey Incised vessels were a "quasi-sacred ware" associated with ritual activity that reaffirmed the natural order as well as the social order. The distribution of these vessels across the upper Mississippi River valley during the eleventh and twelfth centuries AD suggests that groups who received or used these vessels

beyond the Cahokia polity understood the message they conveyed (Pauketat and Emerson 1991).

While Ramey Incised vessels are not known from the Caddo Homeland, certainly the general message conveyed by the design of Caddo vessels would have been equally understood by the groups who used them. Holly Fine Engraved, Spiro Engraved, and Crockett Curvilinear Incised vessels, with their three-part structure (body, neck, and rim) and their often four-part symmetry of the engraved or incised scroll motif reflect the multilevel, four-quartered, cosmic structure that fits the symbolism interpreted for the Ramey Incised vessels (Emerson 1989). Such similarities may be why Holly Fine Engraved, Hickory Engraved, Crockett Curvilinear Incised, and Spiro Engraved vessels were accepted far beyond the Caddo Homeland and even at Cahokia (Kelly 1991; Pauketat 1994).

The iconic symbolism tied to the structure of the Caddo vessel and the scroll motif appears to have stayed relatively consistent throughout Caddo prehistory. However, Early Caddo vessel structures and motifs also suggest ties to even older symbolism associated with groups living beyond the Caddo Homeland. For instance, the engraved or incised lines just below the rim/lip found on many Caddo bowls and bottles are reminiscent of the rim elaboration on incised bowls and jars associated with the Coles Creek culture that developed in the lower Mississippi valley (fig. 11.8). Coles Creek vessels have been recovered from the Formative Caddo and Fourche Maline occupation at the Crenshaw site (Perttula, Nelson, Walters, and Cast 2014). The presence of these vessels at Crenshaw suggests that Early Caddo potters could have adopted this simple form of decoration to vessel forms such as Davis Incised and Hickory Engraved. Whether this decorative similarity translates to transference of iconic themes is open to speculation. How-

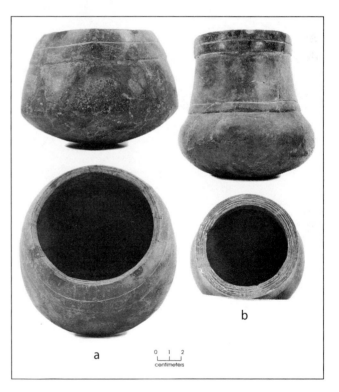

Figure 11.8. Coles Creek Incised bowl and jar from the Crenshaw site collections at the Gilcrease Museum (from Perttula et al. 2014:figs. 7 and 10).

ever, the incised lines on the rim/lips of some Coles Creek vessels are reminiscent of the top-down view of the engraved lines on the neck and rim of the Hickory Engraved bottle that were used above as a structural correlate to the origin of the design of the scroll motif (see figs. 11.5b and 11.8b). This similarity of decoration around the orifices of Coles Creek Incised vessels and Hickory Engraved bottles may indicate early sharing of symbolic expression.

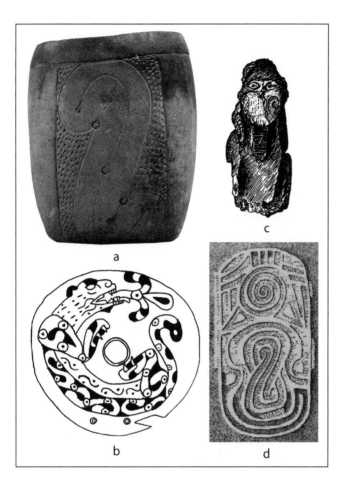

Figure 11.9. French Fork Incised vessel (*a*) from the Crenshaw site collections at the Gilcrease Museum, the Fairfield gorget (*b*), an Ohio Hopewell Mound 25 ivory figurine with the Z-shaped motif carved below its chin (*c*), and a Z-shaped motif on a Swift Creek complicated stamped paddle (*d*) from the Fairchild's Landing site in Georgia (Broyles 1968:plate 1; Greber and Ruhl 2003:fig. 6.28; Perttula et al. 2014:fig. 15; Wood 1999).

Another example of the incorporation of an old motif onto Early Caddo vessels is the Z-shaped element, which may have its origin in Woodland period symbolic expression. As noted above, at least one bowl and a bottle from the George C. Davis site display a scroll with a Z-shaped primary element between straight scroll arms (Newell and Krieger 1949:fig. 33). This Z-shaped element is also associated with the Davis Rectangle, which is basically a scroll motif found on shell cups from Spiro (see fig. 11.2*d*). The Davis Rectangle with its small excised circles, triangles, and squares in the arms of the scroll is reminiscent of French Fork Incised vessel motifs (fig. 11.9*a*). French Fork Incised is associated with the Troyville and Coles Creek periods (ca. AD 395–1250) (Neuman 1984:169). Like the Coles Creek vessels, French Fork vessels were fashioned by groups living in the lower Mississippi valley adjacent to the Caddo Homeland. In addition, the similarities in motif and vessel form between French Fork Incised and Woodland types such as Basin Bayou Incised and Weeden Island Incised associated with groups along the Florida Gulf coast may be indicative of influences coming into the Caddo Homeland ultimately from deep inside the southeastern woodlands (Phillips et al. 1951:100–101; Milanich 1994:150–54; Milanich et al.1997:163–84).

A French Fork Incised square vessel from the Crenshaw site displays a sinuous stand-alone Z-shaped motif on each of its four sides (see fig. 11.9*a*). The motif also has small triangular excised areas and punctations along a central line that appear similar to the central line on the Davis Rectangle scroll arms (see fig. 11.2*d*). And the general form of the Z-shaped primary element of the Davis Rectangle scroll is similar to the stand-alone Z-shaped motif on the Crenshaw French Fork vessel (see figs. 11.2*d* and 11.9*a*). The Z-shaped motif is also common in Middle to Late Caddo ceramic types such as Avery Engraved and Ripley Engraved. It can appear as the central element of a scroll, as a modifying element in the arms of a scroll or surrounding the scroll, or in combination with other elements such as in a band motif (see fig. 11.2*f, i*).

The connections of the Z-shaped element to the type French Fork Incised suggest that it likely came into the Caddo Area from the lower Mississippi valley

through interactions that brought French Fork Incised vessels to the Crenshaw site. However, why the element was accepted and widely disseminated within the Caddo ceramic repertoire may be due to its long-held mythic meaning. That meaning found expression on ceramic and nonceramic artifacts since Hopewell times (ca. 200 BC to AD 500) across the midcontinent and into the Southeast (Byers 2015). For example, a gorget from the Woodland period Fairfield Mounds in Missouri shows a feline, possibly a puma, with Z-shaped markings on its underbelly (see fig. 11.9b; Wood 1999). No ordinary feline, it likely represented a Hopewell-conceived creature of many aspects that may guard the access to the axis mundi and the many world levels (Gadus 2013a; Lankford 2007b:112–13). In fact, the feline on the gorget surrounds a large central hole that may itself be a representation of the axis mundi (see fig. 11.9b).

The Z-shaped element on the puma's underbelly is marked by two dots nestled in the upper and lower curve of the Z-shape. Dots as punctations are present in similar locations on the Z-shape of the French Fork Incised vessel from the Crenshaw site described above. And another example on a Ripley Engraved vessel shows the Z-shape with nestled dots as the primary element at the center of scroll arms (see fig. 11.2f). These dots are likewise present with a Z-shaped element on an extension below the chin of a carved ivory human figurine that was placed as an offering at Hopewell Mound 25 in southern Ohio (see fig. 11.9c). Robert Hall (1989:265–66) likened the Z-shaped motif to the Mayan day glyph *Cimi* or *Kimi*, which can be translated as "death." Whether one accepts a Mesoamerican connection for the element or not, its link to a power associated with the cosmic order as represented by the Hopewell feline seems likely.

Finally, a similar Z-shaped element, again linked to the others described above by the placement of the two dots, can be found on a paddle stamp attributed to a Woodland period Swift Creek Complicated Stamped vessel from the Fairchild's Landing site in southwestern Georgia (Broyles 1968:plate 1). In this example, the Z-shaped element is paired with a prominent spiral that is reminiscent of the Caddo concentric circle element (see fig. 11.9d). Much work has been done to understand the variation within Swift Creek paddle designs and many descriptive names have been given to the various defined motifs (Williams and Elliott 1998; Smith and Knight 2014). However, comparison of these paddle designs across different prehistoric periods and media has yet to be done to help determine their iconic meaning. The Fairchild's Landing paddle design may be interpreted as the axis mundi surrounded by multiple worlds as represented by the paddle spiral, which is again similar to concentric circle primary elements on the Early Caddo scroll motifs. The Z-shape is in the same position to the concentric circle axis mundi as the birds on the Cox shell gorget (see fig. 11.4b) and may represent the actors or powers who control access to those world levels. A Ripley Engraved motif with paired Z-shape and circle-within-a-circle elements may represent a similar association (see

fig. 11.2*i*). In fact, as noted above, the same configuration of concentric circle and Z-shape appears four times on the multileveled Caddo vessel from the Craig Mound (Lambert 2018:fig. 7).

The Z-shaped element is unique because it can hold the place of the primary element of a scroll motif, be paired with a concentric circle that represents the cosmic center, or stand alone and serve as modifying elements on the scroll arms. Its presence on the Fairfield gorget Puma as well as the Hopewell figure suggests that it had a long-held connection to the cosmic world order. Finally, if flipped on its side the Z-shaped element becomes the arms of the scroll. In some representations where the primary element of the scroll is gone, an arm-only scroll motif can appear as a Z-shape with a central line that is similar to the early French Fork Incised Z-shape with a central line (see figs. 11.2*f–g* and 11.9*a*). The various forms of the scroll motif in which the Z-shape can appear may suggest a fusion of Woodland and Caddo iconic themes.

The Caddo scroll motif was a cosmogram for the multileveled world; it developed in the Early Caddo period, with input from Coles Creek ideas, and from the symbolic structure imparted into the vessels themselves by the Caddo potters. This cosmogram was merged with a Z-shaped motif representing an actor or power of the cosmic of world order that came out of Hopewell iconography via lower Mississippi valley and southeastern connections. What better way to emphasize the link between the structure of a vessel and the cosmic order then by placing a reference to the power that controlled access to that order on the side of the vessel?

Summary

This discussion of the origin and iconography of the Caddo scroll motif demonstrates that the motif can be considered a cosmogram representing the multilevel world theme with the axis mundi at its center. The basic form of the scroll motif, found on Early Caddo period bottles and bowls associated with the types Holly Fine Engraved, Spiro Engraved, and Crockett Curvilinear Incised, may have originally emerged from the interplay of the vessel structure, including composite vessels, and simple decorative elements such as engraved or incised lines around the rim and neck of Hickory Engraved and Davis Incised bottles. These simple vessel decorations may also be traced to ceramic influences coming from Coles Creek period groups of the lower Mississippi valley. As the scroll motif continued in use on Middle and Late Caddo period vessels, new elements and combinations of elements were added that associated the scroll and the vessel with particular world powers or actors. One element, the Z-shape, can be placed in the arms of the scroll that revolve around the primary circle or concentric circle, placed next to the circular element, or placed by itself around the vessel body. These placements suggest that it may represent a power or an actor that controls access to the center

represented by the circle, which is the axis mundi, and thereby access to movement between worlds. The Z-shape element is old and is a product of Woodland period iconography. It appears to also have come into the Caddo Homeland and the Caddo belief system via lower Mississippi valley and southeastern connections.

Although a multiplicity of analyses directed at Caddo ceramic vessels have been used by scholars to develop an understanding of the interaction between Caddo societies on both the local and regional scales, little headway has been made in defining what made those interactions possible. The iconographic analysis presented here provides one approach to interpreting those interactions by demonstrating how old and widely held mythic-religious themes and motifs were accepted and survived through Caddo ceramic artistic expression. In this way, the Caddo scroll motif and its association with the Z-shaped element likely took on iconic themes through which social interactions and communication between Caddo groups as well as groups beyond the Caddo Homeland would have been facilitated. This was a communication that helped engender the long-held success of the Caddo people (Girard et al. 2014:132–33).

12

An Exploratory Network Analysis of the Historic Caddo Period in Northeastern Texas

Robert Z. Selden Jr.

> Far better an approximate answer to the *right* question, which is often vague, than an *exact* answer to the wrong question, which can always be made precise.
>
> —Tukey 1962:13–14

The most distinctive material culture item associated with Caddo groups living in northeastern Texas is the ceramic vessel manufactured for cooking, storing, and serving needs, which is regularly included in burials. The decorative styles that adorn these ceramics hint at the temporal spans and geographic extents associated with ancestral Caddo groups that were once widespread across the region. The diversity of decorative motifs and elements associated with Caddo ceramics is substantial, as seen in utility-ware jars and bowls, as well as fine-ware bottles, carinated bowls, and compound vessels. These characteristics are related to distinctive communities of practice and identity, where potters shared a group identity that may be reconstructed through the analysis of suites of technological and stylistic attributes (Eckert et al. 2015:2).

Caddo potters also manufactured vessels in a wide variety of shapes (Perttula 2015b; Selden 2017, 2018a, 2018b, 2019; Selden, Perttula, and O'Brien 2014), employing unique technological traditions associated with suites of attributes that included temper choice, surface finishing treatments, and firing conditions that articulate with well-crafted body and rim designs (Perttula 2010). Judging from the archaeological contexts in which Caddo ceramics have been found, as well as inferences surrounding their manufacture and use, it is evident that ceramics were important to ancestral Caddo peoples for the cooking and serving of foods and beverages, as storage containers, personal possessions, beautiful works of art and craftsmanship, and social identifiers. Certain shared and distinctive stylistic motifs and decorative patterns conceptually distinguish closely related communities and constituent groups, and the co-presence of specific artifact types has informed the iterative development and refinement of the numerous Caddo phases and pe-

riods used heuristically to understand and explain the ancestral Caddo cultural landscape.

The detection and interpretation of relationships between the subjects of research interest—ceramic vessels and arrow points in this study—are the primary goals of network analysis (Brughmans 2010:277). It is of considerable importance to recognize that the results presented here are based on the incomplete and fragmented record of objects left behind by Caddo potters and knappers, and not on the Caddo potters and knappers themselves. However, the information provided by the ceramic vessels and arrow points inform the production of data-driven theories associated with the Historic Caddo period cultural landscape that can be tested in subsequent confirmatory analyses. It is recognized that the full range of complexity associated with social interactions is not captured by social network analysis or complex network techniques (Brughmans 2013:641). However, networks have much to offer in the development of novel, complementary, and competing theories (Borck et al. 2015; Brughmans 2014; Collar et al. 2015; Knappett 2013) and also aid in elucidating the many complex collective dependencies (entanglements) between people and things (Hodder 2012, 2014; Hodder and Mol 2015).

Geography and geographic relationships are factors included in this analysis (Collar et al. 2015:6; Sindbæk 2007:70) (fig. 12.1); however, the possibility that these relationships may not have been of particular importance is also acknowledged (Hart 2012:133). Nevertheless, similarities are considered in the Historic Caddo ceramic and lithic assemblages that conform to tribal locations known from eth-

Figure 12.1. Geographic extent of Historic Caddo network.

nographic works, as well as spatial distributions and currently defined material culture areas or phases and periods (Krieger 1944b, 1946) that are regularly employed as the foundation of discourse for much of Caddo archaeology (Perttula 2017b:8–11). The multiscalar nature of network analysis (Knappett 2011a:33–35; Mills et al. 2015:19) emphasizes the numerous relational connections that transcend predetermined categories.

The goal of this exploratory network analysis (fig. 12.2) is the production of novel hypotheses generated through the use of artifact assemblages recovered from northeastern Texas sites assumed to date to the Historic Caddo period based on taxonomic assignment. Through combining ceramic vessels and arrow point assemblages, it is further assumed that the cultural resolution of the aggregated network will be greater than that of an independent ceramic or lithic network. Some of the communities and subcommunities identified in the network articulate with currently defined Historic Caddo groups and phases, while others represent previously undefined groups that warrant additional scrutiny and testing.

Figure 12.2. Workflow used for exploratory network analysis and production of confirmatory hypotheses.

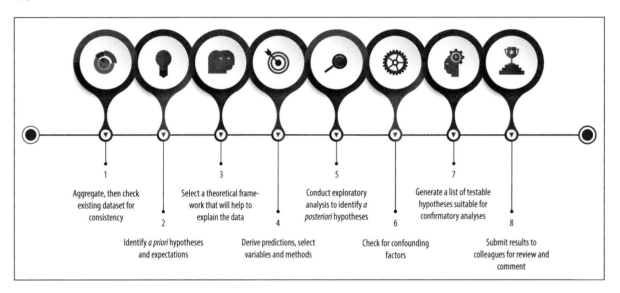

1 Aggregate, then check existing dataset for consistency

2 Identify *a priori* hypotheses and expectations

3 Select a theoretical framework that will help to explain the data

4 Derive predictions, select variables and methods

5 Conduct exploratory analysis to identify *a posteriori* hypotheses

6 Check for confounding factors

7 Generate a list of testable hypotheses suitable for confirmatory analyses

8 Submit results to colleagues for review and comment

Assumptions

Within the context of this study, it is assumed that the taxonomic and temporal identifications are correct; although it is also acknowledged that the current typological constructs are, themselves, an assumption (Brew 1946; Krieger 1941, 1944a; Rouse 1960). A substantive effort has been made to mitigate investigator bias, ensuring that typological identifications remain consistent across the sample; however, it should be noted that bias is also introduced through the algorithms used in the analysis.

Limitations

It is not possible to capture the full extent of assemblage proportions that articulate with the various identified types in the network graphs due to the incomplete and fragmentary nature of the archaeological record. Recognized taxonomic varieties (primarily employed in categorizing fine-ware vessels) and vessel shape numbers (Perttula 2015b) were not employed in this analysis. Should the opportunity arise to incorporate additional data from Historic Caddo sites outside of Texas, these networks will change, warranting revisions to those networks and outcomes generated by this analysis.

Methods

Assemblages of diagnostic ceramic and lithic artifacts recovered from post-AD 1680 Historic Caddo sites in northeastern Texas were used to assess and characterize the potential affiliations and cultural relationships among Caddo communities. Those relationships can be tested with confirmatory hypotheses that question and clarify the frequency of interaction and contacts between communities; trade, exchange, and abandonment of ceramic vessels; as well as population movements; and capitalize on the dynamics associated with ceramic technological and morphological organization among Caddo potters.

The dataset used in the analysis (Perttula 2017b) is the product of twenty-plus years of vessel and projectile point documentation efforts. Using the temporal assignments associated with taxonomic identifications, each vessel was assigned to one of five periods: Formative Caddo (ca. AD 800–1000), Early Caddo (ca. AD 1000–1200), Middle Caddo (ca. AD 1200–1400), Late Caddo (ca. AD 1400–1680), and Historic Caddo (ca. AD 1680+). This study focuses on the last period. Data for the Historic Caddo period of northeastern Texas were obtained on ceramic vessels from forty-eight sites and include the following attributes: (1) site trinomial or collection name (enlisting the county location/centroid if no trinomial was available); (2) vessel and/or burial number, or other accession/catalog information; (3) vessel form; (4) temper, if known; (5) defined type, if known; (6) defined variety, if known; (7) decorative method or decorative elements for vessels of unknown type-variety, and other pertinent information; and (8) the estimated age of sites that include vessels from burial and/or habitation features (Perttula 2017b). In addition to the taxonomic and temporal data available for the ceramics, arrow point data was aggregated from previous analyses of Caddo assemblages.

The dataset was prepared, then checked for consistency prior to importing these data to R (R Development Core Team 2018) to generate and weight the co-presence networks (Kolaczyk and Csárdi 2014; Luke 2015; Peeples and Roberts 2013). The

ceramic and lithic data were made available on Zenodo (Selden 2018c); however, the site location data (latitude/longitude) spreadsheet was omitted due to the sensitive nature of those data. The two spreadsheets, one with site location information, the other with counts of ceramic and lithic data, were converted to CSV files and imported to R. It warrants mention that the network analysis method posited here explores the structure of similarities in the data rather than a system of physical routes, and they are based on objects, not people. Edges in the networks do not correlate with travel, trade, or exchange; rather, they illustrate similar attributes in assemblage-level similarities associated with Historic Caddo sites in northeastern Texas.

ANALYSIS

Three methods were used to define the symmetric similarity and distance matrices to weight the networks: (1) co-presence of types; (2) Brainerd-Robinson (BR) similarity; and (3) X2 distances. While networks employed in the formal analysis are weighted (Peeples and Roberts 2013), binary networks—where edges are either present or absent—are also rendered as an exploratory measure. Weights were applied to the matrices for co-presence, BR, and X2 distances, then plotted (Peeples 2017). The weighted BR networks were rendered at variable scales to illustrate commonalities between typed dyadic assemblages at 25, 50 and 75 percent. The X2 distances used to render the binary networks include defined similarities above 80 percent.

Archaeological networks are inherently incomplete for a variety of reasons, thus considering the potential impact of missing data from the network is an essential step in assessing the sample. This can have implications for interpretations due to variability in global network structure. The procedure allows for the estimation of the degree that certain aspects of this sample do or do not approximate those same aspects of the larger network from which they are derived. Through the production of multiple networks seen in binary and weighted representations, networks of co-presence, BR similarity, and X2 distances, the vulnerability of these data to sampling issues can be assessed (Borgatti and Everett 2006; Costenbader and Valente 2003).

Networks were subsampled at intervals of 10 percent, after which calculations for a set of centrality and centralization metrics were rendered for every replicate at each sampling fraction. Spearman's rho was used to calculate rank-order correlations between metrics for the original network sample and subsample, allowing for an evaluation of the average correlation and error at each sampling fraction (Peeples 2017). Ten thousand replicates were generated for each network. For individual nodes, boxplots were sorted from left to right in rank order of values from the original network, and red lines were used to indicate the observed value for each centrality metric for sites in the network using boxplots that illustrate varia-

tion across the simulated resampled networks (Peeples 2017). As a final means of analyzing the sample, the relationship between sample size in the original data is explored, along with the range of variation expressed by the estimated 95 percent credible interval for each node (Peeples 2017).

The network was subsequently exported from R to Gephi (Bastian et al. 2009), where node (site) locations were plotted using their latitude and longitude with the GeoLayout plugin (Jacomy 2018). The modularity statistic (Blondel et al. 2008; Lambiotte et al. 2014) was then used to identify nodes more densely connected to one another than to the rest of the network based on the co-presence of specific lithic and ceramic types.

Results

The results of this analysis highlight the contribution of exploratory studies, whereby patterns identified in the data provide a series of novel *a posteriori* hypotheses that can, in turn, be tested and evaluated in subsequent confirmatory analyses. A suite of co-presence networks generated using a similarity matrix were analyzed that employ Historic Caddo ceramic and lithic types recovered from archaeological contexts. In the network graphs, nodes are connected by weighted edges; thus, if one node (site) has more types in common with another node, the edges appear thicker. These data inform the modularity statistic used to identify communities and subcommunities in the network characterized by the suites of ceramic and lithic types found at each site.

Rank order correlations for degree, eigenvector, and betweenness centrality point toward a high degree of correlation for degree and eigenvector centrality, and lower, more variable, correlations for betweenness centrality for small samples (fig. 12.3). In the analysis of values for individual nodes, results point toward a reasonable match between observed and resampled networks for degree and eigenvector, and a high degree of variability in betweenness centrality (fig. 12.3 *left*). The relationship between sample size in the original data table and the range of variation represented by the estimated 95 percent credible interval for each node (fig. 12.3 *right*) illustrates greater variability among sites with small samples for degree and eigenvector, and less predictable results for betweenness. A similar analysis was conducted for binary networks that yielded similar results.

HISTORIC CADDO CERAMIC VESSEL AND ARROW POINT NETWORK

The modularity statistic identified two communities based on the suite of ceramic and lithic point types: one in the southern part of northeastern Texas (Community 1), and the other from the Sabine River north to the Red River among Nadaco (Fields and Gadus 2012a, 2012b; Perttula 2007b; Perttula and Nelson 2007, 2014) and Kadohadacho groups (Community 2) (table 12.1 and fig. 12.4). A single node

Figure 12.3. Assessment of the potential impact of missing nodes using sub-sampling for degree, eigenvector, and betweenness centrality, demonstrating a high degree of correlation for degree and eigenvector centrality (*left*). Plots on the *right* demonstrate greater variability among sites with small samples for degree and eigenvector centrality and less predictable results for betweenness centrality.

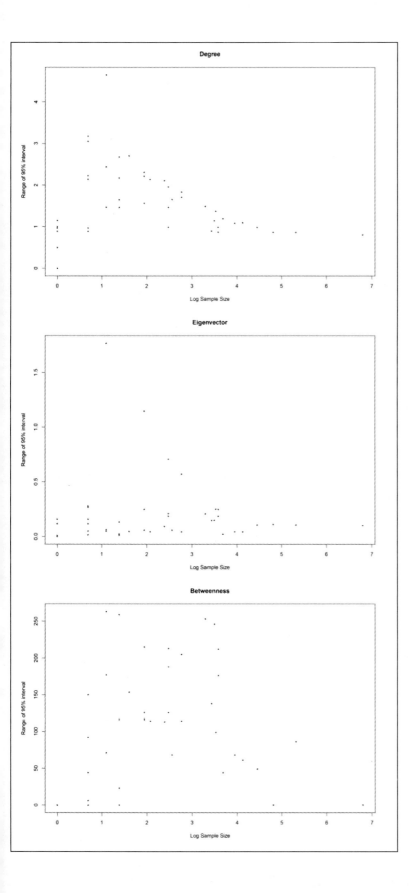

Table 12.1. Archaeological Sites, Community Assignment, and Historic Caddo Ceramic and Lithic Types at Each Site

Trinomial	Community	Historic Caddo Types
41AN2	1	F, P
41AN8	1	C
41AN13	1	PE, PYE, BB, Tu, P, C
41AN21	1	PE
41AN26	1	PE, PYE, PI, F, Tu, C
41AN32	1	PE, P
41AN34	1	PYE, PE, P, C
41AN54	1	HE, PE
41AN183	1	C
41BW2	2	SE, KT, KBI, F, T, N, SS
41BW3	2	KT
41BW5	2	NE, SE, EI, WE, MP, F, M, H, T
41BW512	2	NE, SE, EPI
41CE12	1	BB, HUE, KT, PE, PYE, HE, KP
41CE15	1	PE, PYE
41CE25	1	PE
41CE6	1	PE, HE, PYE, HOE, C
41CS23	2	SE, HTE, HOE, FTI, MOP, TE, KT, PBI, BE, MI, KBI, CE, MI, MP, MN, HDE
41CS25	2	CB, FI, TE, KT, HOE, HAE, BE, PBI, CA, MOP, SE, RE, KBI, NNB, EPI, FTI, Tu, P
41CS37	2	NNB, EPI, NE
41CS5	2	EPI, NE, EPI
41GG3	2	NE, EI, F
41HO64	1	P
41HO211	1	Tu, P, C
41HS13	2	EPI, SE, RE, TE, KBI, LRNB, NE, SE, HE
41HS253	2	BB, CA, CB, MI, SE, BE, AE, NE
41HS261	2	PE, SE, TE, NE, EPI, BB, HOE, MI, PE, KT, F
41HS269	2	NE, TE, SE, LRNB, EPI
41HS825	2	HOE, TE, BB
41LR1	2	WE, NE, SE, EPI, HDE, F, H
41LR2	2	SE, EPI
41NA18	1	P
41NA202	1	NE, PE
41NA206	1	Tu, P, C

Trinomial	Community	Historic Caddo Types
41NA311	1	P
41NA22	1	PE
41NA27	1	PE, HUE, NE, TE, T, Tu, P, C
41NA60	1	F, Tu, P, C
41RA13	2	WE, SE, NE, PE, EPI, WP, F, M, H, T, Tu
41RK132	2	SE, BB, F
41RK3	2	EPI, RE, SI, MI, BB, NE, HOE
41RR16	2	HDE, MP, AE, NNB, EPI, TE, CR, TE, KT, SE
41RR77	2	KT, TE, EPI, SE, TE, KT, EPI
41SA94	3	BR
41SM77	1	HUE, PYE, HE, BB, PE, SS
41TT741	2	WE, NE
41WD109	2	KT
41WD60	2	WE

(41SA94 in the Angelina River basin) that is not connected to the giant component (ceramic/lithic point types) represents an unconnected outlier community. The ceramic type represented at 41SA94 is Belcher Ridged (Suhm and Jelks 1962:11–12). This type is common in Belcher phase (ca. AD 1500–1680) components along the Red River in northwestern Louisiana (Girard 1999; Kelley 2012; Webb 1956, 1959; Webb and Dodd 1941; see also Essay 2) as well as in pre-AD 1680 Nasoni Caddo sites on the Red River in northeastern Texas (Perttula 2015c; Perttula, Nelson, Cast, and Gonzalez 2010; Perttula, Young, and Marceaux 2009). For the giant component, the weighted edges are representative of higher and lower similarities between sites based on the co-presence of Caddo ceramic and lithic point types.

There are forty-one defined ceramic types in the Historic Caddo network, including the thirty-eight in the following list.

Avery Engraved (AE) (Suhm and Jelks 1962:3 and plate 2)
Bullard Brushed (BB) (Suhm and Jelks 1962:21 and plate 11)
Bailey Engraved (BE) (Suhm and Jelks 1962:5 and plate 3)
Belcher Ridged (BR) (Suhm and Jelks 1962:11 and plate 16)
Cass Appliqued (CA) (Suhm and Jelks 1962:25 and plate 13)
Clements Brushed (CB) (Suhm and Jelks 1962:27 and plate 14)
Cabaness Engraved (CE) (Schambach and Miller 1984)
Clement Redware (CR) (Flynn 1976)
Ebarb Incised (EI) (Gregory and Avery 2007)
Emory Punctated-Incised (EPI) (Story et al. 1967:136–38)

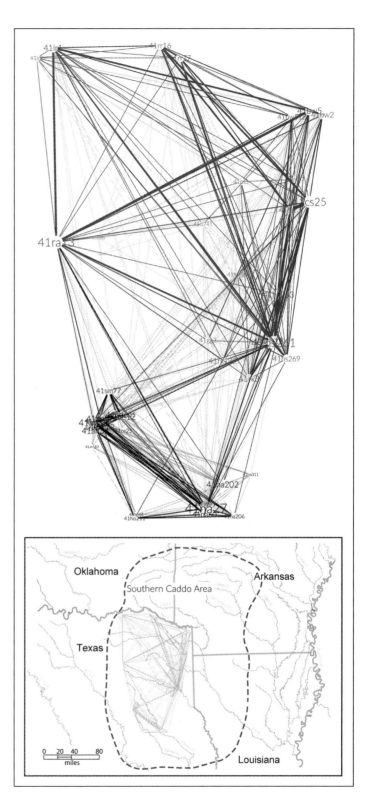

Figure 12.4. Historic Caddo period (ca. AD 1680+) network of ceramic and lithic types and locations of discovery, illustrating two communities (community 1, *bottom left cluster*; community 2, *top right cluster*) in the giant component, and one site (41SA94) not connected to the giant component. Community membership for specific sites can be identified by the color of the trinomial. Trinomials are sized based upon degree, meaning that those sites with a larger number of types/specimens appear larger.

Fatherland Incised (FI) (Brown 1998)
Foster Trailed-Incised (FTI) (Suhm and Jelks 1962:43 and plate 22)
Hatinu Engraved (HAE) (Perttula and Selden 2014:46 and fig. 39)
Hudson Engraved (HDE) (Suhm and Jelks 1962:81 and plate 41)
Hood Engraved (HE) (Perttula and Selden 2014:38 and fig. 30)
Hodges Engraved (HOE) (Suhm and Jelks 1962:73 and plate 37)
Hatchel Engraved (HTE) (Suhm and Jelks 1962:67 and plate 34)
Hume Engraved (HUE) (Suhm and Jelks 1962:83 and plate 42)
Karnack Brushed-Incised (KBI) (Suhm and Jelks 1962:85 and plate 43)
Killough Pinched (KP) (Suhm and Jelks 1962:91 and plate 46)
Keno Trailed (KT) (Suhm and Jelks 1962:87 and plate 44)
La Rue Neck Banded (LRNB) (Suhm and Jelks 1962:93 and plate 47)
Maydelle Incised (MI) (Suhm and Jelks 1962:103 and plate 52)
Moore Noded (MN) (Webb 1959:120 and fig. 122a–b)
Mockingbird Punctated (MOP) (Perttula and Selden 2014:40 and fig. 34a–b)
McKinney Plain (MP) (Suhm and Jelks 1962:97 and plate 49)
Natchitoches Engraved (NE) (Suhm and Jelks 1962:113 and plate 57)
Nash Neck Banded (NNB) (Suhm and Jelks 1962:11 and plate 56)
Pease Brushed-Incised (PBI) (Suhm and Jelks 1962:119 and plate 60)
Patton Engraved (PE) (Suhm and Jelks 1962:117 and plate 59)
Patton Incised (PI) (Perttula, Marceaux, Nelson, and Walters 2014)
Poynor Engraved (PYE) (Suhm and Jelks 1962:123 and plate 62)
Ripley Engraved (RE) (Suhm and Jelks 1962:127 and plate 64)
Simms Engraved (SE) (Suhm and Jelks 1962:141 and plate 71)
Simms Incised (SI) (Perttula 2015b)
Taylor Engraved (TE) (Suhm and Jelks 1962:149, 151 and plates 75–76)
Womack Engraved (WE) (Duffield and Jelks 1961)
Womack Plain (WP) (Perttula and Walters 2015)

There are also eight arrow point types in the network (listed below), as well as an unidentified straight stem (SS) projectile.

Cuney (C) (Turner et al. 2011:187)
Fresno (F) (Turner et al. 2011:191)
Harrell (H) (Turner et al. 2011:196)
Maud (M) (Turner et al. 2011:201)
Nodena (N) (Justice 1987)
Talco (T) (Turner et al. 2011:212)
Turney (Tu) (Turner et al. 2011:214)
Perdiz (P) (Turner et al. 2011:206)

Historic Caddo Network Subcommunities (North)

The Historic Caddo subcommunities defined in the northern part of northeastern Texas include twenty-four nodes (sites) connected by 198 edges of varying weights (table 12.2 and fig. 12.5), representative of 50 percent of the nodes (sites) and 41.4 percent of the edges in the composite network. The modularity statistic segregated the network into three subcommunities based on suites of ceramic and lithic types: one primarily to the west in the region and along the Sabine River that may articulate with the Nadaco Caddo (Community 1), one in the northeast (Community 2) on the Red River and tributaries in the area of Nasoni Caddo settlements in the larger Kadohadaco area, and one in the southeastern part of the region that also includes parts of the Sabine River (Community 3).

Historic Caddo Network Subcommunities (South)

The Historic Caddo communities identified in the southern parts of northeastern Texas include twenty-three nodes (sites) connected by 164 edges of varying weights (table 12.3 and fig. 12.6), representative of 47.9 percent of the nodes (sites) and 34.3 percent of the edges in the composite network. The modularity statistic identified two subcommunities based on the ceramic and lithic types present. The two subcommunities occur in the Neches and Angelina River basins and include Hasinai Caddo sites in the heart of northeastern Texas and upper Neches River basin Historic Caddo groups, perhaps the Nacachua or Nabiti Caddo (Swanton 1942).

Discussion

This exploratory network analysis posits potential contact and interaction between different Caddo groups across northeastern Texas based on the recovery of similar ceramic and lithic assemblages. Using the results of this exploratory network analysis as the basis for a series of subsequent confirmatory tests, interpretations that enlist these data can be strengthened, refined, and abandoned as needed.

Caddo Communities of Practice and Identity

Used in a variety of material culture studies, practice theory has been employed in studies of graffiti (Dhoop et al. 2016), stamp seals (Green 2016), ceramics (Cordell and Habicht-Mauche 2015; Eckert 2008; Eckert et al. 2015), and numerous other categories of material culture, including studies of the pedagogy of archaeology (Handley 2015). Eckert (2012:55) posited that communities of practice consist of social networks in which makers partake in a shared technological tradition. That tradition is culturally transmitted through various means: vertical, oblique transmission, master/apprentice transmission, or horizontal transmission (Hosfield 2009:46; Knappett 2011b:103). However, traditions of practice transcend specific

Table 12.2. Historic Caddo Subcommunities and Types Present in Community 2 (North)

Trinomial	Subcommunity	Historic Caddo Types
41BW2	2	SE, KT, KBI, F, T, N, SS
41BW3	2	KT
41BW5	1	NE, SE, EI, WE, MP, F, M, H, T
41BW512	1	NE, SE, EPI
41CS23	2	SE, HTE, HOE, FTI, MOP, TE, KT, PBI, BE, MI, KBI, CE, MI, MP, MN, HDE
41CS25	2	CB, FI, TE, KT, HOE, HAE, BE, PBI, CA, MOP, SE, RE, KBI, NNB, EPI, FTI, Tu, P
41CS37	1	NNB, EPI, NE
41CS5	1	EPI, NE, EPI
41GG3	1	NE, EI, F
41HS13	1	EPI, SE, RE, TE, KBI, LRNB, NE, SE, HE
41HS253	3	BB, CA, CB, MI, SE, BE, AE, NE
41HS261	3	PE, SE, TE, NE, EPI, BB, HOE, MI, PE, KT, F
41HS269	1	NE, TE, SE, LRNB, EPI
41HS825	3	HOE, TE, BB
41LR1	1	WE, NE, SE, EPI, HDE, F, H
41LR2	1	SE, EPI
41RA13	1	WE, SE, NE, PE, EPI, WP, F, M, H, T, Tu
41RK132	3	SE, BB, F
41RK3	3	EPI, RE, SI, MI, BB, NE, HOE
41RR16	2	HDE, MP, AE, NNB, EPI, TE, CR, TE, KT, SE
41RR77	2	KT, TE, EPI, SE, TE, KT, EPI
41TT741	1	WE, NE
41WD109	2	KT
41WD60	1	WE

social units (i.e., villages, cultures, or ethnic groups) (Stark 2006:25), and three core characteristics must be understood to define communities of practice: mutual engagement, joint enterprise, and shared repertoire (Lyons and Clark 2012:27).

It is worth noting that communities of identity differ from communities of practice in that they are social networks where makers share a group identity (Eckert 2008:3), and unlike communities of practice, where membership is often correlated to unconscious decisions, membership in a community of identity articulates with conscious production decisions that emphasize (or deemphasize) group membership (Eckert 2012:55). Depending on contextual associations and assumed utility, the communities characterized in this exploratory network analysis could be inter-

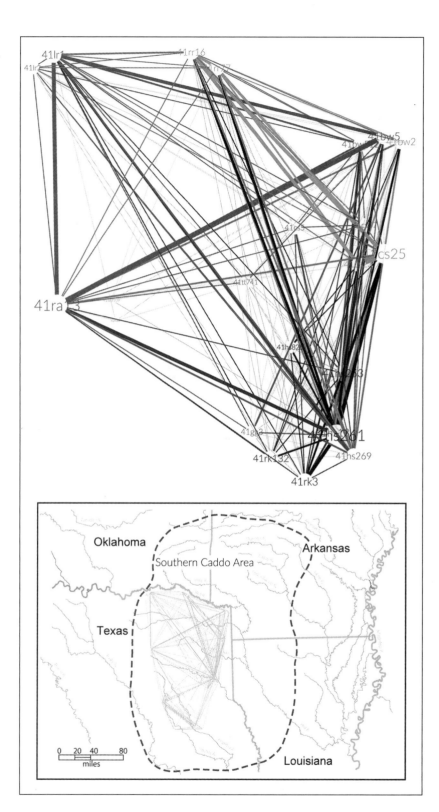

Figure 12.5. Historic Caddo period (ca. AD 1680+) network of ceramic and lithic types, locations of discovery, and results of the modularity statistic (fig. 12.4, community 1), illustrating three potential subcommunities: subcommunity 1, *medium shade*; subcommunity 2, *light shade*; and subcommunity 3, *dark shade*. Subcommunity membership for specific sites can be identified by the color of the trinomial. Trinomials are sized based upon degree, meaning that those sites with a larger number of types/specimens appear larger.

Table 12.3. Historic Caddo Subcommunities and Types Present in Community 1 (South)

Trinomial	Subcommunity	Historic Caddo Types
41AN2	2	F, P
41AN8	2	C
41AN13	2	PE, PYE, BB, Tu, P, C
41AN21	1	PE
41AN26	2	PE, PYE, PI, F, Tu, C
41AN32	2	PE, P
41AN34	2	PYE, PE, P, C
41AN54	1	HE, PE
41AN183	2	C
41CE12	1	BB, HUE, KT, PE, PYE, HE, KP
41CE15	1	PE, PYE
41CE25	1	PE
41CE6	1	PE, HE, PYE, HOE, C
41HO64	2	P
41HO211	2	Tu, P, C
41NA18	2	P
41NA202	1	NE, PE
41NA206	2	Tu, P, C
41NA311	2	P
41NA22	1	PE
41NA27	2	PE, HUE, NE, TE, T, Tu, P, C
41NA60	2	F, Tu, P, C
41SM77	1	HUE, PYE, HE, BB, PE, SS

Figure 12.6. Historic Caddo period (ca. AD 1680+) network of ceramic and lithic types, locations of discovery, and results of the modularity statistic (fig. 12.4, community 2), illustrating two subcommunities: subcommunity 1, *top left cluster*; subcommunity 2, *bottom right cluster*. Subcommunity membership for specific sites can be identified by the color of the trinomial. Trinomials are sized based upon degree, meaning that those sites with a larger number of types/specimens appear larger.

preted as either communities of practice or identity. However, if it is assumed that the shape and form of arrow points, and the shape, form, designs, and motifs associated with Historic Caddo ceramics represent the deliberate, and thoughtful, decisions of Caddo makers, then an interpretation that focuses on communities of identity may be more appropriate. Further, context is of particular importance, and should the artifacts have been recovered from burials, as is the case for much of Caddo material culture in the archaeological record, framing our discussions in terms of communities of identity,

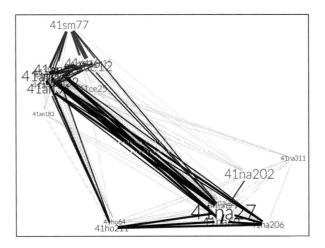

rather than communities of practice, may provide more meaningful and conceptually consistent explanations.

Communities of identity have been ascribed in the past to recognized Caddo phases or aspects through the enlistment of co-presence observations associated with the many decorative attributes that adorn Caddo vessels, the semiotics of which occupy a special place at the core of Caddo ceramic taxonomy (Suhm and Jelks 1962; Suhm and Krieger 1954). The networks illustrate two communities and a possible spatial boundary that warrants additional testing (see fig. 12.4). This result appears to align particularly well with the Allen phase area in the south (Community 1), and the Kinsloe phase in the north (Community 2) (see fig. 12.4). Based on current knowledge regarding the distribution of Historic Caddo groups and defined phases, the area of the Sabine River north to the Red River was occupied by the Kadohadacho (Parsons et al. 2002; Perttula 2005b; Scurlock 1965; Williams 1964) and related tribal groups. Clusters south of the Sabine River more readily articulate with locations of known Hasinai Caddo tribal groups (Eakin 1997; Kenmotsu 1992; Marceaux 2007, 2011; Marceaux and Wade 2014; Mickle 1994; Middlebrook 2014; Wyckoff and Baugh 1980).

The two subcommunities associated with Community 1 (south) overlap to some degree with sites from Anderson, Cherokee, Nacogdoches, and Smith Counties in subcommunity 1, and other sites in Anderson, Houston, and Nacogdoches Counties in subcommunity 2 (see table 12.3). While common attributes (types) exist between both of these subcommunities, additional work is warranted to identify and clarify those distinctive characteristics that may be present. Community 2 (north) includes three subcommunities; one that is expressed throughout the full geographic range of the community (subcommunity 1), and two others that are present in the northeast (subcommunity 2) and southeast (subcommunity 3). Certainly, these results beg the question of whether, and to what extent, subcommunities 2 and 3 continue into northwestern Louisiana, southwestern Arkansas, and southeastern Oklahoma.

There is overlap in the ceramic and lithic types present at some sites; however, the communities and subcommunities are defined by the proportions of types recovered from each location. This raises questions regarding whether and how the similarities and differences among those types found in Community 1 and Community 2 sites may be expressed grammatically through decorative attributes and motifs, as well as technological attributes. In addition to decorative and technological attributes, morphological differences are known to exist between and among artifacts found at Caddo sites and groups of sites that can be further explored through tests of ceramic (Selden 2017, 2018a, 2018b, 2019) and lithic morphology (Selden et al. 2018). While current efforts to identify similarities and differences in Caddo ceramic and lithic shape, form, allometry, and asymmetry enlist geometric morphometrics (Selden, Perttula, and O'Brien 2014), the initial push toward a

more standardized and rigorous analysis of Caddo vessel shape began over forty years ago (Turpin and Neely 1977; Turpin et al. 1976). This network analysis provides a useful exploratory framework that can be used to posit, and then test, additional questions using geometric morphometrics.

Conclusions

This exploratory analysis of Historic Caddo networks demonstrates the potential for significant theoretical and interpretive gains through the employment of aggregated type data for Historic Caddo ceramics and arrow points in ancestral Caddo lands. Aggregation and addition of those data associated with sherds, pipes, lithic and ceramic varieties, vessel shapes, and new discoveries may aid in further refining the current iteration of Historic Caddo networks by increasing their cultural resolution and by providing additional insights into potential affiliations associated with each site. The analysis of the Historic Caddo network articulates well with practice theory, which is seen as a gainful interpretive tool through which to couch the results of future analyses.

Further work remains with regard to the production of a more holistic and inclusive network; however, this effort represents the beginning of a long-term research program aimed at exploring regional similarities in Caddo artifact assemblages throughout the southern Caddo Area. The production of exploratory network analyses for the Late, Middle, Early, and Formative Caddo periods will aid in the continued refinement of this methodological approach, to include the confirmatory analyses that follow. None of the networks presented in this analysis are static, and each will continue to change as additional data and subsequent iterative improvements are incorporated.

Acknowledgments

I extend my gratitude to Matthew A. Peeples for his guidance with statistical methods used to assess missing data in the network, Timothy K. Perttula for his thoughtful comments on an earlier draft, and Suzanne L. Eckert for her comments regarding the vagaries associated with the application of theories of communities of practice and communities of identity. Thanks also to the anonymous reviewers for their thoughtful comments and to the editors for their invitation to contribute this essay.

13

Louisiana Limitrophe

A Morphological Exegesis of Caddo Bottle Shape

Robert Z. Selden Jr.

> In a very large part of morphology, our essential task lies in the comparison of
> related forms rather than in the precise definition of each.
>
> —Thompson 1917:723

Historically, attempts to discern the temporal and spatial dynamics of Caddo
groups in the archaeological record have employed different similarity measures to
link groups of sites or communities with similar features and material culture as-
semblages (Harrington 1920; Krieger 1947b; Newell and Krieger 1949). Some have
posited that Caddo groups and communities first emerged in two areas: one in the
Great Bend of the Red River in southwestern Arkansas and northwestern Louisi-
ana, and the other concentrated in the Arkansas River basin in eastern Oklahoma
(Story 1981); the George C. Davis site, located in the Neches River drainage in East
Texas, is also thought to have been occupied at or before the same time (Story 1998;
Story and Valastro 1977). Others have considered the Fourche Maline culture the
singular antecedent of Caddo culture (Rose et al. 1998; Schambach 2002). Cur-
rent discourse on Caddo origins proposes a model of gradual social and economic
change (Girard 2009) that developed largely in situ (Corbin 1989, 1998) from dif-
ferent Woodland period cultures (Ellis 2013; Schambach 1998, 2002; Story 1990a).
Each of these cultures is indistinguishable from one another biologically (Rose et
al. 1998), but they have discernible differences in mound building practices, settle-
ment complexity, and material culture assemblages (Perttula 2017b).

Caddo cultures are distinct yet sufficiently linked to the Mississippian South-
east (Blitz 2009; Early 2004) and locally to one another. Caddo ceramic types
and varieties often serve as exemplars of these links (Perttula 2008c, 2014; Suhm
and Jelks 1962; Suhm and Krieger 1954), where decorative attributes and motifs,
in addition to features and contextual information, are employed as markers of
group identity. This qualitative dataset can then be paired with the quantitative
data where additional lines of inquiry can be investigated. The quantitative study

of Caddo ceramic shape is not novel (Selden 2017; Selden, Perttula, and O'Brien 2014; Turpin and Neely 1977; Turpin et al. 1976), and this endeavor enlists geometric morphometrics (GM) to test whether Formative/Early Caddo period bottle morphologies differ across the geographies of the preceding Fourche Maline and Mossy Grove culture areas (Perttula 2017b:fig. 21). This basic research effort is focused on testing for differences in shape between two geographical areas where bottle shapes may be said to differ. In this analysis, the Late/Historic Caddo period sample is counterposed with the Formative/Early Caddo period sample across the same geography, providing the requisite baseline data for subsequent studies related to the formal characterization of shape change in Caddo bottles through time. Results are then considered in light of a recent stylistic and compositional analysis in which Formative/Early Caddo period fine wares discarded or interred in the Arkansas River basin in eastern Oklahoma—or the northern Caddo Area—were interpreted to be products of trade or exchange with southern Caddo groups (Lambert 2017 and Essay 8).

Defined as "a vessel with a spheroid or oval body, surmounted by a slender, cylindrical neck," Caddo bottles were initially viewed as a relatively homogenous ceramic form; some were interpreted to be the work of individual makers due to marked similarities in shape and decorative motif (Harrington 1920:187). Caddo vessel shapes are variable among groups and through time, reflective of stylistic, functional, and social change (Perttula 2010). Krieger (1946) previously noted spatial and temporal differences associated with bottle morphologies in East Texas, and a recent partition of bottle shapes has been proposed for northeastern Texas Caddo sites that segregated bottles into twenty-seven idiographic shape categories (Perttula 2015b:fig. 2). In southeastern Oklahoma, shape differences have been noted in the Early and Late McCurtain phase for bottle necks and bodies (Regnier 2013). Caddo bottles demonstrate lower axial asymmetry more than do bowls and ollas (Selden 2017); however, additional work is needed to identify whether—and to what extent—this observation holds true across geography, time, and a broader range of vessel categories. More recently, some have posited that Caddo decorative motifs are directly correlated with vessel shape (Early 2012; Lambert 2017).

Caddo potters were purported to have "had no superiors short of the Pueblo country" (Swanton 1942:239). They elevated local ceramic production to a high art (Smith 1995), leading some analysts to posit that Caddo bottles rest at the apex of Native American ceramic technology (Gadus 2013a). Taxonomic definitions for Caddo ceramics integrate semiotic and morphological attributes, and Caddo types include an expansive range of vessel shapes that comprise bottles, bowls, carinated bowls, and ollas, among others (Suhm and Jelks 1962; Suhm and Krieger 1954). Previous analyses have demonstrated that aspects of morphology differ among Caddo bottles (Selden 2018a, 2018b, 2019) and Gahagan bifaces (Selden et al. 2018) found above and below a northwestern Louisiana shape boundary (fig. 13.1).

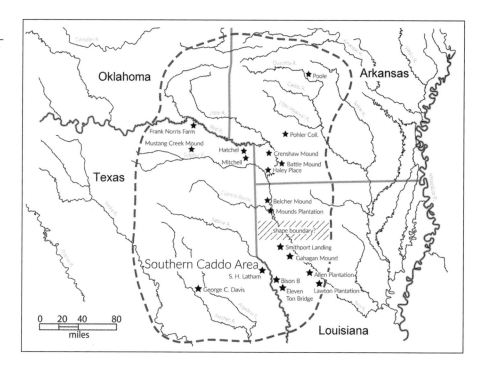

As a fundamental attribute employed in the analysis of archaeologically recovered ceramics, morphology alone may not be able to distinguish the full range of ceramic variability (Shepard 1977). The integrated analysis of shape and size (form) provides information related to the contributions of allometry and isometry (Claude 2008), articulating with the semiotic descriptions characteristic of the Caddo types (Suhm and Jelks 1962; Suhm and Krieger 1954). Webb and Dodd (1941) previously noted the pear-shaped body and basal morphology associated with Hickory Engraved and Smithport Plain bottles found at the Belcher Mound site, and Webb (1959) later discussed the globular and pear-shaped bodies of Smithport Plain bottles in his analysis of material culture from the Belcher Mound and Smithport Landing sites. While ceramic type assignments associated with each specimen are known, with two exceptions, only the temporal association—Formative/Early Caddo or Late/Historic Caddo—and the location of sites north or south of the shape boundary were used as qualitative analytic attributes in this study.

Previous analyses that have enlisted the tools of geometric morphometry (GM) (fig. 13.2) provide the requisite foundation on which this inquiry is built. Geometric morphometric methods have utility in delimiting how Caddo bottle shapes and sizes vary within a cultural framework to generate and test hypotheses of fluctuating vessel shape employed by groups or subgroups of Caddo potters (i.e., Kadohadacho, etc.) and in characterizing how those shapes or forms (shape + size) may have developed or changed through time. These sequences of morphological change can

The figure contains the following text:

STEPHEN F. AUSTIN
STATE UNIVERSITY
NACOGDOCHES, TEXAS

**Geometric Morphometrics in
Archaeology--Interactive Figure 1**

Citation data for geometric morphometric
publications in archaeology were harvested
from Scopus. This interactive graph includes
all nodes (n=3055) and edges (n=4488)
visualised in the network. Nodes are sized
by OutDegree.

If you believe a publication to be missing
from this network, please let us know by
clicking here, and submitting the citation.

i More about this visualisation

Legend:
● Publication/Cited Ref
╲ Incoming/Outgoing Citation
◗ Publications (Maroon)/Citations (Blue)

Search:

Search by name ▶

oiioiioii Oxford Internet Institute
oiioiioii University of Oxford JISC
oiioiioii

be compared across the larger ancestral Caddo territory and can be further parsed
to investigate where and how specific morphological changes are manifested in con-
cert with other qualitative or quantitative variables (i.e., features, artifact classes,
linear measurements, etc.).

The analysis employs seventy-two Caddo bottles from nineteen sites to test the
hypothesis of distinct bottle morphologies associated with sites north and south
of the shape boundary from within the spatial extent of the preceding Fourche
Maline and Mossy Grove culture areas (table 13.1; see fig. 13.1). This analysis was
followed by additional tests to identify whether a difference in Formative/Early
Caddo and Late/Historic Caddo bottle shapes occurs between and among the

Figure 13.2. Interactive
citation network of GM
analyses in archaeology.

Table 13.1. Caddo Bottles Used in the Analysis

Specimen	Site Name	Trinomial	Context	Museum	Type
256	Belcher Mound	16CD13	Burial 5	LSUMNH	Taylor Engraved
267	Belcher Mound	16CD13	Burial 5	LSEM	Belcher Engraved
269	Belcher Mound	16CD13	Burial 5	NSU	Belcher Engraved
271	Belcher Mound	16CD13	Burial 5	LSUMNH	Taylor Engraved
361	Belcher Mound	16CD13	Burial 9	NSU	Belcher Engraved
363	Belcher Mound	16CD13	Burial 10	NSU	Belcher Engraved
404	Belcher Mound	16CD13	Burial 11	NSU	Hickory Engraved
405	Belcher Mound	16CD13	Burial 11	NSU	Smithport Plain
430	Belcher Mound	16CD13	Burial 12	NSU	Smithport Plain
775	Belcher Mound	16CD13	Burial 15	NSU	Belcher Engraved
784	Belcher Mound	16CD13	Burial 15	LSUMNH	Keno Trailed
787	Belcher Mound	16CD13	Burial 15	LSUMNH	Taylor Engraved
788	Belcher Mound	16CD13	Burial 15	NSU	Belcher Engraved
803	Belcher Mound	16CD13	Burial 15	LSUMNH	Belcher Engraved
805	Belcher Mound	16CD13	Burial 15	NSU	Belcher Engraved
845	Belcher Mound	16CD13	Burial 17	NSU	Belcher Engraved
852	Belcher Mound	16CD13	Burial 17	NSU	Keno Trailed
897	Belcher Mound	16CD13	House 6	NSU	Belcher Engraved
997	Belcher Mound	16CD13	Burial 24	NSU	Belcher Engraved
1054	Belcher Mound	16CD13	Burial 26	LSEM	Taylor Engraved
1073	Belcher Mound	16CD13	House 6	NSU	Belcher Engraved
95	Smithport Landing	16DS4	Burial 1	NSU	Smithport Plain
96	Smithport Landing	16DS4	Burial 1	NSU	Hickory Engraved
152	Smithport Landing	16DS4	Burial 10	NSU	Smithport Plain
No #	Smithport Landing	16DS4	Unknown	NSU	Hickory Engraved
142	Allen Plantation	16NA6	Unknown	NSU	Hickory Engraved
955	Gahagan Mound	16RR1	Mound A	NSU	Hickory Engraved
956	Gahagan Mound	16RR1	Mound A	LSUMNH	Hickory Engraved
HFE1	Haley Place	3MI1	Unknown	LSEM	Hickory Engraved
HFE2	Haley Place	3MI1	Unknown	LSEM	Hickory Engraved
HFE3	Haley Place	3MI1	Unknown	LSEM	Hickory Engraved
HFE4	Haley Place	3MI1	Unknown	LSEM	Hickory Engraved
HFE5	Haley Place	3MI1	Unknown	LSEM	Hickory Engraved
55-1-8*	Crenshaw Mound	3MI6	Unknown	CNO	Hickory Engraved
2002-01-18*	Unknown (Clark County, AR)	Pohler Coll	Unknown	CNO	Smithport Plain
2002-01-20*	Unknown (Clark County, AR)	Pohler Coll	Unknown	CNO	Hickory Engraved
2002-01-23*	Unknown (Clark County, AR)	Pohler Coll	Unknown	CNO	Hickory Engraved
2002-01-27*	Unknown (Clark County, AR)	Pohler Coll	Unknown	CNO	Smithport Plain

Specimen	Site Name	Trinomial	Context	Museum	Type
FS7	Hatchel	41BW3	Unknown	TARL	Hickory Engraved
6-2-67	Paul Mitchell	41BW4	Unknown	TARL	Smithport Plain
6-2-78	Paul Mitchell	41BW4	Unknown	TARL	Smithport Plain
6-2-132	Paul Mitchell	41BW4	Unknown	TARL	Hickory Engraved
341-427	Paul Mitchell	41BW4	Burial 9	TARL	Hickory Engraved
341-464	Paul Mitchell	41BW4	Burial 21	TARL	Hickory Engraved
2015-1	George C. Davis	41CE19	Burial F-154	TARL	Hickory Engraved
7	Frank Norris Farm	41RR2	Unknown	TARL	Hickory Engraved
2	Mustang Creek Mound	41RR3	H. O. #568	TARL	Hickory Engraved
SMU16	Bison B	16SA4	Feature 4	SMU	Taylor Engraved
SMU34	Bison B	16SA4	Feature 14	SMU	Taylor Engraved
SMU67	Bison B	16SA4	Feature 16	SMU	Taylor Engraved

Note: The bottle without a number (Webb Collection) is assumed to have come from the Smithport Landing site in fragments. The bottle was later reassembled, but a number was never assigned.

* = Repatriated to the Caddo Nation of Oklahoma

NSU = Northwestern State University (Williamson Museum)

LSUMNS = Louisiana State University Museum of Natural Science

CNO = Caddo Nation of Oklahoma

TARL = Texas Archeological Research Laboratory

LSEM = Louisiana State Exhibit Museum

SMU = Southern Methodist University

northern and southern Caddo groups in the southern Caddo Area. Other tests include whether bottle shape varies with size, whether the null hypothesis of parallel slopes for Formative/Early Caddo and Late/Historic Caddo bottles is supported or rejected, and whether any group displays greater shape or size variation among individual bottles relative to other groups.

All Caddo bottles used in the analysis fall under the Native American Graves Protection and Repatriation Act (NAGPRA) and are known or assumed to have come from Caddo burial contexts, excepting those found in Houses 2 and 6 at the Belcher Mound site (see table 13.1). The Caddo Nation of Oklahoma granted permission to scan the collections with the provision that any scan data used in the analysis must not include the texture (color) file. Full-resolution scan data were sent to the Caddo Nation of Oklahoma with the texture applied. This provides the Caddo with an accurate record of each vessel, and a means of viewing and interacting with the digitally aggregated collection.

Primary data are included in the Open Science Framework, where the unprocessed 3D scan files, images, and metadata can be viewed and downloaded alongside those data from previous GM projects. Processed data can be accessed through

Zenodo at CERN, where they are available for use in subsequent studies under a Creative Commons license. All new 3D meshes used in this study will be uploaded to the Index of Texas Archaeology Type Collections, where users can view and interact with the meshes, view and download photos of the vessels, and browse the associated metadata. The metadata included with each image can be harvested through the Open Archives Initiative Protocol for Metadata Harvesting (OAI-PMH) for use in future projects. All images are open access, can be downloaded at full, medium, and thumbnail resolutions, and shared across more than 270 social media platforms.

Methods

The bottles were scanned with a Creaform GoSCAN 50 at a 0.8 mm resolution or a Creaform GoSCAN20 at 0.5 mm resolution depending on their size. Scanner calibration was optimized prior to each scan, with positioning targets required for increased accuracy, and shutter speed reconfigured in each instance. A clipping plane was established to reduce the amount of superfluous data collected during each scan. Following data collection, resolution for the GoSCAN 50 meshes was increased to 0.5 mm, and meshes from both scanners were transferred to VXmodel where the final mesh was rendered following application of the clean mesh function. This process removed isolated patches, self-intersections, spikes, small holes, singular vertices, creased edges, narrow triangles, outcropping triangles, narrow bridges, and non-manifold triangles prior to export as an ASCII stl file. The stl was subsequently imported to Geomagic Design X (Dx) 2019.0.0, where each mesh was subjected to an automated post-processing routine to detect and correct any abnormal poly-faces in advance of performing a global remesh to improve mesh quality.

Prior to pursuing the mixed-method analysis that employed data from two different scanners, two meshes of the same object—produced with the Creaform GoSCAN 50 and GoSCAN 20—were imported to a computer-aided inspection program (Geomagic Control X 2018.0.1) in an effort to identify any significant deviations that may exist between the meshes in advance of the GM analysis. The tolerance level for the inspection was selected by using the highest resolution of the GoSCAN 20 (0.1 mm). Small areas of the rim exhibited minor differences while the remainder of the vessel is within the arbitrary 0.1 mm tolerance (Selden 2018a, 2018c).

Landmarks and Semilandmarks

A total of nine landmarks and forty-six semilandmarks segregate each bottle into four discrete components corresponding with the rim, neck, body, and base (table 13.2 and fig. 13.3). Discussions of the alignment process and the application of reference geometry are detailed elsewhere (Selden 2018a, 2018b, 2019). Landmarks and

Table 13.2. Landmarks Used in This Analysis

Landmark	Location	Definition
Point01	Rim peak	Horizontal tangent of rim curvature on widest side of vessel
Point06	Rim/Neck	Point of highest curvature (everted rim) or intersection of horizontal line 10 mm below rim tangents (direct rim)
Point15	Neck/Body	Point of highest curvature
Point24	Body/Base	Point of highest curvature
Point28	CenterBase	Intersection of vector and external surface of the 3D mesh
Point32	Body/Base	Point of highest curvature
Point41	Neck/Body	Point of highest curvature
Point50	Rim/Neck	Point of highest curvature (everted rim) or intersection of horizontal line 10 mm below rim tangents (direct rim)
Point55	Rim peak	Horizontal tangent of rim curvature

semilandmarks were populated along the spline, and numbering began on the side of the bottle profile determined to include the widest point. Divisions between each component articulate with those of the spline splits, where landmarks were placed at each of the points in table 13.2, with a series of equidistant semilandmarks between.

While sliding semilandmarks were an early consideration, the decision to use equidistant semilandmarks instead is based on preliminary results from an earlier study (Selden 2019:fig. 3). In the analysis of the Webb collection (Selden 2019), the first landmark and sliding semilandmark configuration did not split the spline between the neck and rim of the bottles, and when mean shapes were generated for

Figure 13.3. Spline splits for discrete components (rim, neck, body, and base) (*left*) segregated by landmarks and equidistant semilandmarks (*right*).

each ceramic type, an anomaly—from the everted rims of Belcher Engraved bottles—was added to the otherwise direct or tapered necks of the Hickory Engraved and Smithport Plain bottles. The use of sliding semilandmarks was abandoned because they could potentially influence the results of this analysis by introducing a morphological attribute to specimens where one does not exist. The constellation of landmarks and equidistant semilandmarks used in this study is influenced by the characteristic points and tangents employed in the study of aesthetic measure by Birkhoff (1933), as well as a selection of studies that followed (Denkowska et al. 1994; Staudek 1999).

ANALYSIS

Landmarks and equidistant semilandmarks were exported as x, y, and z coordinate data from Dx. Those data were aligned to a global coordinate system (Kendall 1981, 1984; Slice 2001), achieved through generalized Procrustes superimposition (Rohlf and Slice 1990) performed in R 3.5.2 (R Development Core Team 2018) using the *geomorph* library v.3.0.7 (Adams et al. 2018; Adams and Otárola-Castillo 2013). Procrustes superimposition translates, scales, and rotates the coordinate data to allow for comparisons among objects (Gower 1975; Rohlf and Slice 1990). The *geomorph* package uses a partial Procrustes superimposition that projects the aligned specimens into tangent space subsequent to alignment in preparation for the use of multivariate methods that assume linear space (Rohlf 1999; Slice 2001).

Principal components analysis (Jolliffe 2002) was used as an exploratory means of visualizing shape variation among the bottles. The shape changes described by each principal axis are commonly visualized using thin-plate spline warping of a reference 3D mesh (Klingenberg 2013; Sherratt et al. 2014). A residual randomization permutation procedure (RRPP; $n = 10,000$ permutations) was used for all Procrustes ANOVAs (Adams and Collyer 2015; Collyer and Adams 2018), which has higher statistical power and a greater ability to identify patterns in the data should they be present (Anderson and Ter Braak 2003). To assess whether shape differs by size (allometry) and site, Procrustes ANOVAs (Goodall 1991) were run that used effect-sizes (z-scores) computed as standard deviations of the generated sampling distributions (Collyer et al. 2015). A Procrustes ANOVA was also run to assess whether shape changes with size. The assumption of allometric slope homogeneity was tested with the *procD.allometry* function using the PredLine option (Adams and Nistri 2010). Should this test not yield a significant result, then allometric slopes are similar—if not identical—across the categories used in the analysis.

A Procrustes ANOVA and pairwise test was used to identify populations where bottle shapes differ. The pairwise test is conceptually similar to trajectory analysis (Adams and Collyer 2007, 2009; Collyer and Adams 2007, 2013) in that pairwise statistics are vector lengths between vectors, but differs in that a factorial model is

not explicitly needed to contrast vectors between point factor levels nested within group factor levels (Adams et al. 2018). Procrustes variance was used to discriminate between groups and to compare the amount of shape and size variation (morphological disparity) across communities (Zelditch et al. 2004), estimated as the Procrustes variance using residuals of linear model fit (Adams et al. 2018).

Results

The mean consensus configuration and Procrustes residuals were calculated using a generalized Procrustes analysis (GPA) (fig. 13.4). This initial view of the data demonstrates the degree of variability in the aggregated sample of Caddo bottles. As an exploratory measure, GM methods—to include GPA—aid in clarifying shape differences as well as the production of novel *a posteriori* hypotheses (Mitteroecker and Gunz 2009).

Principal components analysis (PCA) was conducted on scaled, translated, and rotated landmarks and semilandmarks, and demonstrates that the first two PC's account for 55 (PC1) and 25 (PC2) percent of the variation in bottle shape (table 13.3 and fig. 13.5), with each remaining PC representing eight or fewer percent of the variation (table 13.3). The first two PCs are plotted in fig. 13.5, where warp grids represent the shape changes in PC1 and PC2.

A Procrustes ANOVA was used to test for significant allometry. Results of the

Figure 13.4. Results of generalized Procrustes analysis for the aggregated sample of Caddo bottles. Mean consensus configuration shown in *black*; samples in *gray*.

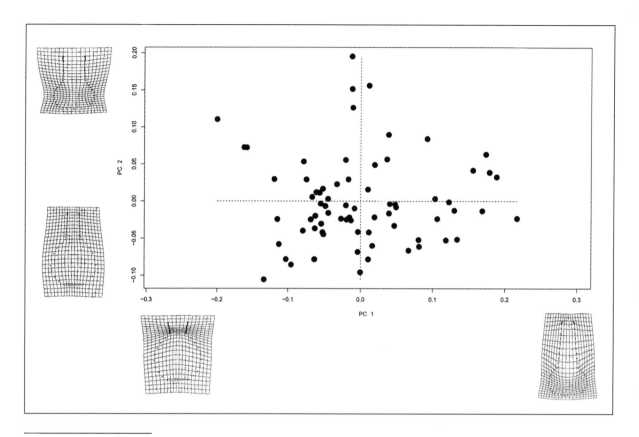

Figure 13.5. Results of PCA with warp grids representing shape changes along PC1 and PC2.

Table 13.3. Results of PCA

	SD	**PV**	**CP**
PC1	0.08911	0.55464	0.55464
PC2	0.06002	0.25166	0.8063
PC3	0.0344	0.08264	0.88894
PC4	0.02592	0.04692	0.93586
PC5	0.01844	0.02375	0.95962
PC6	0.01195	0.00997	0.96959
PC7	0.01115	0.00869	0.97827
PC8	0.008339	0.00486	0.98313
PC9	0.007354	0.00378	0.98691
PC10	0.006475	0.00293	0.98984

SD = standard deviation

PV = proportion of variance

CP = cumulative proportion

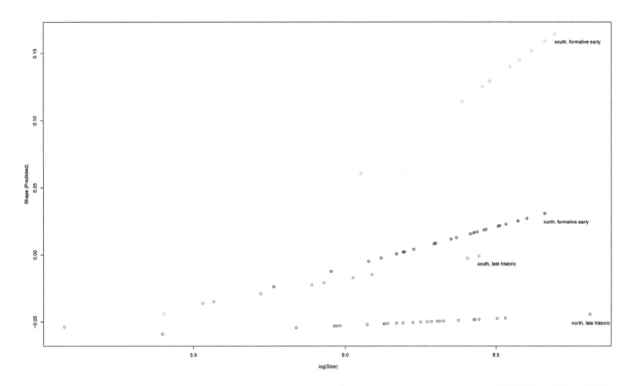

Figure 13.6. Predicted values of Caddo bottle shape by geography and temporal period regressions versus log(Size).

ANOVA indicate that allometry is significant (RRPP = 10,000, Rsq = 0.17594, Pr(>F) = 1e-04), meaning that Caddo bottle shapes vary significantly with size. Plots of predicted allometric trajectories for geography and period are presented in fig. 13.6. The null hypothesis of parallel slopes is rejected by the homogeneity of slopes test for group allometries (RRPP = 10,000, Rsq = 0.04251, Pr(>F) = 0.0038).

A second Procrustes ANOVA was used to test for a significant difference in bottle shape by group (RRPP = 10,000, Rsq = 0.32574, Pr(>F) = 1e-04), followed by a Procrustes ANOVA and pairwise comparison that demonstrates a significant difference between the groups (table 13.4). The test for morphological disparity of shape did not yield significant results; however, the test of morphological disparity by size did prove to be significant (table 13.5).

Discussion

This museum and repository-based analysis of curated intact or reconstructed Caddo bottles resulted in the improved characterization of Caddo bottle shape and provides an additional line of evidence in support of the gradual in situ development of Caddo cultures from preceding Woodland period cultures (Corbin 1989; Girard 2009; Perttula 2017b). Findings demonstrate that the morphology of Caddo bottles found within the Fourche Maline culture area north of the shape boundary

Table 13.4. Least-Squares Mean Distance Matrix *(top)*, Effect Sizes *(middle)*, and P-values *(bottom)* for Advanced Procrustes ANOVA and Pairwise Test of Bottle Shape by Geography and Time

	North, Formative/Early	North, Late/Historic	South, Formative/Early	South, Late/Historic
	0			
	0			
North, Formative/Early	1			
	0.07280543	0		
	3.321468	0		
North, Late/Historic	**0.0047**	1		
	0.12083618	0.17358998	0	
	5.009296	8.2973	0	
South, Formative/Early	**0.0002**	**0.0001**	1	
	0.10330809	0.10109653	0.1487446	0
	3.618667	3.52835	5.114139	0
South, Late/Historic	**0.0033**	**0.0034**	**0.0001**	1

Note: Significant results in boldface type.

Table 13.5. Pairwise Absolute Differences Between Variances *(top)* and P-values *(bottom)* for the Test of Morphological Disparity by Centroid Size

	North, Formative/Early	North, Late/Historic	South, Formative/Early	South, Late/Historic
	0			
North, Formative/Early	1			
	0.002793123	0		
North, Late/Historic	0.3171	1		
	0.0122642	0.0094710769	0	
South, Formative/Early	**0.0009**	**0.0065**	1	
	0.003220716	0.0004275923	0.009043485	0
South, Late/Historic	0.3833	0.9154	**0.0351**	1

Note: Significant results in boldface type.

differ significantly from those found in the Mossy Grove culture area to the south. This result, when viewed in concert with the morphological explication of Caddo bottles in the Webb collection (Selden 2019), analyses of Hickory Engraved (Selden 2018a) and Smithport Plain bottles (Selden 2018b), as well as results from a recent study of Gahagan biface shape that identified a significant morphological difference north and south of the shape boundary (Selden et al. 2018), illustrates a distinct and visible morphological shift in Caddo material culture products across the

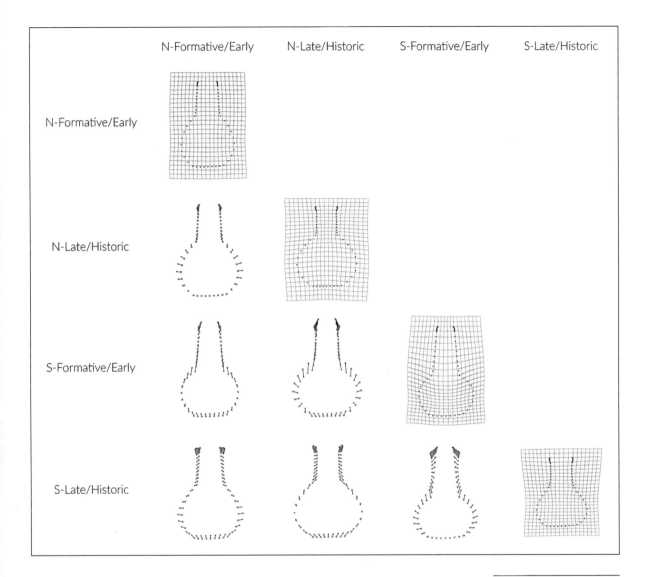

| | N-Formative/Early | N-Late/Historic | S-Formative/Early | S-Late/Historic |

Figure 13.7. Mean shapes and comparisons of morphological differences.

shape boundary. The temporal component of the analysis similarly demonstrates discrete morphological differences between the Formative/Early Caddo and Late/Historic Caddo samples north and south of the shape boundary (fig. 13.7). These morphological differences transcend typological assignments, and illustrate that two distinct, yet sufficiently linked, groups of Caddo potters were manufacturing divergent bottle forms that are most similar in shape when small and most heterogeneous in shape when large.

The mechanisms associated with Woodland-to-Caddo culture change are not well understood (Perttula 2017b), and Corbin (1989) suggested that the earliest East Texas Caddo groups may have been contemporaries with the Mossy Grove groups, thought to have been gradually subsumed or displaced by the Caddo (Corbin 1998).

It is the presence of larger settlements and villages with areas noticeably used for ritual purposes that clearly distinguishes between Formative Caddo and earlier Woodland period sites (Girard et al. 2014). Additional changes in decorative styles, social connections, settlement patterns, and economic factors shifted gradually during the Formative/Early Caddo periods, for which continuities can be traced through historic times (Girard 2018). Such continuities can also be traced through gradual shifts in Caddo ceramic morphology, and this study represents a necessary step toward the formal quantitative characterization of shape change for Caddo bottles in the southern Caddo Area. Quantitatively demonstrating how morphology changes through time can be achieved using phenotypic trajectory analyses (PTA) to test hypotheses associated with temporal changes in discrete morphological traits (Adams and Collyer 2009; Collyer and Adams 2007, 2013; Collyer et al. 2015). The addition of PTA to the toolkit of the ceramic analyst will allow for an improved characterization of how morphology changes across space and time, provide for comparisons of morphological trajectories across a wide range of variables (i.e., culture areas, ceramic types and varieties, river basins, etc.), and allow for the shift from discussions of differences in shape to one of shape change.

While this study demonstrates that significant morphological differences existed between Formative/Early Caddo and Late/Historic Caddo groups north and south of the shape boundary, the results paint a portrait of the Caddo cultural landscape at a broad scale. Results lend support to the assertion that Caddo bottle shapes were not prescribed, but labile (Selden 2018a); however, it also demonstrates that at a larger scale—one that transcends type definitions—morphological trends are apparent that may have communicated membership in an established Caddo community of practice or identity. The fact that all but three of the vessels come from, or are assumed to have come from, Caddo burials places additional emphasis on ipseity, which has been used by archaeologists to ascribe membership to a particular Caddo group or community through measures of similarity (fig. 13.8).

In a discussion of ceramics and the social contexts of food consumption, Mills (1999) demonstrated that differences in vessel sizes are related to household size, status, and feasting. This assertion may have greater utility in a study of Caddo carinated bowls rather than bottles, but the relationship between size and shape (form) warrants further scrutiny. Perhaps the Formative/Early Caddo bottles produced south of the shape boundary trended toward the larger end of the size spectrum due to the need to regularly host traders from the north. Assuming that water storage was associated with bottle function, larger bottles may have had utility in transporting greater volumes of water across geographies where water was scarce during droughts (Perttula 2017b); however, smaller bottles may have been easier to transport. It is also possible that an increase in bottle size articulated with an increase in sedentary behavior as the Caddo shifted from a largely horticultural economy to one of emergent agriculture. The results also illustrated that Caddo

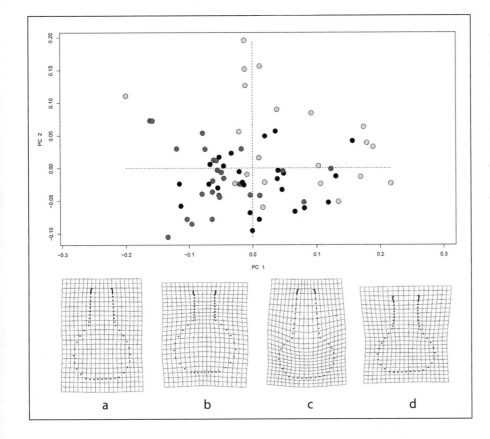

Figure 13.8. PCA and mean shapes for north Formative/Early Caddo (*a and black*), north Late/Historic Caddo (*b and dark gray*), south Formative/Early Caddo (*c and gray*), and south Late/Historic Caddo (*d and light gray*) bottles.

bottles south of the shape boundary generally trend from larger to smaller from the Formative/Early Caddo to the Late/Historic Caddo period, while vessels north of the shape boundary remained comparable in size through time (see fig. 13.6).

There is not a significant difference in morphological disparity associated with the shape of Formative/Early Caddo bottles recovered from sites north and south of the shape boundary (although see Selden 2018a; Selden 2018b, 2019). However, bottles recovered from the southern sites are more restricted in size during the Formative/Early Caddo period when compared with Formative/Early Caddo bottles recovered north of the shape boundary (see table 13.5). Thus, aspects associated with the creativity or innovation of Caddo potters (*sensu* Kenoyer et al. 1991) more readily articulate with bottles recovered at the northern sites, evidenced by greater size variation among individual bottles relative to those recovered from the southern sites. Expediency may yet be another consideration, and it is possible that the skill of Caddo potters matured at different rates, where more experienced makers (*sensu* Longacre 1999)—or those with a higher rate of production (Roux 2003)—manufactured a more standardized product.

This line of inquiry could be expanded to include discussions of decorative elements, motifs, and the design grammar employed by Caddo potters; however, it is

not possible to know whether the same potter that manufactured each vessel also applied those marks. In this case, differences in Caddo bottle shapes can be said to transcend the assignment of types and decorative elements, affording an additional layer of complexity to interpretations of cultural signals associated with Caddo bottles. It remains poorly understood how compositional and decorative elements align with the morphological results, and further work is warranted to parse the numerous adherent and autogenous signals left behind by Caddo potters (*sensu* Kubler 1962). Should a difference in ceramic shape be found to articulate with a noticeable difference in decorative elements and motifs, it would provide for the recognition of a complementary suite of attributes that merit additional scrutiny and discourse. As mentioned previously, morphological attributes associated with standardization, diversity, and—potentially—skill are among those considerations worthy of further inquiry, a task for which GM is well suited (Selden 2018a, 2018b, 2019; Selden et al. 2018; Topi et al. 2017).

"Standardization refers to homogeneity in ceramic materials, vessel shape, and/ or decoration" (Costin and Hagstrum 1995:622), while diversity "can be most generally considered as the opposite of standardization" (Rice 1991:273). In production contexts, standardization may be seen as the results of improvements in efficiency and minimized labor costs (Sinopoli 1988). However, it is also possible that the skill of an individual may decrease in relation to an increase in the division of manufacturing tasks associated with the standardization of material culture products produced by a group (Arnold 1999). One approach to testing hypotheses of expediency or skill in Caddo bottle manufacture may be to assess deviations from axial symmetry (Selden 2017) for bottles recovered north and south of the shape boundary, where results could be couched in discussions of creativity or innovation (fig. 13.9).

A recent stylistic and compositional analysis indicated that Formative/Early Caddo fine wares from Arkansas River basin groups in eastern Oklahoma may have been produced in the southern Caddo Area and traded to the northern Caddo Area (Lambert 2017 and Essay 8). Geographical discrepancies exist between this

Figure 13.9. Deviations from axial symmetry enlist the unique mesh of each bottle (*a*), then revolve a surface using the widest profile in the GM study around the vector to produce a symmetrical surface model (*b*) that is built atop the mesh (*c*), and used to calculate deviations between the symmetrical surface model and the mesh for each bottle (*d*).

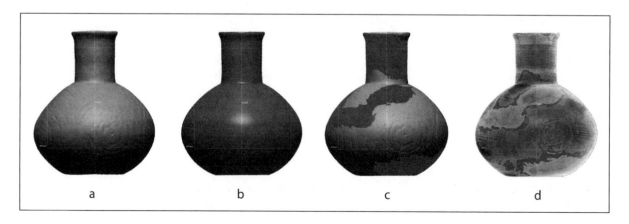

a b c d

study and Lambert's; however, when viewed in tandem, one interpretive prospect is the production of testable *a posteriori* hypotheses related to the location—north or south of the shape boundary—of bottle production in light of the differential morphological attributes discussed above. While the vagaries of Caddo material culture signatures associated with makers and consumers are not well understood, hypotheses that test for similarities and differences between groups of artifacts recovered from disparate contexts and geographies may provide evidence of cultural signals that can inform those discussions (*sensu* Longacre and Stark 1992). Morphological disparity may have utility in clarifying the degree of tolerance for standardization and diversity in and across Caddo vessel assemblages, where a lower tolerance is evidenced by a marked decrease in variation and a higher tolerance by the inverse (Eerkins and Bettinger 2001). Ceramic analysts in the Casas Grandes region have used GM to parse and explore the relationship between standardization and the organization of production (Topi et al. 2017). That model may have some utility in better understanding the morphological nuances associated with the temporal and spatial dynamics of Caddo material culture.

Conclusions

The results presented here demonstrate significant morphological differences between Caddo bottles discarded or interred across northern and southern portions of the southern Caddo Area that persisted from the Formative/Early Caddo period into historic times. This study of morphological patterns in and across ancestral Caddo territory illustrates that: (a) Caddo bottle morphology is protean; (b) similarities and differences in bottle shapes transcend type assignments; (c) bottle forms recovered north and south of the shape boundary in the southern Caddo Area are divergent and differ most at their largest size; (d) Formative/Early Caddo potters south of the shape boundary enlisted a smaller range of size variation among individuals relative to other groups; and (e) Caddo potters operating in the southern Caddo Area were manufacturing two unique bottle shapes, which may be used to posit a potential origin of production—above or below the shape boundary—for bottles recovered from the northern Caddo Area that are considered to be products of trade: an assertion for which the largest bottles would provide the greatest utility.

Acknowledgments

I extend my gratitude to the Caddo Nation of Oklahoma, the Material Sciences Laboratory at Southern Methodist University, the Williamson Museum at Northwestern State University, the Louisiana State Exhibit Museum, the Texas Archeological Research Laboratory at the University of Texas at Austin, and the Loui-

siana State University Museum of Natural Science for the requisite permissions, access, and space needed to generate 3D scans of Caddo bottles. Thanks also to Dean C. Adams, Emma Sherratt, Michael J. Shott, Hiram F. (Pete) Gregory, B. Sunday Eiselt, Julian A. Sitters, and Kersten Bergstrom for their constructive criticisms, comments, and suggestions throughout the development of this research design; to the editors for their invitation to submit this essay; and the anonymous reviewers whose comments improved the manuscript. Development of the analytical workflow and production of 3D scans from the Clarence H. Webb collection was funded by a grant to the author (P14AP00138) from the National Center for Preservation Technology and Training. Production of 3D scan data for Hickory Engraved and Smithport Plain bottles from the Texas Archeological Research Laboratory was funded by a grant from the Texas Archeological Society, and the production of 3D scan data for previously repatriated Caddo bottles was funded by a grant from the Caddo Nation of Oklahoma.

III

Contemporary Caddo Ceramic Traditions

14

Caddo Pottery

Connecting with My Ancestors

Jeri Redcorn

Introduction

Telling how I revived the lost art of making Caddo pottery will begin with my early life to the present day. In 1992, I began to seriously study the history of my Caddo people, and today I am a modern Caddo ceramics artist (fig. 14.1). When I saw the ancient Caddo vessels in museums, university collections, and private collections, it became clear that this was a calling. Although I was not an artist, nor had I studied art, I began making pottery with limited clay knowledge and few learning resources at that time. Initially my goal was to learn how to make Caddo pots and duplicate designs and shapes. Ultimately this broadened into a larger and more complicated endeavor, involving archaeologists, linguists, native peoples, historians, and artists. My research began in Norman, Oklahoma, and expanded to museums and private collections, reaching to the Smithsonian Institution in Washington, DC. With each Caddo vessel I viewed, there was another one to be seen, involving more people, books, and travels. My work as an artist allowed me to travel to many places in the ancient Caddo territory, in the continental United States, and even to Europe. Caddo pottery traditions are an important part of the Caddo Nation of Oklahoma. Pottery was woven into the culture of our Caddo people long ago. My expectation is to nurture this pottery cultural experience now and in future generations. That is the satisfaction my work brings. My struggles in learning about myself, my history, and my tribe took an unexpected introspective turn. Relating the joys, celebrations, and my personal evolution is my contribution to this book.

Early Life

As a child one of my favorite Caddo dances (*Kaoshun*) was the Alligator Dance, which was usually selected by the singers to dance around midnight on the plains in western Oklahoma. Trying to stay awake until dawn for the Morning Dance,

Figure 14.1. Jeri Redcorn holding Caddo Headpot, 2010.

my eyes would close, and I would curl up on a blanket beside my Mom and Dad. When I heard the leader's call "Yo-we-ho" and the dancers reply "Ee-ho," I would jump up and run to the fire in the middle of the dance ground to join in. The leader took us around the dance grounds at a quick pace while holding our hands, where we would end up back up around the drum when the drummers took up the beat to sing "Oh-yah-ne-ho-yah-nay." It was absolutely exhilarating joy! Years later, standing on the banks of the *Ba-ha-te-no* (Red River), in northwestern Louisiana on our ancestral lands, and seeing moss hanging from cypress trees, I knew why we honored the Alligator on the Oklahoma plains where the Caddo presently live. I knew why the Duck, the Bear, the Fish, and the Vine dances were important to the Caddo, for we came from a lush area with rivers, forests, plentiful game, plentiful water, and we were an agricultural people with great knowledge of plants.

When the Caddo people moved from that land of plenty, we lost many things, including the craft of Caddo ceramics. Ancient pottery traditions were but a memory when the Caddos came to the Indian Territory in 1859. While I have had a part in reviving traditional pottery (see www.redcornpottery.com), I am grateful for those who kept Caddo traditions and beliefs unbroken throughout each generation. As I contemplate the status of the present-day Caddo pottery tradition, I feel confident that it will continue to survive and grow. There are young and talented ceramicists who are passionate about both traditional and modern clay art (see Earles 2012; Essay 15). The strength of our people in community, oral history, songs, dances, and other cultural ways has left no doubt of our continued presence.

In 1992, I visited the Museum of the Red River in Idabel, Oklahoma. When I saw the beautiful Caddo pottery, the varieties, and the workmanship, I felt pride, but I also had a sense of having missed a part of my culture. That moment brought an emotional state in my heart of the Caddo losing a significant part of our history. As I began to research and learn how to create these vessels, the shapes, designs, clay, and techniques used by my ancestors, I was ultimately compelled to examine contributing circumstances for this loss. Historical and personal events that shaped who I am as a Caddo, as a woman, and as an American, forced me to confront many appalling truths of this country.

The history of American Indians is the history of America from a different viewpoint (see Carter 1995a). When told only from a Eurocentric view, the long history of the American Indian is often lost, distorted, or reduced. For the United States to attempt to erase the history of these indigenous people, it was necessary to take physical control over them, which they did by taking our land. It was also necessary to take mental control over American Indians, and this was accomplished by controlling their education, religion, and language. It is painful to examine contemporary American values and ways of life in a positive light, knowing the dishonorable actions that led to the devastation of American Indians. In my research on ceramic traditions, I was faced with the following questions: What are the lingering effects of forced assimilation on American Indians today? How has my life been affected by assimilation policies? How can I be a proud American knowing of these subjugating practices that border on genocide? Is this topic relevant today?

Apparently, this topic is still relevant. As recently as 2017 the Supreme Court of the United States heard oral arguments that raised serious legal questions about tribal sovereignty. Arguments in the case refer to the doctrine of discovery and manifest destiny, prompting this question from Justice Kagan: ". . . isn't it true that . . . the theory of the U.S. Government during this period was to try to divest Indian tribes of as many sovereign powers as it could in order to essentially promote assimilation?" And Justice Sotomayor: ". . . it was only after that that the government began to—it wasn't even that it took the land away from the Indians; that through trickery and deceit, they were permitted to sell off their lands" (Supreme Court of the United States [SCOTUS] 2017).

Community and Survival

To tell the story of my experiences with making Caddo ceramics by only telling of how I make the ceramics is not possible. This is because the art and heritage associated with creating Caddo ceramics is much more than simply the methods used to create a ceramic vessel. The Caddo people did not separate or compartmentalize their lives into religion, education, food, earth, sky, or water. These concepts were and are woven into a way of life that is present every day. Caddo people were a communal society where ownership and individualism were dissimilar concepts from the American outlook of living where getting ahead meant others were likely to fall behind. For example, the building of houses with the Caddo was a cooperative effort of the community just as was planting and harvesting crops. Collective decision-making was for the mutual benefit for all. Ceramic making, and the heritage it embodies, is also for the mutual benefit for all.

Sharing food was essential for survival of the people. One of my cherished memories from childhood was of drying corn. Every year my mother and father planted

the multicolored Indian corn in a field away from the other corn to protect the crop from cross-contamination. When it was ready, we picked and shucked the ears in early summer on a sunny day. A fire was built under the big black kettle filled with water. The ears were dropped in the boiling water and very shortly removed. Using spoons to scrape the kernels off the cobs, these precious seeds were placed on a sheet and spread on the roof of the chicken house. My older sisters took turns perched on the roof to turn the kernels and to scare away the birds. At sunset, the corn was wrapped in the sheet and taken indoors, then next morning after the dew dried up, the second day of drying began, and the third day if needed, before it was ready to be stored. There is nothing like the taste of that sweet, nutty flavor of dried Indian corn cooked with meat and served with freshly made fry bread.

Food is dependent on the land. Individualism and land ownership were foreign concepts to the Caddo, who shared almost everything. The Caddo existed in a communal society where life was ordered around kinship ties and providing for the good of the entire community. This lifestyle was rooted in both cultural values as well as economic values.

Colonization and Manifest Destiny

In 1492 the Doctrine of Discovery allowed Christopher Columbus the right to lay Spanish claim to all America (United Nations [UN] 2007). The outcome for indigenous populations was much worse, with an estimated 8 million deaths during the initial conquest, which has been argued to be the first large-scale act of genocide in the modern era (Forsythe 2009:297). In 2007 the UN Declaration on the Rights of Indigenous Peoples recognized the historic injustices of colonization (UN 2007). The goal of colonization was complete domination over a people, to completely assimilate them, including land, economic, political, cultural, and religious ways. Recognizing that the end goal of colonization was not morally right in my personal history, I have been able to make my own choices about my culture.

To understand the truth of colonization it is necessary to understand myself. After World War II when my father came back to farm his land, I was walking with him through a field and he shared a concept I have never forgotten. "I am a ward of the federal government," he said. "I cannot sell my land without permission from the United States." He had been given an identifying number indicating he was incompetent to handle his own business matters. Thus began my own search to comprehend how I fit within the U.S. government and American Indian special relationships. I, too, have a number for all my tribal and federal business.

The pervasiveness of colonialism to control virtually all aspects of our daily lives, including relationships, beliefs, and social values should not be underestimated. The 1803 Louisiana Purchase brought with it the end of the Caddo people living in their own territory. Then, Manifest Destiny, the belief that Americans are superior

and morally entitled to take the land from Native Americans, became the justification for white settlers to squat on Caddo lands.

Certainly, this attitude of superiority existed in the white Americans in my hometown during my formative years in the 1940s and 1950s. However, we, the Indians, did not share that concept. The little western Oklahoma town where I was raised was racially divided between the Indians and white farming community. Looking back, I realize that I experienced a broad worldview. My best friends were Cheyenne, Arapaho, Kiowa, Comanche, Apache, Caddo, and *Inkanish* (white). Privileged to learn the customs of so many different people, I became aware that respecting the traditions of others is good and natural. I had the opportunity to visit many other people and observe the way they did things. Within sixty miles there were diverse languages, dress, and customs, so it was like traveling from one country to another. Although we were different tribes, we shared a lot. When the concept of pow-wows and pan-Indianism came around, it was not such a foreign concept to us.

Caddo Removal and Government Allotment Policies

Caddo Removal in 1835–1859 from our ancestral homelands in Louisiana, Texas, Arkansas, and southeastern Oklahoma was a bitter period (see Cross 2018; Smith 1995). Sometimes it is easier to forget that time of deception and betrayal, because this is painful history. The 1830 Indian Removal Act under President Andrew Jackson was a planned policy to divest Indian tribes, including the Caddo, of their fertile lands in the Southeast United States to make room for white settlements.

I certainly did not learn this in my public-school education. I doubt that very many people know of this despicable story. American settlers, bolstered by the federal government, began to aggressively intrude on Caddo lands after the Louisiana Purchase. When there were no more Caddo lands to be pushed into, and through a series of treaties, Caddo people were forced to remove to Indian Territory.

From 1860 to about 1880 the Caddo were settling into their new lands and communities in Oklahoma Territory. Families grouped together in different areas, keeping political and social values in the tribal fashion with land and resources held in common. Gardens, harvests, and game were shared with family leaders making decisions together. Women shared a major leadership role in decision-making because children followed the mother's line, and the father moved to the wife's camp or community to raise the family.

The 1883 Indian Religious Crimes Code passed by Congress formally denied Indians First Amendment protections for "freedom of religion." Indian agents were ordered to discontinue Indian dances and feasts, Indian ceremonies were banned, religious practices were disrupted, and sacred objects were destroyed or confiscated. The effect of this law was to drive Indian religious ceremonies such as the

Figure 14.2. Grandmother Frances Elliott (Une-hoot) with children (*left to right*) Joe (father), Albert, and Willie Cross, ca. 1909.

Ghost dance and the Sun dance "underground" and far from the purview of white Indian agents. The Caddo Turkey Dance (see Carter 1995b), among other dances, was outlawed and Caddo dances were performed in secret during this time.

My Caddo grandmother Frances Elliott (Une-hoot) did not convert to Christianity but kept the Caddo beliefs (fig. 14.2). The Caddo had a strong belief in one all-powerful deity, *Ah-ah-ha'-yo*. Cecile Carter (1995a:100) writes about *Ah-ah-ha'-yo* "who gave the Indians corn, beans, nuts, acorns, and rain for their crops." In the late seventeenth and early eighteenth centuries when the Spanish missionaries built missions with hopes of converting the Caddo, they did not convert to Catholic Christianity. Instead the missionaries were asked to leave, which they did after burning down the mission they had built (Carter 1995a). There were other forces in nature exhibited through the sun, moon, animals, and plants. Fire, water, air, flint, and tobacco were powerful manifestations to honor, and the Caddo used these for survival. These traditions we continue to this day.

The Dawes Allotment Act of 1887 was the U.S. Government's intended means for the complete takeover of most of the remaining land of the Native Americans. The Dawes act advocated the destruction of communal land ownership through land allotments that intended to turn Native peoples into individual property holders. By breaking up families and communities, the act effectively weakened tribal governmental and social systems and the foundation of tribal culture. One opponent to allotment said, "The real aim of this bill is to get at the Indian lands and open them up to settlement. The provisions for the apparent benefit of the Indians are but the pretext to get at his lands and occupy them . . . If this were done in the name of greed, it would be bad enough; but to do it in the name of humanity, and under the cloak of an ardent desire to promote the Indian's welfare . . . is infinitely worse" (Pommersheim 2009:128).

In the late 1800s Kansas farmers and politicians began pushing the federal government to open Indian Territory (later the State of Oklahoma) for sale to white settlers. Through treaties, most of them forced on Indian tribes, the government yielded to the "Boomers" and "Sooners."

Almost all the tribes in Oklahoma opposed allotting land for individual ownership. A book review of *Savages and Scoundrels* (VanDevelder 2009) states: "[A] riveting, often chilling account of how a young, land-hungry nation . . . invent[ed]

the laws and policies that enabled it to push aside a people who . . . held legal ownership of millions of square miles of ancestral land" (Marc Covert, *The Oregonian*).

My great-grandmother Yune-now was born in 1853, my grandmother, Une-hoot, in 1881, and my father was born in 1906 (see fig. 14.2). Both Caddo women were allotted 160 acres of land in Indian Territory. I grew up on my grandmother's allotment land that was held in trust for her and later for my Caddo father by the federal government. Born in an earthen dugout on this land, my father graduated from the federal government Haskell Institute high school in Kansas (now the Haskell Indian Nations University) and later attended the University of New Mexico on a football scholarship. My father began farming cotton and other crops on the allotted land in 1945 after serving in the Army during WWII. Caddo people were agriculturalists, so with my dad, farming was a natural way of existence. Our lives tended to revolve around the cycle of crops. We, the eight children, did all the work on the farm. Cotton, our only cash crop, involved planting, chopping weeds in the summertime, and pulling or picking cotton in the fall. It was all our jobs to provide a meager income for the Cross family. We took care of the cows, horses, chickens, hogs, and gardens and supplemented this with rabbits, squirrels, fish, turtles, frogs, grapes, sand plums, mulberries, honey, walnuts, poke greens, and other wild plants. On the plus side, our food was organic and free range and most times abundant.

It was an exciting day when my Caddo uncles, aunts, and cousins would come to help butcher a beef or a hog, with everybody involved in cooking, cutting up the meat, and cleaning up. My oldest uncle never learned to drive a car and he would arrive early in the morning in his wagon pulled by two horses and he left in the afternoon because his transportation was not reliable after nightfall. There was teasing and laughter among the elders as they worked through the day, which ended with the dividing up of the cuts of meat to everyone. As children, we would hang around the edges to hear their talk and stories that sometimes ended with one of them being the butt of the joke. They were always ready to laugh at the expense of each other in a goodhearted way.

The Caddo vigorously opposed the Dawes Allotment Act of 1889, as did all the other tribes in Oklahoma. Chief Caddo Jake and the other Caddo Headmen were summoned by the Dawes Commission to "discuss" the tribe's wishes on allotment. Dawes Commissioner Jerome's continual bragging on how benevolent the Government was to furnish "gratuity rations and beef and clothing" etc., to the Indians, brought forth this reply from Chief Caddo Jake on May 14, 1891:

> "The white people know we have no game to hunt and they know it is them that killed all the game; I see buffaloes lying all around; the white people killed them and only took their hides and leave the meat lying around and I think that is why they feed me."

Again, he made it clear that "when you have a little more than you want, you don't want to sell it and *we don't want to sell it or take lands in allotment.*" The commissioners told the Caddo that dissolution of their reservation would happen "one way or the other, either as we propose or under the law" (Chapman 1944:192).

Boarding Schools and Attempts at Assimilation

After allotment in 1901, when the Caddo continued their tradition of communal living, Government Indian Boarding Schools were established to break up families further. I heard practically all my life that the policy of the white educational system as imposed on the Indians was simply "Kill the Indian, save the child," as advocated by Richard Pratt, superintendent of the Carlisle Indian School (Churchill 2004). Using Christian churches to set up boarding schools, the government began the further breakup of families by taking children from parents, sometimes at great distances. When they were young children, my mother and father were sent to federal government boarding schools run by the Catholic Church. My Caddo father was sent to St. Patrick in Anadarko, Oklahoma. My Potawatomi mother was taken from her family in Kansas to attend a Catholic Boarding School in Nebraska. Taught by nuns, Indian children were forbidden to speak their language and were severely punished if caught. Certainly, the teachers let them know that Indians were savages from an inferior race. My mother held a firm belief that assimilation was inevitable, and that Indians would disappear someday. Yet despite the harsh treatment to erase their culture, they were proud of their heritage and passed on many values and social customs to us children. Encouraged by our parents, our family participated in every Indian gathering or dance that we possibly could. Whether it was Caddo, Kiowa, Cheyenne, Arapaho, Comanche, or other Nations, we were there participating in the feasts, dances, and games. If our old car could make it, we were there.

Reviving the Craft of Caddo Ceramics

My first experience with making pottery (besides when I was little) was with Dr. Jim Corbin in Idabel in 1992. He showed a group of Caddo people the basics of coiling clay into pots using commercial clay. When he demonstrated firing a few vessels, with some breaking, I learned my first lesson: to choose dry clay. From that one-time experience, I began to experiment with clay, all commercial. Coiling, shaping, decorating, and firing led to many disasters. My goal was to at least be able to make the shapes and draw the designs used by past Caddo potters and hope later to find clay that Caddos used. I knew nothing of how to process clay let alone temper or firing temperatures. Without the Internet or a teacher, it was a lonely beginning. When I contacted Dr. Don Wyckoff, Oklahoma State Arche-

ologist, in 1994, at the Oklahoma Archeological Survey (OAS), he was able to assist with references and a tour through their ceramics collection. At the time, the collection was inadequately housed in a former naval barracks on the University of Oklahoma's South Base. In 1999 the collection was moved to the current Sam Noble Oklahoma Museum of Natural History (SNOMNH), a state-of-the-art facility on the University's campus.

In 1995, I made a trip to the Caddo Conference in Austin, Texas, with Lois Albert and sponsored by the OAS. Anxiously I set up a table beside Drs. Ann Early and Hester Davis of the Arkansas Archeological Survey (ARAS), and we soon became friends. I met many other archaeologists who became my friends, including Dr. Dee Ann Story of the Texas Archeological Research Laboratory at the University of Texas at Austin. My prices for the pottery ranged from 30 to 200 dollars and I sold almost everything. Everything I made was of commercial clay because that's what I knew. My dream was to have a group of potters working together, happily chatting, as I felt our ancestors would have done. I began a class with about twenty people hoping to spark the passion of the art of Caddo ceramics. We met for about six weeks and indeed there was a wonderful feeling in the group. However, none became the passionate ceramist of my vision.

I called myself a traditional Caddo potter because I felt my connection to my ancestors through this process. Later learning about raw clay, adding temper, and experimenting with many clays from Caddo land, I felt that this endeavor would take precious time that I did not have. Teaching full time, with papers to grade, and meetings to attend, left no time for ceramics, as even weekends were taken with family matters. The important message was to have recognition for Caddo ceramics. Spending a summer in Bremen, Germany, along with other native artists collaborating with German artists, allowed an international connection for my art. As part of the show "Hero, Hawk & Open Hand" (Townsend 2004), I was chosen artist-in-residence at the Art Institute of Chicago. I was fortunate to study Caddo ceramics at the Smithsonian Institution's National Museum of Natural History and the National Museum of the American Indian and have created several Caddo ceramic pieces since that time (fig. 14.3).

Caddo Ceramic Types and Archaeologists

As I became familiar with the ceramic types recorded and created by archaeologists and others, one aspect that particularly troubled me were the names of Caddo pottery types that were being used. Names such as Avery Engraved and Hodges Engraved, for example, which were chosen by an archaeologist, were used to categorize pottery types. In my research beginning in the 1990s, I made a mindful effort to designate the styles and designs in terms of my Caddo ancestry. For instance, I replaced *Sah-cooh* (Sun) for Avery, and *Tay-shas* (Friend) for Friendship

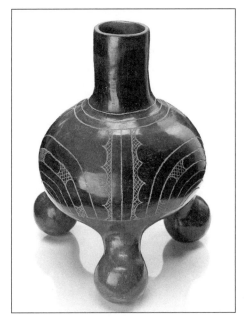

Figure 14.3. Jeri Redcorn with her tripod "Tay-shas" displayed at the National Museum of the American Indian, Washington, DC.

Figure 14.4. Tay-shas. Image used with permission from the Smithsonian National Museum of the American Indian (26/5159).

Engraved (fig. 14.4). I used tribal divisions, animals, chiefs, family names, and nature instead of the archaeological terms. I began a discussion with Caddo folks to change these names into something that would reflect Caddo culture or history. Presenting this before the leaders of the Caddo Nation, the concept received a unanimous vote to proceed.

However, discussions with archaeologists and librarians led to difficulties encountered to complete this endeavor. The overall enormity of Caddo ceramics in so many collections would require a massive undertaking to rename them, involving not only the Caddo Nation but states, libraries, museums, archaeologists, historians, educational institutions, and so forth. Despite these challenges, barriers can be resolved. Changing the ceramic names to names in the Caddo language, place names, and history will serve to honor our ancestors and be a contin-

ual reminder of Caddo antiquity in the minds of researchers. Creating culturally relevant names for present and future generations will afford a view into the Caddo past with hope that we can move toward such a goal with the continued present and future studies of Caddo ceramics.

Conclusions

Surviving as a people, the Caddo endured many hardships, always making decisions that would best serve the tribal nation. Looking at the strength and wisdom of the leaders who kept our ways and traditions, I realize I am just a very small part of contributing to the revival of Caddo ceramics. My experiences through eight decades of living have linked me with the past through Joe Cross, my father; Une-hoot, my grandmother; Yune-now, my great-grandmother, and Ke-yun-net, great-great grandmother, connecting me to the nineteenth, twentieth, and twenty-first centuries. Becoming a potter, using the shapes and designs of my ancestors, has revitalized me as a person and as a Caddo (fig. 14.5). Always, I felt a Caddo would appear with a passion for clay, history, culture, and he did appear. Chase Kahwinhut Earles is the artist, a shooting star, with immense potential (see www.caddopottery.com) (see Essay 15). Witnessing the incredible talents of other ceramicists and artists, it appears these Caddo/Hasinai traditions will last. In 2009, President Barack Obama and First Lady Michelle selected my art, Intertwining Scrolls, for display in the White House Oval Office (fig. 14.6). My heart is grateful for the opportunities that this gift has provided through my heritage.

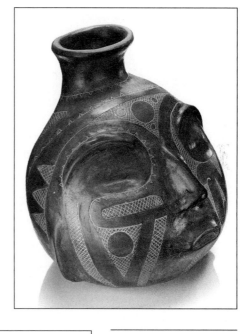

Figure 14.5. Caddo Head Pot. Image used with permission from the Smithsonian National Museum of the American Indian (26/5161).

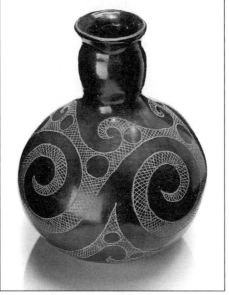

Figure 14.6. Intertwining Scrolls. Image used with permission from the Smithsonian National Museum of the American Indian (26/5160).

15

Ancestors and Identity

Reconnection and Evolution

Chase Kahwinhut Earles

Kumbakihah Kawinhut is how you say "My name is Kawinhut" in Caddo. Julia Edge, an influential elder of the White Bead's of the Caddo Nation of Oklahoma, named me. I was always interested in my culture, my tribe, and my heritage, but it took longing for a voice in artistry to start posing questions. My first was "Did the Caddos make pottery?" I wondered if we ever had a tradition of pottery. Surely we did. It seems like most ancient or older societies made some form of pottery. Being a little naive, I thought that since I had never heard of a tradition of Caddo pottery, if it existed it must have been crude, unskilled, and insignificant. Surely it could not be anything like the grandeur of the Pueblo pottery tradition that I was familiar with having traveled with my family on vacations to New Mexico, Arizona, Utah, and Colorado, almost every year during the summers in my youth.

I had no idea what the Caddo people created and were known for creating. How would I have known? I grew up unattached to my culture or tribe, and few Caddos know about the wealth of their pottery tradition and heritage. I began research and found that we created an enormous variety of finely crafted pottery and that there are many museums in the United States and Europe with collections of ancient Caddo pottery that was made and traded before and during the colonization of North America. The pottery produced in the Caddo Homelands at the peak of our civilization was some of the most refined and sought after in North America. I wondered what happened to these skills and if anyone today knows how to continue them. Was all our culture and the history surrounding it lost?

Through a voice in artistry, I discovered an ancient art form that would benefit not just me, but generations of future Caddo people who will see the benefit of its rediscovery. I quickly realized the need to make public the distinctiveness of our ancient pottery legacy for the sake of those Caddo who would become Caddo potters. The Native American art world in the American Southeast is much different from that of the Pueblo Southwest that I grew up loving. So many Southeast Native American artists are confused about their tribe's specific legacy and tradi-

tional art form. So much so that a broad spectrum of tribes in the region create artwork under the umbrella of "Mississippian" or "Southeastern Ceremonial." It became apparent to me that the Caddo's specific and unique pottery heritage is in danger of being misrepresented in the traditional world of fine art.

Craft vs. Fine Art

I believe there are fundamental differences between craft and fine art. When a cobbler makes a shoe, or a potter makes a mug, or a seamstress makes a shirt, or a carpenter makes a cabinet, are these fine arts? No. They are crafts whose products are to be used and consumed. More often than not, fine art is not meant to be consumed or functional in a utilitarian way. What separates fine art from craft is that the creator elevates the piece above utilitarian use by applying intention, meaning, and skill. There is everyday art, there is decoration, and there is fine art that belongs in a museum that either strikes purposeful conversation or increases the understanding or education of all who see and appreciate it. There is also bad and good art, or I should say there is immature, undeveloped art and carefully refined, mature, and developed fine art created from skill developed from years of experience. A child can paint a picture, which unarguably would be art. But does it belong in a museum? Art does not have to make a specific and direct statement, but it must contain meaning. One can add decoration to any object to make it pretty or even beautiful, but that still does not give it meaning. An artist intentionally setting forth to create an object that has meaning elevates the piece to fine art. For example, my alligator gar effigy bottle was never meant to be functional in a utilitarian way although it is a clay ceramic bottle (fig. 15.1). It is meant to be displayed and to say something or offer meaning to the viewer. It teaches people about the cultural identity of my Caddo people using an exaggerated traditional shape and using traditional methods that reinforce the point of creating fine art.

Figure 15.1. "Batah Kuhuh" alligator gar effigy ceramic bottle. Hand coiled by Chase Kahwinhut Earles.

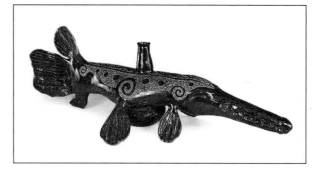

While I grew up loving the pottery of the Southwest, I realized that I had no real connection to the Pueblo pottery vessels that I aspired to create. Certainly, they would be fun to make, and pretty, but they would not be special to me. For all the effort I would put into creating them, they would not be worth anything to me emotionally nor would they have financial value, as they would merely be "knock-offs" of real traditional pottery made by the Pueblo people. Such vessels would simply be pottery replicas and not fine art. I am not a Pueblo Indian, although I gained a respect for the history and culture of the Pueblo people, and I felt that it would be insulting to unwittingly replicate their meaningful works of art that represent *their* voice and *their* record to forever pre-

serve *their* people. I decided that my own artwork would have to be created in my voice as a Caddo and would have to have real purpose or else it would be empty and meaningless. To copy a different tribe's unique pottery tradition would be unethical.

When I first met Jereldine Redcorn (see Essay 14), she already had posed many of the same questions I had, and she had strived to revive the artistic tradition of Caddo pottery. She consulted archaeologists, museums, historical accounts, books, and more books, to figure out, on her own, how to create Caddo pottery like our ancestors. After many talks with Jeri I knew that I had found my calling and a platform for my artistic voice. As a Caddo Indian, I was going to help revive and advance the traditions and history of Caddo pottery so that it could be carried on and not lost. For the first time in my life I felt like I really had a reason to create fine art and had a voice from behind for inspiration. This would be something real and meaningful. I looked inward at my own Caddo heritage and my own tribe's culture and was surprised by the richness of our artistic traditions.

In my formal education in fine arts I was taught that to be a true artist one must be independent. Peers judge artists on the quality, craftsmanship, and beauty of their art. Artists make decisions formulated solely from their own creative mind. They do not get the benefit of being grouped with an internationally familiar group or given exclusive entrance into competitions and exhibitions. Nor are they granted the honor of having pieces requested for museums or official collections without their art standing on its own unattached to any connotation or ethnicity. It is very different for an American Indian artist. If an artist chooses to publicly acknowledge their Native heritage and culture in their artwork they automatically become representatives of that tribe, whether they like it or not. I could say that I was making pottery without ever acknowledging that it was Native American or Caddo pottery, and it could be beautiful and I could be successful and enter galleries without mentioning my tribal affiliation. But the minute I decided to publicly acknowledge that I am Caddo, and that I have created Caddo pottery as a form of fine art, I became a representative for my tribe and was responsible for conveying the traditions and culture of my tribe honestly, accurately, and unselfishly. As a Native American artist and Caddo potter I feel that it is my duty to take these responsibilities seriously and not to be merely an independent fine art artist with no guidelines that describe and define the heritage and culture of my people.

Contemporary vs. Traditional Native American Art

Contemporary art and Native American art have a contentious relationship. The Western or European definition of Contemporary art is art that was made in recent times, the twenty-first century and the latter part of the twentieth century. That is all it means. For example, Modern art came in the period before Contem-

porary art and includes artists such as Vincent van Gogh, Pablo Picasso, Georgia O' Keefe, and Apache sculptor Allan Houser. Some contemporary artists are H. R. Giger, Navajo painter R. C. Gorman, Luiseño artist Fritz Scholder, and Kiowa artist T. C. Cannon. A problem arises when we take into consideration that Native Americans have a long history, sometimes reaching back a millennium or more, of producing art in certain ways and with certain styles using specific methods that are unique to their tribal identity. This long history extends beyond the contemporary timescale. For example, Caddos made extremely fine artistic pottery using very specific designs over and over again for hundreds if not several thousand years (see Townsend and Walker 2004).

It was certainly a tradition how we Caddos gathered and prepared clay, built our pots, and designed them in a certain way to produce a language specific to our Caddo culture and heritage. We also made pottery that was not intended for use but rather created to have a specific meaning. Although today we make pieces in the same tradition, using the same methods and designs, we are not making it for the same purposes as we used to, but rather, we are making objects of fine art that have meanings. Here is where the Western way of thinking has created a dangerous and painful conflation of the terms Contemporary and Traditional to label Native American art.

Simplistically, Contemporary Native American art refers to art created from the latter half of the twentieth century up to the present. Traditional Native art refers to art that was created using the specific ancient methods our ancestors used without employing modern conveniences and methods (such as a potter's wheel). These two terms are *not* mutually exclusive even though present-day Native American art galleries, art markets, art collectors, and art competitions assign artists to either the "Contemporary" category or the "Traditional" category to describe the methods used to create the work of art. The idea is that if an artist uses modern-day materials and tools then the work is "Contemporary" and if an artist uses handmade materials and methods like the ancestors did, then the work can only be "Traditional." Through this, it is easy to see how confusion between these two terms exists. Do we say that the use of the English words "contemporary" and "traditional" are terms only applied to Native American art, or do we subscribe to the Western definition of Contemporary Art and call all Native American art made in recent times Contemporary Art? How then do we distinguish between Native American art made in the traditional or ancestral style from art made using present-day materials and methods?

Traditional Materials and Methods

The Caddo traditional methods and materials used to create pottery evolved over time and were not stagnant. As identified in the archaeological record, at different

times and in different places, we used grog, bone, and shell as temper (Girard et al. 2014). We continued to use tried and true materials and methods but we also adopted new innovative processes. These changes took place before contact with explorers and colonizers. Once the diseases brought by European colonizers and the subsequent loss of our lands affected us, our traditional pottery knowledge eroded in the same way as our culture and community. As such, a thousand years of pottery-making knowledge was lost after about the mid-nineteenth century and so was the evolution of our methods and materials.

While I began making pottery using commercially produced clays because of their availability, I eventually started using traditional noncommercial clays, but not necessarily the local clays of the Caddo Homeland in all cases (fig. 15.2). This was largely because of the great distance between where the Caddo live today and where they lived before removal to Oklahoma. The Caddo potters living in the Caddo Homeland would find and use the easiest obtainable and best quality clay around them rather than carry it for miles. However, I did want to obtain clays from the same rivers and oxbows used by our ancient ancestors. With a little help, I was able to collect clay in and around the Red and White Rivers in Arkansas. I also experimented with digging various types of clays from my property in Oklahoma and processing them like my ancient ancestors (fig. 15.3). The clay on my property is black sticky-silty gumbo buckshot full of silt. I have to screen out small particles of manganese and limestone as well as bone and pyrite, and this extremely silty clay has a tendency to crack in the fire.

As part of my research, I talked to an Arkansas archaeologist and potter named John Miller (see Miller 2011), who confirmed what I had suspected. The clay on my property in Oklahoma needed temper that would help with the shrinkage and

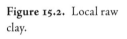
Figure 15.2. Local raw clay.

dehydration in the stress of firing. Traditionally we used crushed bone and fired clay from crushed pottery sherds (grog), and, in some areas, that eventually evolved into the use of crushed mussel shell. I decided to start out by using mussel shell because I thought that it would work the best and would more accurately represent much of our most familiar ancestral pottery (fig. 15.4). Sure enough, my first shell-tempered clay pot survived the extreme firing without a crack. By this time, I also had figured out how to fire properly. Originally, I dug a pit in my yard and tried firing within the cold damp earth. I quickly learned that not only was airflow cut off unless you engineer a more European draft pit, but also water on my property flowed through the area quite often, filling in the pit almost daily from rain occurring miles away. After additional research, I soon realized that Caddos simply used a basic above-ground bonfire and placing a cone of wood around the pot (fig. 15.5). This definitely was easier than dealing with a mud hole, but I had to adjust my fuel. It basically came down to gathering wood around my property and picking the best-sized sticks and twigs. Learning how to water-smoke the pots around the fire was key to the success of many of my later firings. I put the pot directly on the coals before building a wood teepee around it and letting the coals catch the fuel on fire. Learning about oxidation and reduction has been of interest for me as well. Along with the use of certain types of clays, I feel it is important to control the fire as much as possible to create the fully oxidized or partially reduced atmospheres in which the pots take on an intense red or deep chocolate brown color.

Figure 15.3. Digging clay.

Regarding materials and methods, today I see two divisions of Native American pottery: the well-established Southwest Pueblo pottery and the less established Southeast, which includes the Caddo, eastern Woodland, and Mississippian cultures. In the Southwest, there is an almost unbroken line of pottery making dating from well before the seventeenth century and Spanish colonialism. The Southwest has also been the center of the Native American art world for hundreds of years and fosters the cultures of this area (see Hayes and Hayes 2012). For this reason,

Figure 15.4. Crushed mussel shell.

Figure 15.5. Pit Fire of "Nidahhih Hakaayu" (White River) bottle.

the Pueblo potters have mostly held on to traditions passed down to them by their ancestors, and they use traditional methods that they have always used and materials that are located on their homeland where they have always lived. Although some of the paths of knowledge have been lost between specific tribes and styles of different time periods, the majority of the tradition remains intact. In the present Native American art world, one can see Southwestern artists adapting with the use of new materials and evolving their methods to modern-day means. For example,

many potters use kilns to fire their pots so they do not lose as many as in the traditional pit fire. Some potters are starting to use modern-clay slips and store-bought stains instead of making the ancient black dyes. Some potters are simply buying the clay, building the pots, and firing them in a kiln. Collectors, galleries, and the general Native American art world are starting to accept some parts of these "new" methods and materials for the creation of what would be considered "traditionally created" pottery.

The trajectory is different in the Southeast. In the Southeast, most of the paths of knowledge of pottery making were lost or broken as a result of European colonialism, forced migrations and removals, and loss of traditional culture and language. However, within the last 10–15 years there has been a revival of pottery making among Southeastern tribes, such as those from the Caddo, Cherokee, Choctaw, Chickasaw, Wyandot, Shawnee, and Quapaw. I would say half of these revivals of specific tribal pottery traditions have been started using store bought clay and half have been started by exploring and discovering the ancient method of hand collecting and cultivating clay. Where there was not an established market in the Southeast for specific Native American tribal art and also no solid understanding of which tribal identities encompassed which styles of pottery, there has been a somewhat chaotic attempt to reestablish our ties to our ancestral pottery that has been fraught with missteps and a lasting misunderstanding of our own tribal identities. Furthermore, the Native American art community of the Southeast has accepted the varying methods and materials of pottery construction from hand-cultivated to store-bought equally, and this also causes problems. When presenting their work, not all artists are honest in their processes, leading to much confusion among consumers and collectors. Some artists seem to be ashamed that they do not have the knowledge of their ancestral way of creating clay and pit-firing, and some feel like the public and their consumers do not know the difference. Thus, it is much easier to simply purchase materials and fire them in a kiln. Consumers and collectors are presented with deceptive results. All this has served to restrict the evolution and innovation of Southeastern Native American pottery methods and processes. I would like to see the stigma and implications of using modern-day materials erased so that our Southeastern tribes can pursue the strengthening of their pottery culture. Our tribes would adapt, evolve, and innovate. We would not remain stagnant. We would use new materials to further our specific cultural expressions and create new traditions.

Cultural Identity

Cultural identity has become one of the main underpinnings of my life and of my art. Growing up I knew that I was a Caddo native, but I did not really know what that meant. I was not shown. In the time when I was born it was not yet generally

acceptable to be Native American: there were no movements and there was blatant outright racism against Natives. My family, affected by the results of assimilation, chose to shelter us children from the hate. My great grandfather Patrick Kun'teno Miller was full blood Caddo and his Native tongue was Hasinai. He was put through the process of assimilation at both the Riverside boarding school in Oklahoma and the Carlisle boarding school in Pennsylvania. I met his wife, my great grandmother, Onvi, when I was a baby. She passed away soon after, and that was the closest I came to the full, uninterrupted, connection to our tribe's cultural heritage. But I always knew I was still Caddo, and my grandmother, Say'nut, would remind me and show me things such as how to count in Caddo or pictures of her dance regalia. It was not until later in my life that I felt a longing to reconnect myself and my family to our ancestors. Our Caddo people need so much help. One of the things I started noticing about our people is that many are growing up disconnected from our tribe's cultural identity—the very thing that makes us Caddo.

Art has always been something I have been interested in or engaged in, whether it was painting, sculpture, or pottery, but I never felt that I had a voice. I never had anything important to say through my art. One day around ten years ago, when I was facing the prospect of becoming a father, I decided it was time I found a voice for my art and create something for my child. I had initially decided I wanted to do pottery and create the beautiful Southwestern pottery that I loved and had seen growing up. I was ignorant, but quickly learned the importance of my own tribe's cultural identity and the destruction cultural appropriation causes. I decided to look into my tribe's pottery tradition and was overwhelmingly surprised to find that not only did we have a pottery tradition, but also that we had one of the most unique, prolific, skilled, and beautiful pottery traditions of North America. It was then that my voice and my reason for art were solidified.

As I started delving into my tribe's deep history and archaeological record, I came to an understanding that other Southeastern tribes struggle with the same issue. Unlike the Southwest where the tradition of pottery-making was passed down almost unbroken and there were generations of families making their culture's pottery, in the Southeast, many, if not most, pottery-making traditions had either been lost or broken. There were no generations passing down knowledge, and it had become almost all but lost. So, too, was the understanding of our tribe's specific and unique pottery styles that made up our cultural identity. This is when I realized that archaeology was going to play a very large part in helping to reestablish the specific heritage of our Caddo tribe (see also Carter 1995a). Since then I have run across many pottery artists who have been raised without their tribe's cultural identity and rely on unreliable or broken sources to find their pottery traditions. Some are not in contact with knowledgeable or credible archaeologists of their tribe's regions and have no real connection to the truth of their past. The spread of misunderstanding and confusion of which tribe created which pottery

styles and designs is damaging to our tribes and our cultural identity. If tribal members of the Caddo want to grow up and make a living making pottery, they will be faced with the collectors and galleries that have been tainted with the mixed signals that other non-Caddo people have given with their copying of Caddo cultural pottery. This is why I feel it is so very important to work with local and regional professional archaeologists to help tribes in these southeastern regions see their own specific and unique ceramic culture.

The design and the patterns used on the pots, to me, are more about a two-dimensional graphical representation of a language and iconography. From what I have seen and felt from the many ancient pots and other objects, earlier societies liked to portray things in a very representational way that is linked to cultural identity (fig. 15.6a–c). It is important to get the message across to the people on down the road. As the ages roll on, these messages are summarized graphically to create the iconography seen in many different cultures. Much like the traditional Caddo dance songs, words get repeated so many times, through time, that they get shortened and distorted. Sometimes the action of singing the dances and of carving the designs are more important than the original meaning from so long ago. In this way, I feel that the designs are traditional words we repeat and sing onto the pots' surfaces, whether it is about the turkey, the horned snake, or the panther, or any of our old tales. It is important to put these words down on the pot carefully, so that they may be passed on to the next generation. I do feel that our ancestors would have taken as much pride and asserted as much skilled control over the creation of this pottery as I would like to someday achieve. It is what I strive for. I let the beauty of the pots speak for themselves.

Figure 15.6. *a*, Fired Pot "Hadiku" (Black); *b*, Fired Pot "Nidahhih Hikaayu" (White River); *c*, Fired Pot "Hakunu" (Brown).

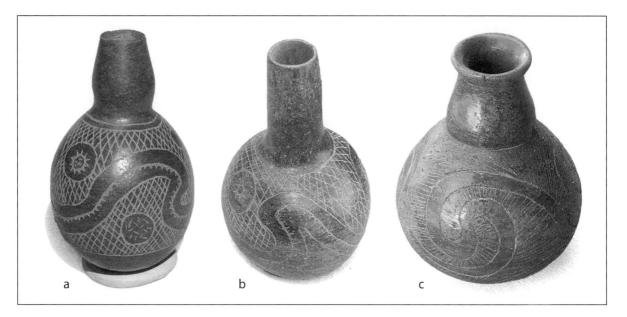

a b c

Through my artistic voice, I have learned the difference between being a cultural ambassador to my tribe as it pertains to education, archaeology, and revival, and being an individual artist in the fine arts world. They are two very different things. Much like having one foot in the contemporary world and one in our traditional Native world, I feel like I have one foot in the world of our tribe's cultural legacy and identity, and the other in the very confusing, tumultuous, debated, and often selfish world of fine art, specifically as it pertains to Native American art.

REFERENCES

Abbott, David R. 2009. "Extensive and Long-Term Specialization: Hohokam Ceramic Production in the Phoenix Basin, Arizona." *American Antiquity* 74(3):531–57.

Adams, Dean C., and Michael L. Collyer. 2007. "Analysis of Character Divergence along Environmental Gradients and other Covariates." *Evolution* 61(3):510–15.

———. 2009. "A General Framework for the Analysis of Phenotypic Trajectories in Evolutionary Studies." *Evolution* 63(5):1143–54.

———. 2015. "Permutation Tests for Phylogenetic Comparative Analyses of High-Dimensional Shape Data: What you Shuffle Matters." *Evolution* 69(3):823–29.

Adams, Dean C., Michael L. Collyer, Antigoni Kaliontzopoulou, and Emma Sherratt. 2018. "Package 'geomorph': Geometric Morphometric Analyses of 2D/3D Landmark Data. R package version 3.0.7." http://geomorphr.github.io/geomorph/, accessed October 1, 2018.

Adams, Dean C., and Annamaria Nistri. 2010. "Ontogenetic Convergence and Evolution of Foot Morphology in European Cave Salamanders (Family: Plethodontidae)." *BMC Evolutionary Biology* 10:1–10.

Adams, Dean C., and Erik Otárola-Castillo. 2013. "geomorph: An R Package for the Collection and Analysis of Geometric Morphometric Shape Data." *Methods in Ecology and Evolution* 4(4):393–99.

Akridge, D. Glen. 2008. "Methods for Calculating Brine Evaporation Rates During Salt Production." *Journal of Archaeological Science* 35(6):1435–62.

Albert, Lois E., and Don G. Wyckoff. 1984. "Oklahoma Environments: Past and Present." In *Prehistory of Oklahoma*, edited by Robert E. Bell, 1–44. Orlando: Academic Press.

Alt, Susan M. 2006. "The Power of Diversity: Settlement in the Cahokian Uplands." In *Leadership and Polity in Mississippian Society*, edited by Brian M. Butler and Paul D. Welch, 289–308. Occasional Paper 33. Carbondale: Center for Archaeological Investigations, Southern Illinois University.

Altschul, Jeffrey H. 1983. *Bug Hill: Excavation of a Multicomponent Midden Mound in the Jackfork Valley, Southeast Oklahoma.* Report of Investigations 81–1. Pollock, LA: New World Research Inc.

American State Papers. 1832. *American State Papers Volume 1, Class II: Indian Affairs.* Vol. 1. Washington, DC: Gales and Seaton.

Anderson, Marti J., and Cajo J. F. Ter Braak. 2003. "Permutation Tests for Multi-Factoral Analysis of Variance." *Journal of Statistical Computation and Simulation* 73(2):85–113.

Andrews, Anthony P. 1983. *Maya Salt Production and Trade.* Tucson: University of Arizona Press.

Arnold, Dean E. 1999. "Advantages and Disadvantages of Vertical-Half Modeling Technology: Implications for Production Organization." In *Pottery and People: A Dynamic Interaction,* edited by James M. Skibo and Gary M. Feinman, 59–80. Salt Lake City: University of Utah Press.

———. 2000. "Does the Standardization of Ceramic Pastes Really Mean Specialization?" *Journal of Archaeological Method and Theory* 7:333–75.

Arthur, John W. 2006. *Living with Pottery: Ethnoarchaeology among the Gamo of Southwest Ethiopia.* Salt Lake City: University of Utah Press.

Aten, Lawrence E., and Charles N. Bollich. 2002. *Late Holocene Settlement in the Taylor Bayou Drainage Basin: Test Excavations at the Gaulding Site (41JF27), Jefferson County, Texas.* Austin and San Antonio: Studies in Archeology 40, Texas Archeological Research Laboratory, University of Texas at Austin, and Special Publication No. 4, Texas Archeological Society.

Avery, George E. 1997. "More Friend than Foe: Eighteenth Century Spanish, French, and Caddoan Interaction at Los Adaes, A Capital of Texas Located in Northwestern Louisiana." *Louisiana Archaeology* 22:163–93.

———. 2010. "The Spanish in Northwest Louisiana, 1721–1773." In *Archaeology of Louisiana,* edited by Mark A. Rees, 223–34. Baton Rouge: Louisiana State University Press.

Baerreis, David A. 1939. "Two New Cultures in Delaware County, Oklahoma." *Oklahoma Prehistorian* 2:2–5.

———. 1940. "The Neosho Focus." *Society for American Archaeology Notebook* 1:108–9.

———. 1941. "Recent Developments in Oklahoma Archaeology." *Proceedings of the Oklahoma Academy of Science* 21:125–26.

———. 1953. "Woodland Pottery of Northeast Oklahoma." In *Prehistoric Pottery of the Eastern United States,* edited by James B. Griffin, 4–53. Ann Arbor: Museum of Anthropology, University of Michigan.

———. n.d. "Cooper Site." Draft manuscript on file, Sam Noble Oklahoma Museum of Natural History, Norman, Oklahoma.

Baerreis, David A., and Joan E. Freeman. 1961. "DL47, A Bluff Shelter in Northeastern Oklahoma." *Bulletin of the Oklahoma Anthropological Society* 9:67–75.

Baerreis, David A., Warren L. Wittry, and Robert L. Hall. 1956. "The Burial Complex at the Smith Site, Delaware County, Oklahoma." *Bulletin of the Oklahoma Anthropological Society* 4:1–12.

Banks, Larry D., and Joe Winters. 1975. *The Bentsen-Clark Site, Red River County, Texas: A Preliminary Report.* Special Publication No. 2. Texas Archeological Society, San Antonio.

Bastian, Mathieu, Sebastien Heymann, and Mathieu Jacomy. 2009. *Gephi: An Open Source*

Software for Exploring and Manipulating Networks. Electronic document, https://gephi.org/publications/gephi-bastian-feb09.pdf, accessed October 1, 2018.

Bastian, Tyler. 1969. *The Hudsonpillar and Freeman Sites, North-Central Oklahoma.* Archaeological Site Report No. 14. Norman: University of Oklahoma Research Institute, Oklahoma River Basin Survey.

Bell, Milton. 1981. *The Alex Justiss Site: A Caddoan Cemetery in Titus County, Texas.* Publications in Archaeology, Highway Design Division Report No. 21. Austin: Texas State Department of Highways and Public Transportation.

Bell, Robert E. 1953a. "The Scott Site, LeFlore County, Oklahoma." *American Antiquity* 18:314–31.

———. 1953b. "Pottery Vessels from the Spiro Mound, Cr1, Le Flore County, Oklahoma." *Bulletin of the Oklahoma Anthropological Society* 1:25–38.

———. 1972. *The Harlan Site, CK6, A Prehistoric Mound Center in Cherokee County, Eastern Oklahoma.* Memoir 2. Norman: Oklahoma Anthropological Society.

———. 1980. "Fourche Maline: An Archaeological Manifestation in Eastern Oklahoma." In *Caddoan and Poverty Point Archaeology: Essays in Honor of Clarence H. Webb,* edited by Jon L. Gibson, 83–125. Louisiana Archaeological Society Bulletin 6.

Bell, Robert E., ed. 1984. *Prehistory of Oklahoma.* Orlando: Academic Press.

Bell, Robert E., and David A. Baerreis. 1951. "A Survey of Oklahoma Archaeology." *Bulletin of the Texas Archeological and Paleontological Society* 22:7–100.

Bell, Robert E., and Charlene Dale. 1953. "The Morris Site, CK39, Cherokee County, Oklahoma." *Bulletin of the Texas Archeological Society* 24:69–140.

Bell, Robert E., Gayle S. Lacy Jr., Margaret T. Joscher, and Joe C. Allen. 1969. *The Robinson-Solesbee Site, Hs9, A Fulton Aspect Occupation, Robert S. Kerr Reservoir, Eastern Oklahoma.* Archaeological Site Report 15. Norman: University of Oklahoma Research Institute, Oklahoma River Basin Survey.

Bender, Margaret M., Reid A. Bryson, and David A. Baerreis. 1968. "University of Wisconsin Radiocarbon Dates V." *Radiocarbon* 10:473–78.

Birkhoff, George D. 1933. *Aesthetic Measure.* Cambridge: Harvard University Press.

Blitz, John H. 1999. "Mississippian Chiefdoms and the Fission-Fusion Process." *American Antiquity.* 64(4):577–92.

———. 2009. "New Perspectives in Mississippian Archaeology." *Journal of Archaeological Research* 18(1):1–39.

Blondel, Vincent D., Jean-Loup Guillaume, Renaud Lambiotte, and Etienne Lefebvre. 2008. "Fast Unfolding of Communities in Large Networks." *Journal of Statistical Mechanics: Theory and Experiment* 2008(10):P10008.

Bobalik, Sheila J. 1977. "The Viper Marsh Site (Mc-205), McCurtain County, Oklahoma." *Bulletin of the Oklahoma Anthropological Society* 26:1–86.

Bohannon, Charles F. 1973. *Excavations at the Mineral Springs Site, Howard County, Arkansas.* Research Series No. 5. Fayetteville: Arkansas Archeological Society.

Borck, Lewis, Barbara J. Mills, Matthew A. Peeples, and Jeffery J. Clark. 2015. "Are Social Networks Survival Networks? An Example from the Late Pre-Hispanic US Southwest." *Journal of Archaeological Method and Theory* 22(1):33–57.

Borgatti, Stephen P., and Martin G. Everett. 2006. "A Graph-Theoretic Perspective on Centrality." *Social Networks* 28(4):466–84.

Brain, Jeffrey P. 1977. *On the Tunica Trail.* Anthropological Study No. 1. Baton Rouge: Louisiana Archaeological Survey and Antiquities Commission.

———. 1979. *Tunica Treasure.* Volume 71. Cambridge: Papers of the Peabody Museum of Archaeology and Ethnology, Harvard University.

———. 1988. *Tunica Archaeology.* Volume 78. Papers of the Peabody Museum of Archaeology and Ethnology. Cambridge: Peabody Museum of Archaeology and Ethnology, Harvard University.

———. 1990. *The Tunica-Biloxi.* New York and Philadelphia: Chelsea House Publishers.

Brew, John Otis. 1946. "The Use and Abuse of Taxonomy." In *Archaeology of the Alkali Ridge, Southeastern Utah,* by John Otis Brew, 44–66. Papers of the Peabody Museum of American Archaeology and Ethnology, Vol. XXI. Cambridge: Harvard University.

Briscoe, James. 1977. *The Plantation Site (Mi63), An Early Caddoan Settlement in Eastern Oklahoma.* Papers in Highway Archaeology 11. Norman: Oklahoma Highway Archaeological Survey.

Bronk Ramsey, Christopher. 2009. "Bayesian analysis of radiocarbon dates." *Radiocarbon* 51(1):337–60.

Brooks, Robert L. 1996. "The Arkansas River Valley. A New Paradigm, Revisionist Perspectives and the Archaeological Record." *Caddoan Archeology* 7(1):17–27.

Brown, Ian W. 1980. *Salt and the Eastern North American Indian: An Archaeological Study.* Lower Mississippi Valley Survey Bulletin No. 6. Cambridge: Peabody Museum, Harvard University.

———. 1998. *Decorated Pottery of the Lower Mississippi Valley: A Sorting Manual.* Jackson: Mississippi Archaeological Association and Mississippi Department of Archives and History.

———. 1999. "Salt Manufacture and Trade from the Perspective of Avery Island, Louisiana." *Midcontinental Journal of Archaeology* 24(2):113–51.

———. 2004. "Why Study Salt?" *Journal of Alabama Archaeology* 50(1):36–49.

———. 2015. *The Petite Anse Project, Investigations along the West-central Coast of Louisiana, 1978–1979,* edited by Charles R. McGimsey. A Special Publication of the Louisiana Archaeological Society. Tuscaloosa: Borgo Publishing.

Brown, Ian W., ed. 2003. *Bottle Creek: A Pensacola Culture Site in South Alabama.* Tuscaloosa: University of Alabama Press.

Brown, James A. 1966a. *Spiro Studies Volume I: Description of the Mound Group.* First Part of the Second Annual Report of Caddoan Archaeology-Spiro Focus Research. Norman: University of Oklahoma Research Institute.

———. 1966b. *Spiro Studies Volume II: The Graves and their Contents.* Second Part of the Second Annual Report of Caddoan Archaeology-Spiro Focus Research. Norman: University of Oklahoma Research Institute.

———. 1971. *Spiro Studies Volume III: Pottery Vessels.* First Part of the Third Annual Re-

port of Caddoan Archaeology-Spiro Focus Research. Norman: University of Oklahoma Research Institute.

———. 1976. *Spiro Studies Volume IV: The Artifacts.* Second Part of the Third Annual Report of Caddoan Archaeology-Spiro Focus Research. Norman: University of Oklahoma Research Institute.

———. 1984. *Prehistoric Southern Ozark Marginality: A Myth Exposed.* Special Publication 6. Columbia: Missouri Archaeological Society.

———. 1996. *The Spiro Ceremonial Center: The Archaeology of Arkansas Valley Caddoan Culture in Eastern Oklahoma.* 2 Vols. Memoirs No. 29. Ann Arbor: Museum of Anthropology, University of Michigan.

———. 2010. "Cosmological Layouts of Secondary Burials as Political Interments." In *Mississippian Mortuary Practices: Beyond Hierarchy and the Representationist Perspective,* edited by Lynne P. Sullivan and Robert C. Mainfort Jr., 30–53. Gainesville: University of Florida Press.

———. 2012. "Spiro Reconsidered: Sacred Economy at the Western Frontier of the Eastern Woodlands." In *The Archaeology of the Caddo,* edited by Timothy K. Perttula and Chester P. Walker, 117–38. Lincoln: University of Nebraska Press.

Brown, James A., Robert E. Bell, and Don G. Wyckoff. 1978. "Caddoan Settlement Patterns in the Arkansas River Drainage." In *Mississippian Settlement Patterns,* edited by Bruce D. Smith, 169–200. New York: Academic Press.

Brown, James A., and J. Daniel Rogers. 1999. "AMS Dates on Artifacts of the Southeastern Ceremonial Complex from Spiro." *Southeastern Archaeology* 18:134–41.

Broyles, Bettye J. 1968. "Reconstructed Designs from Swift Creek Complicated Stamped Sherds." *Southeastern Archaeological Conference Bulletin* 8:49–74.

Brughmans, Tom. 2010. "Connecting the Dots: Towards Archaeological Network Analysis." *Oxford Journal of Archaeology* 29(3):277–303.

———. 2013. "Thinking Through Networks: A Review of Formal Network Methods in Archaeology." *Journal of Archaeological Method and Theory* 20(4):623–62.

———. 2014. "Evaluating Network Science in Archaeology: A Roman Archaeology Perspective." PhD diss., Faculty of Humanities, Department of Archaeology, University of Southampton, Southampton.

Bruseth, James E. 1998. "The Development of Caddoan Polities along the Middle Red River Valley of Eastern Texas and Oklahoma." In *The Native History of the Caddo: Their Place in Southeastern Archeology and Ethnohistory,* edited by Timothy K. Perttula and James E. Bruseth, 47–68. Studies in Archeology 30. Austin: Texas Archeological Research Laboratory, University of Texas at Austin.

Bruseth, James E., Larry Banks, and Jimmy Smith. 2001. "The Ray Site (41LR135)." *Bulletin of the Texas Archeological Society* 72:197–213.

Bruseth, James E., and Timothy K. Perttula. 2006. "Archeological Investigations at the Hudnall-Pirtle Site (41RK4): An Early Caddo Mound Center in Northeast Texas." *Caddo Archeology Journal* 15:57–158.

Bruseth, James E., Diane E. Wilson, and Timothy K. Perttula. 1995. "The Sanders Site: A Spiroan Entrepot in Texas?" *Plains Anthropologist* 40(153):223–36.

Burton, H. Sophie, and F. Todd Smith. 2014. *Colonial Natchitoches: A Creole Community on the Louisiana-Texas Frontier.* College Station: Texas A&M University Press.

Burton, Robert J. 1971. *The Archaeological View from the Harvey Site, SQ18.* Archaeological Site Report 21. Norman: University of Oklahoma Research Institute, Oklahoma River Basin Survey.

Burton, Robert J., Tyler Bastian, and Terry J. Prewitt. 1969. *The Tyler Site, HS11, Haskell County.* University of Archaeological Site Report 13. Norman: Oklahoma Research Institute, Oklahoma River Basin Survey.

Burton, Susan S. 1970. *The Hugo Dam Site, Ch-112, Choctaw County, Southeast Oklahoma.* Archaeological Site Report No. 16. Norman: Oklahoma River Basin Survey Project, University of Oklahoma.

Bushnell, David I., Jr. 1907. "Primitive Salt-making in the Mississippi Valley, I." *Man* No. 13.

———. 1908. "Primitive Salt-making in the Mississippi Valley, II." *Man* No. 35.

———. 1914. "Archaeological Investigations in Ste. Genevieve County, Missouri." *Proceedings of the United States National Museum* 46:641–68.

Bybee, John, Vincent D. Warner, Dawn Bradley, Steve Martin, Duane Simpson, and Kathryn A. Warner. 2016. "National Register of Historic Places Eligibility Testing of Archaeological Sites 34MY329 and 34MY335, Geophysical Investigations and Ground Truthing of Sites 34MY307–34MY311, Mayes County, Oklahoma." Report submitted to the Grand River Dam Authority by Amec Foster Wheeler Environment & Infrastructure, Inc.

Bybee, John, Vincent D. Warner, Dawn Bradley, Kathryn A. Warner, and Tuesday E. Critz. 2014. "National Register of Historic Places Eligibility Testing of Archaeological Sites 34MY21, 34MY322, 34MY323, 34MY334, and 34MY339, Mayes County, Oklahoma." Report submitted to the Grand River Dam Authority by Amec Environment & Infrastructure, Inc.

Bybee, John, Vincent D. Warner, Dawn Bradley, Kathryn A. Warner, and Michael Dulle. 2014. "National Register of Historic Places Eligibility Testing of Archaeological Sites 34MY313, 34MY324, 34MY330, and 34MY336, Mayes County, Oklahoma." Report submitted to the Grand River Dam Authority by Amec Environment & Infrastructure, Inc.

Byers, A. Martin. 2015. *Reclaiming the Hopewellian Ceremonial Sphere, 200 BC to AD 500.* Norman: University of Oklahoma Press.

Carter, Cecile. 1995a. *Where We Come From.* Norman: University of Oklahoma Press.

———. 1995b. "Caddo Turkey Dance." In *Remaining Ourselves: Music and Tribal Memory: Traditional Music in Contemporary Communities,* edited by Dayna B. Lee, 31–36. Oklahoma City: State Arts Council of Oklahoma.

Cartledge, Thomas R. 1970. *The Tyler-Rose Site and Late Prehistory in East-Central Oklahoma.* Archaeological Site Report 19. Norman: University of Oklahoma Research Institute, Oklahoma River Basin Survey.

Chapa, Juan B., and William C. Foster, eds. 1997. *Texas & Northeastern Mexico, 1630–1690.* Austin: University of Texas Press.

Chapman, Berlin B. 1944. "Dissolution of the Wichita Reservation." *Chronicles of Oklahoma* 22.

Chowdhury, Pritam. 2018. "Middle Caddo Whole Vessels from the Ferguson Site (3HE63)." *Caddo Archeology Journal* 28:60–91.

Churchill, Ward. 2004. *Kill the Indian, Save the Man: The Genocidal Impact of American Indian Residential Schools.* San Francisco: City Lights Publishing.

Clark, Cherie A. 1987. "Subsistence Intensification in Deer Resource Use at the McCutchan-McLaughlin (34LT11) Site, Latimer County, Oklahoma." Master's thesis, Department of Anthropology, University of Oklahoma, Norman.

Claude, Julien. 2008. *Morphometrics with R. Use R!* Springer, New York.

Collar, Anna, Fiona Coward, Tom Brughmans, and Barbara J. Mills. 2015. "Networks in Archaeology: Phenomena, Abstraction, Representation." *Journal of Archaeological Method and Theory* 22(1):1–32.

Collyer, Michael L., and Dean C. Adams. 2007. "Analysis of Two-State Multivariate Phenotypic Change in Ecological Studies." *Ecology* 88(3):683–92.

———. 2013. "Phenotypic Trajectory Analysis: Comparison of Shape Change Patterns in Evolution and Ecology." *Hystrix* 24(1):75–83.

———. 2018. "RRPP: An R Package for Fitting Linear Models to High-Dimensional Data using Residual Randomization." *Methods in Ecology and Evolution* 9(7):1772–1779.

Collyer, Michael L., David J. Sekora, and Dean C. Adams. 2015. "A Method for Analysis of Phenotypic Change for Phenotypes Described by High-Dimensional Data." *Heredity* 115(4):357–65.

Cook, Eva C. 2001. "Keeping Up with the Hopewells, or When to Toss the Dishes: A Decorative Analysis of Two Middle Woodland Ceramic Assemblages from Delaware County, Oklahoma." Master's thesis, Department of Anthropology, University of Kansas, Lawrence.

Corbin, James E. 1989. "The Woodland/Caddo Transition in the Southern Caddo Area." In *Festschrift in Honor of Jack Hughes*, edited by Donna Roper, 117–24. Special Publication No. 5. Amarillo: Panhandle Archeological Society.

———. 1998. "Reflections on the Early Ceramic Period and the Terminal Archaic in South Central East Texas." *Journal of Northeast Texas Archaeology* 11:108–16.

Cordell, Linda S., and Judith A. Habicht-Mauche. 2015. *Potters and Communities of Practice: Glaze Paint and Polychrome Pottery in the American Southwest, A.D. 1250 to 1700.* Anthropological Papers of the University of Arizona. Tucson: University of Arizona Press.

Costenbader, Elizabeth, and Thomas W. Valente. 2003. "The Stability of Centrality Measures when Networks are Sampled." *Social Networks* 25(4):283–307.

Costin, Cathy Lynne. 2007. "Thinking About Production: Phenomenological Classification and Lexical Semantic." *Archeological Papers of the American Anthropological Association* 17(1):143–62.

Costin, Cathy L., and Melissa B. Hagstrum. 1995. "Standardization, Labor Investment,

Skill, and the Organization of Ceramic Production in Late Prehispanic Highland Peru." *American Antiquity* 60(04):619–39.

Cranford, David J. 2007. "Political Dynamics of Closely Spaced Mississippian Polities in Eastern Oklahoma: The Harlan (34CK6) and Norman (34WG2) Sites." Master's thesis, Department of Anthropology, University of Oklahoma, Norman.

Crook, Wilson W., III, and Timothy K. Perttula. 2008. "A Foster Trailed-Incised Vessel from the Sister Grove Creek Site (41COL36), Collin County, Texas." *Caddo Archeology Journal* 18:22–25.

Cross, Phil. 2018. *Disinherited: Caddo Indians Loss of their Homelands.* DVD, Phil Cross Productions, Anadarko, Oklahoma.

Davis, E. Mott. 1961. "The Caddoan Area: An Introduction to the Symposium." *Bulletin of the Texas Archeological Society* 31:3–10.

Davis, Hester A. 1986. "More and More Sherds Than Dirt." *Field Notes* (Newsletter of the Arkansas Archeological Society) 211:9–14.

DeMaio, Joanne. 2013. "The Adair Site: Ouachita River Valley Relations Through Ceramic Analysis." Master's thesis, Department of Anthropology, University of Arkansas, Fayetteville.

Denkowska, Sabina, Ewa J Grabska, and Katarzyna Marek. 1994. "Application of Birkhoff's Aesthetic Measure to Computer Aided Design of Vases." *Journal of Machine Graphics and Vision* 7(1/2):69–75.

Dhoop, Thomas, Catriona Cooper, and Penny Copeland. 2016. "Recording and Analysis of Ship Graffiti in St Thomas' Church and Blackfriars Barn Undercroft in Winchelsea, East Sussex, UK." *International Journal of Nautical Archaeology* 45(2):296–309.

Dockall, John, Stephanie Katauskas, and Ross Fields. 2008. *National Register Testing of Four Sites in the Sabine Mine's Area M, Harrison County, Texas.* Reports of Investigations No. 157. Austin: Prewitt and Associates, Inc.

Dowd, Elsbeth Linn. 2011a. "Amphibian and Reptilian Imagery in Caddo Art." *Southeastern Archaeology* 39:79–95.

———. 2011b. *Identifying Variation: A Stylistic Analysis of Four Caddo Pottery Assemblages from Southeastern Oklahoma.* Memoir 15. Norman: Oklahoma Anthropological Society.

———. 2012. "Alternative Conceptions of Complexity: Sociopolitical Dynamics of the Mountain Fork Caddo." PhD diss., Department of Anthropology, University of Oklahoma, Norman.

Dowd, Elsbeth, and Amanda Regnier. 2014. "Archaeological Investigations at the Ramos Creek Site (34MC1030), McCurtain County, Oklahoma." Final Report submitted to U.S. Forest Service, Ouachita National Forest. Report on file at the Oklahoma Archeological Survey and the Sam Noble Oklahoma Museum of Natural History, University of Oklahoma, Norman.

Drexler, Carl G. 2018. "Analyzing the Features at the Holman Springs Site (3SV29), a Caddo Saltworks in the Little River Basin." Paper presented at the 60th Caddo Conference, Idabel, Oklahoma.

Drexler, Carl G., and Fiona M. Taylor. 2017. "Revisiting the 1984–1986 Arkansas Arche-

ological Society and Survey Excavations at Holman Springs (3SV29), a Caddo Salt-processing Site in Sevier County, Arkansas." Paper presented at the 59th Caddo Conference, Natchitoches, Louisiana.

Duffield, Lathael F., and Edward B. Jelks. 1961. *The Pearson Site: A Historic Indian Site at Iron Bridge Reservoir, Rains County, Texas.* Archaeology Series No. 4. Austin: Department of Anthropology, University of Texas at Austin.

Dumas, Ashley A. 2007. "The Role of Salt in the Late Woodland to Early Mississippian Transition in Southwest Alabama." PhD diss., Department of Anthropology, University of Alabama, Tuscaloosa.

Durham, James H. 1964. "Notes on the 1961–62 Excavations at the Crenshaw Site, 3MI6, in Arkansas." *Oklahoma Anthropological Society Newsletter* 21(6):4–8.

Eakin, William L. 1997. "The Kingdom of the Tejas: The Hasinai Indians at the Crossroads of Change." PhD diss., Department of History, University of Kansas, Lawrence.

Earles, Chase K. 2012. "Caddo Pottery in Modern and Contemporary Art, and Protection of Native American Cultures in Fine Arts by the IACB's Indian Arts and Crafts Act." *Caddo Archeology Journal* 22:9–16.

Early, Ann M. 1974. "Winter Archeology, the Hedges Site, 3HS60." *Field Notes* (Newsletter of the Arkansas Archeological Society) 116:3–5.

———. 1983. "A Brief History of Archaeological Work in the Ouachita River Valley, Arkansas." *Louisiana Archaeology* 10:1–24.

———. 1986. "Dr. Thomas L. Hodges and His Contribution to Arkansas Archeology." *The Arkansas Archeologist* 23–24:1–9.

———. 1988. *Standridge: Caddoan Settlement in a Mountain Environment.* Research Series No. 29. Fayetteville: Arkansas Archeological Survey.

———. 2000. "The Caddos of the Trans-Mississippi South." In *Indians of the Greater Southeast: Historical Archaeology and Ethnohistory*, edited by Bonnie G. McEwan, 122–41. Gainesville: University Press of Florida.

———. 2002a. "Arkansas Prehistory and History in Review: The East Phase." *Field Notes* (Newsletter of the Arkansas Archeological Society) 304:4–8.

———. 2002b. "The Mid-Ouachita Phase." *Field Notes* (Newsletter of the Arkansas Archeological Society) 305:10–13.

———. 2002c. "Arkansas Prehistory and History in Review: The Social Hill Phase." *Field Notes* (Newsletter of the Arkansas Archeological Society) 306:10–13.

———. 2002d. "Arkansas Prehistory and History in Review: Deceiper Phase." *Field Notes* (Newsletter of the Arkansas Archeological Society) 307:8–11.

———. 2004. "Prehistory of the Western Interior after 500 B.C." In *Handbook of North American Indians, Southeast, Volume 14*, edited by Raymond B. Fogelson, 560–73. Washington, DC: Smithsonian Institution.

———. 2012. "Form and Structure in Prehistoric Caddo Pottery Design." In *The Archaeology of the Caddo*, edited by Timothy K. Perttula and Chester P. Walker, 26–46. Lincoln: University of Nebraska Press.

———. 2017. "It's All in the Family: Prehistoric Salt Making among Southern Caddo of

Arkansas." Paper presented at the 2nd International Salt Congress, Los Cabos, Mexico.

Early, Ann M., ed. 1993. *Caddoan Saltmakers in the Ouachita Valley: The Hardman Site.* Research Series No. 43. Fayetteville: Arkansas Archeological Survey.

———. 2000. *Forest Farmsteads: A Millennium of Human Occupation at Winding Stair in the Ouachita Mountains.* Research Series No. 57. Fayetteville: Arkansas Archeological Survey.

Early, Ann M., and Mary Beth Trubitt. 2003. "The Caddo Indian Burial Ground (3MN386), Norman, Arkansas." *Caddoan Archeology Journal* 13(2):13–24.

Eckert, Suzanne L. 2008. *Pottery and Practice: The Expression of Identity at Pottery Mound and Hummingbird Pueblo.* Albuquerque: University of New Mexico Press.

———. 2012. "Choosing Clays and Painting Pots in the Fourteenth-Century Zuni Region." In *Potters and Communities of Practice: Glaze Paint and Polychrome in the American Southwest, A.D. 1250 to 1700,* edited by Linda S. Cordell and Judith A. Habicht-Mauche, 55–64. Tucson: University of Arizona Press.

Eckert, Suzanne L., Kari L. Schleher, and William D. James. 2015. "Communities of Identity, Communities of Practice: Understanding Santa Fe Black-on-White Pottery in the Española Basin of New Mexico." *Journal of Archaeological Science* 63:1–12.

Eerkins, Jelmer W., and Robert L. Bettinger. 2001. "Techniques for Assessing Standardization in Artifact Assemblages: Can We Scale Material Variability?" *American Antiquity* 66(3):493–504.

Eighmy, Jeffrey. 1969. *The Fine Site: A Caddoan Site in Eastern Oklahoma.* Archaeological Site Report 13. Norman: University of Oklahoma Research Institute, Oklahoma River Basin Survey.

Ellis, Linda W. 2013. "Woodland Ceramics in East Texas and a Case Study of Mill Creek Culture Ceramics." *Bulletin of the Texas Archeological Society* 84:137–80.

Emerson, Thomas E. 1989. "Water Serpents and the Underworld: An Exploration into Cahokia Symbolism." In *The Southeastern Ceremonial Complex: Artifact and Analysis,* edited by Patricia Galloway, 45–92. Lincoln: University of Nebraska Press.

Erickson, Denise Renée. 2018. "An Archaeological Study of the Earspools of the Arkansas River Valley and Surrounding Regions." Master's thesis, Department of Anthropology, University of Oklahoma, Norman.

Etchieson, Meeks. 2003. *Archeological Investigations for the Weyerhaeuser-Forest Service Land Exchange, Oklahoma and Arkansas.* Ouachita Cultural Resources Report No. 220. Hot Springs: Ouachita National Forest.

Eubanks, Paul N. 2013. "Mississippian Salt Production at the Stimpson Site (1CK29) in Southern Alabama." *Journal of Alabama Archaeology* 59(1 & 2):1–21.

———. 2014. "The Timing and Distribution of Caddo Salt Production in Northwestern Louisiana." *Southeastern Archaeology* 33:108–122.

———. 2016a. "Salt Production in the Southeastern Caddo Homeland." PhD diss., Department of Anthropology, University of Alabama, Tuscaloosa.

———. 2016b. "Salt Production, Standardization, and Specialization: An Example from Drake's Salt Works." *North American Archaeologist* 37(4):203–30.

———. 2018. "The Effects of Horses and Raiding on the Salt Industry in Northwest Louisiana." *Caddo Archeology Journal* 28:5–20.

Eubanks, Paul N., and Ian W. Brown. 2015. "Certain Trends in Eastern Woodlands Salt Production Technology." *Midcontinental Journal of Archaeology* 40(3):231–56.

Eubanks, Paul N., and Kevin E. Smith. 2018. "Preliminary Report of Middle Tennessee State University's 2017 Excavations at Castalian Springs (40SU14), Sumner County, Tennessee, with contributions by Derek T. Anderson, Shonda L. Clanton, Amanda L. Couch, Desirée Goodfellow, and Madeline B. Laderoute." Report No. 10. Department of Sociology and Anthropology, Middle Tennessee State University. Manuscript submitted to the Tennessee Division of Archaeology, Nashville, Tennessee.

Fauchier, Rachel. 2009. "Contextual Analysis of Burial Practices and Associations from a Shallow Fourche Maline Site: Akers, 34LF32." Master's thesis, Department of Anthropology, University of Oklahoma, Norman.

Feathers, James K. 1989. "Effects of Temper on Strength of Ceramics: Response to Bronitsky and Hamer." *American Antiquity* 54(3):579–88.

Fenn, Thomas R., Barbara J. Mills, and Maren Hopkins. 2006. "The Social Contexts of Glaze Pain Ceramic Production and Consumption in the Silver Creek Area." In *The Social Life of Pots: Glaze Wares and the Cultural Dynamics in the Southwest, AD 1250–1680*, edited by Judith A. Habicht-Mauche, Suzanne L. Eckert, and Deborah L. Huntley, 60–85. Tucson: University of Arizona Press.

Ferring, C. Reid, and Timothy K. Perttula. 1987. "Defining the Provenance of Red-Slipped Pottery from Texas and Oklahoma by Petrographic Methods." *Journal of Archaeological Science* 14:437–56.

Ferring, C. Reid, Timothy K. Perttula, Paul McGuff, and Bonnie C. Yates. 1994. *Archaeological Investigations at Four Sites along Potapo Creek, McGee Creek Reservoir, Atoka County, Oklahoma*. Volume V, Part 3, McGee Creek Archaeological Project Reports. Denton: Institute of Applied Sciences, University of North Texas.

Fields, Ross C. 2014. "The Titus Phase from the Top and Bottom: Looking at Sociopolitical Organization through the Pine Tree Mound and U.S. Highway 271 Mount Pleasant Relief Route Projects." *Bulletin of the Texas Archeological Society* 85:111–46.

Fields, Ross C., Marie E. Blake, and Karl W. Kibler. 1997. *Synthesis of the Prehistoric and Historic Archeology of Cooper Lake, Delta and Hopkins Counties, Texas*. Reports of Investigations No. 104. Austin: Prewitt & Associates, Inc.

Fields, Ross C., and Eloise Frances Gadus. 2014. "Interpretations and Conclusions." In *Testing and Data Recovery Excavations at 11 Native American Archeological Sites along the U.S. Highway 271 Mount Pleasant Relief Route, Titus County, Texas*, by Ross C. Fields, Virginia L. Hatfield, Damon A. Burden, Eloise Frances Gadus, Michael C. Wilder, and Karl W. Kibler, 435–82. 2 Vols. Reports of Investigations No. 168. Austin: Prewitt and Associates, Inc.

Fields, Ross C., Virginia L. Hatfield, Damon Burden, Eloise F. Gadus, Michael C. Wilder, and Karl W. Kibler. 2014. *Testing and Data Recovery Excavations at 11 Native American Archeological Sites along the U.S. Highway 271 Mount Pleasant Relief Route, Titus*

County, Texas. 2 Vols. Reports of Investigations No. 168. Austin: Prewitt and Associates, Inc.

Fields, Ross C., and Eloise F. Gadus, eds. 2012a. *Archeology of the Nadaco Caddo: The View from the Pine Tree Mound Site (41HS15), Harrison County, Texas.* 2 Vols. Reports of Investigations No. 164. Austin: Prewitt and Associates, Inc.

———. 2012b. "The Pine Tree Mound Site and the Archeology of the Nadaco Caddo." *Bulletin of the Texas Archeological Society* 83:23–80.

Flynn, Peggy. 1976. "A Study of Red-Filmed Pottery from the Clement Site (Mc-8), McCurtain County, Oklahoma." *Bulletin of the Oklahoma Anthropological Society* 25:127–34.

Ford, James A. 1936. *Analysis of Indian Village Site Collections from Louisiana and Mississippi.* Anthropological Study No. 2. New Orleans: Department of Conservation, Louisiana Geological Survey.

———. 1951. *Greenhouse: A Troyville-Coles Creek Period Site in Avoyelles Parish, Louisiana.* Anthropological Papers No. 44(1). New York: American Museum of Natural History.

Ford, James A., and James B. Griffin. 1938. "Report of the Conference on Southeastern Pottery Typology." Reprinted in *Newsletter of the Southeastern Archaeological Conference* 7(1):10–22.

Ford, Paige. 2019. "In Between Worlds: Past Perspectives on the Neosho Phase (AD 1400–1650)." *Caddo Archaeology Journal* 29:205–17.

Forsythe, David P. 2009. *Encyclopedia of Human Rights, Volume 4.* Oxford: Oxford University Press.

Foster, William C., ed. 1998. *The La Salle Expedition to Texas: The Journal of Henri Joutel, 1684–1687.* Translated by Johanna S. Warren. Austin: Texas State Historical Association.

Freeman, Joan E. 1959. "The Neosho Focus: A Late Prehistoric Culture in Northeastern Oklahoma." PhD diss., Department of Anthropology, University of Wisconsin, Madison.

———. 1962. "The Neosho Focus: A Late Prehistoric Culture in Northeastern Oklahoma." *Bulletin of the Oklahoma Anthropological Society* 10:1–26.

Freeman, Joan E., and A. Dewey Buck Jr. 1960. "Woodward Plain and Neosho Punctate, Two Shell Tempered Pottery Types of Northeastern Oklahoma." *Bulletin of the Oklahoma Anthropological Society* 8:3–16.

Fritz, Gayle J. 1993. "Archeobotanical Analysis." In *Caddoan Saltmakers in the Ouachita Valley: The Hardman Site*, edited by Ann M. Early, 159–68. Research Series No. 43. Fayetteville: Arkansas Archeological Survey.

Fulton, Robert L., and Clarence H. Webb. 1953. "The Bellevue Mound: A Pre-Caddoan Site in Bossier Parish, Louisiana." *Bulletin of the Texas Archeological and Paleontological Society* 24:18–42.

Gadus, Eloise, F. 2010. "Caddo Bowls, Bottles, Social Identity and the Mississippian Cosmos." Paper presented at the Southeastern Archeological Conference, 67th Annual Meeting, Lexington, Kentucky, October 27–30.

———. 2013a. "Twisted Serpents and Fierce Birds: Structural Variation in Caddo Engraved Ceramic Bottle Motifs." *Bulletin of the Texas Archeological Society* 84:213–45.

———. 2013b. "The Hopewell Portal and the Iconography of the Eastern Woodlands." Paper presented at the Southeastern Archeological Conference, 70th Annual Meeting, Tampa Florida, November 7–10.

Gadus, Eloise Frances, and Ross C. Fields. 2012 "Ceramic Artifacts." In *Archeology of the Nadaco Caddo: The View from the Pine Tree Mound Site (41HS15), Harrison County, Texas,* edited by Ross C. Fields and Eloise Frances Gadus, 387–551. 2 Vols. Reports of Investigations No. 164. Austin: Prewitt and Associates, Inc.

Galm, Jerry R. 1978a. *Archaeological Investigations at Wister Lake, Le Flore County, Oklahoma.* Research Series 1. Norman: University of Oklahoma Archaeological Research and Management Center.

———. 1978b. *The Archaeology of the Curtis Lake Site (34LF5A), Le Flore County, Oklahoma.* Research Series 2. Norman: University of Oklahoma Archaeological Research and Management Center.

———. 1984. "Arkansas Valley Caddoan Formative: The Wister and Fourche Maline Phases." In *Prehistory of Oklahoma,* edited by Robert E. Bell, 199–219. Orlando: Academic Press.

Galm, Jerry R., and Peggy Flynn. 1978. *The Cultural Sequences at the Scott (34LF11) and Wann (34LF27) Sites and Prehistory of the Wister Valley.* Research Series 3. Norman: University of Oklahoma Archaeological Research and Management Center.

Gifford, James C. 1960. "The Type-Variety Method of Ceramic Classification as an Indicator of Cultural Phenomena." *American Antiquity* 25(3):341–47.

Gilmore, Zachary I. 2015. "Subterranean Histories: Pit Events and Place-Making in Late Archaic Florida." In *The Archaeology of Events: Cultural Change and Continuity in the Pre-Columbian Southeast,* edited by Zachary I. Gilmore and Jason M. O'Donoughue, 119–40. Tuscaloosa: University of Alabama Press.

Girard, Jeffery S. 1999. *Regional Archaeology Program, Management Unit 1: Tenth Annual Report.* Northwestern State University. Report submitted to Louisiana Department of Culture, Recreation, and Tourism, Baton Rouge.

———. 2000. "Excavations at the Fredericks Site, Natchitoches Parish, Louisiana." *Louisiana Archaeology* 22:143–62.

———. 2002. "Phelps Lake and Jim Burt: Two Middle Woodland Period Mounds in Northwestern Louisiana." *Caddoan Archeology* 12(4):5–17.

———. 2006. *Regional Archaeology Program Management Unit 1, Seventeenth Annual Report, Northwestern State University.* Report on file with the Louisiana Division of Archaeology, Department of Culture, Recreation, and Tourism, Baton Rouge.

———. 2007. "Byram Ferry (16BO17): A Middle to Late Caddo Period Mound Site in the Red River Floodplain, Northwest Louisiana." *Caddo Archeology Journal* 16:9–25.

———. 2009. "Comments on Caddo Origins in Northwest Louisiana." *Journal of Northeast Texas Archaeology* 31:51–60.

———. 2010. "Caddo Communities of Northwest Louisiana." In *Archaeology of Louisiana,* edited by Mark A. Rees, 195–210. Baton Rouge: Louisiana State University Press.

———. 2012a. "The Bellevue Site (16B04): A Woodland Period Mound in Northwest Louisiana." *Louisiana Archaeology* 35:53–78.

———. 2012b. "Settlement Patterns and Variation in Caddo Pottery Decoration: A Case Study of the Willow Chute Bayou Locality." In *The Archaeology of the Caddo*, edited by Timothy K. Perttula and Chester P. Walker, 239–87. Lincoln: University of Nebraska Press.

———. 2018. *The Caddos and their Ancestors: Archaeology and the Native People of Northwest Louisiana.* Baton Rouge: Louisiana State University Press.

Girard, Jeffrey S., and Leslie G. Cecil. 2015. "Comparing Caddo and Coles Creek Pottery Using Petrographic Analysis." *Caddo Archeology Journal* 26:7–18.

Girard, Jeffrey S., Timothy K. Perttula, and Mary Beth Trubitt. 2014. *Caddo Connections: Cultural Interactions within and beyond the Caddo World.* Lanham, MD: Rowman & Littlefield Publishers.

Girard, Jeffrey S., Robert C. Vogel, and H. Edwin Jackson. 2008. "History and Archaeology of the Pierre Robleau Household and Bayou Pierre Community: Perspectives on Rural Society and Economy in Northwestern Louisiana at the Time of the Freeman and Custis Expedition." In *Freeman and Custis Red River Expedition of 1806: Two Hundred Years Later*, edited by Laurence M. Hardy, 147–80. Bulletin of the Museum of Life Sciences No. 14. Shreveport: Museum of Life Sciences and James Smith Noel Collection, Noel Memorial Library, Louisiana State University.

Glascock, Michael D., and Hector Neff. 2003. "Neutron Activation Analysis and Provenance Research in Archaeology." *Measurement Science and Technology* 14:1516–26.

Gonzalez, Bobby, Robert L. Cast, Timothy K. Perttula, and Bo Nelson. 2005. *A Rediscovering of Caddo Heritage: The W. T. Scott Collection at the American Museum of Natural History and Other Caddo Collections from Arkansas and Louisiana.* Binger: Historic Preservation Program, Caddo Nation of Oklahoma.

Goodall, Colin. 1991. "Procrustes Methods in the Statistical Analysis of Shape." *Journal of the Royal Statistical Society. Series B (Methodological)* 53(2):285–339.

Goode, Glenn T., Timothy K. Perttula, Leslie L. Bush, Shawn Marceaux, LeeAnna Schniebs, and Jesse Todd. 2015. *Excavations at the Early Caddo Period Mound Pond Site (41HS12) in Harrison County, Texas.* Special Publication No. 38. Austin and Pittsburg: Friends of Northeast Texas Archaeology.

Gower, J. C. 1975. "Generalized Procrustes Analysis." *Psychometrika* 40(1):33–51.

Greber, Nomi B., and Katharine C. Ruhl. 2003. *The Hopewell Site: A Contemporary Analysis Based on the Work of Charles C. Willoughby.* Cambridge: Eastern National with the Peabody Museum of Archaeology and Ethnology, Harvard University.

Green, Adam S. 2016. "Finding Harappan Seal Carvers: An Operational Sequence Approach to Identifying People in the Past." *Journal of Archaeological Science* 72:128–41.

Gregory, Hiram F. 1973. "Eighteenth Century Caddoan Archaeology: A Study in Models and Interpretation." PhD diss., Department of Anthropology, Southern Methodist University, Dallas.

Gregory, Hiram F., and George Avery. 2007. "American Indian Pottery from Historic Period Sites in North Louisiana." *Journal of Northeast Texas Archaeology* 26:33–76.

Gregory, Hiram F., George Avery, Aubra L. Lee, and Jay C. Blaine. 2004. "Presidio Los Adaes: Spanish, French, and Caddoan Interaction on the Northern Frontier." *Historical Archaeology* 38(3):65–77.

Gregory, Hiram F., and Kim Curry. 1977. "Natchitoches Parish Cultural and Historical Resources: Prehistory." Natchitoches Parish Planning Commission. Report submitted to the Natchitoches Parish Police Jury, Natchitoches.

Gregory, Hiram F., Clint Pine, William S. Baker, Aubra Lee, Reinaldo Barnes, and George A. Stokes. 1987. *A Survey of Catahoula Basin, 1987*. Natchitoches: Northwestern State University. Report on file with the Louisiana Division of Archaeology, Department of Culture, Recreation, and Tourism, Baton Rouge.

Guidry, Hannah, and Larry McKee. 2014. "Archaeological Investigations of the Ballpark at Sulphur Dell, Nashville, Davidson County, Tennessee." Report submitted to Capital Project Solutions by TRC Environmental Corporation. TRC Project No. 212578, Nashville, Tennessee.

Guilinger, Edwin L. 1971. "The Archaeological Situation at the Copeland Site, a Fourche Maline Site in Le Flore County." Master's thesis, Department of Anthropology, University of Oklahoma, Norman.

Hall, Robert L. 1951. "The Late Prehistoric Occupation of Northeastern Oklahoma as Seen from the Smith Site, Delaware County." Master's thesis, Department of Anthropology, University of Wisconsin, Madison.

———. 1989. "The Cultural Background of Mississippian Symbolism." In *The Southeastern Ceremonial Complex: Artifacts and Analysis. The Cottonlandia Conference*, edited by Patricia Galloway, 239–78. Lincoln: University of Nebraska Press.

Hall, Roland S. 1954. "CK44: A Bluff Shelter Site from Northeastern Oklahoma." *Bulletin of the Oklahoma Anthropological Society* 2:49–67.

Hammerstedt, Scott W. and Jim Cox. 2011. "Animal Imagery on Two Artifacts from Eastern Oklahoma." *Oklahoma Anthropological Society Bulletin* 59:129–33.

Hammerstedt, Scott W., and Matthew K. Galloway. 2009. *Archeological Survey of the Big Skin Bayou Area, Sequoyah County, Oklahoma*. Archeological Resource Survey Report 59. Norman: University of Oklahoma, Oklahoma Archeological Survey.

Hammerstedt, Scott W., Patrick C. Livingood, Amanda L. Regnier, Jami Lockhart, Tim Mulvihill, George Sabo III, and John R. Samuelsen. 2018. "Archaeological Mitigation of Four Precontact Buildings at Spiro Mounds, 2013–2014." Draft report submitted to the U.S. Army Corps of Engineers, Tulsa District by the Oklahoma Archeological Survey, Norman.

Hammerstedt, Scott W., Jami J. Lockhart, Patrick C. Livingood, Tim Mulvihill, Amanda L. Regnier, George Sabo III, and John R. Samuelsen. 2017. "Multisensor Remote Sensing at Spiro: Discovering Intrasite Organization." In *Archaeological Remote Sensing in North America: Innovative Techniques for Anthropological Applications*, edited by Duncan P. McKinnon and Bryan S. Haley, 11–27. Tuscaloosa: University of Alabama Press.

Hammerstedt, Scott W., Amanda L. Regnier, and Patrick C. Livingood. 2010. "Geophys-

ical and Archaeological Investigations at the Clement Site, a Caddo Mound Complex in Southeastern Oklahoma." *Southeastern Archaeology* 29:279–91.

Hammerstedt, Scott W., and Sheila Bobalik Savage. 2014. "The Use of Color and Directional Symbolism at Spiroan Sites in the Arkansas River Drainage." Paper presented at the Southeastern Archaeological Conference, Greenville, South Carolina.

———. 2016. "Earth and Sky: Celestial Symbolism in the Spiroan Arkansas River Drainage." Paper presented at the Southeastern Archaeological Conference, Athens, Georgia.

Handley, Fiona. 2015. "Developing Archaeological Pedagogies in Higher Education: Addressing Changes in the Community of Practice of Archaeology." *The Historic Environment: Policy & Practice* 6(2):156–66.

Hanvey, Vanessa N. 2014. "Predictive Modeling of a Caddo Structure in the Ouachita Mountains, Montgomery County, Arkansas." *Caddo Archeology Journal* 24:43–52.

Harden, Patrick, and David Robinson. 1975. "A Descriptive Report of the Vanderpool Site, CK32, Cherokee County, Oklahoma." *Bulletin of the Oklahoma Anthropological Society* 23:91–198.

Harrington, Mark R. 1920. *Certain Caddo Sites in Arkansas.* Indian Notes and Monographs, Miscellaneous Series No. 10. New York: Museum of the American Indian, Heye Foundation.

———. 1971. *The Ozark Bluff-Dwellers.* New York: Museum of the American Indian, Heye Foundation.

Harris, Oliver J. T. 2014. "(Re)assembling Communities." *Journal of Archaeological Method and Theory* 21:76–97.

Harris, R. King. 1953. "The Sam Kaufman Site, Red River County, Texas." *Bulletin of the Texas Archeological and Paleontological Society* 24:43–68.

Harris, R. King, and I. M. Harris. 1980. "Distribution of Natchitoches Engraved Ceramics." *Louisiana Archaeology* 6:223–30.

Hart, John P. 2012. "The Effects of Geographical Distances on Pottery Assemblage Similarities: A Case Study from Northern Iroquoia." *Journal of Archaeological Science* 39(1):128–34.

Hart, John P., and Timothy K. Perttula. 2010. "The Washington Square Mound Site and a Southeastern Ceremonial Complex Style Zone among the Caddo of Northeastern Texas." *Midcontinental Journal of Archaeology* 35:199–228.

Hayes, Allan, and Carol Hayes. 2012. *Pottery of the Southwest: Ancient Art and Modern Traditions.* London: Shire Publications.

Hays, Christopher T., and Richard A. Weinstein. 2010. "Tchefuncte and Early Woodland." In *Archaeology of Louisiana*, edited by Mark A. Rees, 97–119. Baton Rouge: Louisiana State University Press.

Heartfield, Price, and Greene, Inc. 1985. "Data Recovery at Archeological Site 16NA37 (Montrose Site), Natchitoches Parish, Louisiana." Monroe: Heartfield, Price and Greene, Inc. Report submitted to the Louisiana Department of Transportation and Development.

Hodder, Ian. 2012. *Entangled: An Archaeology of the Relationships between Humans and Things*. Oxford: Wiley-Blackwell.

———. 2014. "The Entanglements of Humans and Things: A Long-Term View." *New Literary History* 45(1):19–36.

Hodder, Ian, and Angus Mol. 2015. "Network Analysis and Entanglement." *Journal of Archaeological Method and Theory* 23(4):1066–94.

Hodges, T. L., and Mrs. [Charlotte Hodges]. 1963. "Suggestion for Identification of Certain Mid-Ouachita Pottery as Cahinnio Caddo." *The Arkansas Archeologist* 4(8):1–12. Reprinted from 1945 *Bulletin of the Texas Archeological and Paleontological Society* 16:98–116.

Hoffman, Michael P. 1970. "Archaeological and Historical Assessment of the Red River Basin in Arkansas." In *Archeological and Historical Resources of the Red River Basin: Louisiana, Texas, Oklahoma, Arkansas*, edited by Hester A. Davis, 135–94. Research Series No. 1. Fayetteville: Arkansas Archeological Survey.

———. 1971. "A Partial Archaeological Sequence for the Little River Region, Arkansas." PhD diss., Anthropology Department, Harvard University, Cambridge, MA.

Hofman, Jack L. 1984. "The Plains Villagers: The Custer Phase." In *Prehistory of Oklahoma*, edited by Robert E. Bell, 287–305. Orlando: Academic Press.

Hosfield, Robert. 2009. "Modes of Transmission and Material Culture Patterns in Craft Skills." In *Pattern and Process in Cultural Evolution*, edited by Stephen Shennan, 45–60. Berkeley: University of California Press.

House, John. 1995. "Noble Lake: A Protohistoric Archeological Site on the Lower Arkansas River." *The Arkansas Archeologist* 36:47–97.

———. 1997. "Time, People and Material Culture at the Kuykendall Brake Archeological Site, Pulaski County Arkansas." Paper presented at the Southeastern Archaeological Conference, November 6, 1997, Baton Rouge, LA.

Hudson, Charles. 1976. *The Southeastern Indians*. Knoxville: University of Tennessee Press.

Ingold, Tim. 1993. "The Temporality of the Landscape." *World Archaeology* 25:152–74.

———. 2006. "Rethinking the Animate, Re-animating Thought." *Ethnos* 71:9–20.

Irvine, Marilee. 1980. "Ceramic Analysis from the Williams I Site, 34LF24, LeFlore County, Oklahoma." Master's thesis, Department of Anthropology, University of Oklahoma, Norman.

Israel, Stephen. 1979 *Re-Examination of the Cookson Site*. Studies in Oklahoma's Past 4. Norman: Oklahoma Archeological Survey.

Jackson, A. T., M. S. Goldstein, and Alex D. Krieger. 2000. *The 1931 Excavations at the Sanders Site, Lamar County, Texas: Notes on the Fieldwork, Human Osteology, and Ceramics*. Archival Series 2. Austin: Texas Archeological Research Laboratory, University of Texas at Austin.

Jackson, H. Edwin, Susan L. Scott, and Frank F. Schambach. 2012. "At the House of the Priest: Faunal Remains from the Crenshaw Site (3MI6), Southwest Arkansas." In *The Archaeology of the Caddo*, edited by Timothy K. Perttula and Chester P. Walker, 47–85. Lincoln: University of Nebraska Press.

Jackson, Jack. 1999. *Shooting the Sun: Cartographic Results of Military Activities in Texas, 1689–1829.* 2 Vols. Lubbock: The Book Club of Texas.

Jacomy, Alexis. 2018. "*Gephi Plugins: GeoLayout.*" Electronic document, https://gephi.org/plugins/#/plugin/geolayout-plugin, accessed October 1, 2018.

Jelks, Edward B. 1961. *Excavations at Texarkana Reservoir, Sulphur River, Texas.* River Basin Survey Papers No. 21. Washington, DC: Bureau of American Ethnology, Smithsonian Institution.

———. 1965. "The Archeology of McGee Bend Reservoir, Texas." PhD diss., Department of Anthropology, University of Texas at Austin.

Jeter, Marvin D., ed. 1990. *Edward Palmer's Arkansaw Mounds.* Fayetteville and London: University of Arkansas Press.

John, Elizabeth A. H. 1975. *Storms Brewed in Other Men's Worlds: The Confrontation of Indians, Spanish, and French in the Southwest, 1540–1795.* College Station: Texas A&M University Press.

Jolliffe, Ian T. 2002. *Principal Component Analysis.* New York: Springer.

Justice, Noel D. 1987. *Stone Age Spear and Arrow Points of the Midcontinental and Eastern United States.* Bloomington: Indiana University Press.

Kay, Marvin, and George Sabo III. 2006. "Mortuary Ritual and Winter Solstice Imagery of the Harlan-Style Charnel House." *Southeastern Archaeology* 25(1):29–47.

Kelley, David B. 1997. *Two Caddoan Farmsteads in the Red River Valley.* Research Series No. 51. Fayetteville: Arkansas Archeological Survey.

———. 1998. "Protohistoric and Historic Caddoan Occupation of the Red River Valley in Northwest Louisiana." In *The Native History of the Caddo, Their Place in Southeastern Archeology and Ethnohistory*, edited by Timothy K. Perttula and James E. Bruseth, 91–112. Studies in Archeology 30. Austin: Texas Archeological Research Laboratory, University of Texas.

———. 2006. *The Burnitt Site: A Late Caddoan Occupation in the Uplands of the Sabine River Basin of Louisiana.* Baton Rouge: Coastal Environments, Inc.

———. 2012. "The Belcher Phase: Sixteenth-and Seventeenth-Century Caddo Occupation of the Red River Valley in Northwest Louisiana and Southwest Arkansas." In *The Archaeology of the Caddo*, edited by Timothy K. Perttula and Chester P. Walker, 411–30. Lincoln: University of Nebraska Press.

Kelley, David B., Donald G. Hunter, Katherine M. Roberts, Susan L. Scott, and Bryan S. Haley. 2010. "The Burnitt Site (16SA204): A Late Caddoan Occupation in the Uplands of the Sabine River Basin." *Louisiana Archaeology* 31:4–33.

Kelly, John E. 1991. "The Evidence for Prehistoric Exchange and Its Implications for the Development of Cahokia." In *New Perspectives on Cahokia, Views from the Periphery*, edited by James B. Stoltman, 65–92. Monographs in World Archaeology No. 2. Madison: Prehistory Press.

Kendall, David G. 1981. "The Statistics of Shape." In *Interpreting Multivariate Data*, edited by Vic Barnett, 75–80. New York: Wiley.

———. 1984. "Shape Manifolds, Procrustean Metrics, and Complex Projective Spaces." *Bulletin of the London Mathematical Society* 16(2):81–121.

Kenmotsu, Nancy A. 1992. "The Mayhew Site: A Possible Hasinai Farmstead, Nacogdoches County, Texas." *Bulletin of the Texas Archeological Society* 63:135–74.

———. 2005. *Investigations at the Salt Well Slough, 41RR204, A Salt-Making Site in Red River County, Texas.* Archaeological Reports Series No. 4. Austin: Texas Historical Commission.

———. 2017. "Prehistoric Salt Making Writ Small: An Ancestral Caddo Example." Paper presented at the 2nd International Salt Congress, Los Cabos, Mexico.

Kenoyer, Jonathan Mark, Massimo Vidale, and Kuldeep Kumar Bhan. 1991. "Contemporary Stone Beadmaking in Khambhat, India: Patterns of Craft Specialization and Organization of Production as Reflected in the Archaeological Record." *World Archaeology* 23(1):44–63.

Kerr, Henry P., and Don G. Wyckoff. 1967. "Two Prehistoric Sites, MY72 and MY79, in the Markham Ferry Reservoir Area, Mayes County, Oklahoma." *Bulletin of the Oklahoma Anthropological Society* 12:55–86.

Keslin, Richard O. 1964. "Archaeological Implications on the Role of Salt as an Element of Cultural Diffusion." *The Missouri Archaeologist* 26.

Kidder, Tristram R. 1988. "Protohistoric and Early Historic Culture Dynamics in Southeast Arkansas and Northeast Louisiana A.D. 1542–1730." PhD diss., Department of Anthropology, Harvard University, Cambridge, MA.

———. 1998. "Rethinking Caddoan-Lower Mississippi Valley Interaction." In *The Native History of the Caddo: Their Place in Southeastern Archaeology and Ethnohistory*, edited by Timothy K. Perttula and James E. Bruseth, 129–43. Studies in Archeology 30. Austin: Texas Archaeological Research Laboratory, University of Texas at Austin.

Klingenberg, Christian Peter. 2013. "Visualizations in Geometric Morphometrics: How to Read and How to Make Graphs Showing Shape Changes." *Hystrix* 24:15–24.

Knappett, Carl. 2011a. *An Archaeology of Interaction: Network Perspectives on Material Culture & Society.* Oxford: Oxford University Press.

———. 2011b. "Meso-Networks: Communities of Practice." In *An Archaeology of Interaction: Network Perspectives on Material Culture and Society*, by Carl Knappett, 98–123. Oxford: Oxford University Press.

———. 2013. *Network Analysis in Archaeology: New Approaches to Regional Interaction.* Oxford: Oxford University Press.

Knight, Vernon James, Jr. 2012. *Iconographic Method in New World Prehistory.* Cambridge: Cambridge University Press.

Kolaczyk, Eric D., and Gábor Csárdi. 2014. *Statistical Analysis of Network Data with R.* New York: Springer-Verlag.

Krause, Richard A. 2007. "A Potter's Tale." In *Plains Village Archaeology: Bison-hunting Farmers in the Central and Northern Plains*, edited by Stanley A. Ahler and Marvin Kay, 32–40. Salt Lake City: University of Utah Press.

Krieger, Alex D. 1941. "An Analytical System for East Texas Pottery." *Southeastern Archaeological Conference Newsletter* 2(4):7–9.

———. 1944a. The Typological Concept. *American Antiquity* 9(3):271–88.

———. 1944b. "Archeological Horizons in the Caddoan Area." *Revista Mexicana de Estudios Historicos* 7:154–56.

———. 1946. *Culture Complexes and Chronology in Northern Texas, with Extensions of Puebloan Datings to the Mississippi Valley.* Publication 4640. Austin: University of Texas.

———. 1947a. "The First Symposium on the Caddoan Archaeological Area." *American Antiquity* 12:198–207.

———. 1947b. "The Eastward Extension of Puebloan Datings toward Cultures of the Mississippi Valley." *American Antiquity* 12(3-Part1):141–48.

Kubler, George. 1962. *The Shape of Time: Remarks on the History of Things.* New Haven: Yale University Press.

Kusnierz, Nicole E. 2016. "Leadership and Social Dynamics at Brackett (34CK43): An Archaeological Study of a Mississippi Period Mound Site in Eastern Oklahoma." Master's thesis, Department of Anthropology, University of Oklahoma, Norman.

Lafferty, Robert H., III, Ann Early, Michael C. Sierzchula, M. Cassandra Hill, Gina S. Powell, Neal H. Lopinot, Linda Scott Cummings, Susan L. Scott, Samuel K. Nash, and Timothy K. Perttula. 2000. *Data Recovery at the Helm Site, 3HS449, Hot Spring County, Arkansas.* Report 2000–1. Lowell, AR: Mid-Continental Research Associates, Inc.

Lambert, Shawn. 2017. "Alternate Pathways to Ritual Power: Evidence for Centralized Production and Long-Distance Exchange Between Northern and Southern Caddo Communities." PhD diss., Department of Anthropology, University of Oklahoma, Norman.

———. 2018. "Addressing the Cosmological Significance of a Pot: A Search for Cosmological Structure in the Craig Mound." *Caddo Archeology Journal* 28:21–37.

Lambiotte, Renaud, Jean-Charles Delvenne, and Mauricio Barahona. 2014. "Random Walks, Markov Processes and the Multiscale Modular Organization of Complex Networks." *IEEE Transactions on Network Science and Engineering* 1(2):76–90.

Lankford, George E. 2007a. "Some Cosmological Motifs in the Southeastern Ceremonial Complex." In *Ancient Objects and Sacred Realms: Interpretations of Mississippian Iconography*, edited by F. Kent Reilly III and James F. Garber, 8–38. Austin: University of Texas Press.

———. 2007b. "The Great Serpent in Eastern North America." In *Ancient Objects and Sacred Realms: Interpretations of Mississippian Iconography*, edited by F. Kent Reilly III and James F. Garber, 107–35. Austin: University of Texas Press.

———. 2008. *Looking for Lost Lore: Studies in Folklore, Ethnology, and Iconography.* Tuscaloosa: University of Alabama Press.

———. 2011. "The Swirl Cross at the Center." In *Visualizing the Sacred: Cosmic Visions, Regionalism, and the Art of the Mississippian World*, edited by George E. Lankford, F. Kent Reilly III, and James F. Garber, 251–73. Austin: University of Texas Press.

———. 2012. "Weeding out the Noded." *The Arkansas Archeologist* 50:50–68.

Lankford, George E., F. Kent Reilly III, and James F. Garber, eds. 2011. *Visualizing the Sa-*

cred: Cosmic Visions, Regionalism, and the Art of the Mississippian World. Austin: University of Texas Press.

La Vere, David. 1998. *Life Among the Texas Indians: The WPA Narratives*. College Station: Texas A&M University Press.

Layton, Robert. 1991. *The Anthropology of Art*. Cambridge: Cambridge University Press.

Lee, Dayna B. 2001. "Regional Variation and Protohistoric Identity: A Round Table Discussion from the 43rd Caddo Conference, March 17, 2001." *Caddoan Archeology* 12(2&3):10–35.

Leith, Luther J. 2011. "A Re-Conceptualization of the Fourche Maline Culture: The Woodland Period as a Transition in Eastern Oklahoma." PhD diss., Department of Anthropology, University of Oklahoma, Norman.

Lemley, Harry J. 1936. "Discoveries Indicating a Pre-Caddo Culture on the Red River in Arkansas." *Bulletin of the Texas Archeological and Paleontological Society* 8:25–55.

Lentz, Lindsay J. 2015. "The Bioarchaeology of the Cooper VI Site (34DL48) in Delaware County, Oklahoma." Master's thesis, Department of Anthropology, University of Oklahoma, Norman.

Lintz, Christopher. 1982. "The Turtle Luck Site (34PU100)." In *Phase II Archaeological Investigations at Clayton Lake, Southeast Oklahoma*, edited by Rain Vehik, 122–88. Research Series No. 8. Norman: Archaeological Research and Management Center, University of Oklahoma.

Lockhart, Jami Joe. 2007. "Prehistoric Caddo of Arkansas: A Multiscalar Examination of Past Cultural Landscapes." PhD diss.. Environmental Dynamics, University of Arkansas, Fayetteville.

Longacre, William A. 1999. "Standardization and Specialization: What's the Link?" In *Pottery and People: A Dynamic Interaction*, edited by James M. Skibo and Gary M. Feinman, 44–58. Salt Lake City: University of Utah Press.

Longacre, William A., and Miriam T. Stark. 1992. "Ceramics, Kinship, and Space: A Kalinga Example." *Journal of Anthropological Archaeology* 11(2):125–36.

Lopez, David R. 1973. "The Wybark Site: A Late Prehistoric Village Complex in the Three Forks Locale, Muskogee County, Oklahoma." *Bulletin of the Oklahoma Anthropological Society* 22:11–126.

Luke, Douglas A. 2015. *A User's Guide to Network Analysis in R*. Use R! Heidelberg: Springer.

Lyman, R. Lee, Michael J. O'Brien, and Robert C. Dunnell. 1997. *The Rise and Fall of Culture History*. New York: Plenum Press.

Lynott, Mark J., Hector Neff, James E. Price, and James W. Cogswell. 2000. "Inferences about Prehistoric Ceramics and People in Southeast Missouri: Results of Ceramic Compositional Analysis." *American Antiquity* 65(1):103–26.

Lyons, Patrick D., and Jeffery J. Clark. 2012. "A Community of Practice in Diaspora: The Rise and Demise of Roosevelt Red Ware." In *Potters and Communities of Practice: Glaze Paint and Polychrome in the American Southwest*, edited by Linda S. Cordell and Judith A. Habicht-Mauche, 19–33. Tucson: University of Arizona Press.

Marceaux, P. Shawn. 2007. "Recent Research on the Archaeological and Historical Evidence of the Hasinai." *Journal of Northeast Texas Archaeology* 26:82–98.

———. 2011. "The Archaeology and Ethnohistory of the Hasinai Caddo: Material Culture and the Course of European Contact." PhD diss., Department of Anthropology, University of Texas Austin.

Marceaux, P. Shawn, and Mariah F. Wade. 2014. "Missions Untenable: Experiences of the Hasinai Caddo and the Spanish in East Texas." In *Indigenous Landscapes and Spanish Missions: New Perspectives from Archaeology and Ethnohistory*, edited by Lee M. Panich and Tsim D. Schneider, 57–75. Tucson: University of Arizona Press.

McClurkan, Burney B., William T. Field, and J. Ned Woodall. 1966. *Excavations in Toledo Bend Reservoir, 1964–65*. Papers of the Texas Archeological Salvage Project No. 8. Austin: Texas Archeological Salvage Project, University of Texas at Austin.

McCrocklin, Claude. 1985. "Potter's Pond, 16WE76, A Caddo Salt and Pottery-Making Site." *Field Notes* (Newsletter of the Arkansas Archeological Society) 210:3–5.

McDermott, John F. 1963. "The Western Journals of Dr. George Hunter 1796–1805." *Transactions of the American Philosophical Society* 53(4):1–133.

McHugh, William P. 1964. "A Transitional Archaic and Woodland Site (DL57) in Delaware County, Oklahoma." Master's thesis, Department of Anthropology, University of Wisconsin, Madison.

McKinnon, Duncan P. 2011. "Foster Trailed-Incised: A GIS Based Analysis of Caddo Ceramic Distribution." *Caddo Archeology Journal* 21:67–84.

———. 2015. "Zoomorphic Effigy Pendants: An Examination of Style, Medium, and Distribution in the Caddo Homeland." *Southeastern Archaeology* 34(2):116–35.

———. 2016. "Distribution of Design: The Rayed Circle." *Caddo Archeology Journal* 26:29–42.

———. 2017. *The Battle Mound Landscape: Exploring Space, Place, and History of a Red River Caddo Community in Southwest Arkansas*. Research Series No. 68. Fayetteville: Arkansas Archeological Survey.

———. 2018. "Toward a Collaborative Development of a Truly Comprehensive Multi-State Material Culture Database." *Caddo Archeology Journal* 28:128–30.

McKinnon, Duncan P., Katelyn Trammell, Ryan Nguyen, and Anna Suarez. 2018. "An Inventory of Reconstructed Ceramic Vessels from the Bowman Site (3LR50/3LR46) in Little River County, Arkansas." Paper presented at the 60th Caddo Conference, Idabel, Oklahoma.

McWilliams, Richebourge C. 1981. *Iberville's Gulf Journals*. Tuscaloosa: University of Alabama Press.

Mickle, W. R. 1994. "An Historic Caddo Indian Village (Hasinai) in East Texas." *The Amateur Archaeologist* 1(1):82–83.

Middlebrook, Tom A. 2014. "Early European Descriptions of Hasinai Elites and Understanding Prehistoric Caddo Mortuary Practices in Shelby County, Texas." *Bulletin of the Texas Archeological Society* 85:83–110.

Milanich, Jerald T. 1994. *Archaeology of Precolumbian Florida*. Gainesville: University Press of Florida.

Milanich, Jerald T., Ann S. Cordell, Vernon J. Knight Jr., Timothy A. Kohler, and Brenda J. Silgler-Lavelle. 1997. *Archaeology of Northwest Florida A.D. 200–900. The Mckeithen Weeden Island Culture.* Gainesville: University Press of Florida.

Miller, John E., III. 2011. "Some Notes on Replicating Prehistoric Pottery." *Caddo Archeology Journal* 21:5–28.

Miller, Logan G. 2014. "Ritual Economy and Craft Production in Small-Scale Societies: Evidence from Microwear Analysis of Hopewell Bladelets." *Journal of Anthropological Anthropology* 39:124–38.

Mills, Barbara J. 1999. "Ceramics and Social Contexts of Food Consumption in the Northern Southwest." In *Pottery and People: A Dynamic Interaction*, edited by James M. Skibo and Gary M. Feinman, 99–114. Salt Lake City: University of Utah Press.

Mills, Barbara J., Matthew A. Peeples Jr., W. Randall Haas, Lewis Borck, Jeffery J. Clark, and John M. Roberts. 2015. "Multiscalar Perspectives on Social Networks in the Late Prehispanic Southwest." *American Antiquity* 80(1):3–24.

Mitteroecker, Philipp, and Philipp Gunz. 2009. "Advances in Geometric Morphometrics." *Evolutionary Biology* 36(2):235–47.

Moore, Clarence B. 1912. "Some Aboriginal Sites on Red River." *Journal of the Academy of Natural Sciences of Philadelphia.* 14(4):526–636.

Morgan, David W., and Kevin C. MacDonald. 2011. "Colonoware in Western Colonial Louisiana: Makers and Meaning." In *French Colonial Archaeology in the Southeast and Caribbean*, edited by Kenneth G. Kelly and Meredith D. Hardy, 117–51. Tallahassee: University Press of Florida.

Muller, Jon. 1984. "Mississippian Specialization and Salt." *American Antiquity* 49(3):489–507.

———. 1986. "Pans and a Grain of Salt: Mississippian Specialization Revisited." *American Antiquity* 51(2):405–9.

———. 1989. "The Southern Cult." In *The Southeastern Ceremonial Complex: Artifacts and Analysis, the Cottonlandia Conference*, edited by Patricia Galloway, 11–26. Lincoln: University of Nebraska Press.

———. 1997. *Mississippian Political Economy.* New York: Plenum Press.

Muller, Jon, and Lisa Renken. 1989. "Radiocarbon Dates for the Great Salt Spring Site: Dating Saltpan Variation." *Illinois Archaeology* 1:150–60.

Neal, Larry. 1974. "Archaeological Investigations at the C.H. Stockton and Jim Butterfield Sites, Kay County, North-Central Oklahoma." In *Kaw Reservoir–The Central Section. Report of Phase III Research of the General Plan for Investigation of the Archaeological Resources of Kaw Reservoir, North-Central Oklahoma*, edited by Charles L. Rohrbaugh, 77–110. Archaeological Site Report 27. Norman: University of Oklahoma Office of Research Administration, Oklahoma River Basin Survey.

Newell, H. Perry, and Alex D. Krieger. 1949. *The George C. Davis Site, Cherokee County, Texas.* Memoirs No. 5. Menasha, WI: Society for American Archaeology.

Newkumet, Phil J. 1940a. "Quarterly Field Report, Le Flore County Archaeological Project, 1st Quarter, 1940." In *Archaeological Excavation of Prehistoric Indian Sites, Quarterly Report, First Quarter 1940*, edited by Forrest E. Clements, 31–79. Submitted to

the Works Projects Administration. On file at the Sam Noble Oklahoma Museum of Natural History, University of Oklahoma, Norman.

———. 1940b. "Preliminary Report on Excavation of the Williams Mound, Le Flore County, Oklahoma." *Oklahoma Prehistorian* 3:2–10.

Neuman, Robert W. 1984. *An Introduction to Louisiana Archaeology.* Baton Rouge: Louisiana State University Press.

O'Brien, Patrick. 1990. "An Experimental Study of the Effects of Salt Erosion on Pottery." *Journal of Archaeological Science* 17(4):393–401.

Orr, Kenneth G. 1946. "The Archaeological Situation at Spiro, Oklahoma; A Preliminary Report." *American Antiquity* 11:228–56.

———. 1952. "Survey of Caddoan Area Archaeology." In *Archaeology of Eastern United States*, edited by James B. Griffin, 239–55. Chicago: University of Chicago Press.

Palmer, Edward. 1917. "Arkansas Mounds." *Publications of the Arkansas Historical Association* 4:390–448.

Parsons, Mark L., James E. Bruseth, Jacque Bagur, S. Eileen Goldborer, and Claude McCrocklin. 2002. *Finding Sha'chahdinnih (Timber Hill): The Last Village of the Kadohadacho in the Caddo Homeland.* Archeological Reports Series No. 3. Austin: Texas Historical Commission.

Pauketat, Timothy R. 1994. *The Ascent of Chiefs, Cahokia and Mississippian Politics in Native North America.* Tuscaloosa: University of Alabama Press.

Pauketat, Timothy R., and Thomas E. Emerson. 1991. "The Ideology of Authority and the Power of the Pot." *American Anthropologist* 93(4):919–41.

Peeples, Matthew A. 2017. *Network Science and Statistical Techniques for Dealing with Uncertainties in Archaeological Datasets.* Electronic document, http://www.mattpeeples.net/netstats.html, accessed October 1, 2018.

Peeples, Matthew A., and John M. Roberts. 2013. "To Binarize or Not to Binarize: Relational Data and the Construction of Archaeological Networks." *Journal of Archaeological Science* 40(7):3001–10.

Perino, Gregory. 1981. *Archeological Investigations at the Roden Site (MC-215), McCurtain County, Oklahoma.* Potsherd Press No. 1. Idabel, OK: Museum of the Red River.

———. 1983. *Archaeological Research at the Bob Williams Site (41RR16), Red River County, Texas.* Idabel, OK: Museum of the Red River.

———. 1995. "The Dan Holdeman Site (41RR11), Red River County, Texas." *Journal of Northeast Texas Archaeology* 6:3–65.

Perino, Gregory, and W. J. Bennett Jr. 1978. *Archaeological Investigations at the Mahaffey Site, CH-1, Hugo Reservoir, Choctaw County, Oklahoma.* Idabel, OK: Museum of the Red River.

Perttula, Timothy K. 1992. *"The Caddo Nation": Archaeological and Ethnohistoric Perspectives.* Austin: University of Texas Press.

———. 2001. "Three Mid-1800s Caddo Vessels from the Brazos Reserve." *Journal of Northeast Texas Archaeology* 14:31–36.

———. 2002. "Archaeological Evidence for Long-Distance Exchange of Caddo Indian Ceramics in the Southern Plains, Midwest, and Southeastern United States." In

Geochemical Evidence for Long-Distance Exchange, edited by Michael D. Glascock, 89–107. Westport: Bergin and Garvey.

———. 2004. "The Prehistoric and Caddoan Archeology of the Northeastern Texas Pineywoods." In *The Prehistory of Texas*, edited by Timothy K. Perttula, 370–407. Texas A&M University Anthropology Series No. 9. College Station: Texas A&M University Press.

———. 2005a. "1938–1939 WPA Excavations at the Hatchel Site (41BW3) on the Red River in Bowie County, Texas." *Southeastern Archaeology* 24(2):180–98.

———. 2005b. "The M. W. Burks Site (41WD52), A Late Caddo Hamlet in Wood County, Texas." *Journal of Northeast Texas Archaeology* 23:1–27.

———. 2007a. "Kinsloe Focus Artifact Assemblages and Nadaco Caddo." *Journal of Northeast Texas Archaeology* 26:116–19.

———. 2007b. "Seriation Proposed by Kleinschmidt (1982:Table 19) of Allen Phase and Frankston Phase Sites in the Upper Neches River Basin." *Journal of Northeast Texas Archaeology* 26:150–53.

———. 2008a. "Archeological Survey of the Roitsch Farm and Adjoining Lands, 1991 and 1992 Texas Archeological Society Field School, Red River County, Texas." In *Collected Papers from Past Texas Archeological Society Summer Field Schools*, edited by Timothy K. Perttula, 173–312. Special Publication No. 5. San Antonio: Texas Archeological Society.

———. 2008b. "The Archeology of the Roitsch Site (41RR16), an Early to Historic Caddo Period Village on the Red River in Northeast Texas." In *Collected Papers from Past Texas Archeological Society Summer Field Schools*, edited by Timothy K. Perttula, 313–628. Special Publication No. 5. San Antonio: Texas Archeological Society.

———. 2008c. "Historic Caddo Archaeology on the Red and Lower Sulphur River Areas of Northeast Texas." *Journal of Northeast Texas Archaeology* 28:25–34.

———. 2009a. "The Caddo Ceramics from the Dragover Site (3MN298) on the Ouachita River on Ouachita National Forest Land in Montgomery County, Arkansas." *The Arkansas Archeologist* 48:1–14.

———. 2009b. "Extended Entranceway Structures in the Caddo Archaeological Area." *Southeastern Archaeology* 28(1):27–42.

———. 2010. "Woodland and Caddo Ceramic Traditions in East Texas." In *Regional Summaries of Prehistoric and Early Historic Ceramics in Texas for the Council of Texas Archeologists*, edited by Linda W. Ellis and Timothy K. Perttula, 13–41. Austin: Council of Texas Archeologists.

———. 2011. "The Ceramic Artifacts from the Lang Pasture Site (41AN38) and the Place of the Site within an Upper Neches River Basin Caddo Ceramic Tradition." In *Archeological Investigations at the Lang Pasture Site (41AN38) in the Upper Neches River Basin of East Texas*, assembled and edited by Timothy K. Perttula, David B. Kelley, and Robert A. Ricklis, 145–320. Archeological Studies Program Report No. 129. Austin: Texas Department of Transportation, Environmental Affairs Division.

———. 2012a. "The Archaeology of the Caddo in Southwestern Arkansas, Northwest Louisiana, Eastern Oklahoma, and East Texas." In *The Archaeology of the Caddo*,

edited by Timothy K. Perttula and Chester P. Walker, 1–24. Lincoln: University of Nebraska Press.

———. 2012b. "A Caddo Archeology Map." *Caddo Archeology Journal* 22:17–20.

———. 2013. "Caddo Ceramics in East Texas." *Bulletin of the Texas Archeological Society* 84:181–212.

———. 2014. "The Classification of Late Caddo Period Utility Ware Jars from Sites in the Big Cypress Basin of East Texas." *Caddo Archeology Journal* 24:53–74.

———. 2015a. *Caddo Ceramic Vessels from the Goode Hunt (41CS23) and Clements (41CS25) Sites in the East Texas Pineywoods.* Special Publication No. 42. Pittsburg and Austin: Friends of Northeast Texas Archaeology.

———. 2015b. "Diversity in Ancestral Caddo Vessel Forms in East Texas Archaeological Sites." *Journal of Northeast Texas Archaeology* 56:1–19.

———. 2015c. *Caddo Ceramic Vessels from the Hatchel Site (41BW3) on the Red River in Bowie County, Texas.* Special Publication No. 39. Austin and Pittsburg: Friends of Northeast Texas Archaeology.

———. 2016a. "The W. A. Ford Site (41TT2), Titus County, Texas." *Journal of Northeast Texas Archaeology* 60:1–52.

———. 2016b. "Syntheses of the Caddo Archaeological Record." *Caddo Archeology Journal* 26:5–6.

———. 2016c. "Caddo Ceramic Vessels from the Sam Kaufman Site (41RR16) in the R. K. Harris Collection at the National Museum of Natural History, Smithsonian Institution." *Journal of Northeast Texas Archaeology* 70:121–27.

———. 2016d. "Documentation of the Caddo Ceramic Vessels from the Culpepper Site (41HP1) in Hopkins County in the Upper Sulphur River Basin in East Texas." *Journal of Northeast Texas Archaeology* 65:53–98.

———. 2017a. *Specialized Ceramic Analyses of the George C. Davis Site (41CE19) Ceramic Assemblage, Cherokee County, Texas.* Report of Investigations No. 146. Austin: Archeological & Environmental Consultants, LLC.

———. 2017b. *Caddo Landscapes in the East Texas Forests.* Oxford: Oxbow Books.

———. 2017c. "Utility Ware Ceramic Metrics and Hasinai Caddo Archaeology in East Texas." *Journal of Northeast Texas Archaeology* 70:61–68.

———. 2018a. "The Decorated Ceramic Sherds, Plain Rim Sherds, and Clay Pipe Sherds from the Stallings Ranch Site (41LR297), Lamar County, Texas." *Journal of Northeast Texas Archaeology* 78:59–87.

———. 2018b. *Analysis of the Hatchel Site (41BW3) Platform Mound Ceramic Vessels, Vessel Sections, Sherds, Pipes, and Other Clay Artifacts.* Special Publication No. 45. Austin and Pittsburg: Friends of Northeast Texas Archaeology.

———. 2018c. *8th Edition of The Archaeology, Bioarchaeology, Ethnography, Ethnohistory, and History of the Caddo Indian Peoples of Arkansas, Louisiana, Oklahoma, and Texas.* Special Publication No. 51. Austin and Pittsburg: Friends of Northeast Texas Archaeology.

Perttula, Timothy K., ed. 2005. *Archeological Investigations at the Pilgrim's Pride Site (41CP304), a Titus Phase Community in the Big Cypress Creek Basin, Camp County,*

Texas. Report of Investigations No. 30. 2 Vols. Austin: Archeological & Environmental Consultants, LLC.

———. 2008. *Lake Naconiche Archeology, Nacogdoches County, Texas: Results of the Data Recovery Excavations at Five Prehistoric Archeological Sites.* 2 Vols. Report of Investigations No. 60. Austin: Archeological & Environmental Consultants, LLC.

———. 2011. *Archaeological and Archaeogeophysical Investigations at an Early Caddo Mound Center in the Sabine River Basin of East Texas.* Special Publication No. 15. Austin and Pittsburg: Friends of Northeast Texas Archaeology.

Perttula, Timothy K., and Jeffery R. Ferguson. 2010. "The Chemical Variation in Prehistoric and Early Historic Caddo Ceramics in Eastern Texas." In *Studies of on the Instrumental Neutron Activation Analysis of Woodland Period and Caddo Tradition Ceramics from Eastern Texas,* compiled by Timothy K. Perttula, Article 3. Special Publication No. 17. Austin and Pittsburg: Friends of Northeast Texas Archaeology.

Perttula, Timothy K., Marlin F. Hawley, and Fred W. Scott. 2001. "Caddo Trade Ceramics." *Southeastern Archaeology* 20:154–72.

Perttula, Timothy K., P. Shawn Marceaux, and Bo Nelson. 2012. *Study of the Margaret Hinton Collection of Pottery Vessels from Northeast Texas Caddo Cemeteries.* Austin: Archeological & Environmental Consultants, LLC.

Perttula, Timothy K., P. Shawn Marceaux, Bo Nelson, and Mark Walters. 2014. *Caddo Ceramic Vessels from Sites in the Upper Neches River Basin of East Texas, Anderson and Cherokee Counties, Texas.* Special Publication No. 37. Pittsburg and Austin: Friends of Northeast Texas Archaeology.

Perttula, Timothy K., and Paul McGuff. 1985. "Woodland and Caddoan Settlement in the McGee Creek Drainage, Southeast Oklahoma." *Plains Anthropologist* 30(109):219–35.

Perttula, Timothy K., and Mason Miller. 2014. *Archeological Investigations at the Kitchen Branch (41CP220), B. J. Horton (41CP2), and Keering (41CP21) Sites, Big Cypress Creek Basin, Texas.* Final Technical Report of Investigations, No. 88, 2 Vols. Austin: AmaTerra Environment, Inc.

Perttula, Timothy K., and Bo Nelson. 2007. "The Gum Creek Cluster: Protohistoric Caddo Sites in the Little Cypress Creek Basin, ca. 1670–1720." *Journal of Northeast Texas Archaeology* 26:128–35.

———. 2014. "The Millsey Williamson (41RK3), Bead Burial, and L. N. Morwell Farm Sites on Martin Creek: Historic Caddo Settlements along Trammels Trace, Rusk County, Texas." *Journal of Northeast Texas Archaeology* 44:23–46.

Perttula, Timothy K., Bo Nelson, Robert L. Cast, and Bobby Gonzalez. 2010. *The Clements Site (41CS25): A Late 17th to Early 18th-Century Nasoni Caddo Settlement and Cemetery.* Anthropological Papers No. 92. New York: American Museum of Natural History.

Perttula, Timothy K., Bo Nelson, and Mark Walters. 2010. "Documentation of Additional Vessels from the Johns Site (41CP12), Camp County, Texas." *Journal of Northeast Texas Archaeology* 33:93–105.

———. 2012. *Caddo Archaeology at the Henry Spencer Site (41UR315) in the Little Cy-*

press Creek Basin of East Texas. Special Publication No. 20. Pittsburg and Austin: Friends of Northeast Texas Archaeology.

———. 2016. *Caddo Ceramic Vessels from the Paul Mitchell Site (41BW4) on the Red River, Bowie County, Texas.* Special Publication No. 44. Austin and Pittsburg: Friends of Northeast Texas Archaeology.

Perttula, Timothy K., Bo Nelson, Mark Walters, and Robert Cast. 2014. *Documentation of Caddo Funerary Objects from the Crenshaw Site (3MI6) in the Gilcrease Museum Collections.* Special Publication No. 19. Pittsburg and Austin: Friends of Northeast Texas Archaeology.

Perttula, Timothy K., David G. Robinson, and MURR. 2017. *Specialized Ceramic Analyses of the George C. Davis Site (41CE19) Ceramic Assemblage, Cherokee County, Texas.* Report of Investigations No. 146. Austin: Archeological & Environmental Consultants, LLC.

Perttula, Timothy K., and Robert Z. Selden Jr. 2013. "Bibliography on Woodland and Caddo Instrumental Neutron Activation Analysis and Petrographic Analysis Studies in East Texas, Northwest Louisiana, Eastern Oklahoma, and Southwest Arkansas." *Caddo Archeology Journal* 23:93–104.

———. 2014. "Ancestral Caddo Ceramics in East Texas." *Journal of Northeast Texas Archaeology* 48:9–58.

Perttula, Timothy K., and David L. Sherman. 2009. *Data Recovery Investigations at the Ear Spool Site (41TT653), Titus County, Texas.* Document No. 070205. Austin: PBS&J.

Perttula, Timothy K., and Bob D. Skiles. 2014. "Documentation of Late Caddo Period Ceramic Vessels from Sites in the Lake Fork Creek Basin in Wood County, Texas." *Journal of Northeast Texas Archaeology* 48:59–81.

Perttula, Timothy K., Melinda Tate, Hector Neff, James W. Cogswell, Michael D. Glascock, Elizabeth Skokan, Sue Mulholland, Robert Rogers, and Bo Nelson. 1998. *Analysis of the Titus Phase Mortuary Assemblage at the Mockingbird Site, "Kahbakayammaahin" (41TT550).* Document No. 970849. Austin: Espey, Huston and Associates, Inc.

Perttula, Timothy K., Mary Beth Trubitt, and Jeffrey S. Girard. 2011. "The Use of Shell-Tempered Pottery in the Caddo Area of the Southeastern United States." *Southeastern Archaeology* 30(2):242–67.

Perttula, Timothy K., and Mark Walters. 2016a. "Caddo Ceramic Vessels from the Womack Site (41LR1), Lamar County, Texas." *Journal of Northeast Texas Archaeology* 57:1–12.

———. 2016b. "Ceramic Vessels from Caddo Sites in Wood County, Texas." *Journal of Northeast Texas Archaeology* 63:75–131.

Perttula, Timothy K., Mark Walters, Shawn Marceaux, and Bo Nelson. 2009. *Caddo Pottery Vessels and Pipes from Sites in the Middle and Upper Sabine and Upper Neches River Basins, Smith and Wood Counties, Texas.* Special Publication No. 7. Austin and Pittsburg: Friends of Northeast Texas Archaeology.

Perttula, Timothy K., Mark Walters, and Bo Nelson. 2010a. *Caddo Pottery Vessels and Pipes from Sites in the Big Cypress, Sulphur, Neches-Angelina, and Middle Sabine River*

Basins in the Turner and Johns Collections, Camp, Cass, Cherokee, Harrison, Morris, Titus, and Upshur Counties, Texas and Sabine Parish, Louisiana. Special Publication No. 10. Pittsburg and Austin: Friends of Northeast Texas Archaeology.

———. 2010b. *Caddo Pottery Vessels and Pipes from the Johns Site (41CP12) in the Big Cypress Creek Basin in the Turner and Johns Collections, Camp County, Texas.* Special Publication No. 11. Pittsburg and Austin: Friends of Northeast Texas Archaeology.

———. 2012a. "Early 1960s Excavations at the Sam Kaufman Site (41RR16), Red River County, Texas." *Journal of Northeast Texas Archaeology* 36:1–31.

———. 2012b. *Little Cypress Creek Basin Archeology: Six Late Caddo Period Cemeteries in Upshur County, Texas.* Special Publication No. 22. Pittsburg and Austin: Friends of Northeast Texas Archeology.

———. 2016. *Caddo Ceramic Vessels from the T. M. Sander Site (41LR2) on the Red River in Lamar County, Texas.* Special Publication No. 41. Austin and Pittsburg: Friends of Northeast Texas Archaeology.

Perttula, Timothy K., Mark Walters, Kevin Stingley, and Tom Middlebrook. 2017. *Ceramic Vessels and Other Funerary Objects in the Titus Phase Cemetery at the Tuck Carpenter Site, Camp County, Texas.* Special Publication No. 48. Austin and Pittsburg: Fields of Northeast Texas Archaeology.

Perttula, Timothy K., and Chester P. Walker, eds. 2012. *The Archaeology of the Caddo.* Lincoln: University of Nebraska Press.

Perttula, Timothy K., Bill Young, and P. Shawn Marceaux. 2009. "Caddo Ceramics from an Early 18th Century Spanish Mission in East Texas: Mission San Jose de los Nasonis (41RK200)." *Journal of Northeast Texas Archaeology* 29:81–89.

Peterson, Dennis A., J. Daniel Rogers, Don G. Wyckoff, and Karen Dohm. 1993. *An Archeological Survey of the Spiro Vicinity, Le Flore County, Oklahoma.* Archeological Resource Survey Report 37. Norman: University of Oklahoma, Oklahoma Archeological Survey.

Pevarnik, George L. 2007. "A Polarizing View of Middle Woodland Pottery from the Delaware Valley." *Archaeology of Eastern North America* 35:139–51.

Phillips, Philip. 1958. "Application of the Wheat-Gifford-Wasley Taxonomy to Eastern Ceramics." *American Antiquity* 24:117–25.

———. 1970. *Archaeological Survey in the Lower Yazoo Basin, Mississippi, 1949–1955.* Papers of the Peabody Museum of Archaeology and Ethnology, Volume 60. Cambridge: Peabody Museum, Harvard University.

Phillips, Philip, and James A. Brown. 1978–84. *Pre-Columbian Shell Engravings from the Craig Mound at Spiro, Oklahoma.* 6 Vols. Cambridge: Peabody Museum Press.

Phillips, Philip, James A. Ford, and James B. Griffin. 1951. *Archaeological Survey in the Lower Mississippi Alluvial Valley, 1940–1947.* Papers of the Peabody Museum of Archaeology and Ethnology, Volume 25. Cambridge: Harvard University.

Picarella, A. E. 1999. "The Otter Creek Site (34HS25) and the Fourche Maline Phase of Southeastern Oklahoma." *Oklahoma Anthropological Society Bulletin* 48:1–50.

Plog, Stephen. 2008. *Stylistic Variation in Prehistoric Communities: Design Analysis in the American Southwest.* London: Cambridge University Press.

Pluckhahn, Thomas J. 2007. "Reflections on Paddle Stamped Pottery: Symmetry Analysis of Swift Creek Paddle Designs." *Southeastern Archaeology* 26(1):1–11.

Pluckhahn, Thomas J., Rachel E. Thompson, and Kassie Kemp. 2017. "Constructing Community at Civic-Ceremonial Centers: Pottery-Making Practices at Crystal River and Roberts Island." *Southeastern Archaeology* 36(1):110–21.

Pommersheim, Frank. 2009. *Broken Landscape: Indians, Indian Tribes, and the Constitution.* Oxford: Oxford University Press.

Porter, Larry, with contributions by Emily Beahm, Ann M. Early, Elizabeth T. Horton, Lucretia S. Kelly, and Heidi S. Davis. 2016. "Salvage Excavations at the Wild Violet Site, 3Lo226, a Woodland Period Site in Logan County, Arkansas." Report submitted to the U.S. Army Corps of Engineers and the Caddo Nation of Oklahoma, ARPA Permit No. DACW03-4-13-8244. Fayetteville: Arkansas Archeological Survey.

Powell, Mary L., and J. Daniel Rogers. 1980. *Bioarchaeology of the McCutchan-McLaughlin Site.* Studies in Oklahoma's Past 5. Norman: Oklahoma Archeological Survey.

Proctor, Charles. 1953. "Report of Excavations in the Eufaula Reservoir." *Bulletin of the Oklahoma Anthropological Society* 1:43–60.

———. 1957. "The Sam Site, Lf28, of Le Flore County, Oklahoma." *Bulletin of the Oklahoma Anthropological Society* 5:45–91.

Purrington, Burton L. 1971. "The Prehistory of Delaware County, Oklahoma: Cultural Continuity and Change on the Western Ozark Periphery." PhD diss., Department of Anthropology, University of Wisconsin, Madison.

R Development Core Team. 2018. *R: A Language and Environment for Statistical Computing.* Electronic resource, R Foundation for Statistical Computing http://www.R-project.org, accessed October 1, 2018.

Randall, Asa R. 2011. "Remapping Archaic Social Histories along the St. Johns River in Florida." In *Hunter-Gatherer Archaeology as Historical Process,* edited by Kenneth E. Sassaman and Donald H. Holly, 120–42. Tucson: University of Arizona Press.

Ray, Jack H. 2018. "Ear Spools, Ceramics, and Burial Mounds from Southwest Missouri: Caddoan and Spiro Connections on the Northern Frontier." *Southeastern Archaeology* 37:58–81.

Ray, Jack H., and Neal H. Lopinot. 2008. "Late Prehistoric Culture History for Southwest Missouri." *Missouri Archaeologist* 69:57–102.

Regnier, Amanda L. 2013. "The McDonald Site: An Analysis of WPA Excavations at a Caddo Site in the Glover River Drainage, McCurtain County, Oklahoma." *Caddo Archeology Journal* 23:27–66.

———. 2017. "The Relationship between Becoming Caddo and Becoming Mississippian in the Middle Red River Drainage." In *Mississippian Beginnings,* edited by Gregory D. Wilson, 178–202. Gainesville: University of Florida Press.

Regnier, Amanda, and Elsbeth Dowd. 2013. "Exploring Differences in Caddo Mound Ritual in Southeast Oklahoma: The Mountains vs. the Coastal Plain." Paper presented at the Annual Meeting of the Southeastern Archaeological Conference, Tampa, Florida.

Regnier, Amanda L., Scott W. Hammerstedt, and Sheila Bobalik Savage. 2019. *The Ritual Landscape of Late Precontact Eastern Oklahoma: Archaeology from the WPA Era until Today*. Tuscaloosa: University of Alabama Press.

Reid, Kenneth C., and Joe Alan Artz. 1984. *Hunters of the Forest Edge: Culture, Time, and Process in the Little Caney Basin (1980, 1981, and 1982 Field Seasons)*. Tulsa and Norman: Contributions in Archaeology 14, University of Tulsa Laboratory of Archaeology, and Studies in Oklahoma's Past 13, Oklahoma Archeological Survey.

Reilly, F. Kent, III. 2007. "The Petaloid Motif: A Celestial Symbolic Locative in the Shell Art of Spiro." In *Ancient Objects and Sacred Realms: Interpretations of Mississippian Iconography*, edited by F. Kent Reilly III and James F. Garber, 39–55. Austin: University of Texas Press.

———. 2010. "Two-Stepping in the Dance Hall of the Dead: Dance and the Postures and Gestures of Ritual Performance within the Corpus of Craig-A Style Gorgets." Paper presented at the 67th annual meeting of the Southeastern Archaeological Conference. Lexington, KY, October 27–30.

Reilly, F. Kent, III, and James F. Garber, eds. 2009. *Ancient Objects and Sacred Realms: Interpretations of Mississippian Iconography*. Austin: University of Texas Press.

Renfrew, Colin. 2001. "Production and Consumption in a Sacred Economy: The Material Correlates of High Devotional Expression at Chaco Canyon." *American Antiquity* 66(1):14–25.

Reynolds, Matthew D., with contributions by Jeffrey Gaskin, Ankita Kumar, Elayne Pope, Jerome C. Rose, Robert J. Scott, Mary Beth Trubitt, and James C. Tyler. 2007. "Preliminary Report on Salvage Excavations at 3CL593." Limited distribution report submitted to Arkansas Historic Preservation Program, Little Rock. Arkadelphia: Arkansas Archeological Survey, Henderson State University Research Station.

Rice, Prudence M. 1987. *Pottery Analysis: A Sourcebook*. Chicago: University of Chicago Press.

———. 1991. "Specialization, Standardization, and Diversity: A Retrospective." In *The Ceramic Legacy of Anna O. Shepard*, edited by Ronald L. Bishop and Frederick W. Lange, 257–79. Niwot: University of Colorado Press.

Robinson, David G. 2018. *Ceramic Petrography of Fourteen Earthenware Prehistoric Pottery Sherds from 41SJ160, San Jacinto County, Southeast Texas*. Letter Report No. 347. Austin: Archeological & Environmental Consultants, LLC.

Rogers, J. Daniel. 1980. *Spiro Archaeology: 1979 Excavations*. Studies in Oklahoma's Past 6. Norman: Oklahoma Archeological Survey.

———. 1982a. *Spiro Archaeology: 1980 Research*. Studies in Oklahoma's Past 9. Norman: Oklahoma Archeological Survey.

———. 1982b. *Spiro Archaeology: The Plaza*. Studies in Oklahoma's Past 10. Norman: Oklahoma Archeological Survey.

———. 2006. "Chronology and the Demise of Chiefdoms: Eastern Oklahoma in the Sixteenth and Seventeenth Centuries." *Southeastern Archaeology* 25:20–28.

———. 2011. "Spiro and the Development of a Regional Social System." In *Artifacts from the Craig Mound at Spiro, Oklahoma*, edited by April K. Sievert and J. Daniel

Rogers, 1–12. Contributions to Anthropology 49. Washington, DC: Smithsonian Institution.

Rogers, Robert, Maynard B. Cliff, Timothy K. Perttula, Gary Rutenberg, Sally Victor, Phil Dering, and Mary Malainey. 2003. *Excavations at the Alex Justiss Site, 41TT13, Titus County, Texas.* Archeological Studies Program Report No. 36. Austin: Environmental Affairs Division, Texas Department of Transportation, Austin. Document No. 030089. PBS&J.

Rogers, Robert, Michael A. Nash, and Timothy K. Perttula. 2001. *Excavations at the Herman Bellew Site (41RK222), Rusk County, Texas.* Document No. 000021. Austin: PBS&J, Inc.

Rohlf, F. James. 1999. "Shape Statistics: Procrustes Superimpositions and Tangent Spaces." *Journal of Classification* 16(2):197–223.

Rohlf, F. James, and Dennis Slice. 1990. "Extensions of the Procrustes Method for the Optimal Superimposition of Landmarks." *Systematic Zoology* 39(1):40–59.

Rohrbaugh, Charles L. 1972. *Hugo Reservoir 2.* Archaeological Site Report No. 23. Norman: Oklahoma River Basin Survey, University of Oklahoma Research Institute.

———. 1973. *Hugo Reservoir #3: A Report on the Early Formative Cultural Manifestations in Hugo Reservoir.* Archaeological Site Report No. 24. Norman: Oklahoma River Basin Survey Project, University of Oklahoma.

———. 1982. "Spiro and Fort Coffee Phases: Changing Cultural Complexes of the Caddoan Area." PhD diss., Department of Anthropology, University of Wisconsin, Madison.

———. 1983. "The Varieties of Woodward Plain." In *Prairie Archaeology: Papers in Honor of David A. Baerreis,* edited by Guy E. Gibbon, 29–35. Publications in Anthropology 3. Minneapolis: University of Minnesota.

———. 1984. "Arkansas Valley Caddoan: Fort Coffee and Neosho Foci." In *Prehistory of Oklahoma,* edited by Robert E. Bell, 265–85. Orlando: Academic Press.

———. 1985. "LfGeI, The Geren Site, 34LF36, of the Spiro Phase." *Bulletin of the Oklahoma Anthropological Society* 34:9–82.

———. 2012. *Spiro and Fort Coffee Phases: Changing Cultural Complexes of the Caddoan Area.* Memoir 16. Norman: Oklahoma Anthropological Society.

Rohrbaugh, Charles L., Robert J. Burton, Susan S. Burton, and Laura J. Rosewitz. 1971. *Hugo Reservoir I.* Archaeological Site Report No. 22. Norman: Oklahoma River Basin Survey Project, University of Oklahoma.

Rolingson, Martha Ann. 1998. *Toltec Mounds and Plum Bayou Culture: Mound D Excavations.* Research Series No. 54. Fayetteville: Arkansas Archeological Survey.

Rolingson, Martha A., and Frank F. Schambach. 1981. *The Shallow Lake Site.* Research Series No. 12. Fayetteville: Arkansas Archeological Survey.

Rose, Jerome C., Michael P. Hoffman, Barbara A. Burnett, and Anna M. Harmon. 1998. "Skeletal Biology of the Prehistoric Caddo." In *The Native History of the Caddo: Their Place in Southeastern Archeology and Ethnohistory,* edited by Timothy K. Perttula and James E. Bruseth, 113–28. Studies in Archeology 30. Austin: Texas Archeological Research Laboratory, University of Texas at Austin.

Rouse, Irving. 1960. "The Classification of Artifacts in Archaeology." *American Antiquity* 25(3):313–23.

Roux, Valentine. 2003. "Ceramic Standardization and Intensity of Production: Quantifying Degrees of Specialization." *American Antiquity* 68(04):768–82.

Rowe, Simone B. 2014. "Wister Area Fourche Maline: A Contested Landscape." PhD diss., Department of Anthropology, University of Oklahoma, Norman.

Sabo, George. 1998. "The Structure of Caddo Leadership in the Colonial Era." In *The Native History of the Caddo, Their Place in Southeastern Archeology and Ethnohistory*, edited by Timothy K. Perttula and James E. Bruseth, 159–74. Studies in Archeology 30. Austin: Texas Archeological Research Laboratory, University of Texas at Austin.

Sabo, George, III, Ann M. Early, Jerome C. Rose, Barbara A. Burnett, Louis Vogele Jr., and James P. Harcourt. 1990. *Human Adaptation in the Ozark and Ouachita Mountains.* Research Series No. 31. Fayetteville: Arkansas Archeological Survey.

Sahlins, Marshall. 1976. *Culture and Practical Reason.* Chicago: University of Chicago Press.

Samuelsen, John R. 2016. "A reanalysis of strontium isotopes from a skull and mandible cemetery at the Crenshaw site: Implications for Caddo interregional warfare." *Journal of Archaeological Science: Reports* 5:119–34.

Sassaman, Kenneth E. 2004. "Complex Hunter-Gatherers in Evolution and History: A North American Perspective." *Journal of Archaeological Research* 12(3):227–80.

———. 2010. *The Eastern Archaic, Historicized.* Lanham, MD: AltaMira Press.

Saunders, Rebecca, and Margaret Wrenn. 2014. "Crafting Orange Pottery in Early Florida: Production and Distribution." In *New Histories of Pre-Columbian Florida*, edited by Neil J. Wallis and Asa R. Randall, 183–202. Gainesville: University of Florida Press.

Schambach, Frank F. 1971. "Exploratory Excavations in the Midden Areas at the Crenshaw Site, Miller County, Arkansas." Report Submitted to the National Science Foundation in partial fulfillment of NSF Grant No. GS-2684 by the Arkansas Archeological Survey, Fayetteville.

———. 1981. "A Description and Analysis of the Ceramics." In *The Shallow Lake Site*, edited by Frank F. Schambach and Martha A. Rolingson, 101–76. Research Series No. 12. Fayetteville: Arkansas Archeological Survey.

———. 1982a. "An Outline of Fourche Maline Culture in Southwest Arkansas." In *Arkansas Archeology in Review*, edited by Neal L. Trubowitz and Marvin D. Jeter, 132–97. Research Series No. 15. Fayetteville: Arkansas Archeological Survey.

———. 1982b. "The Archeology of the Great Bend Region in Arkansas." In *Contributions to the Archeology of the Great Bend Region*, edited by Frank F. Schambach and Frank Rackerby, 1–11. Research Series No. 22. Fayetteville: Arkansas Archeological Society.

———. 1988. "The Archaeology of Oklahoma." *Quarterly Review of Archeology* 9(4):5–9.

———. 1990a. "The Place of Spiro in Southeastern Prehistory: Is It Caddoan or Mississippian?" *Southeastern Archaeology* 9(1):67–69.

————. 1990b. "The 'Northern Caddoan Area' was not Caddoan." *Caddoan Archeology Newsletter* 1(4):2–6.

————. 1991. "Coles Creek Culture and the Trans-Mississippi South." *Caddoan Archeology Newsletter* 2(3):2–8.

————. 1993. "Some New Interpretations of Spiroan Culture History." In *Archaeology of Eastern North America: Papers in Honor of Stephen Williams*, edited by James B. Stoltman, 187–230. Archaeological Report 25. Jackson: Mississippi Department of Archives and History.

————. 1995. "A Probable Spiroan Entrepot in the Red River Valley in Northeast Texas." *Caddoan Archeology Newsletter* 6(1):9–25.

————. 1996. "Mounds, Embankments, and Ceremonialism in the Trans-Mississippi South." In *Mounds, Embankments, and Ceremonialism in the Midsouth*, edited by Robert C. Mainfort and Richard Walling, 36–43. Research Series No. 46. Fayetteville: Arkansas Archeological Survey.

————. 1998. *Pre-Caddoan Cultures in the Trans-Mississippi South: A Beginning Sequence.* Research Series 53. Fayetteville: Arkansas Archeological Survey.

————. 2000. "Spiroan Traders, the Sanders Site, and the Plains Interaction Sphere: A Reply to Bruseth, Wilson, and Perttula." *Plains Anthropologist* 45(171):17–33.

————. 2001. "Fourche Maline and Its Neighbors: Observations on an Important Woodland Period Culture of the Trans-Mississippi South." *The Arkansas Archeologist* 40:21–50.

————. 2002. "Fourche-Maline: A Woodland Period Culture of the Trans-Mississippi South." In *The Woodland Southeast*, edited by David G. Anderson and Robert C. Mainfort Jr., 91–112. Tuscaloosa: University of Alabama Press.

Schambach, Frank F., and Ann M. Early. 1982. "Southwest Arkansas." In *A State Plan for the Conservation of Archeological Resources in Arkansas*, edited by Hester A. Davis, SW1-SW149. Research Series No. 21. Fayetteville: Arkansas Archeological Survey.

Schambach, Frank F., and John E. Miller. 1984. "A Description and Analysis of the Ceramics." In *Cedar Grove: An Interdisciplinary Investigation of a Late Caddo Farmstead in the Red River Valley*, edited by Neal L. Trubowitz, 109–70. Research Series No. 23. Fayetteville: Arkansas Archeological Survey.

Scholtz, James A. 1986. "Preliminary Testing at the Powell Site, 3CL9: A Temple Mound Site in Clark County, Arkansas." *The Arkansas Archeologist* 23–24:11–42.

Scurlock, J. Dan. 1965. "The Kadohadacho Indians: A Correlation of Archaeological and Documentary Data." Master's thesis, Department of Anthropology, University of Texas, Austin.

Selden, Robert Z., Jr. 2013. "Consilience: Radiocarbon, Instrumental Neutron Activation Analysis, and Litigation in the Ancestral Caddo Region." PhD diss., Department of Anthropology, Texas A&M University, College Station.

————. 2017. "Asymmetry of Caddo Ceramics from the Washington Square Mound Site: An Exploratory Analysis." *Digital Applications in Archaeology and Cultural Heritage* 5:21–28.

————. 2018a. "Ceramic Morphological Organisation in the Southern Caddo Area: Quid-

dity of Shape for Hickory Engraved Bottles." *Journal of Archaeological Science: Reports* 21:884–96.

———. 2018b. "A Preliminary Study of Smithport Plain Bottle Morphology in the Southern Caddo Area." *Bulletin of the Texas Archeological Society* 89:63–89.

———. 2018c. "Historic Caddo Network Analysis Data." Zenodo https://doi.org/10.5281/zenodo.1475091, accessed October 30, 2018.

———. 2019. "Ceramic Morphological Organisation in the Southern Caddo Area: The Clarence H. Webb Collections." *Journal of Cultural Heritage* 35:41–55.

Selden, Robert Z., Jr., John E. Dockall, and Harry J. Shafer. 2018. "Lithic Morphological Organisation: Gahagan Bifaces from the Southern Caddo Area." *Digital Applications in Archaeology and Cultural Heritage* 10:e00080.

Selden, Robert Z., Jr., Timothy K. Perttula, and David L. Carlson. 2014. INAA and the Provenance of Shell-Tempered Sherds in the Ancestral Caddo Region. *Journal of Archaeological Science* 47:113–20.

Selden, Robert Z., Jr., Timothy K. Perttula, and Michael J. O'Brien. 2014. "Advances in Documentation, Digital Curation, Virtual Exhibition, and a Test of 3D Geometric Morphometrics: A Case Study of the Vanderpool Vessels from the Ancestral Caddo Territory." *Advances in Archaeological Practice* 2(2):1–15.

Sharrock, Floyd W. 1960. "The Wann Site, LF27, of the Fourche Maline Focus." *Bulletin of the Oklahoma Anthropological Society* 8:17–47.

Shepard, Anna O. 1956. *Ceramics for the Archaeologist.* Publication 609. Washington, DC: Carnegie Institution of Washington.

———. 1977. *Notes from a Ceramic Laboratory.* Washington, DC: Carnegie Institution of Washington.

Sherratt, Emma, David J. Gower, Christian P. Klingenberg, and Mark Wilkinson. 2014. "Evolution of Cranial Shape in Caecilians (Amphibia: Gymnophiona)." *Evolutionary Biology* 41:528–45.

Sibley, John. 1805. "An Account of the Red River and the Country Adjacent." *American State Papers, Indian Affairs*, Vol. 1, 705–43, Washington, DC.

———. 1922. *A Report from Natchitoches in 1807,* edited by Annie H. Abel. Indian Notes and Monographs, Miscellaneous Series 25:5–102. New York: Museum of the American Indian, Heye Foundation.

Sindbæk, Søren Michael. 2007. "The Small World of the Vikings: Networks in Early Medieval Communication and Exchange." *Norwegian Archaeological Review* 40(1):59–74.

Sinopoli, Carla M. 1988. "The Organization of Craft Production at Vijayanagara, South India." *American Anthropologist* 90(3):580–97.

Skinner, S. Alan, R. King Harris, and Keith M. Anderson, eds. 1969. *Archaeological Investigations at the Sam Kaufman Site, Red River County, Texas.* Contributions in Anthropology No. 5. Dallas: Department of Anthropology, Southern Methodist University.

Slice, Dennis E. 2001. "Landmark Coordinates Aligned by Procrustes Analysis Do Not Lie in Kendall's Shape Space." *Systematic Biology* 50(1):141–49.

Smith, F. Todd. 1995. *The Caddo Indians: Tribes at the Convergence of Empires, 1542–1854.* College Station: Texas A&M University Press.

Smith, Karen Y., and Vernon James Knight Jr. 2014. "Core Elements and Layout Classes in Swift Creek Paddle Art." *Southeastern Archaeology* 33(1):42–54.

Spaulding, Albert C. 1953. "Statistical Techniques for the Discovery of Artifact Types." *American Antiquity* 18:305–13.

Spielmann, Katherine A. 2002. "Craft Specialization, and the Ritual Mode of Production in Small-Scale Societies." *American Anthropologist* 104(1):195–207.

———. 2004. "Communal Feasting, Ceramics, and Exchange." In *Identity, Feasting, and the Archaeology of the Greater Southwest,* edited by Barbara J. Mills, 210–32. Boulder: University Press of Colorado.

———. 2008. "Crafting the Sacred: Ritual Places and Paraphernalia in Small-Scale Societies." *Research in Economic Anthropology* 27:37–72.

Stark, Miriam T. 2006. "Glaze Ware Technology, the Social Lives of Pots, and Communities of Practice in the Late Prehistoric Southwest." In *The Social Lives of Pots: Glaze Wares and Cultural Dynamics in the Southwest, AD 1250–1680,* edited by Judith A. Habicht-Mauche, Suzanne L. Eckert, and Deborah L. Huntley, 17–33. Tucson: University of Arizona Press.

Starr, Joanne DeMaio. 2017. "The Adair Site: Caddo Relations through Ceramic Analysis." *Caddo Archeology Journal* 27:27–35.

Staudek, Tomáš. 1999. *On Birkhoff's Aesthetic Measure of Vases.* FI MU Report Series, FIMU-RS-99-06. Brno: Masaryk University.

Stein, C. Martin. 2012. "Ceramic Artifacts." In *Archeological Investigations at Arkansas City, Kansas,* edited by Robert J. Hoard, 251–328. Contract Archeology Publication 26. Topeka: Kansas Historical Society.

Steponaitis, Vincas P. 2009. *Ceramics, Chronology, and Community Patterns: An Archaeological Study at Moundville.* Tuscaloosa: University of Alabama Press.

Steponaitis, Vincas P., and Vernon J. Knight. 2004. "Moundville Art in Historical and Social Context." In *Hero, Hawk, and Open Hand: American Indian Art of the Ancient Midwest and South,* edited by Richard P. Townsend, 167–206. Chicago and New Haven: Art Institute of Chicago and Yale University Press.

Stokes, Janelle, and Joe Woodring. 1981. "Native-Made Artifacts of Clay." In *Archeological Investigations at the George C. Davis Site, Cherokee County, Texas: Summers of 1979 and 1980,* edited by Dee Ann Story, 135–238. Occasional Papers No. 1. Austin: Texas Archeological Research Laboratory, University of Texas at Austin.

Story, Dee Ann. 1981. "An Overview of the Archaeology of East Texas." *Plains Anthropologist* 26(92):139–56.

———. 1990a. "Cultural History of the Native Americans." In *The Archeology and Bioarcheology of the Gulf Coastal Plain,* by Dee Ann Story, Jan A. Guy, Barbara A. Burnett, Martha D. Freeman, Jerome C. Rose, D. Gentry Steele, Ben W. Olive, and Karl J. Reinhard, 163–366. 2 Vols. Research Series No. 38. Fayetteville: Arkansas Archeological Survey.

———. 1990b. "Excavated Caddoan Sites with Coles Creek Style Ceramics." In *The Ar-*

cheology and Bioarcheology of the Gulf Coastal Plain, by Dee Ann Story, Jan A. Guy, Barbara A. Burnett, Martha D. Freeman, Jerome C. Rose, D. Gentry Steele, Ben W. Olive, and Karl J. Reinhard, 736–48. 2 Vols. Research Series No. 38. Fayetteville: Arkansas Archeological Survey.

———. 1997. "1968–1970 Archeological Investigations at the George C. Davis Site, Cherokee County, Texas." *Bulletin of the Texas Archeological Society* 68:1–113.

———. 1998. "The George C. Davis Site: Glimpses into Early Caddoan Symbolism and Ideology." In *The Native History of the Caddo: Their Place in Southeastern Archeology and Ethnohistory*, edited by Timothy K. Perttula and James E. Bruseth, 9–43. Studies in Archeology 30. Austin: Texas Archeological Research Laboratory, University of Texas at Austin.

———. 2000. "Introduction." In *The George C. Davis Site, Cherokee County, Texas*, by H. Perry Newell and Alex D. Krieger, 1–31. 2nd edition. Washington, DC: Society for American Archaeology.

Story, Dee Ann, Byron Barber, Estalee Barber, Evelyn Cobb, Herschel Cobb, Robert Coleman, Kathleen Gilmore, R. King Harris, and Norma Hoffrichter. 1967. "Pottery Vessels." *Bulletin of the Texas Archeological Society* 37:112–87.

Story, Dee Ann, and Salvatore Valastro Jr. 1977. "Radiocarbon Dating and the George C. Davis Site, Texas." *Journal of Field Archaeology* 4(1):63–89.

Suhm, Dee Ann, and Alex D. Krieger, with the collaboration of Edward B. Jelks. 1954. "An Introductory Handbook of Texas Archeology." *Bulletin of the Texas Archeological Society* 25:1–562.

Suhm, Dee Ann, and Edward B. Jelks, eds. 1962. *Handbook of Texas Archeology: Type Descriptions.* Austin: Special Publication No. 1, Texas Archeological Society, and Bulletin No. 4, Texas Memorial Museum.

Sullivan, Stephanie M., and Duncan P. McKinnon. 2013. "The Collins Site (3WA1): Exploring Architectural Variation in the Western Ozark Highlands." *Southeastern Archaeology* 32(1):70–84.

Supreme Court of the United States. 2017. *Murphy v. Royal*, 866 F.3d 1164, 1233 (10th Cir. 2017) Carpenter v. Murphy, No. 17–1107.

Swanton, John R. 1911. *Indian Tribes of the Lower Mississippi Valley and Adjacent Gulf Coast.* Bulletin No. 43. Washington, DC: Bureau of American Ethnology, Smithsonian Institution.

———. 1928. *Aboriginal Culture of the Southeast.* Bureau of American Ethnology Forty-second Annual Report for 1924–1925, 673–726. Washington, DC: Smithsonian Institution.

———. 1929. *Myths and Tales of the Southeastern Indians.* Bulletin No. 88. Washington, DC: Bureau of American Ethnology, Smithsonian Institution.

———. 1942. *Source Material on the History and Ethnology of the Caddo Indians.* Bulletin 132. Washington, DC: Bureau of American Ethnology, Smithsonian Institution.

———. 1946. *The Indians of the Southeastern United States.* Bulletin No. 137. Washington, DC: Bureau of American Ethnology, Smithsonian Institution.

Thoburn, Joseph B. 1931. "Prehistoric Cultures of Oklahoma." In *Archaeology of the Ar-*

kansas River Valley, edited by Warren K. Moorehead, 53–130. New Haven: Yale University Press.

Thomas, Larissa A., and Jack H. Ray. 2002. "Exchange at the Dahlman Site (23LA250), A Late Prehistoric Neosho Phase Settlement in Southwest Missouri." *Plains Anthropologist* 47:207–29.

Thompson, D'Arcy W. 1917. *On Growth and Form*. Cambridge: Cambridge University Press.

Thurmond, J. Peter. 1985. "Late Caddoan Social Group Identifications and Sociopolitical Organization in the Upper Cypress Basin and Vicinity, Northeastern Texas." *Bulletin of the Texas Archeological Society* 54:185–200.

———. 1990 *Archeology of the Cypress Creek Drainage Basin, Northeastern Texas and Northwestern Louisiana*. Studies in Archeology 5. Austin: Texas Archeological Research Laboratory, University of Texas at Austin.

Topi, John R., Christine S. VanPool, Kyle D. Waller, and Todd L. VanPool. 2017. "The Economy of Specialized Ceramic Craft Production in the Casas Grandes Region." *Latin American Antiquity*:1–21.

Townsend, Richard F., ed. 2004. *Hero, Hawk, and Open Hand: American Indian Art of the Ancient Midwest and South*. New Haven: Yale University Press.

Townsend, Richard P., and Chester P. Walker. 2004. "The Ancient Art of Caddo Ceramics." In *Hero, Hawk, and Open Hand: American Indian Art of the Ancient Midwest and South*, edited by Richard P. Townsend, 231–45. Chicago and New Haven: Art Institute of Chicago and Yale University Press.

Trubitt, Mary Beth. 2009. "Burning and Burying Buildings: Exploring Variation in Caddo Architecture in Southwest Arkansas." *Southeastern Archaeology* 28(2):233–47.

———. 2012. "Caddo in the Saline River Valley of Arkansas: The Borderlands Project and the Hughes Site." In *The Archaeology of the Caddo*, edited by Timothy K. Perttula and Chester P. Walker, 288–312. Lincoln: University of Nebraska Press.

———. 2017. "Effigy Pottery in the Joint Educational Consortium's Hodges Collection." *Caddo Archeology Journal* 27:51–93.

———. 2019a. "Caddo Pottery from Eight Sites in the Middle Ouachita River Valley." *Caddo Archeology Journal* 29:5–194.

———. 2019b. "A Preliminary Comparison of Two Caddo Mound Sites in Southwest Arkansas." *Caddo Archeology Journal* 29:195–204.

Trubitt, Mary Beth, Leslie L. Bush, Lucretia S. Kelly, and Katie Leslie. 2016. "Ouachita Mountains Foodways: Preliminary Results from 2013–2014 Excavations at 3MN298." *Caddo Archeology Journal* 26:50–79.

Trubitt, Mary Beth, and Linda Evans. 2015. "Revisiting a Historic Manuscript: Vere Huddleston's Report on East Place (3CL21) Excavations." *Caddo Archeology Journal* 25:73–144.

Trubitt, Mary Beth, Timothy K. Perttula, and Robert Z. Selden Jr. 2016. "Identifying Ceramic Exchange and Interaction between Cahokia and the Caddo Area." In *Research, Preservation, Communication: Honoring Thomas J. Green on His Retirement*

from the Arkansas Archeological Survey, edited by Mary Beth Trubitt, 87–102. Research Series No. 67. Fayetteville: Arkansas Archeological Survey.

Trubowitz, Neal L., ed. 1984. *Cedar Grove: An Interdisciplinary Investigation of a Late Caddo Farmstead in the Red River Valley*. Research Series No. 23. Fayetteville: Arkansas Archeological Survey.

Tukey, John W. 1962. "The Future of Data Analysis." *The Annals of Mathematical Statistics* 33(1):1–67.

Turner, Ellen Sue, Thomas R. Hester, and Richard L. McReynolds. 2011. *Stone Artifacts of Texas Indians*. Third edition. Lanham, MD: Taylor Trade Publishing.

Turner, Robert L. 1978. "The Tuck Carpenter Site and Its Relation to Other Sites within the Titus Focus." *Bulletin of the Texas Archeological Society* 49:1–110.

Turpin, Solveig A., and James A. Neely. 1977. "An Automated Computer Technique for Vessel Form Analysis." *Plains Anthropologist* 22(78):313–19.

Turpin, Solveig A., Joel Rabinowitz, Jerry Henderson, and Patience E. Patterson. 1976. "A Statistical Examination of Caddoan Vessel Design and Shape from the Ben McKinney Site, Marion County, Texas." *Plains Anthropologist* 21(73):165–79.

United Nations. 2007. Declaration on the Rights of Indigenous Peoples 107th plenary meeting, 13 September 2007 Annex.

Usner, Daniel H. 2003. *American Indians in the Lower Mississippi Valley, Social and Economic Histories*. Lincoln: University of Nebraska Press.

Van Keuran, Scott. 2006. "Decorating Glaze-Painted Pottery in East-Central Arizona." In *The Social Life of Pots: Glaze Wares and Cultural Dynamics in the Southwest, AD 1250–1680*, edited by Judith A. Habicht-Mauche, Susanne L. Eckert, and Deborah L. Huntley, 86–104. Tucson: University of Arizona Press.

VanDevelder, Paul. 2009. *Savages and Scoundrels: The Untold Story of America's Road to Empire through Indian Territory*. New Haven: Yale University Press.

Veatch, Arthur C. 1902. "The Salines of North Louisiana." In *A Report on the Geology of Louisiana*, by Gilbert D. Harris, Arthur C. Veatch, and Jov. A. A. Pacheco, 47–100. Special Report No. 2. Baton Rouge: Louisiana State Experiment Station, Geology, and Agriculture.

Vehik, Rain. 1982. *The Archaeology of the Bug Hill Site (34Pu-116): Pushmataha County, Oklahoma*. Research Series No. 7. Norman: Archeological Research and Management Center, University of Oklahoma.

Vehik, Susan C. 1984. "The Woodland Occupations." In *Prehistory of Oklahoma*, edited by Robert E. Bell, 175–97. Orlando: Academic Press.

Vehik, Susan C., and Richard A. Pailes. 1979. *Excavations in the Copan Reservoir of Northeastern Oklahoma and Southeastern Kansas*. Research Series 4. Norman: University of Oklahoma Archaeological Research and Management Center.

Walker, Leslie. 2014. "Liminal River: Art, Agency, and Cultural Transformation Along the Protohistoric Arkansas River." PhD diss., Department of Anthropology, University of Arkansas, Fayetteville.

Walker, Winslow M. 1935. *A Caddo Burial Site at Natchitoches, Louisiana*. Miscellaneous Collections 94(14):1–15. Washington, DC: Smithsonian Institution.

Wallis, Neil J. 2007. "Defining Swift Creek Interactions: Earthenware Variability at Ring Middens and Burial Mounds." *Southeastern Archaeology* 26(2):212–31.

Wallis, Neil J., Matthew T. Boulanger, Jeffrey R. Ferguson, and Michael D. Glascock. 2010. "Woodland Period Ceramic Provenance and the Exchange of Swift Creek Complicated Stamped Vessel in the Southern United States." *Journal of Archaeological Science* 37:2598–2611.

Wallis, Neil J., Ann S. Cordell, Erin Harris-Parks, Mark C. Donop, and Kristen Hall. 2017. "Provenance of Weeden Island 'Sacred' and 'Prestige' Vessels: Implication for Specialized Ritual Craft Production." *Southeastern Archaeology* 36(1):131–43.

Walters, Mark. 1997. "The Langford Site (41SM197), Smith County, Texas." *Journal of Northeast Texas Archaeology* 9:38–41.

———. 2006. "The Lake Clear (41SM243) Site and *Crotalus horridus atricaudatus*." *Caddoan Archeology Journal* 15:5–41.

Watson, Rachel M. 2015. "Excavations and Interpretation of Two Ancient Maya Salt-Work Mounds, Paynes Creek National Park, Toledo District, Belize." PhD diss., Department of Geography and Anthropology, Louisiana State University, Baton Rouge.

Watt, Frank H. 1953. "Pottery Diffusions of the Central Brazos Valley." *Central Texas Archeologist* 6:57–85.

Webb, Clarence H. 1945. "A Second Historic Caddo Site at Natchitoches, Louisiana." *Bulletin of the Texas Archeological and Paleontological Society* 16:52–83.

———. 1956. "Elements of the Southern Cult in the Belcher Focus." *Southeastern Archaeological Conference Newsletter* 5(1):21–30.

———. 1959. *The Belcher Mound: A Stratified Caddoan Site in Caddo Parish, Louisiana.* Memoirs No. 16. Salt Lake City: Society for American Archaeology.

———. 1963. "The Smithport Landing Site: An Alto Focus Component in DeSoto Parish, Louisiana." *Bulletin of the Texas Archeological Society* 34:143–87.

———. 1978. "Changing Archeological Methods and Theory in the Trans-Mississippi South." In *Texas Archeology: Essays Honoring R King Harris*, edited by Kurt D. House, 27–45. Dallas: Southern Methodist University Press.

———. 1983. "The Bossier Focus Revisited: Montgomery I, Werner, and other Unicomponent Sites." In *Southeastern Natives and Their Pasts*, edited by Don G. Wyckoff and Jack L. Hofman, 183–240. Studies in Oklahoma's Past No. 11. Norman: Oklahoma Archeological Survey.

———. 1984. "The Bellevue Focus: A Marksville-Troyville Manifestation in Northwestern Louisiana." *Louisiana Archaeology* 9:251–74.

Webb, Clarence H., and Monroe Dodd Jr. 1941. "Pottery Types from the Belcher Mound Site." *Bulletin of the Texas Archeological and Paleontological Society* 13:88–116.

Webb, Clarence H., and Hiram F. Gregory. 1986. *The Caddo Indians of Louisiana, Second Edition.* Anthropological Study No. 2. Baton Rouge: Department of Culture, Recreation and Tourism, Louisiana Archaeological Survey and Antiquities Commission.

Webb, Clarence H., and Ralph R. McKinney. 1963. "An Unusual Pottery Vessel from

Mounds Plantation Site, Caddo Parish, Louisiana." *The Arkansas Archeologist* 4(5):1–9.

———. 1975. "Mounds Plantation (16CD12), Caddo Parish, Louisiana." *Louisiana Archaeology* 2:39–127.

Webb, Clarence H., Forrest E. Murphey, Wesley G. Ellis, and H. Roland Green. 1969. "The Resch Site, 41HS16, Harrison County, Texas." *Bulletin of the Texas Archeological Society* 40:3–106.

Weber, J. Cynthia. 1973. The Hays Mound, 3CL6, Clark County, South Central Arkansas. Report on research conducted under cooperative agreement between the National Park Service Southeast Region and the Arkansas Archeological Survey. On file, Arkansas Archeological Survey, Arkadelphia and Fayetteville.

Wedel, Mildred M. 1978. *LaHarpe's 1719 Post on the Red River and Nearby Caddo Settlements*. Bulletin No. 30. Austin: Texas Memorial Museum.

Weinstein, Richard A., and Ashley A. Dumas. 2008. "The Spread of Shell-Tempered Ceramics along the Northern Coast of the Gulf of Mexico." *Southeastern Archaeology* 27(2):202–21.

Weinstein, Richard A., David B. Kelley, and Joe W. Saunders, eds. 2003. *The Louisiana and Arkansas Expeditions of Clarence Bloomfield Moore*. Tuscaloosa: University of Alabama Press.

Weissner, Polly. 1983. "Style and Social Information in Kalahari San Projectile Points." *American Antiquity* 49(2):253–76.

Wentowski, Gloria. 1970. "Salt as an Ecological Factor in the Prehistory of the Southeastern United States." Master's thesis, Department of Anthropology, University of North Carolina, Chapel Hill.

Wheat, Joe B., James C. Gifford, and William W. Wasley. 1958. "Ceramic Variety, Type Cluster, and Ceramic System in Southwestern Pottery Analysis." *American Antiquity* 24:34–47.

Wheatley, David, and Mark Gillings. 2002. *Spatial Technology and Archaeology: The Archaeological Applications of GIS*. London: Taylor and Francis.

Wiewel, Rebecca. 2014. "Constructing Community in the Central Arkansas River Valley: Ceramic Compositional Analysis and Collaborative Archaeology." PhD diss., Department of Anthropology, University of Arkansas, Fayetteville.

Williams, G. Ishmael. 1993. "Features and Dating." In *Caddoan Saltmakers in the Ouachita Valley: The Hardman Site*, edited by Ann M. Early, 37–48. Research Series No. 43. Fayetteville: Arkansas Archeological Survey.

Williams, Mark, and Daniel T. Elliott, eds. 1998. *A World Engraved: Archaeology of the Swift Creek Culture*. Tuscaloosa: University of Alabama Press.

Williams, Stephen. 1964. "The Aboriginal Location of the Kadohadacho and Related Tribes." In *Explorations in Cultural Anthropology*, edited by Ward H. Goodenough, 545–70. New Haven: Yale University Press.

Wilson, Gregory D. 1999. "The Production and Consumption of Mississippian Fine ware in the American Bottom." *Southeastern Archaeology* 18(2):98–120.

Wilson, Katherine. 2018. "The Ceramics of Washington Mounds (3HE35): An Analysis

of Whole Pots and Decorated Ceramic Sherds from an Early to Middle Caddo Mound Site in Southwestern Arkansas." Master's thesis, Department of Anthropology, Texas State University, San Marcos.

Wilson, Rex. 1962. "The A. W. Davis Site, MC-6, of McCurtain County, Oklahoma." *Bulletin of the Oklahoma Anthropological Society* 10:103–52.

Wittry, Warren L. 1952. "The Preceramic Occupation of the Smith Site, Units I and II, Delaware County, Oklahoma." Master's thesis, Department of Anthropology, University of Wisconsin, Madison.

Wolfman, Daniel. 1982. "Archeomagnetic Dating in Arkansas and the Border Areas of Adjacent States." In *Arkansas Archeology in Review,* edited by Neal L. Trubowitz and Marvin D. Jeter, 277–300. Research Series No. 15. Fayetteville: Arkansas Archeological Survey.

———. 1990. "Archaeomagnetic Dating in Arkansas and the Border Areas of Adjacent States—II." In *Archaeomagnetic Dating,* edited by Jeffrey L. Eighmy and Robert S. Sternberg, 237–60. Tucson: University of Arizona Press.

Wood, W. Raymond. 1963. *The Denham Mound: A Mid-Ouachita Focus Temple Mound in Hot Spring County, Arkansas.* Anthropology Series No. 1. Fayetteville: University of Arkansas Museum.

———. 1981. "The Poole Site, 3GA3, With New Foreword and Summary by Ann M. Early." *The Arkansas Archeologist* 22:7–65.

———. 1999. "The Jaguar Gorget: The Missouri State Artifact." *Missouri Archaeological Quarterly* 16(2):8–11.

Woodall, J. Ned. 1969. *Archeological Excavations in the Toledo Bend Reservoir, 1966.* Contributions in Anthropology No. 3. Dallas: Department of Anthropology, Southern Methodist University.

Worth, John E. 2017. "What's in a Phase: Disentangling Communities of Practice from Communities of Identity in Southeastern North America." In *Forging Southeastern Identities: Social Archaeology, Ethnohistory, and Folklore of the Mississippian to Early Historic South,* edited by Gregory A. Waselkov and Marvin T. Smith, 118–57. Tuscaloosa: University of Alabama Press.

Wright, Alice P. 2014. "History, Monumentality, and Interaction in the Appalachian Summit Middle Woodland." *American Antiquity* 79(2):277–94.

Wyckoff, Don G. 1964. "The Jug Hill Site, My18, Mayes County, Oklahoma." *Bulletin of the Oklahoma Anthropological Society* 12:1–54.

———. 1965a. *The Biggham Creek Site of McCurtain County, Oklahoma.* Archaeological Site Report No. 3. Norman: Oklahoma River Basin Survey Project, University of Oklahoma.

———. 1965b. *The Hughes, Lamas Branch, and Callaham Sites, McCurtain County, Southeast Oklahoma.* Archaeological Site Report No. 4. Norman: Oklahoma River Basin Survey Project, University of Oklahoma Research Institute.

———. 1967a. *The E. Johnson Site and Prehistory in Southeast Oklahoma.* Archaeological Site Report No. 6. Norman: Oklahoma River Basin Survey Project, University of Oklahoma.

———. 1967b. *The Archaeological Sequence in the Broken Bow Reservoir Area McCurtain County, Oklahoma.* Norman: University of Oklahoma Research Institute.

———. 1968a. *The Beaver Site and Archaeology of the Broken Bow Reservoir Area, McCurtain County, Oklahoma.* Archaeological Site Report No. 9. Norman: Oklahoma River Basin Survey, University of Oklahoma Research Institute.

———. 1968b. *The Prehistoric Site of Spiro, LeFlore County, Oklahoma: Its Archaeological Significance and Developmental Potential.* Norman: Oklahoma Archeological Survey.

———. 1970a. "Archaeological and Historical Assessment of the Red River Basin in Oklahoma." In *Archeological and Historical Resources of the Red River Basin, Louisiana, Texas, Oklahoma, Arkansas,* edited by Hester A. Davis, 69–134. Research Series No. 1. Fayetteville: Arkansas Archeological Survey.

———. 1970b. *A Preliminary Report on 1970 Field Research at the Spiro Site, LeFlore County, Oklahoma.* Norman: Oklahoma Archeological Survey.

———. 1970c. *The Horton Site Revisited: 1967 Excavations at SQ11, Sequoyah County, Oklahoma.* Studies in Oklahoma's Past 1. Norman: University of Oklahoma, Oklahoma Archeological Survey.

———. 1980. "Caddoan Adaptive Strategies in the Arkansas Basin, Eastern Oklahoma." PhD diss., Department of Anthropology, Washington State University, Pullman.

———. 1984. "The Foragers: Eastern Oklahoma." In *Prehistory of Oklahoma,* edited by Robert E. Bell, 119–60. Orlando: Academic Press.

Wyckoff, Don G., and Thomas P. Barr. 1964. *1963 Archaeological Activity in the Markham Ferry Reservoir Area, Mayes County, Oklahoma.* General Survey Report 4. Norman: Oklahoma River Basin Survey, Norman.

———. 1967. "The Cat Smith Site: A Late Prehistoric Village in Muskogee County, Oklahoma." *Bulletin of the Oklahoma Anthropological Society* 15:81–106.

Wyckoff, Don G., and Timothy G. Baugh. 1980. "Early Historic Hasinai Elites: A Model for the Material Culture of Governing Elites." *Midcontinental Journal of Archaeology* 5:225–88.

Wyckoff, Don G., and Linda R. Fisher. 1985. *Preliminary Testing and Evaluation of the Grobin Davis Archeological Site, 34MC253, McCurtain County, Oklahoma.* Archeological Resources Survey Report No. 22. Norman: Oklahoma Archeological Survey.

Wyckoff, Don G., Philip Robison, and Thomas P. Barr. 1963. *The Archaeological Resources of the Markham Ferry Reservoir Area, Mayes County, Oklahoma.* General Survey Report 1. Norman: Oklahoma River Basin Survey.

Zelditch, Miriam Leah, Donald L. Swiderski, H. David Sheets, and William L. Fink. 2004 *Geometric Morphometrics for Biologists: A Primer.* Burlington: Elsevier Science.

CONTRIBUTORS

Chase Kahwinhut Earles is a working artist who was born in Oklahoma. He creates his tribe's traditional pottery to help educate and carry on the Caddo culture. This method of pottery making includes digging up the clay and mussel shell temper in the homelands near the Red River, coiling the pot without a wheel, burnishing it to a shine with a rock, pit-firing the pieces in an open bonfire without a kiln, and engraving our ancient designs after firing. Earles considers it critical that Caddo artists like himself preserve the old ways of creating pottery while making new contemporary pieces so others will know the beauty and vitality of the Caddo artistic ceramic legacy. His hope is to bring an almost lost and forgotten pottery identity back into the forefront where it once was in pre- and post-Columbian times. Nonetheless, he feels his tribe's representation and communication through the design and creation of pottery would have evolved over time and with the introduction of new situations and environments. For that reason he also strives to present a new ceramic and sculptural interpretation from his own experiences as an artist and as an ambassador to the Caddo tribe and its ancient cultural identity.

Ann M. Early is the Arkansas state archeologist. She served for twenty-six years as the Arkansas Archeological Survey's Henderson State University regional archeologist. Her research interests include the grammar of Caddo ceramic design, and the development and character of the Caddo tradition in the Trans-Mississippi South. She has directed several archaeological projects at Caddo tradition sites and has written or edited *Standridge: Caddoan Settlement in a Mountain Environment* (1988), *Caddoan Saltmakers in the Ouachita Valley: The Hardman Site* (1993), *Forest Farmsteads: A Millenium of Human Occupation at Winding Stair in the Ouachita Mountains* (2000), and other book chapters and monographs.

Paul N. Eubanks is an assistant professor of anthropology at Middle Tennessee State University. He received his BA from the University of North Carolina at Chapel Hill and his MA and PhD from the University of Alabama. He specializes in the archaeology and history of the southeastern United States and has excavated at salt and mineral springs in Louisiana and Tennessee.

Ross C. Fields is president of Prewitt and Associates, Inc., Austin, Texas. He has an MA from the University of Texas at Austin and has participated in research in the Caddo area since 1975. His most recent efforts stemmed from two large-scale excavation projects in the Sabine River and Cypress Creek basins in northeastern Texas.

Eloise Frances Gadus is a senior archeologist for Prewitt and Associates, Inc., a cultural resource management company based in Austin, Texas. Over her thirty-two years with the company, she has led testing and data recovery investigations at a range of archaeological sites dating to the Archaic, Woodland, Mississippian (Caddo), and Historic American cultural periods. Her interest and expertise in ceramic technology was fostered during investigations at many East Texas Caddo sites. Her interest in the iconography of prehistoric eastern Woodland peoples began as a research associate with the Cleveland Museum of Natural History where she worked on Ohio Hopewell sites. She received her undergraduate degree from Cleveland State University while at the Museum and graduate studies at the University of Florida before joining Prewitt and Associates.

Jeffrey S. Girard has worked as a regional archaeologist for the Louisiana Division of Archaeology and is a research professor at Northwestern State University of Louisiana. He has an MA from the University of Texas at Austin and has conducted research in the Caddo Area for more than forty years. Girard is the author of *The Caddos and Their Ancestors, Archaeology and the Native People of Northwest Louisiana* (Louisiana State University Press, 2018), and co-author of *Caddo Connections: Cultural Interactions within and beyond the Caddo World* (Rowman & Littlefield, 2014).

Scott W. Hammerstedt is a senior researcher at the Oklahoma Archeological Survey, University of Oklahoma. He received his PhD from Pennsylvania State University and researches the archaeology of what is now the southeastern and midwestern United States, with interests in social organization, monumental architecture, experimental archaeology, ceramic analysis, landscape archaeology, and archaeological geophysics and a focus on late precontact (ca. AD 1000–1500) Mississippian and ancestral Caddo people. Current projects include geophysical survey and excavations at Spiro as well as analysis of museum collections from related mound sites in eastern Oklahoma.

David Kelley is the director of the Cultural Resources Division of Coastal Environments, Inc. He received a BA in anthropology from the University of Kansas in 1975 and a PhD in anthropology from Tulane University in 1990. Prior to joining CEI, he worked for the Arkansas Archeological Survey on a number of excavations

in the 1970s and as a field assistant at its research station in Magnolia, Arkansas. Much of his research has focused on the Caddo Area in southwestern Arkansas and northwestern Louisiana. Publications in that area include *Two Caddoan Farmsteads in the Red River Valley: The Archeology of the McLelland and Joe Clark Sites* (Arkansas Archeological Survey Research Series 51, 1997); "Site Preservation along an Active Meandering and Avulsing River: The Red River, Arkansas" [with M. J. Guccione, Michael C. Sierzchula, and Robert H. Lafferty] (*Geoarchaeology* 1998); "The Burnitt Site (16SA204): A Late Caddoan Occupation in the Uplands of The Sabine River Basin" (*Louisiana Archaeology* 2010); and "The Belcher Phase: Sixteenth- and Seventeenth-Century Occupation of the Red River Valley in Northwest Louisiana and Southwest Arkansas" in *The Archaeology of the Caddo* (University of Nebraska, 2012). Dr. Kelley is interested in zooarchaeology. His dissertation concerned Coles Creek period faunal exploitation in the Ouachita River valley in southern Arkansas. An article based on that research was published in *Midcontinental Journal of Archaeology* in 1992.

Shawn P. Lambert is an assistant professor of anthropology at Mississippi State University and senior research associate with the Cobb Institute of Archaeology. His research involves the archaeology of the Southeast and public and collaborative archaeology with a focus on late pre- and post-Columbian ceramics as part of understanding complex social histories of development and the transformation of regional and interregional communities.

Patrick C. Livingood is an associate professor of anthropology at the University of Oklahoma with interests in the archaeology of the ancestral Caddo in eastern Oklahoma and adjacent states as well as the archaeology of the broader Mississippian world. He is the author of *Mississippian Polity and Politics on the Gulf Coastal Plain: A View from the Pearl River, Mississippi* and coeditor of *Plaquemine Archaeology*.

Duncan P. McKinnon is an associate professor of anthropology at the University of Central Arkansas, director of the Jamie C. Brandon Center for Archaeological Research, and research associate at the Center for American Archeology. He has a PhD from the University of Arkansas. His research focus is spatial dynamics and landscape archaeology of southeastern Native peoples. Projects include architectural variation and the organization and use of space and distributional analyses of Caddo art and ceramics. He has contributed chapters to *The Archaeology of the Caddo* (University of Nebraska Press, 2012), *Historical Archaeology of Arkansas: A Hidden Diversity* (University of Nebraska Press, 2016), and *Reconsidering Mississippian Households and Communities* (University of Alabama Press, 2021). He has several chapters and is co-editor of *Archaeological Remote Sensing in North America:*

Innovative Techniques for Anthropological Applications (with Bryan S. Haley, University of Alabama Press, 2017) and authored the book *The Battle Mound Landscape: Exploring Space, Place, and History of a Red River Caddo Community in Southwest Arkansas* (Arkansas Archeological Survey Research Series, 2017).

Timothy K. Perttula is the owner and manager of Archeological & Environmental Consultants, LLC, Austin, Texas and has a PhD from the University of Washington. He specializes in the archaeology and history of the Caddo peoples and has authored or edited several books on the archaeology of the Caddo, including "*The Caddo Nation*" (University of Texas Press, 1992, 1997 editions), *Prehistory of Texas* (Texas A&M University Press, 2004, 2011 editions), *The Archaeology of the Caddo* (co-edited with Chester P. Walker, University of Nebraska Press, 2012), *Caddo Connections* (with Jeffrey S. Girard and Mary Beth Trubitt, Rowman & Littlefield, 2014), and *Caddo Landscapes in the East Texas Forests* (Oxbow Books, 2017).

Jeri Redcorn is a Caddo ceramics artist with a Master's in Educational Administration from Pennsylvania State University. She has been a council member for the Caddo Nation of Oklahoma and is involved in tribal and community affairs. Jeri lectures and conducts workshops on Caddo pottery.

Amanda L. Regnier is the director of the Oklahoma Archeological Survey at the University of Oklahoma. Her research interests include the ritual and social lives of the Caddo in the Red River valley, the archaeology of Spiro and related mound sites in the Arkansas drainage, nineteenth-century Cherokee and Choctaw archaeology of eastern Oklahoma, and European Contact period archaeology of central Alabama. She is the author of *Reconstructing Tascalusa's Chiefdom: Pottery Styles and the Social Composition of Late Mississippian Communities along the Alabama River* (University of Alabama Press, 2014) and co-author of *The Ritual Landscape of Late Precontact Eastern Oklahoma: Archaeology from the WPA Era until Today* (University of Alabama Press, 2019).

David Glen Robinson received his education in anthropology at the University of Oklahoma and obtained his PhD at the University of Texas at Austin. His research and fieldwork has been in the south central and southwestern United States with an emphasis on Texas and a concentration on settlement archeology, aboriginal rock art, and ceramic analysis. Since the early 1990s, he has specialized in ceramic petrography and has numerous publications in that field. His continuing work in ceramic research design has been to develop methods for gaining more precise insights on the archaeological record, especially in combination with instrumental neutron activation analysis, X-ray diffraction, and other technologies.

Sheila Bobalik Savage is an affiliated researcher at the Oklahoma Archeological Survey with a PhD from the University of Oklahoma. She has worked in the central and southern plains as well as the woodlands of eastern Oklahoma. Her interests include zooarchaeology, lithic analysis, plains-woodland exchange networks, changing settlement-subsistence systems after AD 1250, landscape archaeology, iconography, and the myths and traditions of Caddoan-speaking groups.

Robert Z. Selden Jr. (PhD, Texas A&M University, 2013) is a research associate in the Heritage Research Center at Stephen F. Austin State University, a research fellow in the Virtual Curation Laboratory at Virginia Commonwealth University, and an associate professor in the Cultural Heritage Department at Jean Monnet University (FR). He currently serves as the director of the Index of Texas Archaeology and moderator of SocArXiv. His research is focused at the confluence of archaeology, computer science, engineering, art, and the humanities. Research interests include open science, reproducible research, computational methods, archaeological theory, archaeological epistemology, scientometrics, and historic biogeography.

Mary Beth D. Trubitt is a station archeologist at the Arkansas Archeological Survey's Henderson State University Research Station in Arkadelphia. Her research on craft production and exchange in Arkansas ranges from Archaic period stone tools to Caddo period ceramics. She has developed the "Arkansas Novaculite: A Virtual Comparative Collection" website (http://archeology.uark.edu/novaculite/index.html), co-authored *Caddo Connections: Cultural Interactions within and beyond the Caddo World* (2014), edited *Research, Preservation, Communication: Honoring Thomas J. Green on his Retirement from the Arkansas Archeological Survey* (2016), and authored *Ouachita Mountains Archeology* (2019).

INDEX